An Artist in America

AN ARTIST

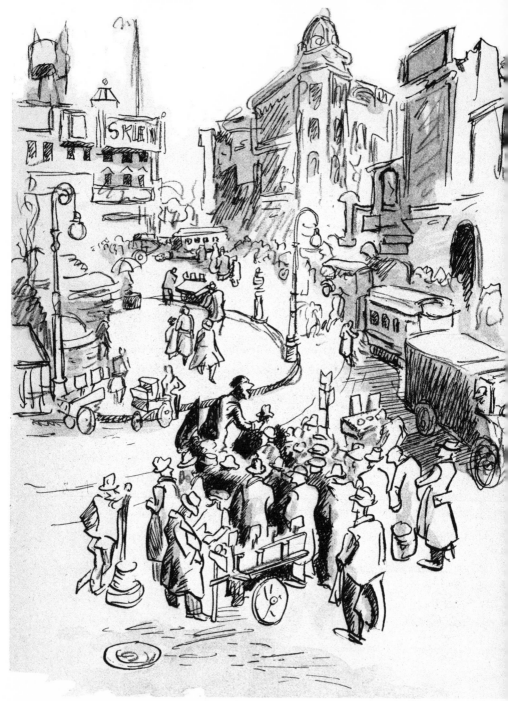

IN AMERICA

Thomas Hart Benton

FOURTH REVISED EDITION

University of Missouri Press

Columbia & London, 1983

Fourth revised edition
© 1983 by the Curators of the University of Missouri
University of Missouri Press, Columbia, Missouri 65211
Library of Congress Catalog Card Number 82–20279
Printed and bound in the United States of America

Library of Congress Cataloging in Publication Data

Benton, Thomas Hart, 1889–1975.
 An artist in America.
 1. Benton, Thomas Hart, 1889–1975. 2. Painters—
United States—Biography. I. Title.
ND237.B47A2 1983 759.13 [B] 82–20279
ISBN 0–8262–0394–9
ISBN 0–8262–0399–X (pbk.)

To T. P.

Who said when Rita corrected his manners,
I don't want to be a gentleman when I grow up.
I want to be like my Dad.

Publisher's Preface

The first edition of Thomas Hart Benton's autobiography, *An Artist in America*, was published in 1937. Two subsequent editions included substantial additional contributions by Benton himself. Since both editions (now out of print) were published long before his death in 1975, since Benton was professionally active until his death, and since there has been a continued interest in his life and work, a new edition is long overdue.

Unfortunately, no final statement from Benton that would finish his narrative could be found. But with the assistance and encouragement given us by a number of people, the publication still speaks for him.

In particular, we would like to thank Lyman Field, a long-time friend of Benton, and The Thomas Hart Benton and Rita P. Benton Testamentary Trusts for permission to reproduce the text and for assistance in acquiring the best possible reproduction of the art; David Miller and Stephen Campbell of the United Missouri Bank of Kansas City for their patience and assistance on the project; Matthew Baigell for providing the foreword and afterword; Osmund Overby, Sidney Larson, and James Bogan for their many suggestions and ideas; Marilyn Florek at the Archives of American Art for assisting us in our attempts to locate any new material; and Russ Nall for taking photographs that added much to the quality of the art in this volume.

Contents

List of Illustrations

LIST OF ILLUSTRATIONS

Foreword to the Fourth Edition

by Matthew Baigell

This is clearly a book that will not disappear. When it was first published in 1937, Thomas Hart Benton was one of the best known artists in the United States—loved, hated, certainly controversial, but well known. When the second edition appeared in 1951, the kind of subject matter Benton preferred and the attitudes toward art he represented had fallen into disfavor in the art world. Aware of his loss of stature and importance, Benton added a chapter written as if in retirement. Clearly defensive, he explained as carefully as possible the intentions of his art and those of Grant Wood and John Steuart Curry, two artists with whom he had been associated. The added chapter seemed to be nothing less than a swan song, the final public appearance of an old warrior recounting earlier battles and trying to set the record straight. The third edition, published in 1968, might have come as a surprise to many. In an additional chapter written for this edition, Benton described how he had adjusted to the contemporary art scene. He also indicated, in enumerating his mural commissions, that he had not been forgotten or even neglected, only that he was no longer at the cutting edge of advance movements. Continued interest in his work indicated that figurative art still appealed to a vast and perhaps even growing audience. Neither he nor it should be overlooked or forgotten.

Through the 1970s and 1980s, the audience for figurative art did grow appreciably, and Benton came to be viewed less as a still active (until his death in 1975) but no longer significant artist than as a survivor whose work and attitudes might have some relevance to recent art. Dispassionate attempts could now be made to locate his

art in the broad stream of American cultural history, especially since the partisan polemics of the 1930s had been softened and altered by the passing of the decades. And, not least, Benton's art could also be enjoyed and studied for its intrinsic qualities, regardless of one's politics.

In effect, the past had changed, and this book, once a partisan declaration of a middlewestern artist, then an elegiac testament by an artist whose time had passed, then a description of the way at least one artist had searched for subject matter and felt about his country, also became a cultural document asserting a once popular aesthetic position that, in very modified form, had become popular again. In its last incarnation, as an important cultural document of a particular period and as the statement of a figurative artist, the book claims our attention today and has prompted the publisher to bring out a fourth edition. Whether this will be the final edition or not is, of course, unknown, but it is certainly welcome and contributes as much to the cultural history of the 1930s as to the cultural history of the 1980s. Benton's comments in yet another chapter would have been wonderful to read, but he died before another edition was thought possible. He did have occasion to say, however, that he felt vindicated by renewed interest in his art, especially by young people who found his incident-filled paintings enchanting. Most important, he hoped that the public would finally come to understand what he had attempted in his art.

What did he attempt and what is his position today? There is certainly no single or right answer to this question. The Americanist content of his art will always produce arguments: many who understand his intentions will always disagree with them. His popularity as a figurative artist will depend on the popularity of representational art at a given moment. And the respect for his art generated by his meticulous technique will depend on interest or disinterest in the craft of art-making. In short, Benton's reputation will probably always fluctuate. Today, it is on the rise.

His place within the broad history of American art is assured, if still

inconclusive. From the early years of the Republic to the middle twentieth century, artists had wanted an art that would be understandable to the public, that could be used as an educational or communicative instrument, and that might reflect the developing American character. These artists, and we might include John Trumbull, Samuel F. B. Morse, Thomas Eakins, and Robert Henri among them, sought the development of an American art distinct from European art. Benton joined this group because of his clearly stated desire to promote an identifiable American art. He sought, as he often said, a subject matter that would have as many meanings as possible for as many Americans as possible. Since Benton acknowledged and accepted the fact that the nation's rural past heavily influenced American experiences, his subject matter, although not always rural, was influenced by rural views. One question immediately prompted by Benton's position is this—is a strong rural influence appropriate in a modern artist? Or, to say it differently, do we regard Benton as a nineteenth- or a twentieth-century artist? Our answers depend upon our attitudes toward urbanization, industrialization, standardization, and centralization and the ways we want to advance or control them. To make definitive statements is presumptuous, but one's position on these matters certainly affects one's attitude toward Benton. His rising popularity, therefore, might be an index of disenchantment with modern American life.

Just as his feelings for the development of an American art derived from essentially nineteenth-century sources, so his aesthetic theories grew from earlier stated positions. In fact, as much as any artist, Benton represents an aesthetic position antithetical to modernism. For him, great art did not necessarily evolve from earlier art, from philosophical systems or abstract speculations. Instead, it developed from the influences of the environment on the artist, his character, taste, and style. In this regard, he seems to be the last in the line of nineteenth-century figures who acknowledged environmental factors as significant for artistic creation. Beginning with the associational psychologists in the early nineteenth century, whose ideas concerning en-

vironmental influences on the development of a unique American character became part of the texture of American thought, down to the environmentalist theories elaborated by Hippolyte Taine in the later part of the century, artists and critics alike recognized the aesthetic importance of the environment—geography, culture, race—on the creation of a work of art. Benton, who admired Taine and admitted to his influence upon his thinking, clearly tried to develop an art based on this point of view. Benton hoped that American experiences and the American character would find expression through his work. It should be mentioned here in all fairness to Benton that several of his contemporaries, John Sloan and Edward Hopper among them, also subscribed to environmentalist theories, but only Benton programmatically sought to create an American art based on them.

Questions immediately arise here, too. Was Benton's position the last gasp of an outmoded aesthetic or part of a continuing dialogue with other systems of thought? Again, definitive statements are presumptuous, but one's feelings for Benton's art are certainly colored by one's position on environmentalist art theories.

Concerning the decades of the 1920s and 1930s, Benton's years of greatest importance, all would agree that he created a style and explored a range of subject matter that he hoped was American and that he articulated his ideas clearly and cogently in a variety of publications including his autobiography. But the question still remains— how do we view his achievement? Again, that depends upon our attitudes toward a variety of factors that make up his art. Should an artist work against or with tradition? Should art be informed by environmentalist or other aesthetic theories? What is the value of nationalism in art? How should we judge artists who work with national and regional myths and paint what they think are regional, ethnic, or racial types? How can we separate aesthetic from political concerns in Benton's work? Should we?

All the worst and all the best motivations were assigned to Benton's art during the interwar decades, and no other artist was as praised and condemned as he. No other artist carried such a heavy burden,

testimony to his importance as a symbol of all that was either good or bad in American art and culture. Looking back from the 1980s, we can say with less approbation and less rancor than was possible at an earlier time that he was indeed an artistic nationalist, but that he was not blind to the nation's faults. In fact, some of his paintings, including the mural cycle in the Missouri State Capitol Building in Jefferson City, are as critical, even vitriolic, as those of any other artist. But his criticisms came from within the system. He condemned as an American. He found abuses and irregularities in government and in the quality of American life that departed from his ideal vision for this nation, not from a theory of class structure. And his vision was essentially a nineteenth-century one—that of the independent, self-contained, and self-supporting individual living in harmony with his neighbor. Where another artist might have sought to contain Big Business with Big Labor, Benton preferred the dismantling of both and the return to a virtually preindustrial economy. Where another person might have preferred governmental intervention to protect people, Benton hoped for greater self-regulation. If in the 1930s Benton's love-of-country was thought to carry nationalist overtones because of his emphasis on specifically American experiences, we might say today instead that he was less a nationalist than an irretrievably out-of-date Jeffersonian adrift in the twentieth century. Although he knew that such a position was really a hopeless one, he nevertheless held to it as representing the American ideal. In this regard, he joins company with artists such as John Trumbull and Thomas Cole whose concerns for the survival of the nation and the perpetuation of its republican (small "r") institutions are apparent in their work.

These thoughts are enumerated here in very compressed fashion, but it is important to realize that the works and ideas of very few other American artists, in their changing relationships to American cultural and artistic history, merit such close scrutiny. For students of cultural and artistic history, Benton is a gold mine. For those interested in American as well as contemporary art, Benton's work is fascinating.

The revived interest in figurative art has certainly encouraged us to look once again at his paintings as well as at those of many figurative artists of the last hundred years whose works do not fit the canons of modernist taste. These artists are being studied and admired with their own aims and intentions in mind, in terms of the ways in which their art reflects a variety of cultural attitudes, and, not least, for the visual pleasures their works provide. No doubt, several artists have regained popularity because a strong and coherent sense of abstract composition, which might not have been so evident earlier, now appears to underline their representative imagery. This, I believe, has helped restore Benton's reputation as an *artist*. A modernist until about 1918, he never lost his skill or desire to provide a logical and legible abstract format for his works. It is true that he admitted discomfort with modernism, and this might be the case if we read abstraction for modernism, but his sense of composition was very modern in his ability to correlate forms and colors across a picture's entire surface and to integrate two-dimensional and three-dimensional patterns. In this regard, he should be linked with Edward Hopper, whose figurative paintings reveal an extraordinary grasp of the principles of modern composition.

In a typical Benton painting, for example, directional movements that start along the edges of one form are carried across a picture's surface through other forms and even colors. These movements establish a loose interlocking network of two-dimensional patterns that form a type of abstract composition complimentary to the subject matter. The human figure, which Benton painted with obvious enjoyment, rarely, if ever, pulls away from the canvas surface but, rather, through an emphasis on contours and the discreet flattening of various body parts, maintains a two-dimensional identity and remains incorporated within the overall design. This is not easy to do, especially since Benton was also so seriously concerned with subject matter. In recent years, then, Benton has emerged as a surprisingly interesting— and modern—figure painter.

In the past, both his painting technique and his figural placement

were considered crude, if not brutish, probably because his paintings were read primarily for content. But just as the surfaces of, say, Jackson Pollock's drip paintings now appear handsome rather than aggressive and ugly, so Benton's surfaces have grown delicate and refined over the decades. In fact, studying a painting by Benton at close range is often shocking because one does not expect the subtle nuances of color and stroke. A knuckle-bending, rather than a wrist or elbow-swinging, painter, he created surfaces covered by innumerable tiny strokes. An ostensibly green field might be really flooded with barely visible yellows and oranges, the blades of grass finished with feathery strokes of wonderfully irregular variety. Clearly, he was an artist with immense technical control, and if at times he wrote and acted like a cowboy, he did not paint like one.

Although the recent interest in figurative painting has brought renewed popularity to Benton's work, the artist's relationship to contemporary figurative painters is a curious one. Few, if any, are interested in the kind of content for which he is best known, nor are they concerned with developing a style that reflects the kind of dynamism Benton found in American life. Probably none would accept his mantle as an Americanist.

The "cowboy" artists of the southwest who paint scenes of Indian and cowboy life are antiquarians and, in glossing over the crudities of past and present life in the west, create idealized scenes that Benton probably would not have found acceptable. For Benton's vision and art were based on what he saw and experienced, and it was not in his nature to idealize a subject if in his view it required harsh criticism.

Photo-realists do paint the American scene, but they do so because their photographic sources are of American scenes. Their paintings of the highway culture and of urban and suburban scenes carry no didactic intent, nor do they seem to carry specific American meanings. Compared to Benton, photo-realists present their images in deadpan fashion. In addition, these are much more precise and realistic than Benton's because they are based on photographs.

Other contemporary figurativists include, without any firm lines

distinguishing one from the next, those who are essentially studio painters and those who do paint with didactic intent. The former use posed models, and, even when content is implied or apparent, formal arrangements as well as color and textural relationships are of paramount concern. Those for whom content is important usually hold a moral position in regard to human activity, be it political, personal, or otherwise, and might be termed enlightened humanists rather than Americanists. The more politically inclined comment through their art on various governmental policies and societal situations in this country from a critical perspective, and they might point out unpleasant, not to say horrific, activities and circumstances abroad, as well. Some, such as the painters of ghetto walls, paint from a special range of experience. Regardless of their backgrounds, however, virtually all of these artists do not identify themselves as American painters dealing with American experiences, but as individuals expressing approval or outrage. They are more concerned with subject matter found in America than with an American subject matter.

Yet these are the artists with whom Benton has most in common even though they are more concerned with the human than with the American condition. For them, art serves a public purpose. It is to be used as a moral force, an instrument to advance an argument and to describe a condition. Benton's renewed popularity perhaps owes more to the presence of these artists than to other figurativists, or, rather, to the climate of opinion that encourages these artists to create their public-spirited works. Whether they agree with, or are even aware of, the premises of Benton's art is not as relevant as their shared belief in the public meaning of art. And since today we can discuss Benton's art in this dispassionate way, we can say that it has been absorbed into the history of American art and culture. Nobody wants to return to the art of the 1920s and 1930s, or to revive a Bentonian type of art. What is important is that we can now look at his art as a manifestation of certain well-defined tendencies at a certain time and then begin to explore and to understand how it fits into the ongoing concerns of American art—as a public enterprise and as a private aesthetic experience. The publication of this new edition says as much.

An Artist in America

I

The Corner of the Century

MY EARLY childhood was passed in a country radically different in atmosphere and flavor from that known to boys today. The little town of Neosho, Missouri, my birthplace, was situated about sixteen miles east of The Nations—a strip of land now part of Oklahoma devoted to a number of Indian tribes moved from the East by the Great Father. The town was set in a series of rolling hills on the edge of the Ozarks. It was a pretty town with a hard rock, clay, and sand foundation, encircled by creeks and running springs. Surrounded by a yard of trees, the brick courthouse with a number of towers stood in the center of the square. Around the yard there was a fence, and beyond that a series of posts with chains hanging in between to which people tied their horses.

Neosho was an isolated town. In the middle eighteen-nineties, when I first began to take notice of things, it was far off from the lines of continental travel and had an old-fashioned flavor. Its people took their time. Old soldiers of the Civil War sat around in the shade of store awnings or lounged about the livery stables, which were, in the horse-and-buggy civilization of the time, important centers of reminiscence and debate. The town was addicted to celebrations. Confederate and Union gatherings occurred every year and the square would be full of veterans, with imprecise triangles of old men's tobacco spit staining their white or grizzled beards. They lived over again their bloody youth. They used to congregate in the law office of my father. The Confederates talked there with a fellow veteran, for Dad had fought with Forrest in Tennessee. The Union

3

men discussed their pension claims. These old war birds of the Great Struggle were a constant part of my early environment and when, years later, I painted a picture depicting the departure of the doughboys of the sixties for the front, I painted them as grizzled and toothless old men. I knew and remembered them as such.

In addition to the gatherings of the veterans in Neosho, there were reunions of the old settlers of the region. They came into town with their families, which ranged all the way from some old grand-pap who looked as though he ought to have been buried a hundred years before down to litters of yapping great-grandchildren. They would eat lunches of cold boiled sweet potatoes, cold fried pork, and fried chicken. Watermelon generally concluded the meal. At all these doings the Neosho town band played. Its personnel was constantly changing, owing to various disagreements on musical theory, yet it was an irrepressible factor in the town. Besides playing at all special gatherings, it put on a concert every Saturday night during spring, summer, and autumn. The young people of the town, dressed up in their best clothes, paraded around the square.

Colonel M. E. Benton, my Dad, had come out to southwest Missouri from Tennessee shortly after the Civil War, knocking the snakes, according to his own story, out of his horse's path with a long stick. Dad, who was not really a colonel, but who, as he grew portly and substantial, was called so after the southern fashion of the day, had stopped long enough in St. Louis after the war to get admitted to the Missouri bar. He hung his shingle out of a Neosho window and, as he was full of rollicking stories and possessed of a full measure of political ability, became not only rapidly successful as a lawyer but also a prominent factor in the Democratic councils of the neighborhood. When he was a successful man, past forty, he built a big house on top of a hill, married a young woman from Texas, and had four children. I was the first of these. I was named after the great hero of the Benton tribe, old Thomas Hart Benton, who, although a Tennessee man, was Missouri's first senator and for

thirty years in that capacity helped, with pompous phrase but determined will, to lay the hand of the West on eastern political policy. The western Bentons, who came out of the Carolinas into Tennessee after the Revolution, were an individualistic and cocksure people. They nursed their idiosyncrasies and took no advice. They were stubborn and had a tendency to regard all but themselves as fools. My Dad was a slice of the block. He was a great eater, drinker, and talker. He was stubborn and there was nothing on earth that could hurry him. He was at times a secretive man, inwardly turned, and, although he had a great belly laugh, was not always quite happy. He was addicted to odd and inexplicable ways of self-communion. He frequently talked vigorously to himself and time and again he settled himself in the privy in our wood lot, which he preferred in warm weather to the toilet in the house. There he sat, adding, subtracting, dividing tremendous figures. This would go on while a client would be waiting in his office on the square, or even while his presence was awaited at court. Messengers came, and my mother would send one of the black men who were always about our house, Jim, Berry, or Uncle Caesar, to try to dislodge him. But no matter how urgent the case, he would not budge till his figuring was done. No one ever found out what it was all about. He derived some strange release in this play with great rows of figures. The walls of our privy, the backs of our books, and the edges of newspapers were covered with them—column after column.

Politics was the core of our family life. Our dinner table was always surrounded with arguing, expository men who drank heavily, ate heartily, and talked long over fat cigars, the ends of which they chewed. These men, in my memory, were mostly big, with big appetites. I remember well a breakfast at our house when I sat popeyed watching Champ Clark and William Jennings Bryan, then in their prime and before the days of their enmity, engulf poached eggs set on the halves of baked potatoes—half a potato and an egg at a bite.

Dad was always campaigning over southwest Missouri, either for

himself or for some other Democrat. This activity was the breath of his life. It was not the holding of office but the getting of office that brought out from within him the grand drive, the expansiveness, the *go* that electrifies existence. He was suspended as United States Attorney by Cleveland because of his participation in state primary activities. He simply could not keep down the impulse to act and talk in political affairs. Cleveland's advisers, sensing his power in the state, had him promptly reinstated.

Almost as soon as I could walk, my father in some pride of spirit about his first child began taking me on his political tours. My taste for travel got an early start. By the time I was eight or nine years old I had become familiar with camp meetings, political rallies, and backwoods hotels. I journeyed over rocky roads and muddy ones, in high-wheeled buggies, by buckboard and stage, for many points of political interest were far back off the railroad lines. The time and place of these trips are vague in my memory. Their scenes are without perspective. But I remember that my father knew everybody by his first name, that men wore big black hats, and that most of the women had sunbonnets. My recollections of the Missouri of my childhood present a very rustic and backwoods atmosphere. The country was isolated, self-sufficient. Corn and wheat were readily grown in the bottoms. Game and fish were plentiful. Life was easy and, although perfectly secure, had very much of a pioneer flavor.

I must not, however, let my memories give too rough a picture of my home country at the corner of the century. Though the pioneer spirit survived there, and for that matter still survives in isolated localities, there were areas of refinement and cultivation. We had, for instance, swell ladies in our towns who wore the very latest and best out of St. Louis. We had ladies who objected to being called "the old woman" when they had passed twenty, ladies who prided themselves on their manners and culture, ladies who were offended by tobacco spit in the fireplace. We even had followers of Frances Wright who thought that women were as intelligent

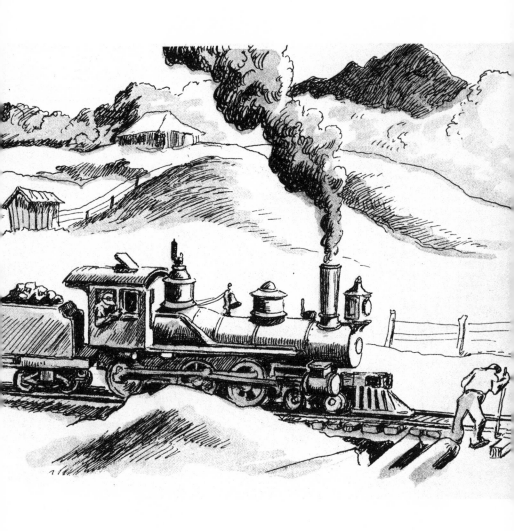

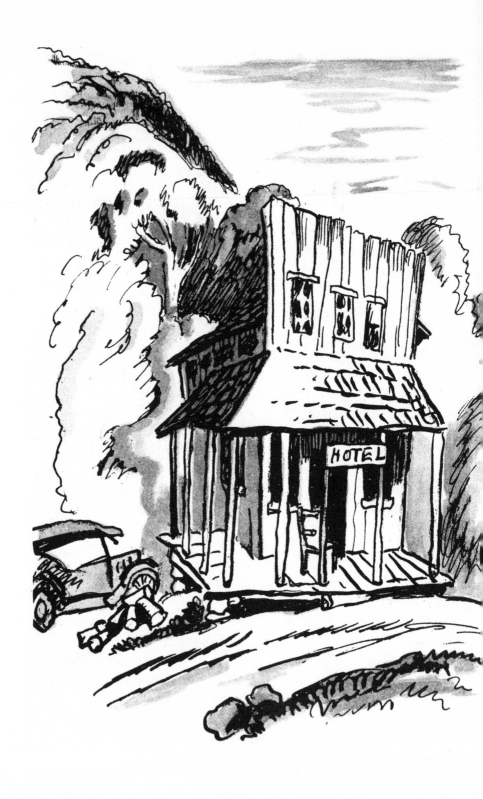

as men and should be allowed to vote. Dad and his political cronies would roar with laughter at the very mention of that idea, although I have distinct recollections of their listening attentively to the opinions of some hotelkeeper's big, fat, motherly wife whose sex in no way kept her from being the boss of things in her environment and the controller of whole families of votes.

Political meetings of the eighteen-nineties were regular carnivals. A campaign orator, on his arrival at a town, did not go to his hotel to rest and prepare himself in quiet conference with his machine managers as he does today. He had to be tough, for the minute he got off his train or stage, he was planted behind the local band and made to march after its blaring horns and smashing drums to a great public "hurrah" in which he had to shake everybody's hand and get slobbered over by all the sticky babies of the neighborhood. He was not supposed to need rest. He ate a big dinner and then went out to the fairground or the camp meeting ground where, under the dried branches of trees set for shade on rickety crossbeams, he was supposed to yell at the top of his voice for a couple of hours. I've seen my father do this time and again. I remember these affairs well, with their flags and big glare-eyed, staring posters. There were always shooting stands around, covered with red, white, and blue bunting, where the incessant crack of rifles and the clang of hit metal would send penetrating and immediate certitudes into the doubtful futurities of political oratory. There were "spinnin' jinnies," the mule-powered merry-go-rounds of the day, pink lemonade stands, gipsy fortunetellers, and medicine shows. On the fringes of things there were huge barbecues and no small amount of potent and inspiring whisky. In my home town I marched in a torchlight parade in honor of what everybody thought was Bryan's certain election after the great sixteen-to-one campaign. That year, though Bryan and his "cross of gold" went down to defeat, my father was elected to Congress and my travels began to be more extensive.

We went to Washington every autumn and returned home in the spring. When congressional sessions were long, we stayed long in the capital and our family was subjected to the impacts of eastern ways of life. My father, who was above all things devoted to Missouri, looked with a disapproving eye on this and, as I began climbing into my teens, he devised means of offsetting the more corrupting influences of Washington on my character. In the summer I had to take care of our stable, the horse, and our two cows. My father devised well as to the latter. One of our cows was a big Holstein named Bluey. Bluey had a disposition. She was full of milk but also of a deep contrariness. She kicked, swung her head and tail, and had all sorts of unpredictable ways of making my dealings with her difficult and miserable. She had a trick of lying down in fresh manure and her bag was invariably filthy. I always had to put in half an hour cleaning her before I could set to milking, and then I'd have to keep my eyes wide open to keep her from kicking over the milk bucket. She was a tough proposition and I hated her.

Dad's devotion to Bluey was immense. He looked upon her as the queen of all cows. He used to put a rope around her horns and hold her out to the bluegrass in our backyard for hours at a time. He would put up with all her contrary moods just for the pleasure of seeing her eat. She'd pretty near pull his arms off at times with sudden and unexpected switches of her head as she shifted from place to place in the grass, but Dad loved her anyhow.

One day in early spring (it was an unusually hot day for the season and the flies were thick), Dad was holding Bluey and reading a newspaper at the same time. He had his tether rope turned around his wrist and wasn't paying much attention to her. The flies got to bothering the old cow. Suddenly she kicked her hind legs up in the air and lit out for a big forsythia bush, then in glorious bloom. She went through that bush like a cyclone and she took Dad along. He trailed about ten feet behind through a

burst of golden flowers and snapping twigs. Unable to get the tether rope off his wrist, he came out the other side looking as if he'd just fought a bobcat.

After that it was given to me to hold the cow out to grass. I fixed her, though. I tied an extra piece of rope to the tether and fastened it to a tree. I held the tether loosely and when Bluey showed an inclination to run I'd smack her with a stick and let her go. After nearly jerking her head off a few times, she eased up on the running business.

The uplifting chores of my father's devising, directed as indicated to keep my eyes on Missouri values, were really unnecessary, for even without them the life offered by my home town could be counted upon to elevate Missouri ways above those of Washington. For a growing boy, the country is filled with more events and provides more opportunities for unrestrained activity than does a city, if we except the slums, where it is undeniable that vicious prospects, the most charming of all for boys, abound everywhere. Neosho had creeks where we went to swim, where we added to our linguistic powers and learned the arts of chewing and smoking tobacco. There was a particular railroad siding where a two-mile ride could be sneaked, where adventurous boys could take the wind hanging on to the side of a boxcar between town and an outlying junction. There were caves to explore, horses to ride, cottonmouth moccasins and copperheads to kill, and exceedingly tall stories to be heard by sidling up to the loafers on the square. In the autumn there were possum hunts out to the west of town, where you ran in the dark of night with kerosene lanterns in your hands, trying to beat your companions to the treed possum, with only the bark of the dogs to guide you.

There were opportunities for gaudy self-expression. At my home we had a big barn where my friends and I would put on great shows and circuses. Because of the stories of Geronimo and the Apaches, then fresh in everybody's mind, we had a mighty passion for Indian shows. Indians from The Nations, a few miles across

the state border, used to come to Neosho on the Fourth of July and put on a powwow and dance, but they weren't wild enough for us. In our shows we'd strip off, paint burnt cork and poke-berry stripes all over our bodies, and jump and howl around the barn the way we believed Indians should really act. The life of Washington had no chance against this. Most of the memories of my boyhood center around southwest Missouri.

From the moment of my birth my future was laid out in my father's mind. A Benton male could be nothing but a lawyer— first because the law was the only field worthy of the attention of responsible and intelligent men, and second because it led naturally to political power. In Dad's mind only lawyers were equipped and fitted to possess political power. As the century turned and I grew up, my father began to get uneasy about me. There was much about my unfolding character that did not fit in with his conception of a budding lawyer. I was argumentative enough but I could not be induced to study and I had a low taste for creek-bank company. I preferred the town bums and the colored boys to the governors, senators, and judges who used to sit at our table. Now, my Dad was a Democrat, but like his idol, Thomas Jefferson, he had certain reservations about gentility and honorable company. These reservations were, however, purely conceptual, ab-stract, ideal, for he himself made no actual reservations in the selection of his own associates. His law office was always full of broken-down, tobacco-spitting old fellows who had no connections with gentility of any kind. These old fellows rarely, or never, had any business in Dad's office. They were there simply because they were congenial. In his family life, however, Dad held his concep-tions of breeding, propriety, and conduct as living values against which his children should be measured. Characteristically, and with his western mind, he saw no discrepancy between the daily battle he had provided me with Bluey's manure and his belief that I should be a sort of paragon of pride and personal dignity.

Dad belonged to a race of men who, with Andrew Jackson, could brawl all over the race tracks and barrooms of Tennessee, shooting, stabbing, and cussing each other, and yet who were capable of maintaining to the death their good breeding and their assumptions of aristocracy. With the first families of the West, gentility was not so much a matter of actual conduct as of attitude. And it was mainly to attitude that Dad referred when he began looking skeptically at me. I didn't perform according to the standards which his attitude set up as proper. He never thought of his own unconventional ways of being and doing.

Dad had laid out a lot of books for me to read. I don't remember all, but among them were *Pilgrim's Progress, Plutarch's Lives*, a *Life of Thomas Jefferson*, my great-uncle Thomas H. Benton's *Thirty Years' View*, and his *Abridgement of the Debates of Congress. Pilgrim's Progress* I read but the rest were too tough for me. I preferred the dime novels hid out in the barn. In the beginning of about my fourteenth year, my father, exasperated because I wouldn't read any of his literature or do any studying on my own account, and because he wanted to break my loafing habits, hired a tutor to push on my Latin. Dad used to boast that he was reading Latin with his father when he was six years old and that there was no word in the English dictionary which he couldn't spell at the time. I imagine he must have had a considerably abridged dictionary, though I must say he did have the most retentive memory I have ever come across. He used to get enraged and red in the face when, at our Sunday Bible readings, I failed to remember the passage where we stopped the Sunday before. I never did remember them unless they dealt with big doings, like putting Shadrach, Meshach, and Abednego in the fiery furnace, or with the activities of David or Sampson, or with the adventures of Joseph. When the Jews began begetting long lines of progeny, laying out precepts and admonishments, I got off. I never liked the New Testament and could never remember a word of it. The doings of Jesus seemed pale and mushy to me beside those of the

heroes of Israel. I remember that I was considerably intrigued by the whore of Babylon who "glorified herself and lived deliciously," but my mouth was always shut up when I wanted the subject elaborated. This Sunday reading was all the religious instruction I ever had. There was some scandal in Neosho about the Benton children's never going to Sunday school, but my mother was a Baptist and my father a Methodist, and they could come to no agreement on the way we should be saved. I did, however, have religious qualms. I remember when I reached the mooncalf age, I'd never indulge at night for fear I might die in my sleep and go to hell. I had to hide out in the barn in the daytime, where no flight of the imagination could quite turn the horse into a beautiful girl, or mistake the smell of cowdung for the perfume of voluptuous princesses.

My father's efforts to put me in the harness of his ideals came to very little. I managed to absorb a little Latin, but my interest in the things he thought important for my future made no gains. One of my peculiarities, which was incomprehensible to Dad, was my propensity for drawing. When I was a little child, he saw no harm in my scribbling, but when I grew up and people began to notice it and wonder whether I aimed to be an artist, he became very uneasy. He never said anything directly about my drawing, because my mother favored the practice, but when he lectured me on the evil and futile ends of lazy habits there was no mistaking the fact that picturemaking was implicated. Dad was profoundly prejudiced against artists, and with some reason. The only ones he had ever come across were the mincing, bootlicking portrait painters of Washington who hung around the skirts of women at receptions and lisped a silly jargon about grace and beauty. Dad was utterly contemptuous of them and labeled them promptly as pimps. He couldn't think of a son of his having anything to do with their profession. But I had drawn pictures all my life. It was a habit and Dad's disapproval didn't affect me in the least. I didn't think of being an artist. I just drew because I liked to do so.

My first pictures were of railroad trains. Engines were the most impressive things that came into my childhood. To go down to the depot and see them come in, belching black smoke, with their big headlights shining and their bells ringing and their pistons clanking, gave me a feeling of stupendous drama, which I have not lost to this day. I scrawled crude representations of them over everything.

When I was six or seven years old, our house was newly papered in some light cream-colored paper. We had a stairway which went around a landing from the lower hall to the second floor. My first mural consisted of a long freight train in charcoal which went up this stairway on the new paper. It began with the caboose at the foot of the steps and ended at the top with the engine puffing long strings of black smoke—because of the heavy grade. The kind of appreciation accorded this early effort was the first intimation I received of the divergency of view on the subject of mural decoration. The question of appropriateness, which later and on other occasions I was to hear a lot about, was then brought up for the first time. Decision in this first case was against me and, after a good lecture, my labors were obliterated with bread crumbs.

I drew railroad trains until the Spanish-American War called my attention to the importance of battleships. My ships were not much good for I knew nothing of them except what I learned from the blatant colored pictures in the barbershops, drugstores, and groceries. Of these there were plenty, for the country was advertising its navy. What I didn't know about ships I concealed with violent explosions full of spread-eagle men, fragments of smokestack and rigging, in the style of a popular print of the time depicting the blowing up of the *Maine*.

Along with the ships, I started in on Indians, stimulated by a volume of hair-raising stories in my father's library. This book was devoted to the adventures of the first hunters and pioneers in the Mississippi valley. I had seen plenty of Indians in my time but they were of the sort that hung around the railroad stations

of Indian Territory watching the trains. They were slouchy fellows in checked or red shirts who wore tall-crowned black hats. The old ones often had braids of black hair coming out of their hats but, except for this, the color of their skin, and a certain solemnity, they were in no way different from the loafers around Neosho. They didn't wear feathers nor did they ever let out any war whoops that weren't generated in libations of corn whisky. They did no scalping and stole no babies to bring up as members of their tribe. They were too tame for me, so I closed my eyes to what I knew and retreated into the ideal, as many a person has done before and since. This ideal was composed of tomahawks, eagle feathers, bloody knives, and fierce expressions. My Indians were always victorious, slaughtering the white invaders left and right. The great work of this period, the picture on which I looked with the greatest admiration, was *Custer's Last Stand*, a large, colored lithograph which, as a barbershop and saloon masterpiece, survived all the efforts of imperialist patriotism to supplant it with the blowing up of the *Maine* and the charge up San Juan Hill.

This interest in Indians, varied occasionally by a return to trains, I maintained until a visit to the St. Louis Fair in 1904 brought me face to face with one of my great Indian heroes. Old Geronimo, the Apache chief, stories of whose ferocity had so often stimulated my imagination, was there to be seen for two bits. I went with an excited heart to gaze on this red warrior who had so recently held all the United States soldiers at bay and put a scare into a good portion of the West. When I faced him all my imaginative world fell down. He was just like the Indians of The Nations I had seen since earliest childhood. Only he was sadder looking, a kind of tired old man who gave bored answers to questions. He was short, thickset, and wrinkled. He had on a long blue Army coat with brass buttons. If there was any bitterness in his heart, it was not marked. There was only apathy. I threw away my dream world. Before the stolid, indifferent, commonplace stare of the last of the fighting Indians that world became suddenly futile.

This visit to the fair marked my fifteenth year and it also marked the end of my winter sojourns in Washington. My Dad had met political defeat.

Southwest Missouri had undergone marked changes as the century turned. The area was always a center of political controversy. Its valleys and little prairies were Democratic, its hill country, Republican. The settlers of the lowlands had, as a whole, emigrated from the low countries of the South, from the grasslands of Kentucky, Tennessee, and the Carolinas. They brought with them their southern character, their slaveholder psychology mixed strangely in the southern way with Jeffersonian liberalism. They were Democratic by habit and inheritance. Our hill people had come from the mountains of the South, from eastern Kentucky and Tennessee and the Carolina highlands. They were Union men. By tradition, they voted against rebels and Copperheads.

Dad's reputation as a potent fixer of pension claims, plus his ability to inspire friendships, won him the allegiance of many old Union clans, enabling him for years to strike a favorable balance for himself and his political alliances at election time. But toward the end of the nineties, industrial interests of an extensive sort began to pile up around the lead and zinc mines located in our district. These were sufficient to overweigh the political scales in favor of high tariffs and Republican principles, and my father was knocked out of office.

This defeat went very hard with Dad. It really marked the end of his more energetic participation in politics. He had frequent moody spells and he indulged extensively in his strange habit of figuring. I lost all intimate connection with him. Since I was a very little boy I had traveled much with my father. I had gone on fishing trips down the rivers of Missouri and of Indian Territory. I had sat in backwoods stores and on the porches of slipshod hotels listening to the voices of political connivance, and I had come to see myself as somehow or other involved in his activities, tied to his life. As I grew up and he began to be dissatis-

fied with my ways and lectured me, I learned to let his admoni-
tions go in one ear and out the other. I had always regarded his
companionship as a source of change, his doings as a promise of
adventure and excitement in unfamiliar places. Because of this I
had overlooked his suspicions about my character which sharpened
measurably as I grew. After the loss of his political grip, our trips
together ceased and Dad and I drifted apart. In a few years, with
my growing independence, our relationship changed so I scarcely
knew him.

I never got close to him again until after twenty years' separa-
tion, when I sat week after week by his bed in a Missouri hospital
watching him die of cancer. We got to be friends again, in the
long hours of my vigil, and I found once more that intimacy
which, without talk or any temperamental kinship, had made my
childhood associations with him a pleasure and a deep memory.
Dad was a character.

When in 1904 we came home from Washington for good, I
had all the cockiness of my fifteen years sitting on my shoulders
and I inaugurated my home-coming by getting in a lot of brawls
and street fights. These were simply the outcome of an exuberant
youthful pugnacity. No real malice was involved in them nor was
any damage done, beyond a few surface scars, bloody noses, and
black eyes. But the town of Neosho was in a state of uplift, and I
was repeatedly hauled up and fined. I acquired a bad reputation
and quite a number of people spoke openly of me as a quarrel-
some nuisance and a disgrace to my family.

My return from Washington at an age of accelerated develop-
ment, with a whole winter of absence from my Neosho cronies to
generate suspicions between us, was attended by the necessity of
some form of self-assertion. I had to re-establish myself among
the home boys who were going, as I, through the age of crucial
change. My brawls and fights fulfilled the requirements of the
situation and enabled me to resume my place in the town.

With those of my age, I hung around the square in the evenings, laughed at senseless jokes, and indulged in the half-lewd horseplay of boys who see themselves as men. I found my way through the back doors of the saloons and learned, with my companions, to stand up to the bar and wash down a jigger of whisky with salted beer. I took notice of girls and preferred older ones. I began to dress up at night and to hang around the drugstores where they came in. I bought a derby hat, learned to waltz, and went to dances. I gave up all pretense of study, spending the evenings, which were supposed to be devoted to my Latin tutor, in the pool halls. I had quit drawing pictures after the disillusioning experience with Geronimo at the St. Louis Fair had smashed the value of my favorite subject matter.

With the increasing scope of my active life provided by girls, dances, drugstores, pool halls, saloons, clothes, etc., I didn't feel any need for the sort of expression that drawing gave. I abandoned its practice. I worked at odd jobs around the town in order to get spending money. After a while that irrepressible itch, so common among western boys, to be up and going somewhere, to have done with home, family, and familiar things, began to get me.

With a companion, I hooked a southbound freight one night and experimented with bumming. We sat in an open boxcar. We watched the moon fade and the dawn come, as the train took us over the Arkansas border. In the chill of early morning, a tough brakeman discovered us and kicked us off in the middle of the woods. We walked back to the nearest town, hung around in a creek bed all day, and grabbed a freight back home in the evening. But the itch to be on the go was strong with me, and I grew more restless every month.

Among the odd jobs I had had around home was one with a surveying party who were laying out our waterworks system. I carried the rod and chain. A cousin of mine was a surveyor up in the lead-and-zinc country to the north, near Joplin, the big town of our world. I wrote him for work and on the basis of my

little experience he gave me a job. We worked around in the burning sun of the diggings, over shale and crushed rock which shimmered in the heat and burned through the leather of our boots. Lead and zinc were on the rise at this time and Joplin, the center of the industry, was on the boom. It was a lively town full of people. The saloon doors—and there were plenty of them—swung constantly. Money was being made, and all the devices of our rough-and-ready civilization were set up to see that it was spent. Everything was there—drugstores, slot machines, real-estate slickers, soliciting preachers, and off the main street, a row of houses devoted to insinuatingly decorated girls. On Saturday nights I went into town and looked things over. There were friends of the family in Joplin, respectable people, but I steered clear of them. I'd left home mainly to get away from contact with respectability. I was in an independent frame of mind. No one questioned my grown-up status. I went in the saloons, drank beer, and put nickels in the slot machines. I was really a man, seventeen years old now, and foot-loose.

One Saturday night I went to town and into the "House of Lords," Joplin's main saloon. I had kept out of there because I knew it was the gathering place not only for miners and entertaining roughnecks but for the substantial businessmen of the whole region, and I didn't want to risk meeting anyone who would know me and make me come out to some family dinner where I'd get treated as a boy and where my consequence would depend wholly on the fact that I was Colonel M. E.'s son. But the House of Lords had a big name for glittering swank and I had to see it. I went in and ordered a beer. Across from the bar hung a big painting. This was a famous painting in the locality. It depicted a naked girl with a mask on her face. She was lying across a sort of bed and appeared to be dying from a knife wound. In the background was a young man in fancy costume. He was about to stab himself. I believe that the story, which hung in gold letters beside the picture, told that the girl was his sister with whom after a night

at a masked ball he had engaged in amorous play, ignorant of the relationship that existed between them. In any case, it was someone he shouldn't have been playing with in the nude, so he had stuck his knife into her and was ready to go to work on himself. I must have got sufficiently absorbed in this masterpiece to attract attention, for I became aware of some laughing down the bar, and I turned around to meet a line of grinning fellows and a barrage of kidding. These fellows saw how young I was. They probably sensed how hard I was laboring to be a man and they laid into me with all the obscenities bearing on the picture they could think of. They made me hot with embarrassment. In desperate defense of my position, I stated that I wasn't particularly interested in the naked girl but that I was studying the picture because I was an artist and wanted to see how it was done.

"So, you're an artist, Shorty?" one of my tormenters asked skeptically.

"Yes, by God! I am." I said. "And I'm a good one."

I don't really remember the conversation that followed, but those kidding roughnecks with their good-humored, amused faces, lost as they are to me in the vague memory of the shining bar at the House of Lords, with its bright lights, glittering silver and glassware, determined in a way the life I was to follow. Their bantering skepticism about my claims to artistry tied together the loose strings of all the purposeless activities of my adolescence. They threw me back on the only abilities that distinguished me from the run of boys, those abilities which I had abandoned for more active things. By a little quirk of fate, they made a professional artist of me in a short half-hour. One of them asked me where I was working. When I declared that I was out of a job but looking for one, he suggested that I should try the new paper and, probably to test the veracity of my artistic claims, even offered to take me there. There was nothing for me to do but to accept. So I was led down the next block where some brightly lit second-floor windows

shone above a dark stairway which tunneled steeply up to them. I went up. And I went, strangely enough, with perfect confidence.

I don't think that it had ever seriously occurred to me before that I wanted to be an artist. Certainly, until the kidding in the House of Lords, I had never declared myself one. I had never thought of being an artist in any definite way. In school and at home I gave lip service to the idea, because the practice of drawing, besides giving me pleasure, allowed me to avoid boresome study hours. But I would never take any training. I didn't see my drawing critically as something to improve but merely as a means of describing things that interested me. After I made a picture, I cared nothing for what happened to it. When I entered the stairway leading up to the Joplin *American*, I hadn't touched a pencil for many months. Yet I was as sure of myself as if I were a trained and constant practitioner.

At the top of the stairs I came into a long room smelling of printer's ink, hot iron, and oil. In the front was a desk where a man with a short gray beard sat reading. He was alone.

"Do you need an artist on this paper?" I asked.

He looked up at me and smiled. He had a kindly face. After a little while, with an amused chuckle he replied, "Yes, we need an artist," and then as I stood silent, "but we need a good one."

"I'm your man," I said, and believed it.

"Are you?" he laughed.

We were silent for a while. Then after a bit of rumination, he led me to the front window. "Sonny, do you see that drugstore across the street?"

"Yes."

"Do you see that man behind the counter near the window?"

"Yes."

"Well, go over there. Tell him you're the artist from the *American* and that you want to make a sketch of him. Make it look like him. I don't know whether we can use you or not, but if you

can make a drawing that'll look like that man there's a pretty fair chance we can give you work."

Borrowing a pencil and sheet of paper, I made my sketch—the first that I'd ever made directly from a living person. It was, by the grace of God, a sort of likeness. I took it back to the newspaper office. There were several men there now and they passed my sketch around. "Can you do that in ink?" someone asked.

"Yes," I said, "I can. I've done a lot of pictures in pen and ink."

I got the job. Fourteen dollars a week! This was monumental as compared with the four dollars I was making by carrying the rod over the hot rock of the diggings. I bade my cousin and the surveying outfit good-by and rented a room in Joplin.

Pretty soon I teamed up with the paper's cub reporter, now Ben Reese of the St. Louis *Post Dispatch*, and settled down to a newspaperman's life. I learned the jargon of the press and inked my drawings under the red-hot corrugated iron roof of the office. It was my business to draw some prominent person of the town each day. The heads of my drawings I made big and set them on little bodies, according to the cartoon fashion of the day. Around my people I drew the paraphernalia of their trade or business. Somebody at the office supplied the comment. This was a feature designed to interest the town in the new paper. How I did the work is a mystery to me. How I made my heads recognizable as individuals is beyond explanation. I would start with the nose and hang the other features on to it, but somehow or other, in this crazy way, I managed to make likenesses.

All summer I worked for the *American*. In the afternoons I clamped my foot importantly on the bar rail of the House of Lords and drank beer with the miners, the mine owners, the businessmen, and the newspapermen. Everything was jake. I was a man—and free. I was completely satisfied, except when I caught sight of my face in the mirror of the bar. It annoyed me that I looked so young.

I made the acquaintance of a fellow who frequented the houses

of the decorated girls. He took me with him occasionally and I sat in the parlor and drank beer at a dollar a bottle. One night my virginity was taken by a black-haired young slut who wore a flaming red kimono and did her hair in curls like a little girl. The experience clashed with my submerged romanticism and I looked no further into the mysteries of sex.

One day, toward autumn, I went home for a week end. My family were very uneasy about my staying in Joplin. They were not sure but that the town offered too many opportunities for a seventeen-year-old boy to go to hell. Besides, they were worried about my education. They wanted me to finish high school and go to college. Having tasted freedom, academic harness was abhorrent to me, and I balked. What! Another year of high school and then four years more? Unthinkable! I was a man of the world, and no damned schoolboy. If I quit the paper I wanted to go to Chicago and study art. I knew there was a big art school in Chicago. I'd study there for a year and then get a big-time newspaper job and get rich. The family objected to this and after hours of discussion we reached a compromise. I agreed to do a year in a military school up in Alton, Illinois, if I could go to Chicago the next. I gave up my job on the Joplin *American* and found myself strutting around in a gray uniform. I couldn't smoke in the military school so I chewed tobacco. I went out for the football team and got my letter. When the football season ended the place was a bore to me. I couldn't stand it.

The beginning of the year saw me in Chicago. I rode in an automobile from the railroad station to my first room in a big city. I had seen a few automobiles in Joplin, but I had never been in one. In Chicago there was horse manure on the streets but the smell of gas was beginning to dominate its rich aroma.

The century's corner was turned.

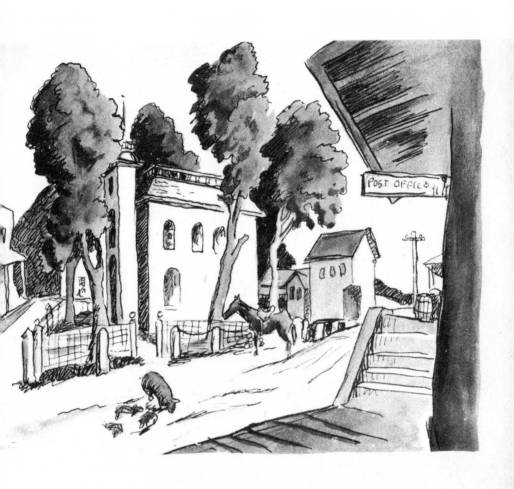

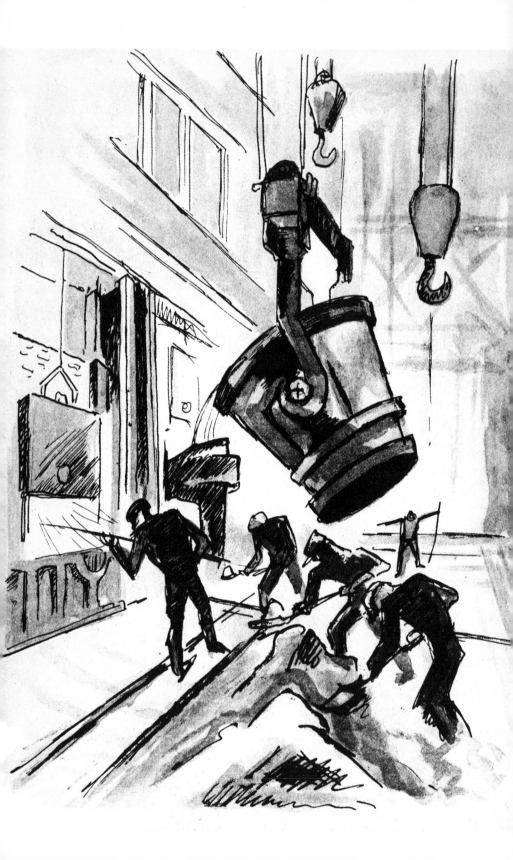

II

Art and the Cities

O N A lecture trip in the Middle West a few years ago, I was asked by one of my auditors, expecting an exposition of the aesthetic advantages of urban life, why the artists all lived in New York City. I returned the answer that it was because a great city offered the best chances for the artist's living. There is, of course, some truth in this, but it is only a small part of the whole truth.

When I went to Chicago in 1907, I was drawn by many things quite unconnected with the business of making a living. Although I declared to my parents that my main purpose was to study art and to get rich in a big-time newspaper job, and although, in a vague way, I meant this, the prime thing that motivated my urge toward the city was deeper. Chicago promised escape from a certain uneasiness I had been feeling for some time in the presence of the respectable society of my home country. Because of my family I was closely tied to this society, from which even very considerable excesses would not be likely to loosen me, owing to the traditional lenience of our kind. Joplin had, for a little while, promised asylum, but when I became known there I began to get as closely tied to the conventions of my background as I was at home. The Joplin friends of my family began to swamp me with respectable invitations. The kind of uneasiness that I felt will be recognized by every artist who has come out of a family devoted to such practices as law, politics, and business, in which shrewd connivance and acute attention to courses of action are the prime matters of life. A workingman's son, or an artist's, or craftsman's, or

student's son may understand this uneasiness, but he will never get it as an emotional reality. It is a vague thing, without any really substantial or reasonable cause, which comes stealing, like a mist, over the first years of an artist's adolescent self-concern, where the inability to conform to accepted behavior patterns, so characteristic of the imaginative in a practical society, brings up brooding suspicions of unfitness along with a moody dissatisfaction. The business of gratifying my pretensions to manhood, which motivated my first flights from home, did not, at any time, quite rid me of the disturbing feeling that my attitude toward things was different from that of my class and kind. I had the artist's interest, which exists quite apart from practice in the simple existence of things. I gave little attention to what things were going to do or to what could be done with them in a practical sense. I do not mean that I could not see a log in the creek as anything but just that. Like other boys I could see it as something on which to ride down the rapids. But I could have enough interest in its merely being *there* to fail to catch it in time to put it to use. I was liable, as are all artists, to abstract every idea of purpose from a thing just because its mere existence, its color or form, would grip me. I could sit for long periods simply staring at something.

Years before I commenced the practice of referring to actual objects for the subject matter of my pictures, I would get fascinated with the nature of a fence post, a bush, a rock, or a ripple of water, and I would pass from an abstracted study of one of these into a long and, as far as I could ever explain it, an empty reverie. This psychological failing developed long before I ever thought of myself as an artist. It was a thing that my Dad could never understand. He had plenty of abstracted moments himself, but they were never of the kind that would make him miss a train because he was interested in the smoke of its engine. The abstractions of my Dad, in fact of all of his kind, and I may say of all the substantial people of the great Middle West, were devoted, in prewar days, mainly to calculation. Whether they did anything or not they

pondered action. They were purposeful. When they considered things they considered them in terms of use. I do not mean that they could look at a sunset, or a pretty woman, and not be moved by the beauty of these, but rather that ideas of purpose and use dominated their psychology.

Not only my father, but other people noticed that I was a variant of our stock. I was laughed at frequently, as I grew up. Once, in a high school football game, I got so interested in an opposing runner carrying the ball that I let him pass within two feet of me without making a move. This cost me my place on the team, in spite of the fact that, up to this abstracted moment, I had performed well. My schoolmates frequently looked askance at my erratic ways, even in grade school. Had I been a weak boy I might have suffered a good deal from derisive taunting, but I was strong and pugnacious and my ways got by. I was never a lonely boy lacking friends or playmates. If I ran off-color at times, I made up for it at others and held my place with my youthful contemporaries.

As I grew up, however, I became increasingly self-conscious about what people regarded as my funny quirks, and I developed a slightly defensive defiance, especially in the presence of my elders. My father said that I rarely looked a man in the eye on being presented to him, and that if I did, it seemed as if I were getting ready to hit him with a rock. Actually, violence was frequently in my mind because I didn't like the way so many of Dad's friends looked me over. Smart, shrewd men could tell at a glance that I would never make a lawyer. Dad's cronies loved him, and I always felt that they were sorry he had such a queer duck for a son. The practical men of our life, while they didn't get my number, caught very quickly the fact that it didn't belong to any good Missouri series of the time, and they regarded me with a considerable degree of humorous skepticism.

By the time I went to Chicago there were moments when my uneasiness was intolerable. As the spells came on, the desire to submerge myself in the loneliness of strange places and peoples bit

like a hot flame. The intimacies of the military school burned me up, and though I controlled my inner rages there, sitting alone secretively chewing tobacco, I dived into Chicago as into a cool bath.

Every artist in a world of "practical" men shares somewhat the uneasiness I describe, but those who came out of the Middle West at the beginning of the century, I imagine, have had a larger dose than all others. There was, throughout the great valley of the Mississippi, from the eighteen-eighties up to the Great War, the most complete denial of aesthetic sensibility that has probably ever been known. That natural human interest in the simple nature of things which is possessed to some degree by all men, was crushed almost utterly in favor of a short-range philosophy of action. This is recognized by all commentators on our civilization and is attributed, as a rule, to the exigencies of pioneer needs, where the mind was supposedly grooved to action alone. The claim is generally made that the hardships of pioneer life made the cultivation of aesthetic sensibilities impossible and that the pioneer psychology once established remained in the habits and ways of people, keeping them on a level of low sensibility. It is forgotten, however, that our aboriginal tribes, living under equal hardships, were able to cultivate aesthetic attitudes and practices to a very high degree. It is also forgotten that up to the time of the Civil War our pioneers themselves cultivated quite a number of arts and that they were particularly great singers, orators, and dancers. Andrew Jackson, that archetype of successful frontiersman, took enough pride in his dancing to exhibit his prowess in a *pas à deux* with his wife Rachel before the elite of New Orleans, who, the story goes, stood amazed, uncertain whether to applaud or to laugh when the great general cavorted to the wailing music of his Tennessee fiddlers. The arts of our pioneers were simple arts perhaps, but they were genuine and they were assiduously cultivated. In the backways of our country many of them have survived up to this day, and in little churches hidden away in the depths of our mountains, it is possible sometimes to hear music that is, though simple, just as genuinely music

as any that may be heard in the churches of the great cities. No, it was not pioneer hardship that crushed aesthetic interest in the great valley and made the eighties and nineties so sterile in feeling and sympathy.

What really crushed it was the rise of the parvenu spirit during the great exploitative period following the Civil War, and the enthronement then of the ideals and practices of the go-getter above all other human interests. The psychology of the parvenu is destructive of the appreciation of the qualities of things. His is a quantitative mind. He is intent on expansion rather than on the cultivation and preservation of value in things. Things—all things—are, for his kind, merely instruments extending areas of control and promoting his wealth and power. Aesthetic values cannot survive when the particular pragmatism of the parvenu is socially dominant. Aesthetic responses are based fundamentally upon the recognition of value in *what is*, in the simple qualities of things. This is true in spite of the aesthetic use to which such qualities may be put within the conventions or aims of an art. Where such values are denied in a society, as they must be when the go-getter's strictly material interests in economic expansion dominate the pattern of life, they become an oddity.

The intellectuals of a society reflect its nature. They may be protesting radicals who react against it, or they may accept and rationalize it. The men of my father's entourage, the intelligent people of my country, as a whole, accepted the pattern of the parvenu society of the eighties and nineties and worked within it. The lawyers, the politicians, the newspapermen, though more intelligent and better informed than the businessmen, nevertheless reflected the attitudes of these, and, more or less unconsciously, drove their policies into legislative and legal practice and into their own philosophies. The radical protestants, the philosophers, artists, writers, musicians, for the most part ran in a body to the cities, to New York and Chicago, just as in France they fled to Paris from the materialism of the provinces.

When I began to itch for Chicago—and this commenced even when I felt pretty well satisfied with my beer-drinking manhood in Joplin—I was impelled to a great degree probably by a submerged desire for association with my own kind. Escape was not the only thing involved. There was an unconscious yearning for sympathetic companionship. The mere assertion of my status as a man, while highly gratifying, did not completely fill my bill.

While southwest Missouri, as I have indicated, was under the influence of the parvenu spirit, it was not, at the time I left it to study art, a modernized country. Roads were poor, and rock, dust, and mud prevailed. The horseless carriage was so rare that the entrance of one into a town would empty all the stores. The courthouses and squares belonged to Civil War days. The country changed rapidly during my childhood, but its society remained, as a whole, behind the go-getting propensities of its dominant members, and even today the flavor of a leisurely past hangs, by inherited custom, in many places. The shrewd and narrow practicality of the dominant classes—the lawyers, politicians, merchants, and bankers—was almost a surface veneer. It was, however, thick enough to kill any profitable aesthetic activity. It was enough to kill even the simple home arts, and, under the influence of mercantile persuasion, the fine old patchwork quilts and hooked rugs of the grandmothers and the solid hickory chairs and benches of the grandfathers were thrown out of home after home in favor of cheap, jerry-made, but showy manufactures. The new became synonymous with the better, as is characteristic of parvenuism. My own family fell with others under the influence of sales talk, and we had plenty of horrible decorative monstrosities about our house to represent our advanced status.

Still, we of southwest Missouri were lagging in the headlong race of commercial modernism, so that when I struck Chicago it was as if I had pushed up the clock. I had lived in Washington, but the Washington of my time was a leisurely place. When I left

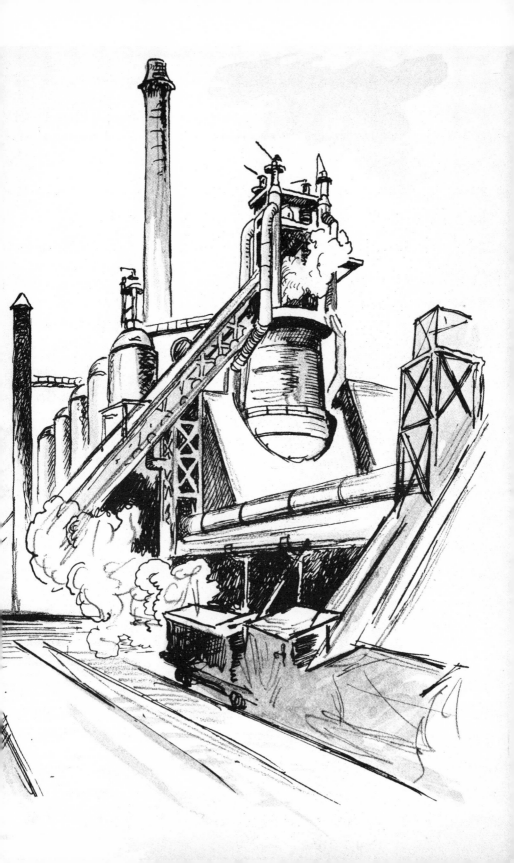

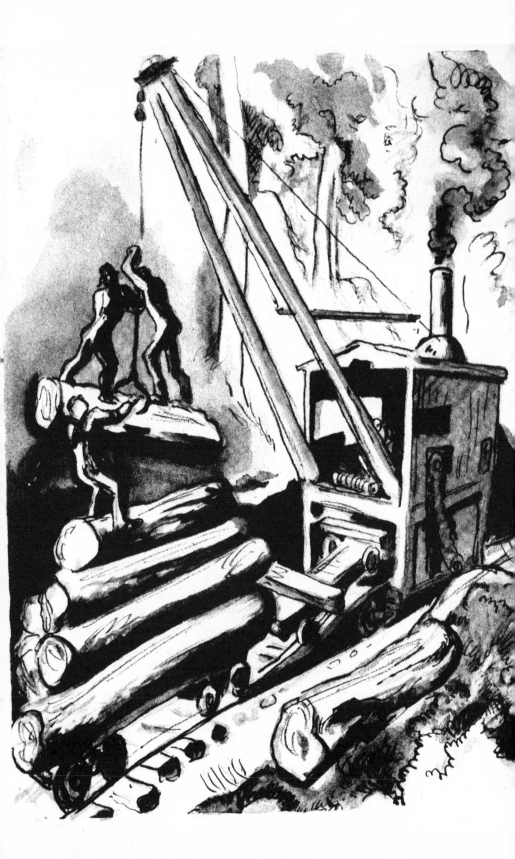

it in 1904, it was still a brick-and-stone, horse-and-buggy town. I had never been in a roaring city, in a city of steel and steam and fierce activity. I was frankly scared and for a while very homesick. But the place was fascinating. There was, when I arrived, a good deal of building going on. The downtown and lake-front areas were in their first period of transformation from the brownstone to the skyscraper era. I spent much time watching the donkey engines manipulate the great steel beams, and I got the first touch of that mania for fire and steel and soaring height which was to dominate America for the next twenty-five years.

During the period of crude expansion, of brutal commercial exploitation, of crass parvenuism which grew out of the Reconstruction period, swamping aesthetic interest and practice in the country, all that was romantic and aspiring in the American spirit found its expression in steel. The outreaching railroad lines, the great bridges, the engines, the ships of that expanding exploitative period were converging, when I reached Chicago, toward its final expression, the skyscraper. I am aware of all the false logic that lies behind the skyscraper, of its foundation in deviously manipulated land values and brutal standards of living, but it stands, nevertheless, as the first effort of the American spirit to give itself an original monumental expression. It stands above the crude commercialism that generated it, the first sign of the rebirth of our aesthetic sensibilities. These buildings of our great cities, for all that is evil about them, that is cheap and tawdry in their surface decoration, for all that they are practically devoted to, are, nevertheless, evidence of a new spirit awakening within us, which cries for expression. They symbolize the end of that era where everything was calculated for profit, for they are not just buildings, but strivings for dramatic effect and form. And in many instances they achieve it. Only one utterly blinded by the self-conscious moralities of uplift and reformist pretensions can fail to see the beauty of these great structures, lifted above the dirt and squalor at their feet into our bright American sky.

Our land has been gutted, the people of our land have been squeezed, tricked, and wheedled into mortgaging their lives and hopes. The great potentialities for good lying in our mineral and power resources have been sacrificed to the calculations of financial skullduggery, where even those holding the whip hand seemingly derive no permanent benefit. Our forests have been mercilessly stripped for short-range profit. Out of all this our great cities have risen, full of life, Meccas for all the cunning and merciless schemers of the land, packed to the top with sordid and vicious self-seeking, but possessed as well of a dark and strange beauty.

I made friends in Chicago and in a little while I was living with a flock of boys of my own age in an old brownstone house on Michigan Avenue, where the Hotel Stevens now stands. At night we frequented the old Congress Café and the chop suey joints, and we made occasional expeditions into the sporting districts of the South Side. During the day, we studied, or pretended to study, in the Art Institute.

I was put to drawing casts of Greek statues in the usual conventional way of art schools. This was humiliating to me, for after the Joplin *American* I regarded myself as a professional artist and above such drudgery. I hated those casts. I have often thought what harm old Poussin has done to the artists of the world by initiating those academic procedures which send the young artist to art before he has any knowledge of life to give him understanding. How can he appreciate what the Greeks have done when he has never tried to *do* himself? The beautiful solutions of the Greek figures, shining through mutilation and dead plaster, can only be apprehended after one has known the living body. Learning to copy them before such knowledge has been acquired ends only in a thoughtless imitation of their appearance—in a copy, pure and simple. Very few artists who are able to perform successfully in the cast drawing of the schools get over the stultifying effect on their creative abilities of the mechanical habits engendered there.

They remain copyists for the rest of their lives, or, in some late frenzy of revolt, turn into blind extravagance and mystic silliness. I revolted from the casts within a week after I had begun. I simply couldn't do them. I commenced sneaking into the life classes, where, after a while, I was accepted. I watched people paint and I tried it myself.

From the moment I first stuck my brush in a fat gob of color, I gave up the idea of newspaper cartooning. I made up my mind that I was going to be a painter. The rich, sensual joy of smearing streaks of color, of seeing them come out in all sorts of unpremeditated ways, was too much for me and I abandoned my prospective fortunes in the big-time newspaper business without a qualm.

Having determined to be an artist, I bought a black shirt, a red tie, and a pair of peg-top corduroy pants. I wore this outfit with a derby hat which, when I let my hair grow, sat high on my head. I began to be regarded as a genius among my companions—my garb was proof of it. This suited me fine and I was as happy for a while as when I first got free in Joplin and stood before the bar of the House of Lords, an independent "man." But though I was among "artistic" companions, among young men who like myself were probably regarded in their midwest home towns as a little nutty, a little off-color, and who should have been, therefore, perfect associates for my temperament, I began nevertheless to have recurrences of my old spells of uneasiness. As I became known around artistic circles in Chicago, I again confronted, particularly with the more advanced young men, the same quizzical, skeptical, questioning surveys that I had encountered in my home country among my Dad's political and business friends. The shrewd practicality I had more or less consciously fled from at home was here again, though in a different form. The majority of the young men of art in Chicago aimed to be illustrators for the great magazines, and, after sowing a few wild oats of rebellion, they settled

down to taking the kind of training at hand in the Chicago Art Institute and in the other schools of the city.

I took no training. I wouldn't learn anything. I simply smeared paint and water color without any critical afterthoughts. My expressionistic indulgences were fervent but they produced, as my companions began to suspect, no results of consequence. I myself never looked back on the work of yesterday, so I had no gauge of my progress. But, although I didn't judge my work, nor esteem any of it enough to save it, I did like the idea of being a genius and grew resentful of those who questioned it. I moved away from my friends and took a room way out on the South Side where I could be alone and nurse my conceptions of myself without interference. Here my dress, representing one of my notions about what was fitting and appropriate for a genius, was subjected to devastating assault the first week of my stay. There were some pretty girls who sat in the afternoons on the front stoops of the houses on my block. One day, coming early from the Institute, I had to pass a flock of them.

"Look at that crazy freak," a young lady on the first stoop giggled as I passed. Down the block toward my door I ran a gauntlet of mounting, hilarious feminine laughter, echoed by the catcalls of a gang of boys across the street. I was furiously embarrassed. That night I slipped out, got a haircut, and rolled the paraphernalia of genius in a bundle. I used to slip it on at school, but I kept off the streets with it from that time on.

Like my father before me, I have always been more or less conspicuous in appearance. I get either all spruced up in overpressed elegance, or, on the other hand, I get careless and my pants fall down and my shirttails get out. I cock my hat too far on the side or I forget to put on a necktie or I put on one too resplendent for the rest of my outfit. When I was in the prime of my boyhood I walked fast and swung my shoulders in a cocky way. I was noticeable enough in the South Side of Chicago without my genius outfit and I was almost constantly on the verge of street

brawls, incited by the taunts of the gangs which hung around the corners. With the thought of battle in my mind, which these gangs engendered, I took up boxing with the more athletic-minded boys of the Institute and went with them to a club on the North Side, where we used to put on the gloves and slug each other after school hours. We carried our athletic activities down into the school, where we made a nuisance of ourselves, throwing new students down the coal chute and interfering with the pursuits of the serious. Because of our doings a number of us were expelled from school, but on a promise of better behavior we were allowed finally to return.

In spite of my reform in the matter of dress and of my pugnacious activity, I still held to the idea that I was a genius. As time passed, however, I realized that very few about me shared the notion. There were others in the school to whom that appellation was, in the eyes of the students, more deservedly applied. This irked me, for we were in the age of Walter Pater and Arthur Symons, of Oscar Wilde and Aubrey Beardsley, and one *had* to be a "genius" in the fine arts. I began to think of larger fields and to write persuasive letters home about New York and Paris. I knew that there was money at home for my education and I set myself to get it. With my mother's backing I finally succeeded and set out, when I was nineteen years old, for Paris.

The story of my life in Paris is the story of all who went there before the Great War—a lady friend to look after you and run you, a studio, some work, and a lot of talk. I went into the Louvre and felt my eyes get moist before the *Winged Victory*, then set dramatically at the head of the great flight of stairs. I wept openly as I listened to the organ in Notre Dame.

Paris had a way of putting young men in highly romantic and emotional states of mind before the War. Maybe it still has. I know that I walked in an ecstatic mist for months after I arrived, and I know that there were others like me. Many never got out of that mist. I arrived when the doors of appreciation were first open-

ing to Cézanne. I looked him over, but found Pissarro my greatest love. I tried the schools, but hated their formulas quite as much as those of Chicago. Old Jean Paul Laurens at Julien's looked scornfully at my efforts to draw, and, to the snickers of the young internationals about, waved me away toward the casts—the same damned casts that had repelled me in the Art Institute. I fled my fellow students just as I had done before in Chicago, and, retired in my studio, decided that I should find my own way of being an artist.

How many of us who are painting today have run from the dull, stupid, lifeless copying of the schools and have set out untrained in our craft because of it? Things are changing today, the old formulas are breaking, but when I started to study art, thirty years ago, you took the academic grooving or you got nothing. Because of my revolt against the patterns of the schools, I spent fifteen years on my beam-end, rocked by every wave that came along. I floundered, without a compass, in every direction. Of course, the compasses of the schools were all cockeyed. No course could be charted with them on a modern sea, and had I depended on their services I should have been no better off in the long run. But it was tough never to know where you were and yet, in the face of the world and for your pride's sake, be compelled to pretend that you did.

There were others like myself who backed away from traditional training. I saw them around "the Quarter" and met them now and then in the Dôme, which was the café most frequented by the internationals. There was George Grosz, Wyndham Lewis, Epstein, Rivera, Marin, Arthur Lee; there were the Steins and others. These people were all known around the Quarter, but I shied away from them for I soon discovered they were all more talented and capable than I.

It did not take me very long after I arrived in Paris to realize that my gifts were of an extremely limited nature, and that my "genius" was purely an imaginary affair. But I was proud and

stubborn and I could not stand association with people who, I felt, would regard me as an inferior and patronize me. So far as my feelings were concerned, there was no difference between the shrewd, canny lawyers of Missouri and the aesthetes of Paris. I had the same uneasy defiance of both.

But I found two American friends. One, John Thompson, lived (and fought) with his girl from the Variétées in the studio next to mine. Thompson was a short, strong, tough fellow who frequented the professional pugs of Paris and attended all the fights. He had a big chest, sloping shoulders, and was a prime bag puncher. He fitted in with my athletic memories of Chicago and with my submerged pugnacity and we got pretty close to each other. Besides our athletic interests we shared the same uneasiness about the intellectualism of the kings of the Quarter. Thompson was older than I and more experienced as a painter but he did not patronize me. He painted as an impressionist and introduced me to the impressionist technique of representing things with little spots of pure color.

Thompson's lady friend and my own didn't get along very well, each regarding the other as a pretentious slut. But though we were, both of us, pretty well run by our ladies, we'd manage frequently to get them together for dinners, where we'd drink a great quantity of wine and talk about art until late in the night. We were joined at times by a moody, erratic, but gifted fellow named Carlock who died during the World War. Carlock knew more than either of us and though he was jerky and confused in the articulation of his ideas he made a considerable impression on me. He had passed through impressionism and was interested in the classics. It was Carlock who first awakened me to the qualities of the masterpieces in the Louvre. I feel that I owe my first great artistic debt to Carlock, because in all the years of my floundering, he gave me, through his introduction to the values of the classic masterpieces, something to cling to and return to.

I had been in France more than a year when I met my next

friend. This one was to be the only artist in all my life who, as an individual, was able to get past my suspicions of bright and clever people and to have an influence on my ways. Stanton Mac-Donald Wright, the California painter, was the most gifted all-round fellow I ever knew. He was the exact opposite of Thompson, who was a plodder. He was facile, tall, good-looking. He drooped, attitudinized constantly, and had the assured manners of a young lady-killer. Without training of any kind, he could paint, and he also had a quick mind, capable of rapid and logical summations of all sorts. He was as brilliant and open as I was confused and devious. He was outspoken, where I was secretive. While I was losing the physical cockiness of boyhood, he was entering into the intellectual cockiness of young manhood. Paris had shorn me of my outward assurance. It added to his. I met him in what was for me a period of deep depression. By some strange sympathy that was between us, he pulled me out of it. We were an odd pair of friends. We were totally unlike and argued incessantly. We agreed on only one thing. That was that all in Paris, but ourselves, were fools. This saving conviction I had clung to for myself even in my most depressed moods. I was happy to find someone to bolster it, even if I had to share honors with him. On all other subjects but this we could not talk for five minutes without violent disagreement. Wright would frequently leave me in disgust and I would wish him to hell, as he went. A few days would pass and we would be at it again. Wright was more lucid than I, more logical, and got the better of most of our arguments. This was tremendously good for me because the sting of defeat kept me alert and out of the despondent sloughs into which I was so often liable to sink after I discovered how poor was my "genius." With him I got rid of that lurking uneasiness underlying all my contacts with the world. We studied together in the Louvre, arguing about the merits of pictures, and sat under the great spreading trees of St.-Cloud in the autumn, daubing spots of paint on canvas. Wright associated with the intellectuals of the Quarter and relayed

their opinions to me. He defended me before the busybodies among them who said that I should go back to America and try something at which I had a chance of success.

After three years I did go back. I spent a few depressed months at home in Missouri, restless and dissatisfied after the life of Paris. In 1912, after a three weeks' try of Kansas City, I went to New York. I landed as if by instinct in the old Lincoln Square Arcade at Sixty-fifth Street and Broadway. That rambling building provided a refuge for everything and everybody. The doors of its long dark halls opened on every known sort of profession. Signs tacked on its walls told of Mme. So-and-so, Astrologer from the Court of his Hindu Majesty Shah So-and-so, or of Dr. So-and-so, King of the Muscle Builders, or of Mme. Minnie who guaranteed Beauty and sure Love Power through her treatments. There were dancing schools, gymnasiums, theosophical societies, theatrical agencies, and all sorts of queer medical quackeries. There were prize fighters, dancers, models, commercial artists, painters, sculptors, bedbugs, and cockroaches. Everything was in that building. Ambitious youth and the failures and disappointments of broken-down age jostled one another along its corridors. Settling in the Arcade, I tried everything to make money, but without success, and frequently had to write home to my bitterly disappointed Dad for the wherewithal to eat. Finally I did manage, here and there, to pick up odd bits of work that I could do. I went around New York in French clothes and carried a cane. I met good fellows, went to parties, and got in hot water with girls in whom I was much interested but with whom I could never seem to get along for any satisfactory length of time. In the Arcade, one of my young ladies, in a fit of pique, stuck a knife into me. Another tried to mix me up with the Revenue Office for alleged hop smoking. Others were nicer. But with none could I set up a permanent liaison.

Through the influence of Rex Ingram, who went from a novitiate in sculpture where I first knew him to the *Movie Art*, I got scenic jobs in the Fort Lee Studies and earned, for a while, the

exalted sum of seven dollars a day. I looked up historical settings. I painted portraits of the movie queens of the day, Theda Bara, Clara Kimball Young, Violet Mercereau, and others. I knew Warner Olin and Stuart Holmes. With the latter I had a great knockdown and drag-out fight one night over a drunken party argument about who should entertain the ladies present on a player piano.

Rex Ingram, who sponsored my movie jobs, was in those days a highly temperamental young Irishman. He was full of theatrical romance and was always writing scenarios and trying them out on me. He used to get me in a corner, mess his hair up, roll his eyes, and recite his concoctions in the most dramatic manner he could think of. I would sweat and take it for the seven dollars a day he controlled. One time Rex got it into his head that I might be made into an actor and gave me a part in a barroom scene with Paddy Sullivan and Jimmy Kelly and a lot of the other pugs of those days who put on the fights for the movies. When that picture came out it went into theaters in Missouri and some friends of my father's saw it, recognized me, and told him about it. The old man was outraged and wrote me a scathing letter about where my artistic ambitions were leading me. Soon after, I quit my picture jobs over some quarrel about my pay.

While I was working in the movies, I never once regarded the material offered there as fit for serious painting. I missed the real human dramas that existed side by side with the acted ones and in my studio I painted lifeless symbolist and cubist pictures, changing my ways with every whiff from Paris.

My old friend Wright came back to America before the gathering war clouds of Europe. He came back, the founder of a new school, synchromism, which he had flung in the face of Paris, much to the dismay of his more timid countrymen who, as good followers of Frenchmen, regarded his act as gross effrontery. Wright was a welcome addition to the life of New York. Talk in his society was lively. He had come home with the intention of taking New York by artistic storm, and when the city failed to capitulate

he wandered around from studio to studio full of picturesque blasphemy. He was the most devoted skirt chaser among us and our most continuous philosopher on the perplexities of sex. He was the originator of many great and hilarious statements pertaining to the ladies, and the father of many excellent tactical precepts directed to the conquest of the more reluctant among them.

Wavering as I was in all the winds and isms of the time, Wright's synchromism offered enticing formulas. Synchromism was a conception of art where, in practice, all form was supposed to be derived from the simple play of color. It was a complex of the various theories of the time relating to color function, and was certainly the most logical of all. If one admitted, and we all then did, that the procedures of art were sufficient unto and for themselves and that the progress of art toward "purification" led away from representation toward the more abstract forms of music, then synchromism was a persuasive conception. Arguing rebelliously because I still loved represented things, I set out to experiment with it. But I had neither the talent for good imitation nor the conviction to turn my friend's procedures to any ends of my own, and I got poor results. Nevertheless, I began to have my pictures hung in exhibitions and the newspapers noticed my existence. In the Forum show of 1916, which was the first exhibition of American modernists, I had a whole row of things half-imitative of classic composition and half-synchromist. Wright got me in that show. No one else wanted me. But uncertain and unconvinced as my efforts were, I achieved some status as an artist. I even sold a few pictures.

My chief cronies, at this time, were Wright and Thomas Craven. Craven was a poet at the beginning of his writing career and of course could make no money out of his work. To supply his pecuniary needs he was in the habit of taking teaching jobs in small colleges and high schools in outlying places. One year he'd be down South, another in Porto Rico, another on the West coast. After earning a year's salary hammering Greek and Latin into

small-town skulls he'd return to the big city and lie around in an old bathrobe, reading stacks of books. When he was in town we generally lived together.

Another friend was Ralph Barton, the caricaturist. I had met him when I first returned from Paris. He had a fancy for me and carried me through many tough moments. He was clever, made money easily, and spent it—no small amount on me. I was always living in studios or apartments for which he had paid the rent. He was a Missourian from Kansas City. His grandfather had been shot and killed in a duel with my great-uncle, Thomas H. Benton, on an island off St. Louis in the Mississippi. When we discovered this fact it cemented our friendship.

Barton was a curious fellow. He was a little man with a big head, much concerned with women and very attractive to them. He was secretly vain and ambitious to be a "serious" artist but could never give up his easy commercial successes for the discipline necessary to the career which he dreamed of. There was always a conflict within him between what he knew himself to be and what his vanity prompted him to be, and he was as a consequence subject to nervous crises and spells of pettiness. In the end this conflict unsettled him and led to suicide. I always liked Barton though my other friends, Craven and Wright, couldn't endure him. I had a kind of pity for him as well as friendship, for underneath the pretensions of his vanity it was plain to see that he suffered.

Getting money for food and paint was always a problem in these Bohemian days. It was solved in a thousand ways. One day on the street I met an old Chicago friend. When I first knew him he was a tall, handsome, dark-eyed boy with a most poetic face which inflamed all the girls. He was too good-looking to come to any good. When, after years, I met him again in New York he had been through the mill of indulgence and was a confirmed drunkard. In his spells of sobriety he made money writing advertising copy. He was good at this. Tom Craven, my brother Nat (then

a law student at Columbia University), and I were living together at this time. We took in this fellow ("Mac the drunk," we called him) and kept him sober until he'd get thirty or forty dollars worth of copy assignments. We'd feed him, meanwhile. When he'd have his material assembled we'd hold a bottle of whisky before his nose. We'd promise him all he wanted when his stint should be done and he'd get furiously to work. Invariably, when he had delivered his script and got his money he'd make for a saloon. One of us would follow him, head him off, and tell him how much drunker he could get at home for his money. He'd end up by buying a quart or two of whisky. We'd let him get about half-stewed and then, having taken his money from him for "safekeeping," we'd use glimpses of a persuasive bottle, which we kept secreted, to put him to earning again. Mac required considerable attention but he kept our larder full. He was really a good fellow, and apart from drink, thoroughly capable. He fell in with a woman at last who put it into his head that we were using him, and one day he disappeared. Mac exemplifies the straits to which we were put to make a living. We had other methods too, some worse, some better.

The life I lived in New York had no significance for my art. For me, as for all my kind, art was a purity divorced from the common ways of the day. Though some lip service was given to the relations of art and life, in our gatherings, and we talked of art and social idealism and discussed the effect on art of the war that raged in Europe, none of this affected what we did. We were studio painters. We were essentially Bohemians, adrift from the currents of our land and contemptuous of them. We cultivated romantic and esoteric notions and beliefs. New York's high temple of aesthetic pose and lunatic conviction was maintained by Alfred Stieglitz, the engaging and romantic photographer at 291 Fifth Avenue. In his shop, the artistic elite would gather and spout for hours on end. Up in the Bronx a rival station was maintained by John Weichsel, a learned man with Utopian urges about an ab-

straction called "the people" which he believed would support art if given a chance. Apart from his Utopian urges, Weichsel was a man of sound sense who held the run of conversation and discussion in his place on a saner level than was maintained downtown. Weichsel's allusions set me to reading the theoretical literature of the day, and I made the acquaintance of James, Dewey, Freud, and Karl Marx, among others.

At this time I got involved in psychological theory and worked up elaborate though confused psychological defenses of my painting. But my painting practice itself remained tied to studio habit, to an eclectic combination of classic and ultramodern ways. I did constantly improve my drawing by sketching the girl models who were always hanging around the studios looking for entertainment and by an intensive study of my own anatomy in a mirror. But I regarded drawing as an exercise existing apart from the higher abstract values of painting toward which, though I couldn't define them, I had deep hankerings. I still professed to believe, with the other young men of my entourage, that no really fine art was representative. I declared that it must convey abstract *principles* to have eternal value. I pretended to see, in those Renaissance masters I loved so much, nothing but geometrical orders. I was full of *principle*. And yet, at bottom, I didn't believe in my own logic. I carried a front, but, unlike my friend Wright, I couldn't carry my professions to their logical end and paint geometrical abstractions with the facets of the spectrum.

When the time for America's entrance into the World War arrived, I was in the most confused and, secretly, depressed state of mind I had ever been in. Chicago, Paris, and New York had left me finally in a purposeless void. The great cities and the "life of art" had failed me.

Tom Craven and I were living together when the news of America's mobilization plans hit the country. We were in line for the draft. We did a lot of tall thinking. Neither of us relished

the idea of stopping bullets. We were well aware of the fact that the country was out to defend the affairs of citizens with whom we had little or nothing in common. We could see no point in taking risks for dollars which we could never share. Weighing all the propositions in sight, from a declared pacifism to flight to Mexico, we decided that the safest and least troublesome asylum would be the Navy. Others had decided the same thing earlier than we, and we had some difficulty getting in. I was shut out, at first, because of my height. The height ruling, I suspected, was devised to keep such shirkers as myself in the soldiering business. I had no faith that it would save me when the drums began to roll. Remembering that I was the son of a Democratic politician and that we were going to war under a Democratic administration I lit out for Washington.

I went in to see old Governor Dockery of Missouri, a friend and political crony of my father's. He was Assistant Postmaster under Wilson. Getting into his office I introduced myself. He looked me up and down with squinty eyes.

"So you're old M. E.'s boy Tom, the artist feller. . . . Well, Tom, what can I do for you?"

"Governor," I said, deciding to be frank, "I'm in line for the next draft and I don't want to interfere with the progress of any German bullets."

The old boy nearly fell out of his chair laughing. He laughed till he cried.

"Why Tom," he said, "I don't blame you. I wouldn't want to get in the way of any of them things either but what can I do. The country's at war!"

I told him I had naval ambitions. After considering the matter a little, he gave me some letters and I not only got in the Navy but in the intelligence service, where I figured things would be pretty soft. I heaved a sigh of relief and returning to New York settled down to await my call.

My call finally came, but through some mix-up in my papers

it led me to the coal pile and I found myself, not in a swivel chair, but down in Virginia with a shovel, loading boats with dirty coal. This was tough. But I was strong, just thirty years old, and I could take it.

Along with all the art business in New York, I had maintained enough interest in athletics to hang around gymnasiums. I swam much in the summers and prided myself on my physical condition. Still, the coal pile was not the most desirable location for exercise, and I began looking about for ways to escape it. I noticed that a group of privileged young men hung about doing nothing. These, I found, were athletes and athletic instructors. Conniving with one who was friendly, I declared myself an athlete and escaped the pile. I paid for this escape by taking a beating every Saturday night, for the entertainment of the sailors. I set up as a boxer, and though I looked good in preparatory performance, I had poor ring psychology and got licked by boys that I should have handled easily. After a month of this, my papers got straightened out and I found myself in Norfolk at the new naval base. I was put in the architectural service as a draftsman. Having had no training in the business I had visions of a return to the coal pile. There were thousands of them around Hampton Roads. So I set about making drawings of the base as records for the architects.

This was the most important thing that, so far, I had ever done for myself as artist. My interests became, in a flash, of an objective nature. The mechanical contrivances of building, the new airplanes, the blimps, the dredges, the ships of the base, because they were so interesting in themselves, tore me away from all my grooved habits, from my play with colored cubes and classic attenuations, from my aesthetic drivelings and morbid self-concerns. I left for good the art-for-art's-sake world in which I had hitherto lived. Although my technical habits clung for a while, I abandoned the attitudes which generated them and opened thereby a way to a

world which, though always around me, I had not seen. That was the world of America.

There were forces, however, beyond blimps and airplanes which worked for a change in me. Down there in Virginia, I was thrown among boys who had never been subjected to any aesthetic virus. They were boys from the hinterlands of the Carolinas, from the Tennessee country, from all over the South, in whom I discovered, despite all the differences in our experiences, bonds of sympathy. They possessed characteristics which I had known in my child-hood companions around Neosho. I got along with them easily. I realized that psychologically I was much nearer to these boys than I was to the cultivated people of the Chicago, Paris, and New York art worlds. Their egos were not of the frigid, touchy sort developed by brooding much on the importance of the self. They were objective. They were interested in things, rather than selves. With them my own secret internal animosities, which were always boiling in me against people, ideas, or pretensions, faded away. I felt perfectly natural and at ease for the first time since the old creek-bank days in Missouri.

When the War was over I came back to the city full of a cocki-ness that I had not known since I discovered, in Paris, that my "genius" was not a thing to be much depended upon. I had found that it was not necessary to look into myself and my "gen-ius" to find interesting things. I had found that these things ex-isted in the world outside myself and that it made no difference whether I had any "genius" or not. I was released from the tyranny of the prewar soul which everybody so assiduously cultivated in the world of art and which was making of it such a precious field of obscurities. I proclaimed heresies around New York, talked on the importance of subject matter, then under rigid taboos among the aesthetic elite, and ridiculed the painters of jumping cubes, of cockeyed tables, blue bowls, and bananas, who read cosmic mean-ings into their effusions. In a little while, I set out painting Ameri-can histories in defiance of all the conventions of our art world.

I talked too much, and trod on all sorts of sensibilities and made enemies. But I didn't care.

Our old prewar aesthetic world had disintegrated. Its power to put a blanket of gloom over me was gone. Alfred Stieglitz had given up his 291 Fifth Avenue and the droning talk of the aesthetic soul probers he sheltered was ended. It was usually empty talk but always insidious to young artists.

Now that it is well in the past and its troublesome effects on my youth forever gone, I think sometimes of that 291 crowd with a sort of regret. It had a kind of glamorous character which I never expect to find again. I think of little quiet Abe Walkowitz so deeply serious that you could never understand anything he said, of Max Weber so in love with his own "genius" that he preserved his every brush stroke as a gift to posterity. I think of Marsden Hartley with his distressed egotism and his fishlike hand, of Leo Stein (brother of the famous Gertrude) with his keen but tortured intelligence, and of old Stieglitz himself, with his Socratic poses and his boundless, infinitely shaded egotism.

It was a picturesque crowd that Stieglitz gathered under the roof of 291. I never fitted very well under that roof but I must give it its due for the sheltering of more intellectual curiosities than I have ever seen anywhere else.

There was Willard Huntington Wright, young enough at that time to think that he could rationalize aesthetics. He was a brother of Stanton Wright. Willard was a character in those days, before he became the famous S. S. Van Dine. He wore a square beard and was ostentatiously pro-German when that was most unpopular. He was devoted to Nietzsche and did all that was possible to live up to his conception of the iron-willed and ruthless Nietzschean superman, taking haughty attitudes with doorkeepers, elevator men, hotel flunkies, and any of his acquaintances who would stand for it. He patronized German delicatessen stores, going into them with the airs of a Junker aristocrat and combing his beard over the potato salads to the consternation of the Teutonic proprietors, who

were afraid to say anything to him for fear that he might really be one of the great ones of the Fatherland over on some secret mission.

There was Traubel, who had sunk his personality into that of Walt Whitman and who lived completely in reminiscence of the master. There was the extraordinarily genteel Henry McBride, who was trying, and for that matter still is, to be the delicately cultivated wit of art criticism. And there was Cortissoz of the *Tribune*, who was so much in love with art that he never saw any of it. There was Lee Simonson, now a famous scenic designer, who runs over to Europe every summer and brings back the latest fads to incorporate into American scenic technique.

Lee in those days still thought he was a painter. He thought it on the surface, however. In his soul he was in much doubt. Stanton Wright, who had a sadistic genius for torturing the uncertain, used to turn poor Simonson inside out by telling him he looked like a Hungarian rug dealer who'd got a paint brush in his hand by mistake. I always thought Simonson looked like one of those ifrits in the *Arabian Nights* who had somehow or other escaped from the bottle in which Solomon had sealed him and who was in constant fear of being put back. Simonson had all the effrontery of the fearful-minded.

And then there was Stanton Wright, the only one for whom I had any real use in that crowd. Stanton went away after the War to California. He was tired, he said, of "chasing art up the back alleys of New York." He was certainly the most intelligent fellow in the whole outfit, and the most talented. With the exception of Tom Craven, Wright was the closest friend I ever had. He was an incalculable friend in some respects. He'd get the girl I was interested in or even my mother, and, under the guise of witty conversation which would hide the lapse of good taste, let them in on all the secrets of my career. When my doings weren't interesting enough or low enough he'd embroider them. But in spite of this twist of loyalty I depended a good deal on Stanton Wright's

friendship, and in spite of the mounting self-assurance that came to me after the War I had a sincere regret when he departed for the nut state.

With the dissolution of that old prewar crowd which formed the nucleus of artistic society in New York, somehow or other I began to expand and live. Their cultivated sensibilities had always affected me adversely. When I got among them I felt as if I were down cellar with a lot of toadstools. I always secretly thought they were an intellectually diseased lot but I didn't have enough confidence in myself to break with them and turn my mind out into the real world.

After the experiences of the War I got free of them—of all their sickly rationalizations, their inversions, and their God-awful self-cultivations.

In my postwar period of renewed confidence I got married. This occasioned much consternation among my friends, who were certain, knowing something about my experiments, that it would be impossible for me to live permanently with any woman. I fooled them. Or it might be better to say, my wife fooled them.

I had first met my wife five years before, while holding down a sort of uplift position for the Chelsea Neighborhood Association. I conducted a gallery on the edge of the West Side for the purpose of raising the cultural status of the locality, and at night I taught free art classes in the public schools. My wife was one of my students. She was slim, dark-eyed, and beautiful. She wore a red hat and was disposed to be friendly. We commenced going around together. I never had any money, for my salary with the Chelsea Association barely paid for my rent, paint, and food, and my new girl had to settle all of our entertainment bills. She didn't mind and as I had long ago lost any chivalrous ideas about the proper economic relations of males and females, we got along. I had no false pride to bother me.

Rita was an Italian, a Lombardian. Her people spoke no Eng-

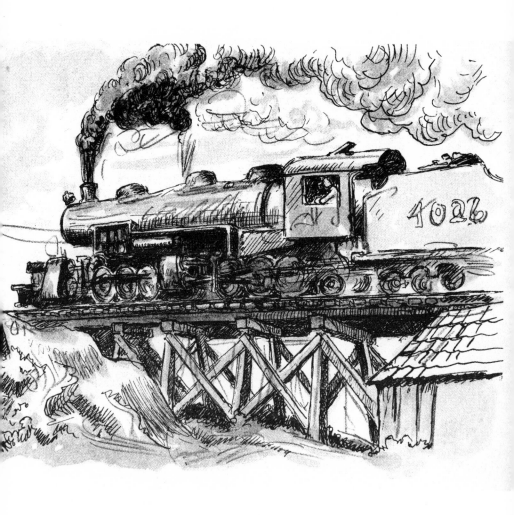

lish. When I came back to New York from the Navy I used to go to her home for Sunday dinner. Tom Craven would go with me. We'd sit in silence and stuff ourselves with great Italian courses, get in a stupor with wine, and then rise silently and go away. We never said a word.

When after a few years the question of marriage was presented to her parents by Rita, her father thought it might be well to get more intimately acquainted with me. One Saturday afternoon he showed up in my studio dressed up in his Sunday clothes with his watch chain hung across his belly. He greeted me with great dignity and sat down. He was a big man and the chair squeaked under his weight. I faced him, knowing what was on his mind. We had no way, however, of communicating with each other, so pretty soon I got up and went to painting. I worked and my prospective father-in-law sat. Hours passed and when night fell he got up. With an affable gesture he reached out his hand. I took it, and we parted.

After our marriage Rita and I lived from hand to mouth, but we lived. Besides working on compositions depicting American history, I continued the practice that I had started in the Navy— drawing pictures from the things of the world. I drew around the streets and water fronts of New York and my wife sold my pictures at low figures. Doctor Raabe, an old friend of mine who practiced medicine up in the Bronx, used to take the sketches he found around my studio floor and pin them up in the houses of his patients. After a while he'd come and take them down, but by that time the people of the household would have become used to the pictures and the space they had occupied would look bare, so they'd buy them, generally on the installment plan.

My wife designed hats and posed with them for fashion periodicals, so we got along. It was pretty tight business, though, and took some close management. After about a year of marriage we got a break which not only immensely improved our economic status but opened up a new and entertaining world.

In her hatmaking business Rita had become acquainted with a young woman named Sally. Sally was a plump, good-looking vaudeville actress who trooped about the country with a couple of pickaninnies, singing mammy songs. In one of her New York engagements she had met Denny. Denny was a criminal lawyer, tenderloin style, and at the very top of his form when he and Sally came together. He wallowed in ready cash. The fruits of that well-known tree which grows so well on the pavements of the great cities, and whose roots slipping down through a thousand hidden cracks lie in the lush slime of low politics and criminal racketeering, were his to gather. And Denny gathered.

I don't remember just how or where Denny met Sally, but when he did he fell in love. According to all accounts, it was a desperately romantic love, a poetry-writing, flower-strewing, diamond-buying love. Denny not only loved but expatiated on the idealistic qualities of his sentiments. He talked in high-flown language, as only they can who live in precarious social areas where the acrid mud of dark and devious paths sticks to the feet, and where the soul's call for compensation runs hard to extravagant sentiment. Denny's idealism offset the shadiness of his mundane activities. It was as chivalric as the loyalties of that murky world of thugs and thieves which adjoined his own legal one.

Strange as it appears, it is mainly along the social border lines that we must look for the sublimated eroticism of the poets. In the unconventionalities of that world it is a living rather than a linguistic factor. The inhibitions of respectability, of upright self-consciousness, put no restraints on the acting out of flaming illusions in this land of fierce reality. None dares to be so pure as the defiled. The children of racket, fraud, and vice seem to be more capable than all others of resolving the contradictions involved in fact and conception. The strip artist, putting the last bead on her eyelashes before going out to wag her tail at the drooling slobs in the first row, looks in the mirror, not at a little slut, but more often than not at one who is ready in spirit to give and take the

uttermost in extravagantly idealistic and flower-bordered love. The blue-chinned, puffy-eyed gambler, daddy of the sure-thing racket, speaks with contempt of those who lack high-mindedness in affairs of the heart. He gives the "little ladies" their complete romantic due. He does this even though in the field of everyday actuality it becomes sometimes necessary for him to bust them in the eye. The crooked bondsman, the sharp-practicing lawyer of our urban borderlands, are with their allies capable of the most astonishing idealism. They are frequently as grandiose in their ideals as are those gentlemen of higher social rackets whose souls break so emotionally over the notion of liberty and constitutional right.

On the edge of the underworld, chivalry makes its last stand. In the dread impermanence of its life there comes to this land a rush of strange and extravagant sentiments, loyalties, devotions, and hates. Among other things, the perfume of the lilies of love comes there, an extraordinarily pungent narcotic to disguise with the grace of tender illusion the sinister wills and compulsions of the rackets.

Well, anyhow, when Rita met Sally, Denny was in love with her and had her beautifully set up in a brocaded Riverside Drive apartment where lavish Bohemian entertainments were the constant order of the day, or rather the night. Rita and I were invited to these entertainments and became for three years part and parcel of this higher strata of New York's underworld.

I remember well the first of these parties that we attended. I had an agonizing feeling on arrival of being utterly out of place. I had known Bohemias before, those of art students, young writers, models, and chorus girls out of work, but they were Bohemias of the poor into which I fitted easily because of their equalitarian nature. Here I was a practically unknown and impecunious artist in a rich Bohemia where easy money, confident gesture, and the displays of quick and questionable success were much in evidence. I had a sneaking feeling that I was invited there because my wife was attractive and I felt like a sort of pimp. Before the celebrities

of the stage and bar who were the lights of this affair, I was something less than nothing. No one but my wife paid the slightest attention to me. I sat in a corner and listened to the momentary geniuses of Tin Pan Alley wheedle the piano and warble love and moonlight synthetics. Once or twice in desperation I tried to dig in on the conversation, but even with the help of excellent pre-prohibition whisky I fell flat against the flamboyant sentimentalism of the lawyers and the extravagant lyricism of the actors. These people were worse than the movie queens of my Fort Lee days. Theda Bara was a considerably extravagant person but she wouldn't have classed in this crowd.

There was a famous old judge, an expert on federal law, who attended the party. Starting from the utter poverty of a Russian immigrant boy, he had worked himself up, against all the disadvantages of strange language and practice, to a high position in his profession. His hair was white and his carved Semitic face seamed with lines of ardent study. Apart from his grooved chins and hanging belly, which bespoke uncontrolled gluttony, he had a certain air of nobility and intellectual strength which made him stand apart among the tenderloin legalists about.

The judge had come to that age where so many serious and hard-working men, suddenly taking count of life, check the value of their laborious successes against certain other values, for which in the days of their youthful energy they could spare no time. When he first caught my attention he was sitting in a corner under a dim pink-shaded light trying with the aid of suggestive conversation to refind the past in the reluctant eyes of a blond musical comedy actress. The girl, as her glance wandered indifferently from that of the questioning old judge, caught sight of my bored face ,and seeing in it a possibility of rescue beckoned me over. She was a friend of Rita's and knew all about me and introduced me to the judge as an arriving artist, a person of great talent and promise. She embroidered the matter of my qualities so considerably that the judge was piqued and launched into a sudden, and com-

pletely uncalled for, tirade about the low intellectual ability of artists as compared with that of lawyers. It was plain enough what was stirring the old fellow's resentment. The fact that his lady friend should have called over a damned nondescript artist when he, the great and famous judge, was favoring her with intimate conversation was utterly unendurable. Hurt in his pride, when he was just touching the fringes of an old man's amorous emotion, he set about taking it out on me.

The judge, however, was mad and I wasn't and in the argument that ensued I got much the better of him. This incident saved the party for me. Others joined the discussion and in a little while I was at ease. I talked and drank, and before the end of the evening I was in a high and happy state.

In time I came to like Denny and Sally and their friends a great deal and looked forward to their parties. Sally, whose heart embraced the welfare of everything and everybody, induced Denny to buy my pictures and pretty soon the brocaded walls of her apartment were full of them. Every time Denny saw a new one hung he'd study it with long, serious, and doubtful stares. When observed by any of his legal or political cronies, he'd take quick refuge in Broadway wisecracks. Denny was very skeptical about my paintings at first but in time he became proud of them and they got to be one of the main topics of conversation at his dinner table. There was one picture, a big exercise in figure arrangement, about which there was much argument for a proper title. The name *Figure Composition* didn't suit Denny's crowd, so after several sessions of hilarious and liquid discussion, the painting became known as *Basketball in Hell.* I took a lot of kidding about my pictures at Denny's but as long as I had my face over a highball I didn't mind and returned as much as was given me. Denny paid money for my pictures, Sally was continually giving Rita things for our apartment, and we lived well.

For a while I had some pretty mixed-up feelings about Denny and his kind. Their activities ran plainly into shady places, the

people they brought around were frequently coarse and brutalized. But in time I came to see that in spite of this they were very human and that their extravagant sentiments had a sort of reality for them. I found that lawyers with burnt fingers and politicians with an easy sense of municipal responsibility could be very loyal and entertaining friends, and that their wisecracks never took on the malicious character of the witticisms of the artistic world. Strange as it may seem, lots of these fellows in comparing themselves with me found that I was calloused and cynical. This was because I found it impossible to share their sentimentality, or look upon their moral views as other than compensatory frauds. I was never quite able to reconcile the sweetness of their sentiments with the devious nature of their actual ways, and my undisguised and simple realism shocked them. But in spite of this I got along extraordinarily well with the most of the crowd. Maybe it was because I knew how to laugh.

One day after I had known Denny a long time he came into my studio and announced enthusiastically that he had found a way for me to turn up a lot of dough. I was to go over to a certain Tammany club, he explained, and introduce myself as the artist commissioned to do the portrait of the new alderman—who had had his instructions and would sit for me. I was to make a good snappy portrait, for the club had agreed to buy it. Denny had the idea that once such a precedent was set all the Tammany organizations in New York would be calling me in to memorialize their chiefs.

I regarded this proposition with my tongue in my cheek, but I didn't want to offend Denny or seem to spurn his generous effort to help me along, so I took my painting outfit the next day and went to the club as directed. The clubhouse was uptown just off the skirts of black Harlem. It was a conventional brownstone affair. Its window shades were drawn and it looked forbidding. I went inside. The rooms, dimly lit, were full of lounging men. Cigar and cigarette butts littered the floors. Wooden camp chairs

and some big tables did for furniture. At most of the tables card games were in progress. I stood around a few minutes and looked at the faces of the men, trying to catch an eye. A low coarse set of faces they were for the most part—stupid but at the same time shrewd.

Putting my canvas and paintbox down I approached a couple of young fellows inspecting a racing sheet and asked for Mr. So-and-so, the alderman.

"Wot'cha want wid 'um?" said one.

"I'm the artist Denny sent to make his portrait," I replied. As they looked blankly and suspiciously at me, I explained the matter. Denny's name, once it became plain that I knew him, was enough to fire interest and one of the boys left for the back of the house. The other returned to his sheet. I stood around. Generally I can make some sort of talk with people, but against the dead cold indifference of the faces in this house I was dumb.

After a long time my messenger returned and took me down a flight of back stairs. He made me sit down on a bench in the basement hallway while he briskly opened and shut a door leading into a side room. In the split second that the door was open he shouted, "Here he is, Benny!" Then he went back up stairs and left me.

I sat in the faint light of the hall for fully twenty minutes. Enraged finally, I got up and opened the side room door myself. Jammed close together, a pack of men surrounded a table in the center of the room. Some kind of game was going on but I couldn't see what it was.

"Say gentlemen," I called, "Denny So-and-so sent me down here on business. I can't wait all day. Where's the man I'm to make the picture of?"

The men about the table turned with amazed stares. There was a guffaw from inside the circle. "Aw, it's Denny's nut," a voice said. "Take care of 'um, Sam, I'll be there in a minute."

A short kinky-haired fellow disengaged himself from the circle

and took me by the arm. I resisted. "Say, buddy," I said talking loud but trying to be friendly, "if it's Benny I'm to make the picture of, let's get a look at him. I can't paint if it gets dark. Denny told me everything was fixed for me here." Sensing its potency, I stressed Denny's name.

The circle of men parted and out came the very prince of young aldermen, the very archetype of young Tammany schemers. Benny, the neighborhood political genius, took me off my feet. He was *it* so thoroughly, so completely, that without my eyes to show me I shouldn't have believed him real. He was immaculately dressed. His swank derby was cocked at the exactly correct aldermanic angle. His broken, flattened nose was squashed over his fat lips and his uptilted cigar was a silent cock's crow to the world.

"Hello there." He extended his hand with a grand good-humored air of patronage. "So you're Denny's boy. Well, anything I can do fer Denny goes easy with me. Wot's yer name?"

"Benton." I ignored his lofty manner for the magnificence of his style.

"Eyetalian?"

"No—Missouri Benton. Old Democratic family, you know." It occurred to me that this might impress him but it didn't. His political background didn't extend beyond his own ward. "Denny told me," I went on, trying flattery, "that you were the up-and-coming man in this town and that your friends wanted an oil painting of you."

"That's right, that's right," he agreed. "The boys do want the pitchur. But I'm a busy man and haven't got no time so I brought some good photos fer yuh. You can do yer stuff from them and I'll come in with the boys and help you out ever once in a while. Git them photos, Sam," he commanded.

"No, no," I remonstrated as Sam produced a bulky envelope. "Let the photos go. Give me just half or three-quarters of an hour and I'll do you a real job."

Benny revolted, but with a liberal use of Denny's name and all

the tricks of persuasion I could think of, I finally got him to consent to sit for me. He wanted to get back to his game and was a little self-conscious about yielding to me before his gang, but we finally proceeded to an empty room on the second floor. Sam led the way with the envelope of photographs.

"Show 'im them pitchurs, Sam," Benny commanded.

"No, no," I protested. "Just sit down and let me get started. I'll look at the pictures later."

I got Benny down in a chair, put my canvas on another, whipped out my palette and colors, and began to sketch. Benny jerked off his derby, straightened his necktie, and took his cigar out of his mouth.

"Stay as you are," I pleaded. "Put your hat back on."

Benny turned on me. "Hey, you!" A gleam of suspicion came into his eyes. "None o' that. Wot yuh think I am—a mug, to have my pitchur taken wid a hat on! This here's a clubhouse pitchur. Show 'im them photos, Sam."

Well, I had to look at the photos. As I expected, they looked more like Rudolph Valentino than Benny the alderman. His busted nose had been smoothed over and all the other marks of his picturesque individuality wiped out.

"I can do better than these," I said. "I'll make you look like a man."

"Yeah," said Benny, a little hurt.

"Yes," I urged, "just keep still and give me a chance."

Benny wouldn't put the derby back on but he settled down and I began to work as fast as I could. Sam stood behind my back. He was joined pretty soon by some of the loafers from downstairs who'd got wind of Benny's ordeal. They watched me silently. I put on all the steam I could, drawing with stains of brown paint on the white canvas. I got the aldermanic head in rapidly.

Forgetting all about Denny's plan to treat this portrait as the start of a money racket, I simply painted the face in front of me as it was. Absorbed, I forgot the onlookers at my back. As I put

the last dent in the broken nose and was preparing some flesh tones to lay over the basic drawing, I saw the aldermanic eye look past me to his loafing henchmen. I caught the restless question in its glance and sensed the negative sign that replied. Benny jumped up and looked over my canvas.

"Hey, wot's that!" he growled indignantly. "Wot yuh think this is? Yuh think Denny sent yuh here to make a monkey out o' me?"

"What's the matter with it?" I asked, blind in my enthusiasm over my sitter's picturesque countenance.

"Git them photos, Sam."

He held one out. "That's me," he barked with crackling emphasis.

"Sure," I replied, coming out of my painter's trance and waking up to the situation, "but I'm not finished. Wait a little, I'll get you all right."

"Work from them photos till I come back. Sam and the boys'll help you." He pushed out of the room. That was the last I saw of him.

Sam spoke up. "Say, yuh don't want to make no pitchur like that. Ain't you got no respec' for a man's position? Tha's a mug you made there."

It seemed to me that there was a touch of menace in Sam's voice, veiled but positively there. I thought a minute.

"Do you think I got the shape of his head?" I asked in as conciliatory a tone as I could muster.

"A pitchur ought not to be so fat in the back of the neck," one of the ward boys behind me spoke up.

"That's right," said Sam. "A pitchur is a pitchur."

I picked up one of Benny's photographs. "Does that look like the chief?"

"That's a good pitchur," said Sam.

"But the chief has a broken nose," I insisted.

"That's a accident," replied Sam. "We don't want no pitchurs of accidents. You make the chief like he is without any accidents. You better get it fixed. The boss don't feel so good about you."

I began to feel certain that I was going to lose my sketch if I didn't do something about it. I sensed that these fellows would never let me take it out of the building. I didn't give a damn about the commission, but I wanted my young alderman.

I felt my canvas and knew that it was sufficiently absorbent to hold what I had so far done. I coated it with retouching varnish. Then deliberately taking my time so that the varnish would dry, I mixed up a lot of thick flesh-colored paint. I picked up one of the photographs and with a light touch copied it over my original. I worked an hour or more. Sam kept around me. He'd go away for a while and then come back with suggestions. The other fellows left for good.

By the time it was dark I had a pretty fair copy of the photograph. I asked Sam how it was.

"It's a better pitchur but it still don't look so much like the chief," said Sam.

"You're a pretty good critic," I ventured.

"Yes," Sam agreed. "You know I'm an artist myself. I'm a barber. I'm Benny's barber. I shave him every day. I know how he looks."

"Well, I'll have to come back and finish this from the chief himself," I said. "You think we can get him to pose if I phone tomorrow? You seem to have some influence with him," I insinuated flatteringly, "maybe you can help me."

Sam responded to my suggestion of his importance. He spoke with a sort of friendliness.

"I'll help you O. K.," he said. "You just call me here at noon. I'll fix it with the chief."

I packed my stuff. "I'll have to take this home," I said, picking up my canvas, "to keep the paint from drying."

"That's O. K.," said Sam. "You call me tomorrow noon. I'll fix it for you. One mistake ain't nothin' with the boss." Then he whispered, "Don't forget who helped you out with this."

He let me out the front door.

I rushed home with my canvas. Tenderly I scraped off the surface

paint with a palette knife. My original was there, blurred a little but easy to fix. While my memory was good I touched up my alderman.

That was the first of a long series of American portraits.

When Denny saw the picture he was sore.

"Can't help a nut," he said. "You threw away a gold mine."

Later, however, he confided to Sally, "Tom sure nailed that mug."

That was some crowd of Denny's. It is now long broken up. Denny, like his pal Bill Mallon, is dead, and the Broadway where they splurged has forgotten them. Mallon, because of the flamboyant nature of his talents and vices, became the hero of a book but Denny coughed himself into simple oblivion. It was a strange crowd, rounders and shady legalists. The one I liked best in it was Lon. Hook-nosed, clever-eyed, sentimental Lon, who, because he was more sensitive and less calculating than the rest of his kind, became the catspaw of their sharp practices and ended by getting disbarred. Lon and I remained friends for years. On the downgrade he ran a second-class hotel uptown. One winter he turned the dining room of his hotel over to me for a studio. It was there that I made the plans for the New School mural.

During the years in which my wife and I shared the evening gaieties of Denny and Sally and their crowd, my reputation as artist continued to improve. It wasn't exactly that anyone accepted me but that they noticed my work and commented upon it.

My first public success came in Philadelphia at a large exhibition of American moderns where my canvases attracted considerable attention and drew the interest of one of the foremost collectors of modern works. This collector was and still is one of the rare cards of the picture business. A Philadelphia patent medicine manufacturer with the manners of Benny the alderman, Albert Barnes had become deeply interested in painting some years before, and was

when I met him well informed about what was going on in the field of modern experiment. Barnes did not himself buy my pictures. They were, however, purchased by one of a group of lady psychologists who worked with him and whose opinions he dominated, so I and everybody else thought that I had Barnes' approval. He did take a liking for me and with Tom Craven, who was another momentary shine of the collector, I paid him many week-end visits which were devoted to discussing art and the problems and meanings of art. The Philadelphian was a well-educated but hard and ruthless business realist. He was also a great spinner of aesthetic cobwebs. Although I finally quarreled with him, as has nearly everybody else who has had much to do with him, I really got a good deal, in the matter of stimulation, out of his conversation.

He was the one collector I ever knew who had something of the painter's technical view of painting. In addition he was an informed and ingenious thinker and a hard man to down in argument. He could not stand opposition and used to pace the floor like a caged animal when Craven and I got him in a corner. His temper was always well controlled when we were in his presence but in his letters, which were frequent, he went into gutter manners which made dealings with him finally impossible.

In the last analysis, Barnes had, for all his intelligence, the typical collector's psychology. He was after rarities and geniuses. He was interested in the *things* of art rather than in art as human activity, and he had in addition so rationalized his preferences for certain kinds of art that he was almost impervious to the effects of others. Barnes preferred the Venetian painters and based his aesthetic structures on their color processes. With my own preference for the Florentines, to whom I was technically much devoted at that time, it was inevitable that we should come to a break. Barnes has since written a large and ponderous book about art. It is dull reading and now outmoded but it bears witness to one amateur's unquestionable seriousness.

Although he was much disliked, the Philadelphia collector had considerable influence in the art world. Because it was thought he had bought my works, other people in Philadelphia and New York bought them also. My professional reputation advanced rapidly. I was still pretty clumsy with my paint and could not achieve clear color but my developing art became distinctively mine. In my studio I had been working secretly for five years on an ambitious American history series. I began showing them in the Annual Architectural League shows and the critics noticed me as a prospective muralist.

A year or so before we were married, my wife and I had made summer trips to Martha's Vineyard, off the Massachusetts coast. We continued to go there, and every spring would leave our New York apartment, subletting it to actors or southern girls who came north to study. We would stay away until autumn. We lived in a made-over barn which was covered with rose vines and which looked out over Vineyard Sound. It was in Martha's Vineyard that I really began to mature my painting—to get a grip on my emerging style and way of doing things.

I painted the landscape there and the old people. About the old Yankees of the island there was something deeply appealing. Many of them, for all their crotchety ways, had the nobility of medieval saints. They were not, however, all noble. Some were more picturesque than saintly but I painted them just the same. I made pictures of Billy Benson, Frank Flanders, Chester Poole, Dan Vincent. Old George West and his wife hang now in the Whitney Museum. Painting these plain American people and their environment, I got clear of all the hang-overs of France and the isms of modern aesthetics. Looking out over the sea, I got rid of most of my upsurging cockiness too. I lost the assurance, recaptured on my return from the Navy, that all were fools but me. But this time I didn't lose it in despondency. I saw that, so far as I and my art were con-

cerned, it didn't much matter who was a fool. I learned that in the face of the land and the sea and with people who were real.

Rita and I lived in the Vineyard like a couple of savages. We swam, gathered berries and mushrooms. I tried the mushrooms out in small doses on our company. We hardly ever put on respectable clothes and when our son, T. P., was born he ran naked over the dunes and was sunburned to the color of mahogany.

At a party on the island, I met Boardman (Mike) Robinson just returned with a flaming red beard from the new republics of Russia. Mike and I, after getting drunk one night and turning over all the summer privies, became fast friends and worked and argued together beautifully. Mike was the world's most famous cartoonist but was starting out almost in his novitiate as a painter. We had much to discuss.

Martha's Vineyard had a profound effect on me. The relaxing sea air, the hot sand on the beaches where we loafed naked, the great and continuous drone of the surf, broke down most of the tenseness which life in the cities had given me. It separated me from the Bohemias of art and put a physical sanity into my life for four months of the year. Providing me with a homely subject matter and a great quiet for reflection, it continued what my experience in the Navy had begun—it continued to draw me from the stultifying effects of those theories of art which, born in the confused struggles of my era, made me see all aesthetic effort as directed toward the exemplification of principle. It freed my art from the dominance of narrow urban conceptions and put me in a psychological condition to face America. It was in Martha's Vineyard that I first really began my intimate study of the American environment and its people.

My experiences during wartime had turned me away from myself, had given me objective interests, but I still was a psychological child of the paved streets, provincial and narrow as only they can be. The city, though it had been for me a well of personal stimulation, had

left my art barren and aloof from reality. Although I later dealt extensively in my painting with New York life, I did not learn to approach it pictorially until after the little Massachusetts island had freed me from its illusions and opened my mind to receive the great American world beyond it.

III

On Going Places

WE AMERICANS are restless. We cannot stay put. Our history is mainly one of migrations. Those families are few who remain more than one generation in any locality. Modern historians are prone to lay all the emphasis in explaining this on economic pressure and an urge to alleviate the subsistence struggle among those in areas of original settlement who found themselves without wealth or goods. In a large sense, this covers the matter. But not wholly. There seems to have existed since earliest times in this country an adventurous foot itch which made it difficult for men to plant themselves and settle for all time. While in Europe they remained on the land from father to son and could trace their tenure for hundreds of years. In America under identical economic circumstances they pulled up stakes and moved on. It is true that here opportunities for moving on existed that had no parallel in Europe, but the fact remains that in thousands of cases people left their eastern lands where they could have maintained positions undreamed of by the peasant farmers of Europe, for reasons, considering the standards of their time, which cannot be considered economic except by the most infatuated adherents of theory. Their moves, furthermore, were undertaken more often than not on the wildest hearsay, and for many resulted in more hardship and more violent and dangerous battles for mere food and shelter than would ever have been known had they rested content in familiar localities. Men moved before they took thought and under impulsions that were not always those of economic necessity.

65

My maternal grandfather, Pappy Wise, was one of these. In his youth he started going places. Along the upper reaches of Green River in Kentucky, he cut timber and with his companions constructed rafts. These, loaded with produce of various sorts collected in the rich bottom lands of the region, were floated into the Ohio and the Mississippi and, after weeks of labor, brought to New Orleans. With their profits, slim or great, according to market conditions about which they had no way of knowing anything, they walked back. In armed bodies they labored up the Natchez Trace and across Tennessee into the back doors of Kentucky to start again cutting timber. My grandfather did well and managed to set himself up as storekeeper. He became, for the Green River country, a substantial man possessed of goods and enough leisure to sit on his store gallery and get expert with the fiddle. He married and had three children. Then for no ascertainable reason beyond that of the foot itch mentioned above, he loaded his store goods in a great wagon and, with a horse and buggy for his wife and offspring, set out westward in 1854 for the Missouri country. In those days that was a long and hard journey. The best of roads were little better than trails. But Pappy Wise made his way and settled in southeast Missouri a few miles from the Mississippi.

He bought up some fine bottom land, cleared it, plowed it, and brought in a good corn crop. He traded some of his Kentucky store goods for hogs and with these and his corn looked forward to a good start in his new world. But he built his corncrib without reckoning on the temper of the Mississippi, and the water rose in a winter flood sending his whole crop packing down the river. He turned his hogs loose in the woods. There was nothing to feed them. Under hardship he got by and the next year brought in another good corn crop and bought more hogs. With the new hogs and those he could round up from the brush, he calculated profits in a substantial "down-the-river" pork business. Warned by the disaster of the preceding winter, he built his corncrib above the reach of

floodwater. But an epidemic of hog cholera hit south Missouri and killed off his hogs. There was corn, but nothing to feed it to.

With the two years of such experience he had enough of Missouri, but instead of returning to the safeties of Kentucky he listened to tales of Texas and, without considering whether he might not be going from bad to worse, traded his lands, the buildings and pens he had put up, and set out westward with his wagon, his buggy, and an additional child seven months old. He was moved by other ideas than mere economic security, which could have been refound among his kin in Kentucky. He was by no means destitute. He still had store goods, a wagon, horses, and a buggy, and he might have gone into business right where he was. But no, he followed that blind lure of the faraway which so pulled at the hearts of his generation and which implants yet in its descendants a nostalgic craving to be up and going.

On the threshold of middle age, over barely broken trails in the passes of the Ozarks, he made his way down into Texas. There his wanderings came to an end. He stopped in town. Being clever with his hands, he went into the business of making saddles. The men of Texas were horsemen, and his trade was profitable. But though his land wanderings were over, Pappy Wise settled to no one way of making his living. He ventured here and there and, in the crucible of varied experience, learned to do many things. When the Civil War came he was expert enough as a mechanic to make and mend guns for the Confederate army. He ran, at different times, a blacksmith shop, a carpenter shop, a furniture shop, and a wagon shop. He traded in land and cattle and goods and begat ten more children. Late in his life he went back to farming and moved to the cotton plantation where I knew him, an old man with erect gait, long white hair, and a plaintive fiddle.

Pappy Wise was one of those who girded himself and went simply because he wanted to go. No doubt, in his mind was the thought of bettering himself; certainly that was his expressed reason for going, but I suspect that at bottom he simply yielded to a restless

urge for change. How many are the tales of settlers in possession of perfectly good land who, the moment some of the safeties of civilization gathered about them, grew dissatisfied and moved farther out on the frontier, dragging their unhappy wives into loneliness and danger for obscure reasons totally unconnected with economic security. The annals of the valleys of the Mississippi are full of such tales of pure restlessness.

A further proof of the insufficiency of the economic motive to explain fully the forces operating upon the moving westerners lies in the wholly unreasonable land selections of the mountain people of the South. In their westward treks they perversely passed up the rich land of the valleys and plains which were, in many instances, available, and they located once again where they had to plow and hoe their cornfields on thirty-two-degree slopes—no different from those of the Appalachians they had left. Even when they departed from their homelands under pressures of an economic nature (and there is no doubt that such pressures, frequently of an intolerable sort, existed), they used no economic logic in selecting the places where they were to rest. The location of their homes was determined mainly by psychological forces rather than economic ones. These psychological forces, nostalgias, restless yearnings, unexplainable dissatisfactions, in addition to such pulls of habit as seem to have operated on the southern mountaineers, are factors which in our current rage for a logical explanation of everything, we are in danger of forgetting. But they are important, not only historically, but because they are yet with us.

When I was a boy, the trains running from St. Louis down through Indian Territory and Oklahoma were full of movers from the valleys of the great rivers eastward, from Illinois, southern Ohio, Indiana, and northern Kentucky. These movers were different from the older settlers who had come by wagon. They were psychologically more dilapidated. They were the advance guard of the great army of dispossessed, who, through hard luck, merciless foreclosure, incapacity, and pure inability to settle down, were being forced into a

hopeless dependence on the shrewd and grasping go-getter and the absentee owner. But in spite of many brutal economic pressures patently operating on them in the regions they had left, they were as a whole the most hilariously hopeful people imaginable. As I remember them, there was rarely anything to indicate a forced migration and certainly the better part assumed that they were acting of their own free will, which is in fact just as effective on attitudes and temper as if they were. Except for some occasional old couple, draped in cherished memories of the past, they were happy to be going. The mere fact that they were off somewhere, far away, seemed to wipe out all their difficulties and give them an immense vitality. In the chair cars of our trains they chewed and spat, ate out of their enormous boxes of provender, talked and argued with their fellow passengers, recounted zestful histories of their lives, and expanded on their future. Their children, swarming by the dozens, energetically sucked stick candy and wiped their wet sugary hands over everything. It apparently never occurred to these movers that in the lands of Oklahoma and Texas to which they were going they would find that better organized and more predatory men had come before and that their lot in the future might well be worse than in the past. They were too much under the influence of the moving itch to take thought. They were under the spell of El Dorado. Many of them still in possession of unencumbered land had sold out at any price, some, it is said, for little more than the price of railroad tickets, before the persuasive voice of rumor, which promised everything for the newly opened lands of the West.

The farther they were going into these new and unknown places, the more zestful they seemed to be. The idea of distance was like a potent drug which injected into their souls the most glamorous hopes. Our main railroad, the Frisco, was a far-flung line. To travel its length was called by the movers "goin' on through." This meant that they would pass up the more settled eastern lands of Oklahoma and Texas and venture into the areas farthest away. Movers getting off at some little southwest Missouri or eastern Oklahoma station

would look wistfully at the traveling acquaintance who was "goin' on through." To "go on through" meant something far more appealing than a mere promise of success, and young men and old would cock their big black felt hats at an angle when they had the satisfaction of telling fellow passengers that their destinations were out on the limits of the line.

I have often wondered what must have been the effect of the Oklahoma and Texas plains on these people who, for the most part, had been used to lands of green trees in the watersheds of the Mississippi and its tributaries, and who, when they got off their trains, faced for the first time the illimitable stretches of sky and land which is the plain's country. I have often wondered too if any of them managed to hold on to their land after oil was struck in the West. I have heard of the old settler who sold his Texas farm for a pittance because it had greasy black patches on which nothing would grow. There must have been many like him. Somehow it is hard for me to believe that the movers of my boyhood could have had any luck in the rapid exploitative mechanization of the country coming on the heels of their trek. A few of them were, of course, shrewd enough for the main chance, but I expect that the majority, romantic and nomadic rather than economic-minded, with their sons and daughters, drifted into tenantry, moving from place to place, getting at all times worse and worse off and ending their lives and lineage in the bitter serfdom of the sharecropper. But however they ended or whatever happened in the meantime, they were, when I knew them, young and old, filled to the brim of their souls with the romance of going—of going places that were far away and unknown and therefore full of the "promise of heaven."

For the nomadic urges of our western people, the prime symbol of adventurous life has for years been the railroad train. No doubt before its advent, the Conestoga wagon, the six-horse stage, and the river boat held a place equally suggestive. With the coming of the automobile, the railroad train is losing its high place, but all during

my boyhood it was the prime space cutter and therefore the great symbol of change. Above all other things it had the power to break down the barriers of locality. Its steam pushed promises, shook up the roots of generations, and moved the hearts of men and women with all the confused mixtures of joy and pain that accompany the thought of separation and departure. For all bitten with the urge to pull up stakes and be done with familiar boredoms (and that urge, as I have indicated, is deep in the American spirit) the steam train bearing down on a station or roaring out of a curve of the hills, or disappearing over a distant ridge, was a thing replete with suggestive motion.

It is not so long ago that when the passenger train came into a western town everybody who could went down to meet it. As soon as I was able to get loose from my mother's skirts, I followed the boys of Neosho to the railroad station and watched with the yearning loafers of the town the evening passenger roll in. I soon learned that the proper way to receive a train was with a nonchalant familiarity; that it was "in form" to speak of her as "Number so-and-so," knowingly to inspect the unloading of her mailbags and express packages, and to lay great stress on the number of seconds or minutes she was before or behind time. This is the way we covered our emotions. It occurred to no one, young or old, that our very presence at the station was an indication of impractical romanticism and that our knowing ways with technicalities were swaggering fakes. More so than the other boys of the town, I was an habitual traveler. I went long distances to and from Washington and made frequent short trips with my father, but I think, in spite of that, that I was more emotional than any of them when the engine came pounding down on us. I often had to keep a strong hold on myself to restrain welling tears of excitement. To this day I cannot face an oncoming steam train without having itchy thrills run up and down my backbone. The automobile and the airplane have not been able to take away from it its old moving power as an assaulter of space and time. Its whistle is the most nostalgic of sounds to my ear. I never

hear a train whistle blow without profound impulsions to change, without wanting to pack up my things, to tell all my acquaintances to be damned, to be done with them, and go somewhere.

In my part of Missouri, besides the trains, there were other sources suggestive of the faraway and unknown, suggestive of strange faces and glamorous doings. People were known to have made flatboats on our rivers and creeks, and to have floated them down over shoals and rapids, under cliffs and through forests, to the great rivers, into the Mississippi, and down to New Orleans. At our swimming holes we boys used to sit on the bank and discuss such possibilities.

Many hundreds of people, thousands even, in the Mississippi valley, have yielded to the call of the rivers, and all up and down the great watercourses they live today a precarious hand-to-mouth existence in rickety shanty boats and in tents pitched temporarily under the great sycamores where they fish and distill "white mule." These people would not, as a rule, trade their wandering life on the water for any certain security. They know that the price of security is loss of freedom and they prefer their tax-free homes where they can end dissatisfaction with a locality simply by untying a rope and where, to meet their standards of good living, they need only some fishing tackle, a shotgun, and a copper coil. They trade fish for meal and, occasionally, shoot some farmer's hog that has wandered too far down along the riverbank. In winter they trap, and in the summer, in order to get a little cash, they pick up odd jobs in the logging camps or sawmills of the backwaters. In the towns they have a bad reputation and are called "thievin' river rats," but my own experience from sitting and talking on the stoops of little river stores suggests that many a fellow with a steady job and a responsible local reputation looks with unconscious envy on their unconventional lives, and the opportunity offered therein for constant change of place and scene.

Today, however, though people continue to respond to the urges set going by the trains and rivers, these are not such potent instigators of moving as are the cars and buses of the paved highways,

where the price of a few gallons of gasoline offers a perfect and
rapid satisfaction for nostalgic yearnings. Continental odysseys un-
dertaken for no reason at all except for the love of going, we all know
about. It would seem that with the great facility for going, some
of its charm would be lost, but anyone who talks with the run of
travelers in the tourist camps will find that this is not the case and
that the call of change and distance, for Americans, has not been
modified, but has been subjected simply to spatial extension. It is
the same as in the past, only its reaches are greater. There is, it is
true, some loss of that irrevocability which, for the majority of
train movers, was connected with the purchase of a ticket and which
made their decisions and the day of their going momentous. The
automobilist may stay or go, tomorrow or the next day makes no
difference. He is, consequently, freer of a sense of fate than was his
earlier foot-itching brother for whom the train whistle not only sug-
gested journey but, after the ticket was bought, commanded it. This
loss of the sense of the irrevocable which, in spite of the fact that
one might return railroad tickets and have one's money refunded,
was a concomitant of railroad travel, is an emotional loss for the
traveler. The idea of fate, even when its inexorability is manifested
in nothing more supernatural than noisy steam-spurting pistons, is
a deep-rooted and persuasive factor of drama. For the poor man
whose last penny bought a ticket to some faraway and hopeful
place and who without success there could never get back to his
home, the fateful significance of a railroad ticket is plain. But it
existed for more prosperous people too, and I remember well the
days of nervous preparation we used to make in my family for our
journeys to and from Washington or down into Texas where my
grandfather lived. Our tickets bought, we awaited, as for the crack
of doom, the day of our going.

Except among very poor and unfortunate people, ignorant and
backward and left to drift on the edges of the machine age, the fate-
fulness of travel is past. It persists yet, somewhat, among the poor
Negroes and white sharecroppers of the southern back countries,

frequently even for travel by auto. Only lately I have heard men, among these, speak of a trip planned to extend no farther than an adjoining country in a way that indicated that the matter was in the hands of God. Part of this may have been occasioned by a doubtful trust in the capacities of "that thar ol' car" which was to take them, but it made me think how common were such feelings only a few years ago when the railroad stations would be wet with the tears and resonant with the sobs of irrevocable going.

The great and intricate systems of paved roads drawing all places together, plus the ease of manifesting individual will in automobile travel has, for most of us, removed all traces of the hand of fate from our treks. In Texas during prohibition, cow hands of the Pecos thought nothing of driving to the Mexican border for a drink. All over the country people will travel hundreds of miles for an overnight stay, for a party, or even to hear some lecturer spout.

When I came back to New York from my sojourn in the Navy, I began getting the itch for change. That was eighteen years ago. For eight years previous, wrapped up in aesthetic theory and swamped by the disappointments of futile practice, I had been satisfied with what change was offered in the various sections of the city. With the releasing effects of my experiences at the Naval Base, with people and things as a stimulus, I began to look yearningly beyond the tall buildings. The long-drawn hoarse whistles of the steamships in the rivers would set up a dissatisfied brooding when the coming of spring opened our city windows. I began taking long walks over in Jersey and up into the Catskills. I went alone with a knapsack and stayed as long as ten or fifteen dollars would last, putting up in cheap hotels and picking up rides wtih truckmen and farmers who were then not so suspicious of hikers. I began carrying a pad for drawing. When my wife and I went to Martha's Vineyard, my wandering itch was allayed for a while. I got interested in the Yankees, heretofore unfamiliar to me, in their ways and doings, in their fishing boats, and in the charm of their island country. But after a while, especially after T. P. was born, and my wife had me

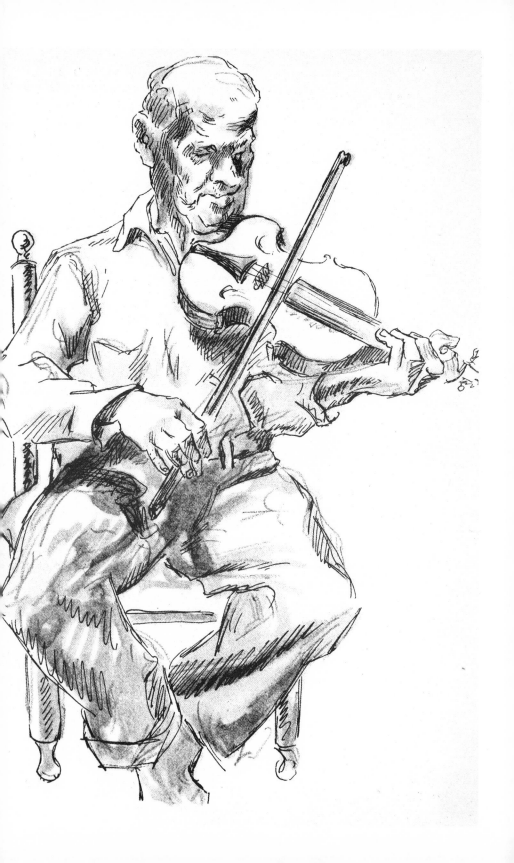

well enough housebroken to help with the diapers and the dishes, even the Vineyard could not hold my restlessness. The bonds of marriage did not lay very heavily on my back, but I began to feel rather too well tamed and to itch for freedom.

In 1924 my Dad came to the end of his rope. I went out to Missouri to be with him. His old friends came where he lay, week after week, in a hospital bed to talk with him and tell him good-by. I met people old and young whom I had forgotten. I listened to old-timers try to revive my father's failing interest in things by tales of their mutual doings of the past and I got a renewed sense of the variety and picturesqueness of his life and of the life of the people of my home country which the infatuated artistic vanities of the city had brought me to regard as stale and stuffy. I discovered that underneath the dry practicalities of his friends which, in my boyhood, used to put me in an uneasy state of defensive animosity, there was a deep run of common human sentiment which I shared. I found that the Missouri brand of the philosphy of go-getterism had left, still, a residue of interesting and unregimented character. Seeing this, I liked the people who came to my father's bedside, and when an old grizzled politician, looking over the new clothes I had bought to come home, said to my father, "Colonel, your son maybe is a good boy but he looks like a kind of a dude," I was moved to nothing but sympathetic laughter and an appreciation of the background out of which such a remark could come.

Missouri, though some Missourians may not like to hear it, is a rural-minded country. The flavor of a premachine-age past hangs in its drawling speech. In the skepticism of its people there is a good deal of the old doubting backwoods farmer who isn't going to be dragged into newfangled situations without long consideration. Missouri is a state which does not rush wildly to decision. Outsiders may laugh at its skeptical slowness, or the radical-minded fume because their significance is not recognized, but there are

no gag laws on the Missouri statutes and its people as a whole are pretty genuinely democratic.

Missouri has come out of the great exploitative rages of yesterday, not with an unscarred soil and soul but with one less scarred than you find in most other places. Its rural conservatism has preserved, in prejudice and action, a large residue of that old-time American individualistic psychology with which we are going to need a large measure of acquaintance if we are to avert disaster in our further social travels.

Individualism is not only an economic doctrine the practicality of which is apparently coming to an end but it is a stubborn assertion of the high value of the personal will. The particular forms of that exploitative finance which has ruled our destinies from the great cities were only particular manifestations of that will. They were simply its time and opportunity expressions. The individual will, regarded among theoretical radicals as so completely antisocial because it has been confused with the financial jugglery which was the field of its most public demonstration, is with us yet. Belief in it is deeply grooved in the American character. So deep is it that juries will often not return a conviction on patent grafting dishonesties for fear of fouling it. They would rather suffer exploitation than risk a decision that might impair their own precious rights to do as they please. This, with a certain contempt for the regulatory claims of governing bodies, is a heritage from our pioneer fathers. It is persistent and those who talk glibly of the solidarity of the oppressed and miserable and lay their hopes for a trip to better social places on class action do so without taking it into account. For the hang-overs of idealistic social theory, Missouri is a grand pickup. My stay in Missouri in 1924 was a pickup for my own hang-overs, not those of any convinced social theories, because I had none, but for those attenuations of aesthetic theory which had survived the War and my experiences in the Navy.

I cannot honestly say what happened to me while I watched my father die and listened to the voices of his friends, but I know

that when, after his death, I went back East I was moved by a great desire to know more of the America which I had glimpsed in the suggestive words of his old cronies, who, seeing him at the end of his tether, had tried to jerk him back with reminiscent talk and suggestive anecdote. I was moved by a desire to pick up again the threads of my childhood To my itch for going places there was injected a thread of purpose which, however slight as a far-reaching philosophy, was to make the next ten years of my life a rich texture of varied experience.

I started going places, but I sought those which would present best the background out of which my people and I had come and I left the main traveled roads, the highways, and plowed around in the back counties of our country where old manners persisted and old prejudices were sustained. Having no beliefs as to what was good for man, no moral convictions as to conduct, and no squeamish bodily reluctances, I was able to enter intimately into much that was automatically closed to social investigators with uplift psychologies. I saw a good deal that was raw and no small amount that was overdone, cooked into a stale hardness, but I got in my journeys a love for my country which I maintain is more real than that of any of the great nationalistic "whoopers up" who invariably confuse their monetary interests with patriotism. I traveled without interests beyond those of getting material for my pictures. I didn't give a damn what people thought, how they ate their eggs or approached their females, how they voted, or what devious business they were involved in. I took them as they came and got along with them as best I could.

With the next chapter I start telling some of my experiences of the road. By those who have participated in these experiences, should they come upon my accounts, I shall undoubtedly be named a liar and a mocker. My own brother, to whom I showed my accounts of the Missouri of my childhood, dubbed me a fabricator of the worst sort. He maintained that my father sat in the smokehouse rather than in the privy for his figuring, and he insisted that our

cow, Bluey, was not given to the contrariness I claimed for her. Having seen him, in exasperation, hit Bluey over the head with a piece of two-by-four when he inherited the milking business from me, I concluded that, as a citizen of Missouri who had remained steadfastly on the soil, he was merely protecting the honor and belongings of the family and that his opinion about the reality of my memories, conditioned by his growing respectability, were untrustworthy. Though he is now a successful prosecutor with a great and laudable itch to slide people into the penitentiary, I remember well that in his high school days at home he was a member of a well-organized band of boy chicken thieves and egg suckers, and that later as a law student in New York he had no respectable objections to living off the earnings of "Mac the drunk," after Tom Craven and I had "borrowed" the monthly sum my father sent for his law education.

I raise these matters simply as a warning to those who, respecting his present sober social position, shall listen to his tales with more respect than mine when, for the honor of state and family, he begins contradicting me. I have encountered great difficulty not only with verbal reminiscence but with the records of my pen and brush, when it came to sharing and reviewing my findings with others who have been on the field of experience with me. I once made a careful and accurate portrait of one of my brother's friends, a state senator of Missouri. I pictured him engaged seriously in his legislative business with all the proper paraphernalia of his trade. He was an interesting man and I flattered myself that I had presented him not only as interesting but with all the nobility becoming his character as a statesman. To my great surprise I heard that his family regarded my realism as a libelous slur and as a thing which "would do him no good." The sum of this, I conclude, is that no two people experiencing the same object will have the same effects, and that in things which cannot be reduced to numerical sequence, there is no dependable gauge of truth.

In our descriptions of the world of our experience, we are very

much like two witnesses of a motor collision whose respective brothers were the drivers of the opposing cars. They see according to their conditioned attitudes and describe under the pressure of their interests.

In saying this I realize that I withdraw all claims to an absolute objectivity from my accounts. I waive such claims cheerfully and admit all the implications. I recognize the distorting offices of the self. Nevertheless, I am trying to tell the truth about my going places. I aim to keep as close to it as possible. I deliberately disguise specific localities for the reason that there are many to which I want to return. After having given my account of a place, I don't want to risk going back there in the flesh and have some enraged inhabitant bust me in the mouth for what he may regard as willful ridicule of his home and his ways. Experience has shown me that people do not like to be regarded as quaint or entertaining. They will not be laughed at, whether they are camp meeting hill folk or convening Shriners. This is as applicable to city people as to rustics. I have seen some extremely funny and ridiculous antics in the picket lines of garment-loft strikes in New York, and glorious absurdities in the pomposities of legislative halls, but I know that the actors in these humanities are full of a solemn and serious righteousness and would resent being applauded as clowns.

If you do not take people at their own valuation, they are almost sure to regard your accounts of them as those of a liar and deliberate enemy and even your expressed sympathies will have, for them, the color of affected superiorities.

It will be noticed that my travels around the back roads of America have produced few drawings of women. Women are extremely touchy about being regarded as old-fashioned or outmoded, and unless they are highly convinced of their style or beauty or up-to-dateness they cannot be induced to sit the ten or fifteen minutes it takes to make a drawing. No matter where I have been in America, how far off the lines of regular travel, the popular monthlies of style and chic have preceded me. The women of the backwoods

are perfectly aware that they do not appear like the illustrations of these magazines and they are convinced, therefore, that you intend ridicule when you ask for permission to make a sketch of them. The most well-considered and careful flattery is of no avail in the matter. The minute I get out my pencil women flee. With men it is different. Male vanity soars above all the conditions of correctness in dress or manner. The man, like the barnyard rooster, is well satisfied with himself whether he is on a dunghill or in a modern coop. He may see plainly that he is no roaring success, but he puts the blame for that on circumstances and never reads it back into failings of his own. The world may have done ill by him but he himself in his own naked character is all right. As a consequence of this, men are easy to draw. Seeing themselves as interesting in spite of all detrimental conditions or the shaggiest of appearances, they regard it as quite natural that others should see them so. Rarely has a man balked when I suggested making a picture of him.

For a time my outland journeys were made afoot and alone. That is, they started afoot, but I soon found that I could make useful acquaintances as well as ease my feet by accepting proffered rides. I never asked for them nor stood on the pavement jerking my thumb in the direction I wanted to go. I walked along, usually on a country road aiming south or west, speaking to people if they spoke to me, but acting, whether they did or not, as if I had no care for my mode of travel. I really had no care. I furnished myself with travelers' checks before leaving the city, and when I wanted to go long distances I got on a bus or a train. For short ones, I could walk as well as ride. I was never in a hurry. My expenses were very low on the back roads and with my ways of travel. Part of the time I received both meals and beds for nothing. My hosts would not take pay. After a while, as winters of studio life began finally to soften me, the walking business became too much and I took to driving with Bill, one of my students. When Bill and I first got together he was very young, very good-looking—he still is—and very inexperienced with rustic character. Every once in a whole he'd make things

hot for me by ordering iced coffee where people, never having heard of it, would think him crazy, or by ordering soft-boiled eggs when good judgment, considering the nature of the eating place, indicated plainly they should be ordered scrambled. In the beginning of our travels he was always making some high-toned faux pas. I have some stories on him. When he reads them he'll probably tell his friends and his girl, too, if he has one at the time, that they're damned lies. But they're not.

I traveled once for a month in Wyoming and Colorado in a broken-down and temperamental Ford with Slim, another student. He can tell some good stories on me, for he was more familiar with that particular ground and the ways of its inhabitants than I and he knew how to keep his feet uncut. I'll anticipate him a little, though.

I traveled for longer and shorter periods with others. I was introduced to the oil fields of the Texas Panhandle by an old Neosho friend, Mr. Frank Miller, and, through the kindness of the Mississippi Valley Barge Company, to the new towboat life of the Mississippi. Thanks to many, whose names I have forgotten, I got into the great steel mills, shipbuilding plants, and other industrial concerns of the country. I made hundreds of drawings—of furnaces, converters, cranes, drills, dredges and compressors, rigs and pumps, rakes, tractors, combines, and oldfashioned threshing machines. I stuck my nose into everything. Under the flying sparks and in the metallic din of opening blast furnaces I have tried to draw running steel while the hunkies kidded me and the company guards looked on, wondering what had got into the bosses' heads that they should turn a "nut" loose in the plant.

Once, in a coal mine, I was dropped five hundred feet into the earth with the speed of a falling stone, that I might give the car boys at the foot of the shaft a laugh when I let go the hand rungs of the bucket and stepped out under the floodlights of the pit in a white sweat of fear and surprise. A drunken cowboy in a honkey-tonk across the Rio Grande jumped on my back to make a horse

of me. I got the better of this kidder though, for I bucked him suddenly into the lap of a hussy who threw her beer in his face and reduced his effervescent manhood to a cringing "Aw, ma'am, 'twarn't my fault," and forced him to a sheepish exit.

I've been the butt of many more jokes, some of them so dependent on riotous obscenity for their points that I can't put them in print, but I've found, in my travels, that if you go without pretensions and with a reasonable fund of good humor, the run of mankind is without malice, inclined to be friendly and helpful.

Experience has convinced me that the prime necessity for those who would go places and not bring back simply what they took with them is to be rid of all opinions before starting. If you can't be rid of opinions, then the next necessity is to learn to keep your mouth shut about them for you will otherwise find yourself in the hot waters of dispute and get in those messes of words which, among men in any stratum of life, operate to confuse understanding. Opinions and principles are no doubt noble things, essential factors in the forward moves of humanity—and in the reactionary ones as well— but they are poor things to take along when you are going places with the intention of seeing and knowing what is there.

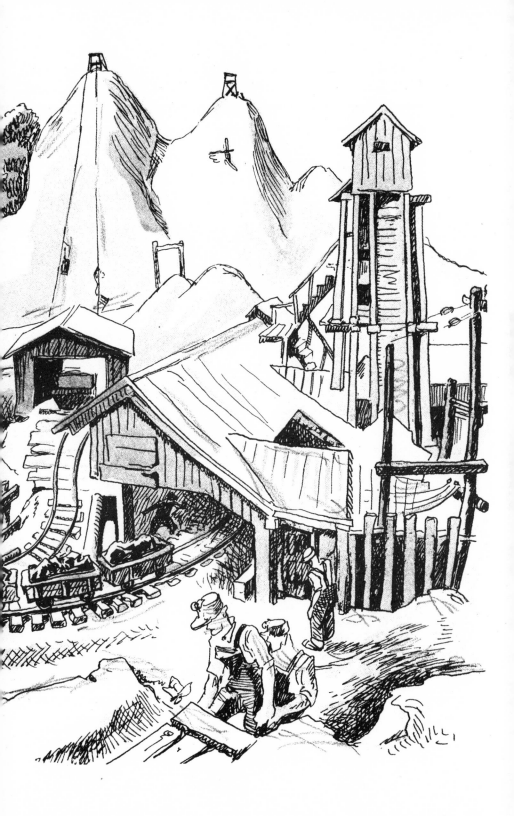

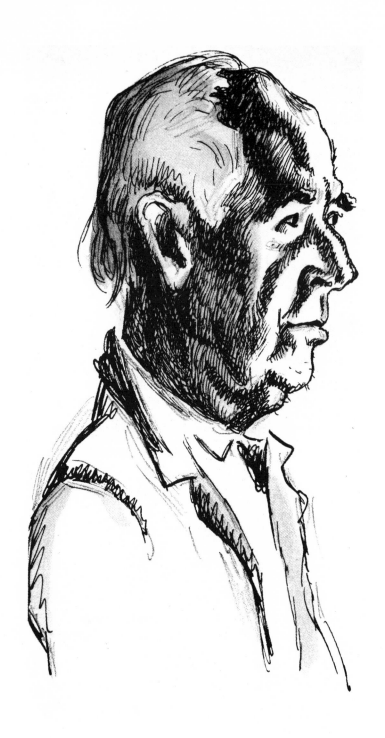

IV

The Mountains

WE HAVE rediscovered our mountains. Of the southern Alleghenies, the Blue Ridge, the Great Smokies, and the Ozarks, descriptive literature has in the last fifteen years made a monument. Our past social history in its pioneer phase is, to a great extent, embedded in the ways of our mountain people. In order to represent that history, writers, pressed by the necessities of linguistic logic, come easily to make a tremendous demarcation between mountain life and the contemporary world outside. To emphasize their social points, they give to the mountain folk a cultural isolation that is a little overdone and they fail to blend with old customs and habits quite enough of the vulgar practices of our modern world which have been absorbed by the mountain people. Amateur philologists, discovering Elizabethan hang-overs in the hillbillies' speech, make their talk entirely Elizabethan. They forget that "oh yeah," indicating skepticism, and "hot dawg," indicating satisfaction, are with a thousand other modernities as much commonplaces of mountain speech as of city speech.

While the mountains do hold our simple pioneer past in their bosoms and while they do, in many instances, give us the peace of old, quaint, and quiet traditions, they do not always do so. My own experiences in the southern hill country have revealed no well-ordered patterns which would lead me to say that the people of such and such an area are typical of this, and those of another typical of that. Diversity of practice and attitude in the mountains is as great as anywhere else, perhaps even greater than in most

places. My mountain wanderings have covered large portions of the states of Virginia, West Virginia, Kentucky, Tennessee, Georgia, the Carolinas, Missouri, and Arkansas. Nowhere have I discovered a pattern of life of which it might be said, "This is mountain life," nor a people who could be called representative of the genus "mountaineer."

I have seen no more solidarity of race in the hills than in the valleys, and not nearly as much of the clannishness that is supposed to be the outstanding characteristic of hill people as I have found in the racial pockets of the great cities. The hillman is about like the rest of us Americans, only, as I might put it, more so. Not being as subject to the assaults of fashion and mechanical change as are those people in the lines of regular travel and exchange, his prejudices are a little more deeply grooved and his ways, for the same reason, more conservative and less given to experimentation with newfangled devices.

Mountain people are, as a whole, pretty steady but they are subject to the same ambitions, willful determination in the protection of their interests, and idiosyncratic animosities as the rest of us. While they occasionally hold together against outsiders, they are not, even with cause, persistently inimical and they are far more likely to nurse their dissatisfactions with each other than turn in a body on a "furriner." I, as a stranger, have more than once had confided to me long analyses of the disreputable and unmannerly conduct of a confidant's neighbor whose cabin was within a stone's throw. I rode once in Arkansas with an old Ozark Missourian who had moved just over the border and who, apparently, did not get on with Arkansas neighbors, though in appearance and manner he was in no way different from them. "These here Arkansawyers," he told me, "are a mean lot. They ain't no man can have peace with 'em." Reflecting a little, he continued, "I guess their meanness comes out of their ancestors and ain't altogether their fault, but they sure is a hard people." Curious, I asked about these ancestors and got ι

piece of unrecorded history which is certainly worthy of investigation by a competent historian.

"I've heerd tell," my Missourian explained, "that a long time ago, Memphis, over thar in Tennessee, got all full up of whores and whoredogs and the good people not bein' able to sleep or do business fer their racket gits up one night and wint an' rounded 'em all up on a raft and towed the raft over the river to Arkansas and told them whores and whoredogs that wuz the place they'd have to live in, and if they come back to Memphis they'd git shot. Them people, they say, wuz the ancestors of Arkansas."

This was from a Missouri hillman who, of course, was nursing his Missouri superiority and, as I found later, his Republican principles which, it appeared, stood alone in a Democratic Arkansas community. But it is characteristic not only of neighborly division but of a kind of sectional animosity that is very prevalent in the hills. In a trip through an extremely rough part of our eastern mountains, in an area just off an extensive coal field, I was constantly warned that to go farther would endanger my peace and goods. On going further I would be met with manifestations of great surprise that I had escaped depredation in the thieving area I had just left.

The bad name going with the appellation hillbilly has, I believe, come largely from those areas where industrial development has run a devastating hand into old custom, destroying the delicate social adjustments of generations and giving sanction, by ruthless example, to all sorts of willful brutalities. The highly strung individualism of the mountain man, his utter faith in the rightness of his personal will, which is developed even beyond that of most Americans, functions pretty satisfactorily in a simple agricultural background where certain ways, beliefs, and restrictions are regarded, because of their long standing, as manifestations of the will of God. Where, however, willful individualism, uneducated and suspicious of the new, comes in contact with the shrewd, exploitative devices of business and industry, where patently, even to the simplest,

God has been thrust aside in the interests of profit, it becomes readily explosive.

Where the hills run down into industrial areas crime increases. Property rights, assaulted by cunning business legalities, are seen as open to assault by other means and robbery, relatively unknown among the agricultural simplicities of the back hills, becomes frequent. The hillman of the "breaks" thrust by business interests off his land, to which half the time his title is faulty and which he has held simply because no one else wanted it, is forced into what he considers slavery, into tenantry, or dependence on the wages of industry. He frequently enough, and with plenty of reason, regards himself as injured and robbed, and rather than submit tamely to the system responsible he takes measures to outwit it. The camp followers of the army of business provide him with techniques. The entrance of any industry into an area is always accompanied by a motley crowd of whores, cheap gamblers, and easy livers who, like drug addicts, seem to have a mania for converting people to their ways. Among many of the dispossessed hill people they find willing, if crude, disciples.

Some years ago when my mind was full of painting an industrial history of America, I went out into western Pennsylvania to make drawings of mines and miners. I was driving with Bill, the student spoken of in the preceding chapter. Having no comprehensible reasons for entering mine property, we were ordered off place after place by company police. We were told that permits were essential if we were to pursue our monkey business around the mines. Permits, we found, were not to be had for the asking and we kept running south, begging one mine superintendent after another to give us papers that would let us get by the guards and enable us to study undisturbed the tipples, waste piles, and mining towns of the industry.

After a good many days of fruitless trying, still going south, we ran into deep mountains where long stretches of timber broke the pattern of the coal business. There, taking the advice of some

miners to whom we confided our desires and difficulties and who advised us to go ahead and do as we pleased, we gave up the idea of obtaining a permit. Discovering a picturesque mine, we set about making drawings. This was on the lower edge of West Virginia. The mine here, breaking out of the mountain side, offered rich material for study. Uninterrupted, I worked all morning and almost filled a book with drawings. When the noon hour came a lot of miners who worked about the powerhouse and tipple were sitting around with their lunches. I took my sandwiches and sat with them. I offered my book of drawings for criticism and when their interest was aroused I commenced making portrait sketches of them. Some of my sketches occasioned much hilarity, the miners kidding each other boisterously on the representation of their facial characteristics. A change of shift in the mine proper brought out a larger audience and I became the center of a lot of good-humored noise. In the midst of our hullabaloo—where I, taking advantage of the situation, was making portraits as fast as I could—a mine guard walked up. He was friendly and asked to see my book of drawings. When, with some of the men going back to work, the crowd thinned he said to me, "Buddy, I don't see no harm in this stuff but we ain't supposed to let strangers come on this property. You ain't got no right here and I can't let you take this here book away. If I let you do it and it got around, I might lose my job. I've got to take you down to the superintendent. If he says what you're doin' is all right, it's all right, but I can't take any risks."

"Sure," I said, "I understand, and it's O.K. The superintendents," I ventured, "don't mind this sort of thing. What they're afraid of are plans."

The miners who were left with us agreed.

"Well," he went on, "you go on over to the road and run your car down by that path." He pointed to a spot a quarter of a mile away to where a footpath running down the mountain side joined the road. "I'll be down there pretty soon and take you to the office."

Bill and I drove to the path. We waited ten minutes, twenty, half

an hour, without the guard showing up. I got out a new sketchbook and made another drawing. Then it occurred to me that the guard, disposed as he was to friendliness, was giving me an opportunity to make a getaway. When this crossed my mind we lit out, sailed down the mountain past the company offices, and, with great satisfaction, got beyond what we thought was dangerous territory. Our confidence, however, was premature, for in about three-quarters of an hour, slowing down before a sharp curve which ended on a bridge marking the entrance to a town, we were boarded by two armed deputies who ordered us to the courthouse.

We had struck the county seat, where the sheriff, informed by telephone of our trespass on mine property, had been instructed to look over and confiscate all papers in our possession. The sheriff, I found, was not very well informed as to what the trouble was and I started a great argument about the rights of travelers on the highway and the impositions of suspicious operators. This must have been a touchy point for the sheriff was plainly a little embarrassed. Doubtful about the nature of my offense, he questioned me. Remembering the last drawing I had made in the new sketchbook, I maintained that I had simply stopped my car on the highway and made a little harmless sketch and that the whole claim of my trespassing and possessing suspicious papers was all in some fool guard's mind. Accompanied by a deputy, I went to the car and, dragging out the new book with the one drawing, showed it to the sheriff.

He laughed, "Well, that don't look very dangerous." Then after thinking the matter over and sizing up Bill and me as a couple of harmless nuts out on a lark, he said, "I won't hold you boys. Go on about your business, but keep away from mine property."

I reached for my sketchbook. "No, you'll have to leave that here," the sheriff said. "I've been asked to hold your papers. This book is pretty harmless, I guess, but I'll keep it anyhow."

I started to protest.

"Aw, get to hell outta here," said one of the deputies, less friendly

than the sheriff. "You ought to be glad you ain't put in the cooler."

We were glad and went, I in high glee that by some fortunate accident the telephonic communication that had stopped us had not been sufficiently clear to show the extent of our trespass. Though I had got my full sketchbook for the moment out of the sheriff's clutches, I was afraid that some representative of the mine, better instructed than he, would show up and have me reapprehended. Looking at the map, I found that a narrow dirt road cutting off the highway would lead us quickly across the state line into Virginia. We made for it and before dark were beyond the jurisdiction of West Virginia sheriffs and suspicious operators.

That night we camped by a small stream in the hills. On three sides of us were dense woods. Before us a cleared patch of ground on which corn was yellowing indicated the proximity of a house. Finding the house, I told a woman there alone that we were camping over in the woods and wanted to buy some eggs. She sold me the eggs without question and without evidencing any curiosity. But through her the news of our arrival must have gone far for we had no more finished supper than visitors began slipping up to us from out of the woods and from across the corn patch. The first two fellows who came up, shaggy, unprepossessing toughs, prepared us for those to follow and let us know the company we were in.

"Well, ye got clear," one of them said. "What was ye sellin'?"

It occurred to me suddenly that the road we had used to get out of West Virginia was a road of flight and that our being here betokened flight and nothing else. Catching the situation, I laughed and told our story, just as it was. By that time some more roughnecks had congregated and were draped on the ground around our fire. Taken all together, with the red light of the campfire shining on their hard faces, they were as tough-looking an outfit as could be imagined. Hillbilly protestants against the evils of industrialism, they were nearly all natives of West Virginia who had found the state too hot and who lived a precarious border life, selling prohibi-

tion whisky, white mule, to the miners, or engaging in other lawless activities such as the peddling of stolen goods, dirty pictures, and filthy literature. They were perfect examples of the degradation that may come to the hill people with the advent of industrial enterprise.

In the long exchange of talk that went on around our camp until midnight I heard some pretty bitter tales of expropriation and brutal injustice. Granted that only a part of them were true, or even that part exaggerated by ignorance and revengeful disposition, it was plain that these men had grievances and even a fair excuse for criminal activity. One young fellow told me that his pap had been run off a good piece of land that had belonged to his family "as fer back as inybody could recolleck," because a coal shaft was making it dangerous. He said the "ole man" got some money for going but it wasn't enough to last him and he took to digging coal from a hole he knew of in the woods, selling it over in Virginia. He got arrested for that and jailed because, it seemed, the mines owned the property where he was digging. When he got out of jail he took to making whisky and was jailed again for peddling it. I asked him where his pap was now.

"I reckon if he ain't daid he's still a-makin' whisky. He wuz a mad man las' time he come out the cooler and he said if they kept a intaferin' with him he'd blow somebody. He mighta done it. Maybe he's in the penitentury," he ended with a laugh. "I ain't seen 'im since Maw died, nigh seven years ago."

The word *they*, in its reference to the law, the police, or other property powers of West Virginia, was used by this boy, who was only about seventeen, as it was by the rest of the crowd to denote a hostile, merciless, and hated force which was always bearing down, stamping out liberties, and working up senseless persecutions. The society which had grown up with the coal industry in their locality they saw not as something which brought schools and opportunities for making cash money but as an enemy to be outwitted, robbed,

and wheedled without compunction. They hated the niggers and furriners the mine operators had brought into the land.

"I'm just a-waitin' my chanc't to blow that 'ere damn buck's haid off'n him," one of them said, in reference to a black man about whom another had been complaining. They ran easily to murderous thoughts.

Their language with us was not in the least restrained and I had difficulty, though I'm no novice in the improper, in making my conversational expressions tally with theirs. They indicated great interest in our car, our blankets, and our camping tinware. They had a good time with my drawings. I felt perfectly safe with them, as did my companion Bill after a few uneasy minutes following their arrival. They bore out the old French bourgeois saying about the community of artists, whores, and thieves. We were one of them. Farther back in the mountains or in distinctly agricultural areas these men would, no doubt, have run to shiftlessness and would have been called in mountain parlance "no account," but they would not have reached their present low viciousness nor have been run into a state of positive social revolt.

They were good fellows. They could not see the advantage, now admittedly doubtful, which made so many of their brothers welcome the mines and turn with alacrity to long shifts under the mountains because of the cash money to be obtained. Habituated, however, to the excitements and varieties offered in the teeming populations of the coal area, whose dark shack towns nurtured vice as well as misery and whose cities offered such grand opportunities for petty racketeering, they could not return to the simpler life of their fathers, even had there been a place where they might find it. Though outside its laws, they were tied to the coal lands with their stinking palls of smoke, long rows of gas-erupting coke ovens, and dark miseries of disorganized union battle where at the time the miners' potential power for improving their lot was lost in fratricidal animosity, in racial hate, and in the chicaneries of low politics.

I asserted, some pages back, that I had not found the mountain man nearly so inimical to furriners as he is reputed to be. I must qualify this by excepting furriners of marked racial strain and particularly Negroes. The southern mountaineer's dislike of the Negro goes back to slave days and the deadly economic pressures which the chattel slaves put in the great planters' hands, enabling them to push the mountain people and their produce off the maps of profitable exchange. The great planters, like the coal barons after them, were merciless about title flaws and the history of many a mountain family who originally held fertile piedmont lands is one of dispossession and forced retirement to the high ridges.

Instead of laying the whole blame on the holders of economic power, the hillman read a great deal of it into their instruments and though in the Civil War he sided with the North against the planters, thereby doing his part toward emancipating the Negroes, he continued to hate them and has at all times resisted their entrance into his domain. Nevertheless, the Negro has little by little found his way into the hills and, particularly in the industrial regions, his settlements are plentiful. This occasions a good deal of tension which at times breaks into positive racial war, and which is always fathering odd, difficult, and sometimes amusing situations. Of the latter, I recently came across a good example.

I wandered one evening, a couple of summers ago, into a small isolated county seat on the outer rim of the Blue Ridge where it breaks into the Cumberlands. I ate supper at the Commercial Hotel and strolled down the little narrow main street which was the town. Stretched in front of a barn-like shack, the movie palace, lodge chamber, and convention hall of the place, was a huge rough-lettered sign on canvas. It stated that a minstrel and cabaret show would be presented by "Five Famous Colored Artists and Entertainers" that evening at eight. Entering the pool hall next door, I asked some of the loafing boys what the show was.

"Ah don't reckon they'll be no show," one of them said.

"Why?"

"Aw, it's a bunch of uppity niggers, and we don't 'low no niggers in here."

"What are you going to do?" I sensed some unhappy drama.

"I ain't goin' to do nothin'," said the boy, "but I heerd tell they's a bunch gonna run 'em out, come dark."

"What's the matter with the niggers? What have they done?"

"These here 'uns ain't done no harm as yet," said an older man, sidling into the conversation, "but they's a powerful feelin' 'bout niggers hereabouts."

Putting questions as to why and wherefore, I learned that a number of years back the town had tolerated a Negro settlement on its outskirts. There was, at the time, a quantity of fine walnut in the vicinity and industrious hillmen were making a good thing of it. Two brothers, it seems, had for a long period cut and hauled logs to the town sawmill and were due to receive a considerable sum of money.

On the day they were paid they advertised the size of their roll and made, apparently, a rather boastful to-do. Their homeward journey after dark led past the Negro settlement, which was strung along a railroad track leading over into a big coal pocket in the next county. Coal trains along this track were frequent. Two misguided Negroes inflamed by the tales of the brothers' big money, thought they saw an easy opportunity. When the hillmen, none too steady from a little natural carousing, crossed the railroad in the dark of night on their way home, the Negroes assailed them with axes, cut them into unconsciousness, robbed them, and threw their bodies on the track. They counted on a coal train, about due, to cover their crime with the appearance of accident. Unfortunately for their future ease they failed to kill one of the brothers, who regained consciousness just before the train came and managed to roll off the track. He lived long enough to tell the tale. The next day the town rose up, surrounded the Negro population, hung a number along with those actually guilty, and drove the rest away.

Our Negro minstrels were the first of their race to venture

since this horror within the confines of the town. They came, of course, in ignorance of the story but by the time they were ready to perform they had got wind of it and, I imagine, must have had some grave discussion far removed from the technique of minstrelsy before they decided to brave chance and put on the show.

A little before eight, two of the Negroes stepped out in front of their theater with an ashen pallor deadening their dark skins and running to the edges of their lips painted white like those of clowns. They stood for a minute irresolutely. One had a cornet and the other a drum to which, besides the usual percussion brass, was attached a pair of cowbells. Bravely but frenziedly, after their one irresolute moment, they set to jazzing the crowd that gathered about them. The cornet player, his long black neck bulging and swelling to the needs of his instrument, his eyes rolling with something far from anticipatory relish of applause, brought prompt roars of laughter from the people gathered about. The ludicrousness of his fear, which was proclaimed by his frightened eyes and denied by the painted grin of his thick white lips, worked better than any mummery he could have devised to cool whatever there was of hot animosity in the townspeople. Sensing fun, suspecting its cause, the Negroes, with the quick adaptability of their race, made the most of it and put on an exaggerated musical pantomime of suspicious fear.

The show went on. Everyone put out his dime for a ticket.

It was a rotten affair though. Three Negro boys and two girls, poor adventurous mummers who had learned the sad little tricks of their trade from medicine shows and carnivals of the South, recited stale jokes about old maids and sang "corney" jazz songs. Once in a while a tremor of fear came over them again. The cornet player blared out and shook the rafters of the building in a wild bid for restored confidence, and the singers, throwing their heads back, their mouths wide open, attempted to keep up with him. These spasmodic injections of reality moved the audience to

high glee. The people applauded clamorously, unaware of what was behind such high points. I myself got to laughing and assented readily to the comment of my neighbors that "it was a purty good show."

To this little town, evidently starved for entertainment, any performance would probably have contained enough merit to outweigh a disposition to criticize. In the night, the "Five Famous Artists and Entertainers" slipped away unharmed. A boy in the hotel said to me next morning, "Them niggers was all right."

In addition to the disturbing wedges of the coal industry another industrial factor has driven its psychological upsets into the mountains. Southward, the great textile mills, built under promise of cheap non-unionized labor, as well as for nearness to the source of raw supply, have lured the people of the hills into wage slavery and dependence and encouraged, along with some better things, a disreputable urbanity. The lure of cash money has been strong in the mountains and desire for its possession has come to the shiftless as well as to those who could fall in with the rigid patterns of industry and work for wages. The textile towns, like the coal towns, have their shack patches of cunning, misery, and embittered revolt. Miserable hillbillies descending on the great mills find themselves temperamentally unfitted either for the long monotonous hours of work or for subjection to foremen and bosses. They do not, however, return to their corn patches of the interior but hang about, digging their subsistence out of the fields of vice which abound in newly congregated populations.

The industrial South is a great land for riotous whoredom. The loudmouthed, Bible-quoting morality of its public citizens is a thin layer of hypocrisy over a lot of sexual filth. Nowhere in the country have I had so many obscenely gestured invitations as in the South. Nowhere is fornication so completely in accord with the evil implications of the word. Even with the respectable young of the South, sex is a snickering indulgence, an expedition into a domain of stink and foul association. This may have its origin in what

is reputed to be the southern habit of sowing one's wild oats in black loam—regarded, in spite of its fertility, as inferior ground. There may be other reasons, such as the cultivation of a puritan gentility and a chivalrous pretense that really fine women do not do certain things. Whatever the reason, the sexual attitudes of southerners are anything but civilized. When they are exhibited in the lower reaches of society they are frequently monstrous. I am not a touchy person, but the sexual ribaldries of the South are too much for me. They are not Rabelaisian, but dirty.

It is to the lower reaches of the mill towns of the South that the workless hillbilly drifts with his women and his ignorant emulations. He is a tough social problem, not only for the sheriffs and bosses, but for intelligent millworkers who would develop some social solidarity among all the "have nots," for the political protection of their own interests. The vagrant hillbilly has drink and vice, both strong pulling magnets. He has something else, too. He has religion, and religion with a strong sexual flavor which acts disruptingly on reason and so encourages, by its exhibitionist aspects, the flamboyant individualism of the mountaineer that he spurns the idea of coöperative effort in the service of anything not the Lord's.

Fitting well with the social doings of the "hillbilly on the loose" in the mill towns are the ways of the poor tenant farmers who cultivate the bottom lands and provide the cotton for the mills. Absentee ownership has worked its irresistible evil on them. According to the notion that what one does not see does not exist, large landowners resident in the cities allow their tenants to be submitted to unbearable pressures. They pay them with nothing but a bitter subsistence and a dose of pellagra. Under the strain, vice and religious hysteria with sexual implications call imperatively, and to the vagrant hillman is added the vagrant farmer. Both keep but one step ahead of the sheriff and the chain gang.

"Is this the South?" some nice old Carolina lady will ask, as she sits on her cool veranda in her prim white dress with her Bible

and her cat. She will talk to her neighbors about it. They also are nice ladies whose chicken pots are full and whose manners are beyond question, and they will conclude that some lying Yankee is merely venting his spleen. It is true that it is not all of the South I picture here, but it is no small part of it.

Considerably large areas subject to the social effects described though not always with the presence of the hillbilly, stretch from Texas, through Arkansas, Mississippi, Alabama, and Georgia, to the Carolinas. I do not like to risk prediction, but this seems to me, more than any other area in the country, to promise bloody violence for the future. Violent characters are made and the paths to hysterical rages are paved—"And the banner of the Lord and the word of God" will have no small measure of responsibility for whatever difficulties come in the way of the social readjustments of tomorrow. The religious furies of the southern poor are blinding. The rich believe on Sundays and with a proper degree of respect for the "things that are Caesar's" and for the physical things that are the devil's, though they take the latter with a snicker, but the poor believe all the time. They know nothing about Caesar's things and they easily confuse the devil's urges with the "will of the Lord," or, when they are too flagrantly not of "His will," as objects for gorgeous and exciting testimonial penance: "And I seen that woman a-washin' herself in the brush, brother, with her paps a-stickin' up, and the devil bein' in me—"

The peculiar brand of ecstatic religion popularly known as the Holy Roller Faith which has been sweeping the South for the last fifteen years, and which is such a wild mixture of sex, exhibitionism, and hysteria, had its origin in that home of extravagant idiocy, Los Angeles, California. This I have on the authority of one of its preachers, a Tennessee man who, with a group of brothers, was "missionaryin'" in the mountains of western Virginia on the edge of the coal pockets some years ago. He told me that the Lord had visited a black man—amazing proof, to his mind, of the inexplicable and mysterious ways of the Deity—out in a Los Angeles

meetinghouse, and that this black man had been instructed in the true ways of the Church of God and had been told to spread them over the face of the earth. The preacher told me also that he had, because of his belief in this nigger's divine message, been much persecuted by Baptists in his own county and that he had left there "on God's work," followed by a shower of stones. He was a banjo player and had written on his instrument case the word "Holiness." Three of his brethren of the faith played guitars and when the four got together, as they did shortly after my talk with them, they made a persuasive rhythmical music. With the energetic beat of their feet and the high lilt of their voices, they could turn mediocre tunes into veritable "shouts of the Lord." The first complete example of their God's work was shown to me in a deep mountain gully under the dark, spotted shade of high and thick timber. A great gathering was there. Around the sides of the gully on outjutting edges of rock sat the half-convinced and the utterly skeptical. Down in its center were gathered the faithful, around a rough stand of planks. The worshipers left an open space before the stand, ten or twelve feet square. My preacher and his guitar-strumming brethren got on the stand and bowed their heads in silent prayer. Out of the utter quiet of wordless worship, broken by no whisper, accentuated by the dark motionless canopy of green above, they rose suddenly, smiting their strings and bringing their feet down and their voices up in one mighty burst of roaring sound. Their hymn, a fast two-four, evidently very familiar, was taken up by the crowd with almost the precision of trained performers. The whole outfit sang and clapped their hands in a swiftly mounting crescendo. When the rhythmical din was at its height, a young girl in a simple white dress and a little cheap but stylish hat moved slowly into the clear space before the stand. Her eyelids were half-closed. She walked around, a sort of Appalachian Oread, tapping her feet to the music. Her shoulders and hips began to move. Two men stepped into the opening. They shouted, "Amen. Blessed be His name," and they took to dancing about the girl. Others joined

them. Suddenly, the girl, with a piercing cry, "Jesus, sweet Jesus!" flopped on the ground and began to roll under the feet of the men, back and forth, throwing her arms and legs in every direction. Then she stopped. The hymn ended. The girl lay on the ground, her hips rising and falling in the semblance of an orgiastic spasm. She twitched. Her breasts quivered. Her breath came fast. Spit rolled down the chins of the men about her as they cried out "Holy be His name! Blessed be the will of God," and shook the treetops with their resonant "amens."

"Stinkin' slut!" said a determined and skeptical-looking mountain mother to her old man whose seat adjoined mine. The old man's assent was feeble. He saw some advantages in this new religion.

Another hymn started up. Other girls and women rose, jiggled their breasts, wailed, pranced, and rolled. They were not as pretty as the first, who lay exhausted in the arms of two women on the side, and I noticed a marked decrease in the fervor of the male shouts and amens.

"Stinkin' lot of no-accounts!" said the old woman to her old man. "They ain't one bit of God's mercy in 'em."

After a couple of more hymns, testimonials were taken. Men and women got up and recited their sins and told of God's various gracious interventions. Somewhere along in here a great sermon was given. The preacher, using one of the Norfolk and Western double-cylinder mountain engines familiar to the neighborhood as a symbol of the Lord's power, gave a grand pantomimic imitation. He represented the engine pulling a heavy load of sinners up the grade of heaven, and he blew, puffed, stomped, and let out steam in a most convincing way. He ended his sermon with a great shout and the banjos, guitars, and voices sailed in on the *Promised Land,* in which everybody, even the skeptical, even the old mountain mother beside me, joined.

All this took place in the morning. At noon, great lunches were spread over the ground and all were invited to partake. Following the lead of a bunch of cynical young toughs from over in the coal

country, who seemed to know by instinct where the good cooking was located, I ate a good meal of fried chicken, sliced ham, spiced pickles, and cake. When some old hard-bitten mountain woman's eatables looked inviting, we'd say, "Praise God! Ma'am," and we'd help ourselves. She'd say, "In God's name! brother." I ate reasonably, but some of my young toughs ate enough to founder a giant.

In the afternoon there was a baptism. A small mountain stream had been dammed up with rocks and sticks and mud, making a pool about four feet deep and ten or twelve feet across. Two of the preachers waded out in the middle of the pool whooping and shouting: "God is in this here valley this day!" "God's a-lookin' down on us brothers and sisters!" "God's a-manifestin' His holy will here, friends!" "He's a-makin' us give up them brazen idols of sin!" Several women and a couple of moronic young men were immersed and came up spluttering and shouting.

The final subject was a girl about twenty years of age. Activities in the pool had ceased while her family, grouped about her on the bank, offered congratulations and shouted, with hands upraised to the Lord. When their hullabaloo had ceased, the preachers led the girl in. Just as she was ducked a frightened water snake coming from under a rock ledge at one side of the pool began swimming around the water as fast as he could go. The girl, catching sight of the snake, tried to make for shore but got tangled with the preachers and started screaming at the top of her voice. A hulking old mountain cynic brayed out above the din, "Thar goes the devil a-comin' out'n her!" and a roar of laughter broke from the coal-field toughs. The girl, humiliated and offended but, I imagine, partially convinced about the character of the snake, made the bank, but kept screeching in a way to burst her lungs. Finally, everything quieted down. The preachers thanked the Lord for His visitation, the faithful prayed, and all, dragging together their belongings, left.

I saw a good deal of God's work off and on in further expeditions along the edges of the hills. There were times when its Dionysiac

madness moved me deeply. There were others when my sides would split with suppressed laughter. The people who belong to this faith, that is, the white people, are nearly always the very lowliest around. Among the Negroes, the faith reaches higher types of individuals but black men and women, normally responsible workers, become enraged maniacs under its influence. They beat their heads and bodies in furious assaults on the benches and posts of their temples.

The temples of the faith are usually broken-down churches abandoned by Baptists or Methodists. Sometimes they are mere crazy shacks which rock precariously when God begins manifesting His will. It is generally the men who take the lead in exhortation, but a summer or so past I ran across a woman preacher who had a reputation for efficacious prayer in case of sickness. She was a young woman, slim, quite handsome, and full of conviction. She was ignorant but gave the impression of being sensitive and even delicate-minded. She had none of the marked sexuality that goes with so many of the women adherents to the Rolling Faith. She was a North Carolina girl. God had told her to leave her mill job and enter His service. She had a large following of what seemed to be perfectly steady, though somewhat moronic, mill people. The church where she performed was divided about the extent to which vision and ecstasy should be manifested in action. While some whooped things up, others sat reserved, in a state of mind bordering on disapproval. I asked her about her faith. Unlike my Tennessee preacher, she had no clear story, but she told me that its great tabernacle was way up in Brooklyn, New York, and that thousands and thousands of people gathered there to worship God in the true way. This was a myth, probably. If there were such a tabernacle, I should have known of it.

As she was close to the mills and had worked in them, I thought she might know something about the unionization of the southern textile workers that would be new to me. She backed off suspiciously from my questioning on the subject and said, "There is no true

union but with God." She spoke a reasonably good English. There
were few slurs in her speech, which was reflective and slow. But
she had the faraway look of the mystic and her fingers moved
constantly with the jerky quivers of the hysterical. Although she
and the particularly reserved group she represented in the Church
of God were somewhat above the low and sex-obsessed run of peo-
ple in the Faith, it was to the latter that I owed my acquaintance
with her.

My old student Bill and I, accompanied by a foreign newspaper
correspondent who wanted to see if the Caldwell play, *Tobacco
Road,* was true, were making a short tour of the southern back
roads. Our correspondent, a chubby, fat man, who took much pride
in his cultivation and who hated discomfort, was paying our ex-
penses. Although the newness of Bill's car, in which we were
traveling, forbade our venturing deep into the interior shambles of
the country, we managed to drag our man from one disreputable
dump to another. We hunted for places that would offend his
sensitivity. As he was in search of *Tobacco Road* color, he should
have been grateful, but he was frequently in a bad humor.

One evening, coming from a mountain road onto the highway,
we met a strange procession. Against the protests of our writer,
who was in one of his bad spells, I stopped the car and halted the
procession. I had recognized it as a march of Holiness people. There
were three men, two women, and a couple of children. They were
stretched out single file on the highway. One of the men, a fat,
middle-aged fellow, struggled along on a peg leg. The other two
men had banjos. The women carried blankets. One of the children,
a girl, had a frying pan strapped to her back and dangled a coffee-
pot in her hand. They were sweaty, dirty, bedraggled and flea-bitten.
They told me that they had been missionaryin' up in the mountains
and had been walking for two days on their way home, a mill town
some thirty miles south. They were tired, especially the children,
and I offered to give them a lift if they'd take me into their church
and let me make some drawings. With the help of their leader,

"Red," a glorious banjo-smiting vagrant, I struck a bargain with them and arranged to meet them the next day. Getting our correspondent out of the car to pace the road with me, Bill loaded up with the Holiness people and drove away. He took them home, impressed the location of their dwellings on his mind, and came back. Our new friends left the car full of fleas. These made for our writer and gave him something to think of beyond his temperamental troubles. Bill and I were not bothered.

The next evening about dusk we called on our Holiness friends. They dwelt in a leaning shack of warped boards. The chimney was broken. There were gaping holes in the top of the house. The porch slanted crazily on one side. The red earth, rain-splashed and dust-blown, stained their abode to within a few feet of the roof. A few measly sunflowers grew in the packed dirt of the yard, littered with old tires and lots of iron junk. The street was a rutted welter of dust and lumped clay. It was lined by houses like their own. At the edge of their shambles was a large field. Beyond that, rising in beauty from a clean lawn, rose a great textile mill. The white cement of its tall smokestacks caught the final afterlight of the sun. Coming from its ranked windows was a blue electric radiance. It was a magnificent thing, in the oncoming night, an architectural dream. Our friends did not see it, nor think of it. We were greeted by Red, the leader of yesterday's cavalcade.

"You all had supper?"

We answered in the affirmative. Although Red was obviously relieved by our answer he protested highly.

"Why, you all oughtn't to a done that. We jist cooked up two chickens. We wuz a-expectin' you all to eat with us. The gals got all fixed up."

We sat on the porch. There was no smell of chicken about. The peg-legged man came out, a little surly this evening. He stared at us and with a particularly vicious leer at our uneasy correspondent stumped away. Red stuck his face into a glassless window by the porch and called in, "Bessie, say, Bessie, the boys is here."

"Go —— yourself," a voice came back.

Unperturbed, Red explained, "Bessie ain't feelin' so good tonight."

"What about the meeting?" I asked. "We want to meet the folks at church."

"'Tain't time," said Red.

We sat on the porch and swung our feet. Conversation lagging, Bill and our writer strolled away. Red poked me in the stomach. "Come hyar," he said, and dragged me around the corner of the house. "I got somp'n." He drew a bottle out of his pocket. "I got lots of it. Taste it. You'll want some of this 'fore you go 'way."

I tasted his gasoline. "Sure, we'll get some before we leave tonight," I said, "but we better not start drinking before church time."

"Naw," said Red, "that's right. We got a woman preacher this evenin' and she's funny 'bout likker. Tain't no harm in it, though. We wuz made to have it." He snickered a little. "You'll like that preachin' gal." He chucked me in the ribs. "You jist git behin' her when she's a-bendin' over preachin'." He smacked his lips at the thought. After a minute's reflection, in which his thoughts took another tack, he said, "Say, I'll git you a gal better'n her. She's funny, but the gal I'll git you ain't. She kin do it. She will, too. She's the best tail in this town. I know," he went on boastfully, "I oughta know. I done played on every fiddle round here." And then returning to what was deepest in his mind, "But you gotta have likker. You can't do nothin' with gals if you ain't got likker."

"Sure, you're right," I agreed, "but I don't want to get the liquor before church."

"You could lock it in your car."

"No, I'll wait." He saw that I wouldn't buy at the moment.

"Say," he said, "if I git you a gal you wouldn't mind a-helpin' me a little, would you?"

I led him on. "Not if I like her."

"Aw, you'll like her all right," he asserted. And then, ruminating

a little, "You might have to help her some, too. You wouldn't keer 'bout helpin' a nice gal a little, would you?"

"Of course not."

We went back to the porch. Bill and our writer, the latter sweating with annoyance, were shuffling around the yard.

"Say," whispered Red, "how 'bout them? they'd like a little 'nucky' too." Then, plowing heavily into the dignity of our foreign correspondent, he remarked, "Say, Dad, you're still a man, ain't you?"

He received an ungracious and contemptuous stare. Bill laughed.

"Aw, boy, I knowed you wuz, I kin see by the way yore pants hang." Red roared at his joke.

Getting enough of this and seeing no end to it if we remained here, I told Red we were going to the church.

"Jist a minute and we're all a-goin'," he said.

He jumped into the house and entered into a long conversation with Bessie. Bessie came out with him, her feelings all right. Her lips were a blatant orange. She had powder on her face. Its murky white ended halfway down her dirty neck. She walked with me. Red ran ahead.

"Where's Red off to in such a hurry?" I asked.

"Aw, you know," said Bessie leaning on me. "He's g-o-n-e." She drawled this last and ended with a kind of lilt, like the whine of a hot cat. She stuck her finger in her mouth.

I realized that I was the object of some devious strategy. Bessie made me uneasy.

When we got into the House of God the woman preacher was at work on a sickly child. She was praying. I managed to slip into a seat that would put a couple of people between Bessie and me. I saw nothing more of her.

The woman healer prayed. She stepped quickly back and forth on the pulpit, raised her hands, and prayed again. After a while I saw Red climb up on the platform. He sat with his banjo among a lot of other players, fiddlers, guitarists, and harmonica blowers.

He was moved by the seriousness of the occasion and I could see his lips saying, "Amen, amen."

The healer started a hymn. The instrumentalists broke in. The congregation burst into voice. The rafters shook. Three or four roaring hymns were sung and stamped. Then the woman preacher started again. Her soft, careful voice droned on and on. The little child, the object of her attention, was asleep in an old man's arms. The church was still. Never in a Holiness gathering have I seen such quiet.

Suddenly from outside the church came a great moan, followed by a concerted shouting and roaring calls for God's mercy. The holy wail of the Faith, rhythmical but raucous, came smashing into the unusual silence of the church. The benches to the rear were emptied instantly. I rose to go but the people about me were irresolute, and though restless, kept their seats. Rather than be too conspicuous I remained seated. There were two services going on, one in the church and one out. Tears rolled down the cheeks of the woman preacher. She had kept her people against what she must have known was an almost irresistible pull of curiosity. At least she had kept enough of them to assure her that God was with her. She was a discerning person, however, and brought her services to a rapid close. Everybody rushed for the door.

When I got out the darkness and the dense crowd kept me from seeing anything. I edged my way into the circle of shouting people. A young boy lay back on the ground, his shirt bloody and torn. Just as I caught a glimpse of him, the praying and shouting ceased and he got up and walked off with his friends. He had been knifed, but only slightly, and had rested on the ground as soon as he saw he was not hurt in order to let God and his church brothers have the benefit of his cure. His assailant was gone, on his way to the chain gang, according to one of the witnesses to the affray, who said that the sheriff was after him on another count. "Deputy got 'im on his first move," he said. "Wuz a good thing, fer he's a mean 'un. He'd a killed our boy."

It seems that the boy was sitting on the rear bench of the church with a girl and that the knifer, his rival, had called the girl out. When she got up to go the boy followed, had the better of a little fisticuffs, and then faced a knife lunge. It had barely scratched his skin, and a deputy detailed for the church corner had rushed in at the moment and, recognizing the fellow with the knife, hauled him in.

Dodging Red and his likker and his promised gal, I returned to the interior of the church and talked with the peg leg. He was better disposed than he had been earlier in the evening. Most of the congregation were around. I made friends and conversed with the woman preacher. I drew a picture of her. Her mystic conviction gave her an assurance and lifted her above thoughts of the images in movie and fashion magazines which have generally stood between my pencil and the faces of women. She didn't like what I made of her but the drawing appealed to the others and made them agreeable when I asked them to let me have a try at them. Red came back and hung around my side. He was ostentatiously my friend. Seeing that his Holiness superiors took to me, he made much of having found me and acted as if I were a sort of contribution he was making to the church. He took occasion to lean over and whisper, "Don't fergit." A little later he maneuvered me aside. "Say," he said, "lend me a dime to give to my church." I fished in my pocket. A girl stood with her back to us. Red made a caressing motion toward her rear and winked. "Don't fergit," he said again. He took the dime I gave him and dropped it loudly in a cigar box on the altar.

Bill and our wearied and disgusted writer were yawning. I said to Red, "We're tired tonight. See you tomorrow at your house." He looked shocked and puzzled. I gave him no opportunity to protest, however, and, accompanied by some of the congregation, went to our car. "We'll be back tomorrow night," I called out to everybody and drove off. We didn't go back.

This church was a relatively quiet one the night of our visit. But

beneath its quiet lay an itch for frenzy, shown by the rapid rise of wailing and shouting by the side of the knifed boy, and deeper still lay a whole morass of groveling sexuality, represented by Red and his kind. The presence of this latter was felt even in the delicate faces of young girls who, if they hadn't yet yielded to bodily sexual urges, had a sort of mystic concern with it and sublimated it in suggestive twitchings directed heavenward.

There is among the Holiness people no conscious mixture of sex with religion. Even Red would have been violently shocked had you openly suggested that there was any connection between his God and his "nucky." This, in spite of the fact that he had spoken suggestively of the healer of his church, seeing her for the moment as a woman. The frenzies of Holiness folk are not directed, as are the rituals of many primitive peoples, to exciting desire. Without doubt, that is their actual consequence at times, but, I believe, they are sedative for the most part and end in a temporary depression of physical urge. Girls and women coming out of church after a good session generally have a look of wilted satiety. I am sure that had there been a really good roaring to-do this night, my friend Red would have forgotten all about his plans for himself. But he had no opportunity to lose his mundane concerns in an exalted dramatization of his ego which, even though it might have been unconsciously motivated by the turn of some church girl's behind, would have led him clear out of the physical world. Self-exhibitionism, self-display, seems to be the dominant force in Holiness. Therein lies its power to draw and hold converts.

Young girls and boys, though they are patently suffering the itches of adolescence and make all the moves of orgiastic release in their religious spasms, do so with a sort of mystic purity that can come only when the self, the lonely ego, rises to an exalted declaration of its supreme place before the throne of God. Girls and women little better than whores, and men who are the filthiest lechers, releasing their egos in testimony, shout, and prayer, fly them beyond

all the contaminations of reality and make them actually pure and shining in God's sight and their own. Simple and good people of the Holiness Faith—and in spite of the above pictures there are many—seeing this, are convinced that their God does in fact wash away all sin and brings evil to an end. They overlook the prompt return to earth of the weaker brethren and fail to see also the unadmitted intimacies of the crowded benches in their churches.

Other factors than sexual ones enter, of course, into the attractions of Holiness. Poor, beaten people rising to testify find themselves, for the moment, the center of attention and thereby get some compensation for the miseries of their unnoticed lives. If in testimonial they can work up the courage to experiment with the gift of tongues, they become the Lord's anointed and receive fervid attention. The gibberish of the "Lord's language," a meaningless play of harsh consonants—"Miki Taki Meka Keena Ko-o-o-la Ka"— is much affected in testimonial exhibition and is invariably rewarded with shouts of approval and vigorous amens.

Holiness must have some latent hysteria to grow upon. Certainly, among those to whom it appeals, unsettled psychologies are common. But although this is so, Holiness is an active agent in increasing mental irregularity, and where before its advent there were only sporadic tendencies to hysteria, now there are mass actions of an overt nature displaying it. It seems to me that the Faith, by its assiduous cultivation of frenzy, is developing hysteria in much the same way that a war spirit is developed. Psychological attitudes making the war spirit possible are always with us. It takes a particular kind of furor, however, to bring them to the surface. For submerged hysterical attitudes Holiness is supplying the furor, and over the face of the industrial South it is encouraging the growth of madness, of crazy idiosyncrasy, and social irresponsibility. Maybe it is the last decadent flare of that Protestantism which accompanied the rise of capitalism over the world. Maybe its lunatic, distintegrating wildness is a portent, a symbol of the end of social ways which are also disintegrating, wild, and irresponsible. Whatever it is, it is

cultivating a weed patch of aberrant psychologies which will be very difficult to clear out of the fields of our future social plantings.

Though Holiness is growing in the mountains it has not reached everywhere. Back in the high ridges and in the deep valleys other religious forms predominate. Holiness borrows and takes over their more flamboyant rituals. This often leads to confusion, and good shouting Baptists and Methodists are frequently called Holy Rollers by the indiscriminate. Actually, there is a great difference. Baptists and Methodists of the hills would have nothing to do with any Negro messiah or with anything that was new. They are traditional religionists, formal. They keep ecstatic sisters in their places and are more ceremonial than the Holiness brethren. They seem to be less concerned with what is under their skirts or in their pants. It is true they whoop things up at times and are capable of making a great din, but their rituals are relatively measured, solemn, and dignified. They lay great stress on ancientness. They reverence the word "old."

A Baptist preacher in a weather-beaten church on a lonely hillside prefaced his sermon one Sunday by saying, "This here is the *ole* church of the Mount of Olives. It's a-ben a-standin' here a rock fer the Lord all my life. It was a-standin' endurin' my Pappy's life and fer all I know it was a-standin' here since Jesus died to save us pore sinners. It's a *ole* church."

It's an "*old*-time religion" that the people of the interior hills are attracted to. The new, they spurn. They allow no stringed instruments in their churches and do not confuse God's song with the Devil's. Where the hymns of the Holy Rollers verge on dance music, as they must, to encourage the prancing proclivities of the faithful, those of the Baptists and Methodists are slow and mournful. Modal tunes of great age, full of a deep minor sadness, continue to be handed down in the churches. They have singing masters who regulate the "singin's." They select the voices, assigning to each member of the choir the part to which his voice is fitted. With a rudimentary knowledge of music, handed down, generally, from father to son,

and with some old-shape-note music book as reference, these music masters are looked up to and heeded. They suppress the rampant individual who wants to roar out above all others and whose encouragement, among the Rollers, leaves Holiness music nothing but rhythm. They are proud of their positions and sincerely devoted to their music.

I knew a music master of the mountains who, though nearly seventy years old, would cradle wheat all day and then stand gesticulating, admonishing, and encouraging his choir for three hours at night, so great was his love for his music and so intent was he that it be rendered "right." Cradling wheat is hard labor. A heavy wooden fork, the length of a scythe blade, is attached to the lower end of the scythe handle that it may catch the cut wheat and facilitate neat bundling. To swing one of these instruments in the mountain fields is a man's job. To swing it all day and then go arduously to drilling a choir at night bespeaks not only love for music, but a deep well of energy besides. I spent several evenings with this old wheat-cradling musician.

His church had purchased some years back a new batch of sacred hymnbooks from a Tennessee music publisher. The new books, paper-bound, were printed in a shape-note system, but the old man complained grievously of the songs. They weren't as good as those sung in his youth, he said, and were also much harder to read because the notes were so close together. He and a couple of other aging men sang for me from *The Harp of Columbia*, one of the old hymnbooks which had survived long use in the church choirs. They sang three-part songs with odd changes and long holds. Even after I had learned to read the peculiar notation system, with its signatureless staff of moons and crescents, squares, stars, and triangles, I could not find reasons for the changes of tone and the long holding of particular notes which occurred often in the middle of a phrase. They insisted that they sang what was written, but I do not believe it was so. They sang what they had learned in a tradition of singing and only used their notes as a general reference.

There is much traditional music in the hills, profane as well as sacred. This is no discovery of mine. Interested people, better equipped than I, have been ferreting it out for years. It does not seem to survive industrialism and the songs of the coal fields and textile regions are poor attenuations of the old ones and full of the conventions of Tin Pan Alley. Movie halls, phonographs, and radios wreck the old free play with music. Young singers, with the references of canned music always at hand, sing in the standardized fashion of the cities, where a certain kind of rigid pattern for hillbilly music has been popularized. In the song festivals, which have been revived lately in the Appalachians, urban expertness gets too much applause. The old-timers are backing away.

An aged mountain fiddler, Uncle Lawrence, said to me when I asked him whether he was going to attend a certain highly publicized festival, "I went up thar a time or two, but they warn't nobody'd let me play. It's always some carn-y-val fiddlers they lets play an' at gits the prizes. Seems like they don't want us old fellers no more." This latter was hardly true, for the festival producers do try to get the old people, but the reference to "carn-y-val" fiddlers had substance.

I don't know whether they received all the prizes or not, but radio hillbillies drew the heavy applause in the festivals I have attended. The young mountain people no less than the town and city visitors gave their hand to proved professionalism. The fiddle arms of many of the old players are not what they might be, but it has been my experience, from Virginia to Arkansas, that their tunes are more entertaining than those of the professionals and the young hill musicians who pattern after them. In the fiddle contests, still matters of importance in the mountains, the tunes selected by the competitors are those which show off flashy playing. Most of the very old boys, with their rheumatic arms, are out of such contests. The young musicians also look askance at their versions of the old tunes. They forget that these old pappies played before canned music began setting up orthodoxies for reference.

I remember well the case of a family of Ozark musicians where the boys shut the old man up every time he drew his bow because he wasn't playing according to "the record." Dudley Vance, a Tennessee fiddler, old enough to know, told me the records "never wuz right." Dudley's house sat on a shaded hill above a creek. You had to go through his barn and pig lot to get to his dwelling. His son played a guitar. He had organized several bands in his time—fiddle, banjo, and guitar combinations—and had been a champion fiddler. "Wuz a time," he said, "when I'd cross bows with any fiddler from here to Florida."

Vance had a friend, a banjo player, named McNamara, about twenty or twenty-five miles away. He told me old Dad McNamara was the finest banjo player in the whole country. I called on McNamara and heard him play his banjo with three picks attached to his fingers with rings. He ran a store and gristmill. A tall friendly man, a mountain man, not a hillbilly, he and his pretty daughters played and sang together for me one whole summer's evening.

I have always looked for musicians when in the hill country. I like their plaintive, slightly nasal voices and their way of short bowing the violin. I like the modal tunes of the old people and the odd interludes, improvisations, often in a different key, which they set between a dance tune and its repetition. I've played with, and for, the hill folks on a harmonica and have picked up unwritten tunes and odd variants of those which have found their way into music books. I've heard *Old John Hardy, Chuck Ole Hen, Shortenin' Bread, Shoot Ole Danny Dugger, Old Smoky, Wild Bill Jones, Pretty Polly, Sourwood Mountain,* and a large number of ballads played and sung in many different ways, modes, and times and I have come to the conclusion that there is no right way for the rendering of any of them. From Virginia to Arkansas I've attended "Wednesday night singin's," profane and religious. I've listened to hot arguments and discussions on the correction of a tune. Uncle Dan Sevier (Sévère) says, "The young 'uns don't keer no more fer music since they've tuk up with this hyere nigger drummin' in

town." The old music cannot last much longer. I count it a great privilege to have heard it in the sad twang of mountain voices before it died.

The hospitality for which the South is famed is more prevalent in the hills than in the lowlands. This, at least, has been my experience. In the deep South, I have been entertained, and handsomely, but only when I had a proper introduction. In the hills I've walked, many a time a perfect stranger, into a house and, after a little parleying, have been invited to dinner or supper and treated with such simple friendliness that I felt like one of the family. This would occur sometimes when there was little more to eat than fried pork, corn bread, and molasses. As a rule, I've found the hill folks most considerate of another's difficulty and, when night caught me far from a town, quite willing to put themselves out for my accommodation.

Walking once, seven or eight years ago, over a broken, rutted road in the hills I came to a pass where the ridge broke and from which my way led down into the valley and the scraped highway. The sun was setting and I looked dubiously at the long dark walk ahead. On the plateau at the crest of the pass there were two houses and a store. One of the houses was built of logs, in the traditional backwoods style, the other and the store were made of undressed boards nailed vertically to the studdings. All were weatherworn, gray-brown, and, through the warping of the timbers, inclined at precarious-looking angles from the stone foundations built up at the corners. Around all were split rail and brush fences.

The store was made of two sections. The front, where a porch hung over the slope, opened on a room with a counter and a few shelves of tinned oysters and salmon. There was a gristmill there and a gas engine to run it. In the back were living quarters, glimpsed through an open door, and off to the side a kitchen with an iron stove which shot its pipe out of the side of the wall. Sitting on the porch was a little boy, teasing a cat with his bare toes.

"Hello," I said, "is this your store?"

"It's Paw's," he replied, looking me over.

"Where is your Paw?"

"He's down in's corn patch. He's hoein'."

"Go tell him there's a man here wants to see him, will you?"

The little boy went off down the hill. I waited in the approaching twilight. From one of the houses came the sound of a melodeon, cracked, wheezy, and mournful.

Nearly half an hour passed before the little boy came in sight again, climbing slowly up the hill with his father and mother, their hoes over their shoulders, their feet bare and covered with red-brown mountain soil. They were young, and the woman was pretty, as are so many of the women of the hill countries when they are young. As they approached the porch where I was sitting, the mother without looking in my direction shied off to the side and ran quickly round to the back, slamming a door briskly as she went in. The boy and his "Paw" came on. I put my business out quickly.

"Friend," I said, "I want to get put up for the night. I've been walking all afternoon and it's too late to make town. Can you give me supper and a bed around here? I can pay."

He reflected a bit. His voice was friendly. "We ain't got no hotel up here. Ah don' know where ye can stay. Ah reckon ye can git supper all right but sleepin' over is diffrunt."

"I'm not particular," I said. "I'll be satisfied with whatever I can get. Just a pallet will suit me." Then I explained that I was an artist just bumming around, making drawings of things that interested me. I took my sketchbook out of my knapsack and passed it over. The little boy was immensely interested and he and his father went over every page intently. The melodeon kept wheezing and the dark came on without a word between us. I petted the cat.

The little boy spoke up. "Ah *like* to make pictures," he said.

"Do you?" I replied. "What do you draw?"

"Ah jist makes things up."

"Have you got any of your drawings here?"

"No, we ain't got no paper now."

The atmosphere became friendly. "Well," I said, "don't you think you can find some way of putting me up for tonight?"

"Ah'll talk to the woman," said the man, and went indoors.

Time is of little moment in the hills and decision is leisurely, but after a while the couple came out on the porch. The woman, really just a girl, had washed up, her face shiny with soap.

She had on a clean print dress and over her legs, which were bare when she came up the hill from the corn patch, were drawn a pair of pink silk stockings and on her feet were high-heeled yellow shoes. She had a straight clean look out of her wide eyes.

"I reckon," she said, "if ye kin stan' we 'uns, we kin stan' ye."

We had supper and when night had come for good the little boy and his mother took the lamp and went in to bed. After a bit she called out, "All right, Jim," and the man led me into the back room where there were three double beds with high feather mattresses.

"Ye'll sleep in this 'un," he said, pointing to the bed near the door. The boy and his mother were covered up at the other end of the room. "Ah'll sleep here," and he sat down on the middle bed and blew out the light.

This is an example of mountain willingness to serve a stranger in difficulty. These people would accept no pay. They gave me breakfast and sent me on my road with a friendly "come agin."

There are times, however, when the hillman is not friendly, when for some reason or other he becomes suspicious and will have nothing whatever to do with you. Once, trying to make a short cut to a certain county seat I took a seldom used trail over a mountain. It was pointed out to me by a friendly farmer. The trail was a difficult one, hardly discernible, but I made the mountaintop and found a plainer road on the other side.

For an hour or so there were no signs of human habitation, only the big timber and the rutted road. Finally I came abruptly on a split rail fence, some gray-boarded outbuildings, and a rambling log house to which additions of all sorts and of all materials had

been made from time to time. From a piece of stovepipe sticking out of a lean-to, smoke was curling.

"Howdy," I called out. "Anybody home?"

There was no answer. I called a second time and a third. Finally, like a flash, a woman's sunbonneted head popped out of a glassless window and popped back. Silence and no other signs. I waited a little and then, as if from nowhere, the figure of a man appeared, a rifle across his arm. His big black hat was pulled down about his forehead and his black eyes and face were devoid of all expression.

There came across my mind suddenly all the tall tales I'd heard about moonshiners and dead strangers who had stumbled into places where they had no business, all the lurid mountain tales with which the town boys of the hill country had regaled me. I hung my arms across the rail fence to show that I was unarmed. "This road all right for the Gap?" I asked. Through the Gap the road to the county seat passed over the hills.

He pointed with his thumb, saying nothing. I hung on the fence a minute and then turned up the trail. I could feel his eyes in the middle of my back until the foliage hid me.

I have no particular reason to believe that this man had anything suspicious to hide. Corn whisky was certainly made in these hills and in considerable quantity but it was not likely that a still would be set near even the least frequented of trails.

I had strapped to my back at this time a Red Cross knapsack. I wore khaki pants and leggings. This man may have thought that I was a government man, perhaps one on a belated hunt for information about draft dodgers, of which, during the War, there were reputed to be many in the mountains. Or he may simply have come in from squirrel hunting, and finding me by his fence suddenly got the notion that I wasn't there for any good. He may simply have been taciturn, habitually speechless, and may have treated me as he treated all people. He was an uncomfortable cuss, though.

I was caught another time by a wave of suspicion which put me

to a considerable hardship. It was spring. I was walking in the White River country along the Arkansas-Missouri line. After having tramped all morning, I came to the river and one of those trolley ferries that are propelled by the current. The ferryboat was across the stream on the edge of a mud flat. There was no ferryman in sight and though I hallooed, none came to view.

Ordinarily, I should have looked about for a log, tied my clothes and knapsack to it, and swum across, but at this time the river was up, the current was strong, and I didn't know where I'd land on the other side. Besides, I was afraid of snags. So I sat and waited. After a while I caught sight of a fellow in a cap and overalls standing half-hidden by a big sycamore tree near the ferryboat. I hailed him but he promptly disappeared. I thought this strange but I decided to wait and see if he would go and tell the ferryman of my presence. I waited an hour or more. Finally a team and wagon came up behind me and pulled up at the ferry landing. I said to the driver, "Don't seem to be anybody over there."

"Oh, he's there all right," said the wagoner and let out a whoop.

The very same fellow that I'd seen by the sycamore tree came out of the bush, poled the ferry off the mud flat, and set her out across the river. Collecting a dime from me before letting me on, he ferried us over. The wagoner went on. I said to the ferryman, whose face was fat like a pillow and whose blue eyes were narrow, deep-set, and squinty, "Didn't you hear me call?"

"Never heerd you," he replied and then, for no reason at all comprehensible to me at the moment, "Say, I c'n tell clever people no matter how they's dressed. I c'n tell 'um by their eyes."

"What to hell do you mean?" said I.

"You know," he said. He looked me over wisely and with an air which indicated plainly that he had my number.

Curious to find why he was suspicious of me and what was behind it, I walked with him toward his house, which lay beyond the fringe of trees on the riverbank.

"You don't mind if I sit on your porch and eat my lunch?"

"Set all you want." He turned and went inside.

I ventured remarks on this and that, but to no avail. I could hear him puttering around in the house, where he seemed to be alone.

Finally having eaten my sandwiches and giving up hope of finding what was in his mind, I called to him that I was going and asked him if there were any short cuts to Mr. So-and-so's store up the hill road about fifteen miles. There were some people near this store, I'd been told, who took in strangers, hunters and fishermen, and I proposed to spend the night there.

My ferryman came out and, still with that look of confident perspicacity with which he had first looked me over, pointed to a path that led down by the river. "That's shorter," he said.

I didn't like the funny glint in his eye with which he said it. He looked too much as if he were outsmarting me, but I took the path indicated, even though it went down into the river bottom instead of up to where I was headed. Pretty soon, under the big trees, I forgot him, his suspicions, and my own later ones.

It was cool in the shade, and I walked briskly. Getting down deep in the bottom I found that the ground had all been flooded and that the path was covered with a deposit of mud, now caked, cracked, and hard. By the openings in the underbrush it was easy to see where the path had been, so I kept on. It was easy walking on the baked mud. I must have been going three-quarters of an hour, when a great fallen sycamore forced me to leave my way. Beating the thick brush I made my way around it and kept going on what appeared to be a continuation of the path. Running into denser underbrush, I got puzzled. I realized that I was off the trail. Knowing the river was somewhere to the left of me I set out to find it. I was sure the path was somewhere between me and the river because I could make out a bluff rising perpendicularly in the thick foliage to the right and I knew no footway would climb that. The underbrush was thick. The mud became a little sticky, and it got hot and steamy. There were rotting logs all about. Bending down to get under an overhanging branch which made it difficult to step

over a log in my way, I looked straight into the eyes of a big, ugly cottonmouth. His dirty gray coils lay just beyond the log ahead, on a flat of mud. Walking upright, the leaves would have concealed him and I should have stepped right into him. My backbone shivered and my hair tingled. I thought to myself that there must be a lot of snakes around here. This was their home ground.

There were no rocks in the bottom with which to hit the fellow in front of me, so I looked around for a chunk of mud. Digging up a flat cake I stooped down and though the brush about me kept me from getting an energetic swing I hit him in the middle of his coil. I suppose I didn't hurt him much for deliberately and slowly he unwound himself and crawled sluggishly out of sight. I gave him plenty of time and then moved cautiously on.

Having got the idea of moccasins in my head, I was in a sweat. I deliberated about going over toward the bluff. I figured that if I could climb it I might find the regular road somewhere above. Then I thought of copperheads and the possibility of rattlesnakes in the ledges and gave that up. I got a regular snake phobia and was afraid to turn in any direction. I said to myself, "What was that God-damned son-of-a-bitch ferryman up to when he sent me down in this hole?" I squatted down and thought up all the filthy names I could call him. This did me good and pretty soon I got up and, finding a stick, I said, "To hell with the snakes!" and went on.

I never rediscovered the path, but after struggling with mud and brush for another hour I came out on a field where a fellow was plowing. He showed me the way to the road but eyed me doubtfully.

Getting on the road, I finally made the store of which I had been told. It was dark. A long lean skeptical-looking old Ozarkian with a white beard was on the store step. He stuck his thumb under his galluses and eyed me coldly when I asked if there were a place about where I could put up for the night.

"There's no place here," he said emphatically.

"Is there a place farther on the road?"

"Don't know." He turned away from me.

I was enraged but there was nothing to do. Dead tired as I was from having walked all day and from my struggle in the river bottom I went on down the road in the dark. I could hardly see in the faint light and stumbled over rocks and ruts. After about three miles I came to a house. The people here were also suspicious and would have nothing to do with me. They told me that the river made a big bend above and that by recrossing it I could make a short cut to Forsyth, the county seat, where there were hotels.

"How far is it?" I asked.

"About six miles," I was told.

"And how am I going to cross the river?"

"There's a skiff ferry." The man I was talking to seemed anxious to get rid of me. "You'll have to hurry or you'll miss gittin' it. The feller that runs it sets his fishin' lines in the evenin' but he don't stay thar all night."

Well, it must have been my informant's six miles to the ferry only. Sometimes I didn't think I could walk another step, but I made the landing and found the ferryman just through with his lines. I tried to get him to put me up for the rest of the night, but he said he had no room. He also told me that it was twelve miles farther to the Forsyth bridge. It was as if he had said a hundred. I saw a few houses, but their lights were out so I made no more inquiries about stopping. Past midnight I got to the town, woke up the hotelkeeper, and got to bed. Next morning, stiff as a board, I heard that three days before there had been a big bank robbery down in Arkansas and that the robbers had been reported coming north. I understood then the morning ferryman's remark about my "clever" appearance, and the suspicious rebuffs I had received along the road. I figured, with the hotelkeeper to whom I told my story, that I had made a continuous walk of nearly fifty miles.

Since this experience the roads of this country have been paved. It has become a resort. Well-to-do people from the towns and cities to the north of the hills have built swanky cabins there and have

put docks and boats on the river. Last year I looked for the road of my dark stumbling trek but I couldn't recognize it.

This country, as it breaks farther north into areas of business enterprise, is full of gangs of marauding and shiftless hill people who make a living by their wits. Their wits are crude and they are always in trouble with the sheriffs. As in the hill breaks everywhere, they are a tough lot. Seeing probably many questionable operations of property interests about them, feeling the pressure of these interests with their techniques of foreclosure and eviction on themselves or their friends, they have developed a highly cynical attitude toward society and, like the dispossessed riffraff of the Appalachians, they have turned to "doing it." During prohibition they made a living bootlegging and discovered that the best of people had no more respect for the law of the land than themselves. This tended, of course, to increase their cynicism. The records of the county courts are full of their depredations, their wild quarrels, and their equally wild fornications in which old men jump out of the bushes on thirteen-year-old girls and young bucks indulge aberrant urges at the point of a gun.

They take their difficulties uproariously. One sixty-five-year-old raper was conducted to the penitentiary in the company of a young fellow who had stuck a knife into a rival. The old fellow's crime, an attack on a child, was enough to have turned the stomach of the toughest, but his companion made game of the matter. It was a great joke to him. Whenever, on their way to incarceration, they passed a group of little girls the young fellow would rattle his handcuffs and nudge the old man. "Close yer eyes, Uncle," he'd say. "The sight o' asses like them is what got you in this fix." Or, "Lookit them little asses, Uncle. You ain't goin' to plug no more o' them fer a long, long time."

These hillbillies, if they are not off on devious affairs of their making, hang around the courts when they are in session. As a matter of fact they'll give up any affairs of their own for a good show in the courts. They come into town in droves with their

women and kids as to a circus, and will sit for hours giving the utmost attention to all the procedures of the law. Though contemptuous of the law in their average conduct, they love its operative spectacles. They are always on hand as witnesses and will perjure themselves with absolute aplomb. Their women, gaudy in cheap paint and perfume, lie with a straight face and produce indignant gestures when, under grilling, their veracity appears questionable.

It is not only in the breaks of the hills that this love of law as a spectacle prevails. It is equally strong in the deep hills. The county seats of the back countries will always be packed to overflowing on court weeks. The hillman wants his law flamboyantly presented, and prosecuting and defending lawyers, both, are supposed to rant, rave, and froth at the mouth in delivering their arguments. I've seen trials that looked like Holy Roller meetings. The lawyers of the hills are a cagey lot. They put on their shows like good actors with never the slightest suggestion that their cavortings and rages are not the result of conviction and necessity. They play to the gallery with a neat precision. The judges, though they appear to go to sleep at times under the strain, present a contrasting dignity. They sit like solemn deities above the turbulent winds of controversy. They break their poses only to lean forward and, under cover of the hand of reflection laid against their brows, squirt tobacco juice into the hidden spittoons at their feet. I've always noticed that when a judge's hand goes to his brow his mouth's also full.

This is not all that I have found in the hills. I can go on indefinitely from one story to another. So many things have happened in my treks there. I've run across strange cases of pride and many outrageous modes of hilarity. I've seen bitter and ridiculous situations. There was an old woman at whose cabin I stopped over for a drink.

"Thar at th' well," she said. "Draw ye a drink."

The bucket came up so battered and full of holes that the water spurted in all directions and I couldn't get near it. She came running

out with a gourd. "Why, what's the matter with that ole bucket?" she said. She looked at it critically. "Why, the hateful thing is a tuk to leakin', jist whin a stranger wants to drink. I'm jist ashamed uv it."

There was the mountain girl sitting on the porch rolling snuff on her gums and spitting copiously. I took her by surprise with a request for eggs. She jumped into the house, reappeared in a moment very ostentatiously chewing gum, pulling it out in long strips. There was Bill, who, invited to a lumberjacks' breakfast, mistook the thick bacon-grease gravy for oatmeal, poured canned milk and sugar on it, and, being ashamed of his mistake, had to eat it while the boys looked on wondering at his strange and virile tastes.

There were lots of other things.

V

The Rivers

THE pilot rules posted on the Ohio, Missouri, and Mississippi River steamboats, after enumerating the big streams where compliance with these rules is mandatory, conclude with ". . . and for the Red River of the North." There is about this conclusion an immensely romantic suggestiveness. It is like an afterthought, which following a businesslike cataloguing of practical commonplaces admits reluctantly the existence of some mysterious unknown. Sitting once in the pilothouse of an Ohio River boat I asked about this stream. There were several rivermen sprawled about in the chairs above the easy water but all were uncertain as to the exact whereabouts of the Red River. One told me vaguely that it was above the headwaters of the Mississippi. Another thought that it ran north in the Dakotas. As no one was energetic enough to hunt up a map I learned no more about it.

Such meager knowledge as was given me, however, was more than I wanted. I was quite satisfied that the prosaic verities of a map be left alone. I wanted to keep my first imaginative picture of a river extending far away in deep northern forests, running in dark lands of snow and ice, unknown, blood-red, and dangerous.

Why I should have got such notions in my head about this northern water it would be hard to say. There was probably in the mere word pattern of its naming some poetic suggestion that recalled Kublai Khan and his mysterious river of the caverns. Like Kublai Khan I had a vision, and sitting with the drowsy, silent men in the pilothouse I elaborated upon it. I got the feeling that while the

pilot rules posted above the big steering wheel in front of me might be applicable to the Red River of the North, they were so only if one could get there. Yielding to my mood I made up my mind that few ever got there and when they did they never came back. This was of course extravagant. But it symbolizes in a way the attitudes that most of us take toward our American rivers. The innumerable stories of lonely and dangerous voyages over their waters which occurred only yesterday, and which live still as dread realities in the memories of old men, give them a romantic quality which even the filth-spitting factories on the banks of so many of them cannot dispel. People who have been on the big waters the better part of their lives, who live a thoroughly practical existence on them, have a way of romancing about them and magnifying their doings. They dwell on the fatal unpredictability of their ways, on the mystery of their sources and the glamour of their histories. Tall tales and tall notions are today as yesterday an inescapable part of river life. The half-horse and half-alligator men have left their footprints and the flavor of their extravagances along the muddy shallows of the great rivers.

A shanty-boat man, whose rickety craft was tied up in a creek above Cincinnati, told me with great seriousness about a whirlpool in the Mississippi below Memphis where a large part of the river was sucked underground. He said that hundreds of people had been pulled down there and that in low water the smokestacks of old packets could be seen in the raging vortex. The gigantic legends of the old flatboat men of the Ohio and Mississippi survive, and among the poor and ignorant people of the rivers are sometimes fully believed.

Mike Fink, who lived in the early eighteen hundreds and who could outshoot, outswim, outchew the ears off people as well as outdo all his contemporaries in the production of wood's colts among the river girls, was a great raconteur. He made enormous stories and in time became the hero of them. Along the rivers, as everywhere else, men make their legends and become—if they

speak with conviction—what they say they are. "Wet" Willie Ahler, a contemporary river brave, saw himself and spoke of himself as a tough guy. He kept his co-workers on the towboats of a few years ago in a constant state of worship for his prowess and in a constant state of uneasiness about the direction it might take in action. It is told of him that on a pay-off night of drunken revelry, after he had wrecked a couple of southern brothels and been subdued by the police and jailed, that he bit off the thumb of the turnkey who brought him his morning-after breakfast. I suspect, if this story is true, that it put an end to Wet Willie's demonstrations of his supermanhood for a long time. The tempers of outraged southern policemen would certainly have seen to that. This hero was off the river when I heard of him but his spirit was much in evidence. He was becoming a figure of hearsay, already a legend, a modern Mike Fink. The boys who knew him liked to talk of him and of his hard-boiled meanness.

River tradition runs toward toughness. I knew an old Mississippi second mate who lost his place on one of the modern towboats because he insisted on maintaining the character of a rip-roaring old-style riverman, "tough as a hickory nut" and "mean as a rattlesnake." He was sixty-eight years old, about five feet two inches tall, but round and hard. The crew and roustabouts of his boat were scared to death of him. He believed it was his privilege, even his duty, to cuss out everybody rating below himself and that the proper way to maintain discipline and respect for authority was by the liberal use of a stick of cordwood. He nursed a dramatic picture of himself formed in his packet-day youth when a dead nigger or river rat was simply food for the fishes and no concern of the courts. Instead of giving up this picture he gave up his job, commenting scornfully on the decadence of company rules which were trying to inject an impractical and unworkable softness into river ways.

Considering the actualities of contemporary river traffic with its modern boats and sanitary quarters, with its systems of mechanized loading where skill rather than brute force is the order of the day,

the attitude of this old mate toward his river craft was as foolish as my poetic one toward the Red River of the North. It was just as pure romance and just as untenable. But the old boy held to it and like myself spurned any reconsiderations or practical revaluations which would interfere with his sense of drama.

Negroes along the rivers are gorgeous romancers. They are full of stories of catfish as big as whales, of enormous snakes, and of incredible treasure finds. To the latter many look hopefully forward for the solution of all their difficulties in life. They put up with a miserable muddy existence year after year in the hope that floodwaters may bring some great prize which will enable them to satisfy all of their dreams. "Ole Man River" is for the colored children of his banks very much the measure of all things—he is fate, hope, and tragedy all in one.

The most desirable job a river Negro can obtain is one on a boat which will take him to and from such legendary and inspiring river places as Cincinnati, St. Louis, Memphis, or New Orleans. The cook of a towboat on which I journeyed from Cairo to New Orleans was so proud of his position and his view of himself as a much traveled man that he could even speak of the sporty children of Beale Street as "dem niggahs." His lips curled scornfully about the "shiftless no-'count niggahs," who lived on the riverbanks waiting for flood riches and who "nevah got nuthin' but a mess o' catfish and a han'ful of ole boards."

River Negroes and shanty-boat whites are inveterate fishermen. They will sit immovable as turtles on the mud banks or in shallow skiffs waiting hour after hour for a big catch. Up and down the river capable and lucky fishermen are known to the towboat people. When about a couple of miles from the point of a good fisherman's location, the pilots pull a long blast on their boat whistle. The fisherman, with his catch in a sort of weighted chicken coop of fine-meshed wire which is towed behind his skiff, pulls out in the middle of the big water. The towboat on arrival will slow down and pilots, cooks, and crew look over the catch. I've seen some powerful

and lusty catfish come out of the river fishermen's coops. The Negro cooks will not handle these big fish until a spike has been driven through their heads. They are afraid of the long catlike feelers which are reputed to sometimes "swell up a man like he wuz drownded."

When I was a little boy the landing below Eads Bridge at St. Louis used to be lined with river boats. This was before freight carrying on the rivers had fallen completely into the hands of the towboat firms. For years, crossing the bridge by train, I looked down the yellow river at the rows of white steamers with their gingerbread smokestacks and ornate pilothouses. When I was old enough to read *Huckleberry Finn* the sight of them roused the most nostalgic of desires. At the time of the St. Louis fair in 1904 there were still many boats there. They have become fewer and fewer with the passing years and those devoted to anything but Sunday excursion service are now very rare. You see old packets tied up along the backwaters of the river, here and there, but they are not in use. Their time is gone.

On the Ohio between Cincinnati and Louisville in a mud flat on the Kentucky side, one of these steamers of the old days lies crazily up against the shore. She was probably one of the greatest and swankiest of river craft in her day, but now her cabin windows are knocked out, her guys are twisted, and her tall curlicue-decorated stacks are a rusty red. She is like some proud but bedraggled and improvident old woman, who after passing a glittering and gay life has hunted out a secret place in which to die forgotten. I saw her one evening in June when the river was full of the smell of wild honeysuckle and the still water was pearly with twilight reflections. I thought of the land north and south which her journeys covered. I thought of the rich and showy planters who rode on her and of the affected languor of southern girls who once waited on the river landings for her to return their voyaging kinsmen and beaux—of the pretty girls who must have hailed this very boat in

the good days of the past with perfumed lace handkerchiefs and the twittering hysterias of self-conscious class and manner. I thought of the gamblers who schemed on her in the evenings, the gamblers with their neat ways and contained faces. I thought of my Dad, who came up to St. Louis to study law on one of her kind just after the Civil War. And I thought of my grandfather, Pappy Wise, who must have passed boats like her when he went down the river, New Orleans bound, with his rafts.

I was in the pilothouse of a big, new, and highly modern steam-turbine towboat, which had propellers set in tunnels in her hull in the very latest style, when I saw this old hulk. The contrast between the two river craft was immense. The new boat was stocky, short-lined, and powerful; the old appeared for all her decrepitude rather delicate and graceful. Her long swooping sides with their lacework of jigsaw wood told of something more than usage. Beside the workaday solidity of the craft I voyaged on, she was an aristocrat. And like many a true aristocrat of her time she had probably been pretty hard on those who worked in her service. She had probably burnt up the lives of niggers and poor white men without compunction, kicking them overboard when they failed her. It was just this sort of craft that my old second mate had worked on in his youth and done his hard cussing on. Below decks out of sight and hearing of the fine passengers he had probably there learned to use his stick of cordwood, busting the heads and backs of scared Negroes. My own boat was not an aristocrat in appearance but her men were well taken care of, their food was good, the same as was served the officers, and they slept on clean sheets rather than on the deck among boxes and bundles of freight.

The new towboats of the river, while they are not as picturesque as were the old packets, are far more convenient and comfortable for the crews. They have refrigerating plants, showers, and good quarters. Their steel decks get hotter than the old wooden ones but they don't so easily serve for the making of ratholes and bug pockets.

Several years ago I took an eighteen-day river trip on one of the towboats of the Mississippi Valley Barge Company. When I went down to the Cincinnati water front to get aboard, I expected to find some ratty old hulk on which I should have to spend the better part of my nights fighting bedbugs. My notions of contemporary river boats had been formed downstream by a rather dirty old steamer that plied out of New Orleans. I had the surprise of my life when I climbed aboard the spick-and-span new boat and was shown the guest cabin that I was to occupy, with its brightly colored bedcovers, its polished furniture, and its private shower and toilet.

I had never been close to the new boats of the river and had not heretofore even seen one of the propeller type. Off in the distance from the levee banks I had often watched the stern-wheel pushers with their long lines of barges but I never thought of any towboat as offering convenience or ease for travel. I arrived at the Cincinnati landing in old and rough clothes. I wore boots and carried all my belongings in a knapsack. Compared even with the working crew of the boat I looked like a tramp. The officers wore neat white clothes. Looking around in the flurry of immediate departure for someone to take a letter of introduction which I carried from the St. Louis owners of the boat, I heard someone behind me yell "get that bum off the deck."

The old second mate mentioned a few pages back came bearing down on me, his chest swelling, his face red, his white hair bristling, his hands itching, and his mouth ready to spit profanity. Without my letter he would have had me in the river mud in two seconds. Reading my paper he cooled off and we later got to be good friends. I made a drawing of him, with his cap cocked over his ear and his lips curled over bloody reminiscence. I wanted to have that drawing on this page but it was lost some years ago.

The trip down to New Orleans on this boat and her sister ship, to which I was transferred above Cairo, was one of the most restful I have ever known. I sat in the pilothouse and watched the

green riverbanks go by. There was nothing to do but sit, and go three times a day down into the messroom and stuff myself with rich Negro cooking and then sit again.

When you have time properly to consider it, eating is a grand business. All my life I have loved to eat. At home when I was a little boy, I not only ate at mealtimes but made regular trips to the cellar or the kitchen cupboard between times. I crammed myself on all occasions. Even when later I began falling in puppy love with pompadoured girls I could see no discrepancy between romance and an inflated belly. I ate on the towboat as I had in my boyhood, to bursting. At Memphis I bought a big plug of chewing tobacco and took up again one of my old ways of settling down after a debauch of food. After meals I'd put a comfortable chair on deck in the shade of the pilothouse and sit for an hour or so sensually rolling the pungent juice of the tobacco around my jaws. I'd spit far out in the yellow river.

We stopped in Memphis on a Saturday. I went up to Beale Street, the "home of the blues," and watched a few flashy colored sports walk by under the envious eyes of the country Negroes in town for the day. Beale Street was quiet and I was disappointed in it for I had always heard of it as an uproarious place. I wandered into a poolroom but sensed that I was not welcome and moved on. The colored boys in there, giving businesslike attention to their games, were well dressed and spoke quietly. Outside, the country folks were louder, gayer, and more picturesque, but they too seemed to be bent more on business than fun. I hung around for a while after night but so far as I could see Beale Street didn't come anywhere near Harlem or a half dozen other places I had been. For abandoned Negro gaiety it was a flop.

With the exceptions of Vicksburg and Natchez, which stand on hills, the riverway from Memphis to New Orleans is a lonesome one of long stretches of green. Over on the banks now and then, as we went down the river, loggers could be seen at work and in the dense willow thickets there would occasionally come faint

wisps of smoke from some bootlegger's still. Mostly, however, there was just a long, lone, empty green stillness. Now and then a smoke-stack or church spire would appear back of the levees and then disappear again in the dense foliage.

While the banks of the lower river as seen from a boat deck are interminably monotonous, the river itself is not so, at least for those who can read its face. The pilot on duty watches it constantly. In spite of all the help of government patrols and river services, in the line of guide lights and posts, the river must be read by those who work on it, just as it was by the rivermen of Mark Twain's day. A little floodwater on one of its tributaries and it becomes an uncertain matter even for the most powerful of modern boats. Pushing their barges ahead, the pilots have to watch any change of current which might by sudden pressure break their barge couplings.

Going down-river a little below Vicksburg, one of the pilots of my boat pointed out what was to me an insignificant drift of current around the inner side of an island. "We'll have to look out for that on the way up," he said. Coming back from New Orleans some ten days later with a big load of barges we struck the lower edge of this island in the evening. Although the pilot on duty had a powerful searchlight playing on the water and was expectant of difficulty, he was not prepared for the extent of change in the current. The head of the tow was hit suddenly by an oblique rush of water. A cable up front snapped like a cannon shot and was whipped up against the side of an empty barge with drum-like reverberations. The tow began to swing out of line, shaking and banging the barges against one another. Reversing his engines the pilot backed rapidly downstream and maneuvering this way and that got his barges again in line. It was neat work. After a new cable had been adjusted, the tow was swung out in the river and made to take the current head on until its worst rush was past and the regular channel could be again used.

The pilots of the towboat were good fellows. We sat around and

jawed at night behind the slanting rays of the big searchlights. When the after-dinner chores were finished, we'd have the second cook up from below and get him to sing and play on his French harp. The second cook was a rotund little Negro, very black. He was full of religion and would reprimand us frequently for our language. He was proud of being invited to the pilothouse and got so uppity down below that in the interests of discipline we had finally to shut off his visits. The chef couldn't handle him in his pride.

I had a good, easy, fat-productive time on this boat, but coming up the river I got restless and had myself put ashore in Arkansas, where I left the river and made for the hills.

Several years before my towboat trip Bill and I (the same Bill who tried to eat bacon gravy for mush) were bumming around the South in a station wagon which we had fixed up as a sort of combined kitchen, bedroom, and workshop. Interested at the time in my projected history of the United States, I was looking for some of the old river towns where I might get next to authentic first-hand material. We had heard of one down below Natchez where the New Orleans gamblers used to transfer their activities from upstream to downstream boats. When we found the place it was battered, decayed, and overgrown with weeds. It was also seven miles from the river, which in the passage of years had changed its course and left the town dry. Great sycamores were growing where the Mississippi had once run.

There was a rough dirt road leading from the town through the woods to the river front and Bill and I decided that as long as we were down this far we might as well run over and see what the riverbanks of the region were like. The road was bad and it took us some time to get to the water. Just as we arrived and were starting to investigate the banks we were hit by a rip-roaring southern cloudburst. A torrential, smashing rain turned the dirt road under us into a wallow of clinging mud and stuck us fast.

The land, made of soft river deposits, sucked in the rain like a sponge and every movement of the car wheels sunk us deeper and deeper. For four days we couldn't move.

We made the acquaintance here of a shanty-boat fisherman, an old fellow who had come down the river from Iowa. Caught in big floodwaters many years before, he had moored his boat in this locality. When the flood began to subside, he had found himself shut off from the open water by a mass of broken tree trunks and was stranded. He said he used to try to get his craft back in the river but finally gave up the thought and just stayed on. He lived in this lonely place with a cat, a dog, and a Negro man who like himself was alone in the world, without land or a woman. In the narrow cabin of the stranded and rotting shanty boat the two lived with their pets. They were like affectionate brothers. They ate together and worked side by side. The only evidence of any difference in their status was that the Negro addressed his friend as "suh"—"yes suh" and "no suh." In the evening they sat side by side, smoked their pipes, petted their animals, and looked at the river. They fished and sold their catch to the passing towboat cooks, who knew of them, and to a fishing craft that came down from Natchez occasionally. I doubt if they ever bathed, for they were much afraid of the river. When Bill and I proposed taking a swim in it, they rose in emphatic protest.

"They wuz alligator gars in the river hyar," the Negro said, "ez big ez men, who'd like as not bite you leg off'n you, 'fore you tek two stroke." We didn't believe this altogether but it put a sort of fear in us and we remained dirty and sweaty rather than take a chance.

We ran out of food, and getting tired of catfish morning, noon, and night had the fisherman's man Friday guide us over a path which led through the dense moist woods to a Negro settlement a mile or so away. We wanted eggs and a couple of young chickens.

The settlement was interesting. In a flat bottom, long rows of cabins were perched high on stakes. They had fences of dry brush

about them and in the enclosures turkeys, pigs, and chickens ran. The Negroes were very clean. I couldn't make out what were their relations to the land they occupied, whether they were tenants or just squatters. The only answers to my inquiries were, "This here 'n's my patch" or "That 'er 'n's his'n." This referred to corn and bean patches. The shanty-boat fishermen told me when we got back to the river that the Negroes didn't own the land but "just lived thar." He knew nothing about their real status. He said they had survived many floods in their high-perched dwellings where with the advent of high water they'd gather all their possessions, their fowl, their pigs, cats, dogs, and children.

In the evening we were sitting around talking with our shanty-boat friends about the Negroes when a steamboat came up the river. The advent of this boat turned my mind completely away from the settlement and the junglelike existence of its inhabitants. Before the steamboat hove in sight blowing its hoarse whistle for the river bend below, the fisherman's Negro rose suddenly to his feet. "Dar's old *Tennessee Belle,*" he said. "She ain' ben up hyah long time now."

I looked out over the river. In a few minutes, around a point of woods came an old packet bucking the current and belching smoke in the path of the setting sun, a perfect picture from the past.

"Cotton shippin' now," remarked the fisherman. It was early September.

I had a sudden memory of the old days when the packets came into Memphis loaded to the tops of their pilothouses with cotton bales. When a little boy, on a visit with my Dad to Tennessee kinfolk, I had seen the Memphis landing covered with thousands of bales brought in by the river boats.

"Do they carry cotton by packet any more?" I asked.

"*Tennessee Belle* carries it," the fisherman said. "They's a landin' or so below here a ways, on the Louisiana side, where she gits big loads sometimes. They ain't no railroads handy to this side of the parish so lots uv the planters over there ships to N'Urleans by water."

Bill and I looked at each other. We both had the same thought. Here was something we shouldn't miss.

"What's the names of these landings?" I asked.

The fisherman studied a little. "Red River landin' is one of 'um," he said. "It ain't far below here."

"We'll go tomorrow if we can get the car out," I said to Bill.

We did get the car out with the help of a mule from the Negro settlement. It took a tremendous lot of heeing and hawing to make the animal pull our outfit out of the mud and up to hard ground, but it was done and we made our departure.

Some fifty miles below, we got over the Mississippi on a ferry and started to hunt for our landing. The fisherman had told us it was just below his own location but we ran all up and down two parishes and for two days before we found it. It was an isolated spot below the mouth of the Red River—the Red River of the South this time. The landing was about a quarter of a mile out from the levee and slanted abruptly down to the water. A few cotton bales were on the ground near a shack. A Negro boy coming up from fishing told us the *Tennessee Belle* had just gone south. We were much disappointed, assuming that the boat, in our two days of running about the country, had done her loading and had returned down the river for good. The boy, however, relieved us on that score. He said the steamer had not stopped at the Red River landing. He couldn't tell us whether she would come back or not. But as there were cotton bales about, which had to be carried away somewhere, Bill and I decided to camp and wait awhile. The next morning a truck of bales came over the levee. They were piled on the ground and a tarpaulin drawn over them. The truckmen told us the *Tennessee Belle* would take the cotton but they didn't know when.

I was determined to make drawings of a riverbank loading, a rare event in these days, so Bill and I settled down to wait out the boat. We camped a whole week. The land from the levee to where it broke down into the water was flat. There were thorn trees

covered with Spanish moss scattered here and there. They made a thick shade. We set up housekeeping under one of them.

Shade or no shade, it was hot. Our butter melted. Our bacon turned into a rancid grease spot. We were afraid our eggs would walk off. Our corn meal developed a case of worms. The river water—all that we could get to drink—was at blood temperature. Things got desperate, so on the morning of our third day Bill drove to a town about fifteen miles back off the river and got a new store of provisions and three hundred pounds of ice. In the meanwhile I dug a deep pit in the soft ground. I cut right through the roots of a thorn tree with shovel and ax, so as to keep the pit as much in the shade as possible. When Bill came back we put the ice in the pit and covered it with sycamore and dock leaves. We laid our provisions down there. We filled a bucket of water and put it down there also. The hot muddy water settled and got cool. The food stayed good. We covered our icebox with more sycamore and dock leaves and put a blanket over it.

The problem of food and water solved, time was on our hands. There was absolutely nothing to do. Neither of us fished nor did we have the wherewithal. Back of the levee there was a row of nigger cabins, whitewashed shacks each with its banana tree and "houn'" dog. The pickaninnies would lie on top of the levee and look over at us and laugh. We could see their braided wool and their bright eyes behind the grass and weeds but when we approached them they fled. I wanted to make drawings of them but even when I put a shiny dime out on a stump at the foot of the levee they would take no chances with us. I made some sketches of the houses they lived in, but the grown folks like the little ones would go indoors when either Bill or I came near. Negroes are generally friendly but our camping out on the levee for no apparent purpose generated suspicion and made this bunch very shy. We didn't force the matter of acquaintance.

Nearly every morning a truck load of cotton bales came to the landing. After its departure the place was one long silent emptiness.

Bill and I, though we remembered the alligator gars, took to venturing in the river. It never cooled us off much. Most of the time we sat naked in the mud and stared at the opposite bank. Nothing ever happened. At long intervals in the bend below we'd see smoke and get all set for the coming of the *Tennessee Belle*, but it always turned out to be a towboat pushing empty barges upstream. We saw one long wood raft but it was far on the other side of the river. We got bored and were on the point of leaving several times. I couldn't, however, give up the chance of making drawings of the unusual scene promised so we hung on.

After midnight of our sixth day we were awakened by the whistle of a steamboat close inshore. We jumped up, slipped on our pants, and rushed to the landing. There, for sure, was the *Tennessee Belle* edging in.

"God damn it," I thought to myself, "she's going to load in the dark, and after waiting around here all this time I won't be able to make a single drawing."

The boat pushed close up and a gangplank was run ashore. Two big blacks carried off a packing case and rolled it up to the shack by the piled cotton bales. They went back and the plank was hauled in with a rattle of pulleys. With a throaty blow the packet shoved off and pounded on up the river, cutting the night before with her searchlight. We didn't know what to make of it.

Another day and night passed. Then early in the morning of our eighth day a whole line of wagons and trucks arrived with cotton. The negroes from the cabins behind us came out and sat on the landing expectantly. A lot of cars with white men showed up. About ten o'clock the *Tennessee Belle* came down the river. At first I thought she was going to pass again but a little below us she turned and made in toward the bank on a long slant. Flipping her stern paddle she eased gently to the landing. Lines were put out and made fast. I went to drawing immediately.

Negro roustabouts piling over the gangplank from the lower deck of the packet came shouting and whooping up the landing.

With grabhooks they began maneuvering the cotton bales down the steep slope to the boat. This was tricky business, for cotton bales are heavy and there was but one man to each bale. The Negroes, naturally well co-ordinated, handled their weight skillfully and no bales got away to roll in the water. The *Tennessee Belle*'s captain in white suit and big old-style black hat stood on the upper deck by the pilothouse and watched operations. The mates directed the disposition of the bales below.

Bill and I were all around the place drawing as fast as we could, trying to get all the details of the scene. We finally attracted the captain's attention and he beckoned us to come aboard. We jumped at the chance and scrambling over the gangplank made our way to the upper deck. We were greeted with courtesy. The captain was a friendly old man. We told him the story of our week's waiting to make pictures of his boat. He was much pleased.

"Ah'm the last carryin' packet on the lower river," he told us.

I made his portrait. He liked it and chuckled slyly. Later, when I was going ashore to take another crack at the loading operations, he sent his first mate, one of his sons if I remember rightly, to tell me that he would be pleased if my friend and I would have dinner on board at one o'clock. Accepting, Bill and I went up to our camp before dinnertime and put on clean shirts. We saw a considerable number of well-dressed men approaching the boat from the levee and judged that they also were coming to eat.

The dinner turned out to be a celebration in honor of the cotton planters of the parish who gave their carrying business to the *Tennessee Belle*. It was a veritable feast, a magnificent display of Cajun cooking, rich, hot, and spicy. In the old main saloon of the boat, surrounded by rows of cabin doors to which the gilt of more splendid days still clung in broken patches, a long table was set up and covered with white linen. About this table the planters seated themselves. Bill and I found places.

Tall glasses of what I took to be iced tea were set before us. I reached for the sugar.

"Hold on, son," said an old gentleman next to me, "you'd better taste it fust. It's sweet enough."

I tried it. It was not tea but wine, and wine with a considerable kick.

I said to the old gentleman, laughing, "Doesn't the captain know that alcoholic liquor is under prohibition in this country?"

"Son," replied the old man, "we live undah the Code Napoleon down heah. That code does not attack ouah digestions."

The dinner was a regular Rotarian affair with speeches and compliments. It lasted a long time and Bill and I as well as several of the planters got sort of boozy with the wine. In the afternoon when the loading was finished the guests went back to land and the captain and his crew prepared for departure.

Bill and I watched the old packet pull off the landing and make a wide turn down the river. The captain and mates waved to us. We watched the boat until she slipped out of sight around the river bend, her smoke trailing lazily like the last fringes of a fading memory of the past.

I read in a St. Louis paper last year that the *Tennessee Belle* was wrecked and went down below Vicksburg.

Years ago, before the railroads sent their prongs into every nook of the country, all the rivers of the Mississippi valley were regarded as potential deepwater trafficways. Towns, playing up their land values and bidding for settlers, made much of the fact that they were on or near a river. It made no difference whether or no this had ever been traversed by anything larger than a skiff. To the speculators who were whooping up values, the mere existence of water was enough to call their town one of the coming centers of western river traffic. There are many stories of the most lunatic attempts to drive steamboats over sandbanks and shallow rapids in order that real-estate connivers could offer a navigable river as an inducement to prospective purchasers. With the advent of the railroads this struggle was abandoned and the illusory hopes of the

backwater towns that they were to become centers of deepwater traffic were forgotten.

However, in spite of the fact that most of the smaller tributaries of the Mississippi could carry steam traffic but a few miles above their mouths and had no true prospects of ever becoming deep channels, they did serve as arteries of trade and travel to an extent almost unbelievable today. At periods of high water, rafts, keelboats, and flatboats were poled, pushed, and dragged almost to the mountain sources of streams. Both in the Appalachians and in the Ozarks there are many towns which, in the past, depended wholly for their outer-world supplies on a stream that today would not be regarded as fit for the transportation of saw logs. The rivers, undependable as they were, offered frequently the only path to the outside world over which the cost for hauling goods was not so great as to eat all the profits coming from their sale. River transportation, though long and difficult, was better than that of the roads.

Besides the regular haul of merchandise in respectably large lots, a great deal of peddling went on up and down the rivers. Whole families made a living trading or selling light goods, some of which they purchased on speculation, some of which, like ax handles, baskets, chairs, and medicinal herb concoctions, they made.

There was an old Ozark hillbilly, with whom a few years ago I had many talks, who maintained a sort of river business up to the very present. This old fellow would spend six or eight months digging bits of lead out of the Arkansas hills. When he had enough of the ore, he'd build a raft on the upper reaches of the White River and with a couple of skiffs in which he loaded his family and dogs set out downstream running clear to the Mississippi trading and selling. His lead was cut and rolled in small bits for shotgun shells or used in hunks by fishermen for their lines and nets. The old boy certainly didn't make much of a living by his trade but he furnished his family with enough hardship to make them thoroughly appreciate the difficulties of life. On one of his trips

his whole gang, including a lot of little children, were taken with malarial fever. They camped in the woods and the old hillbilly with a little quinine and a lot of stewed herbs nursed them all back to health. He thought nothing of this, regarding hardship as a matter of course for river life.

Also a matter of course for the rivers are the thieves who infest their backwaters and who steal anything from a fishing line to a boatload of merchandise. Outlawry on the rivers has always been a prevalent feature and it continues in many forms. The habit of turning all loose corn into illicit whisky is as much a river practice as a hill one and is unabated today. The "river mule" is extraordinarily potent and many stories are told of the great ear chewings and eye gougings for which it has been responsible. Only lately I arrived in a northeast Arkansas town to hear from a friend how river mule had affected a family picnic which had taken place the day before, a little ways back in the country. A large family clan had gathered at the cabin of one of its members to celebrate a birthday. The celebration was accompanied by overliberal libations of the mule. At dinnertime a quarrel developed between two brothers about which of them was to go to the spring for a bucket of water. From hot words came blows, then a knife lunge, and then a pistolshot which lay one of the brothers dead.

Much of the romancing of the rivers is tied like that of the West to thoughts and memories of violence. Perfectly gentle people who would harm no one relish lurid tales of the waterways and have a strange lenience for their lawbreakers. Ignorant and adventurous boys of the banks run readily to irresponsible action, egged on and sanctioned by unconventional tales which are told everywhere with an attitude of admiration rather than censure. Wet Willie Ahler was one of these. People who build summer resorts and vacation nests on the riverbanks only too frequently feel the effects of the liberal property views of the river rats, who make no bones about furnishing their own places at the expense of strangers or of in-

creasing their pocket money by the sale of whatever effects of theirs may be picked up.

There is something about flowing water that makes for easy views. Down the river is freedom from consequence. All one has to do is jump in a skiff at night and by the morrow be beyond the reach of trouble. In the past this was a sure method of ridding oneself of difficulty, and fellows who had been too handy with the knife or gun or who found their children too many or their wives too troublesome could float off into a new world and begin again.

It is not only for those of reckless or antisocial proclivities, however, that the river waters are suggestive of release. Their currents sing of freedom to everyone. The thought of floating effortlessly away on running water has an irresistible charm whether or no there is any real purpose or end set to it. In *Huckleberry Finn*, Mark Twain has caught the spirit of this, and back of the adventures of Huck and Jim and those with whom they meet there is always the moving river and the promises and hopes that lie around its unfolding bends.

On the rivers of Missouri a profitable business is kept up by guides who take fishing parties on floats. This is an old and beloved sport of the country. A crowd, generally of men, get together and hire a train of flatboats and skiffs. These are loaded with tents, fishing paraphernalia, and a lot of whisky and beer which is taken along to make the fish bite. They camp at night on the sand bars.

I remember when I was ten or eleven years old I went on such a trip with my father and a group of his friends up in the Gasconade country of middle Missouri. With our goods and boats loaded on wagons we labored over the most terrible of rutty roads to get to the head of our float. We camped for a while beside an ice-cold spring which ran from under a bluff into the river. On the rocks about this spring, where I played while my Dad and his friends were off fishing, I got a stone bruise which became infected and gave me a fever, and brought the trip to an unhappy end for me.

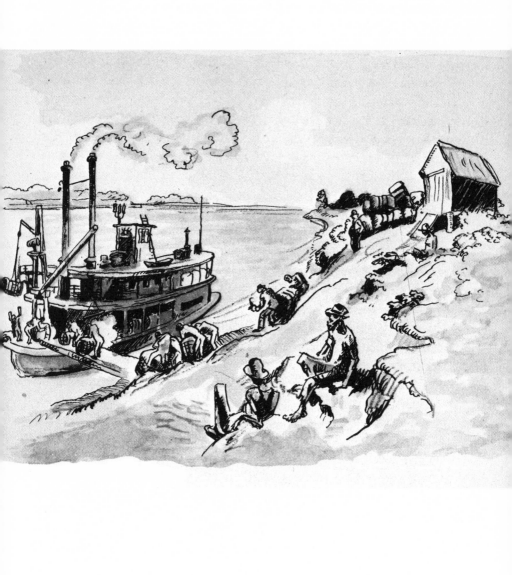

The condition of my foot broke up the party and instead of a leisurely float down the river we had to get as rapidly as possible to the railroad, where I could be carried to a doctor. There were rapids in the Gasconade and to insure my safety I was placed in the boat of one of the guides, an expert poleman who could be counted upon to keep his craft steady. But they overloaded my man with a camp stove as big as a kitchen range which shifted its place and turned the boat over in the rapids. Fished out quickly, no harm came to me. I always remember the fellow who dumped me because of his incredible cussing over the accident and because of the way his Adam's apple ran up and down his long throat as he vented his rage. I took other floats later in McDonald County and over in Indian Territory which were happier, and I learned to know the lure of running water and the immense sense of freedom given to those who yield to it.

The rivers of Missouri are often very beautiful. Many of them have their sources in immense hill springs which pour out of the limestone bluffs at the rate of thousands of gallons a minute. The water runs cold and clear for a while but is eventually muddied by tributaries from the lowlands. Muddy or not, the rivers have charm. Great sycamores hang over their banks and in the summer when the current moves slowly these are duplicated in the stream below. On one side or another of the rivers outcropping white bluffs hang and break the monotony of tree branch and foliage. To get in a skiff and row out in the middle of one of these rivers on a summer night when the moon is full is to find all the spirit of Spenser and his "faery lands forlorn." Missouri's summer moon is big and white and cuts out vivid and clear edges, but this only intensifies the somber interior depths of the tree shadows and adds an air of impenetrable and silent mystery to them. There is over these summer night waters and on the shadowed lands that border them an ineffable peace, an immense quiet, which puts all ambitious effort back in its futile place and makes of a simple drift of sense and feeling the ultimate and proper end of life.

These quiet summer rivers, however, can become in a few hours raging and fierce torrents. A few extra-heavy autumn rains and they swell in fury, sweeping great battering-rams of uprooted trees against the bridges and low-lying farmhouses. Spring thaws push them over their banks in no time at all. A few, rising at once, easily produce a major flood when they pile their rushing waters into the big streams.

At this writing I have just returned from a flood-stricken area in southeast Missouri and upper Arkansas. The St. Francis River rose under heavy Ozark rains and then the Ohio, after flooding Louisville, Paducah, Evansville, and other places, came rolling down into the protective basin below Cairo, Illinois, putting thousands of acres and hundreds of east Missouri homes under water. Description can give no sense of the dread realities of flood misery—the cold mud, the lost goods, the homeless animals, the dreary standing around of destitute people. Red Cross officials and army engineers reported crisply and with no waste of words that the flood situation was in hand and that full relief measures were functioning properly when I arrived. This was true in so far as bare physical fact was concerned. The water had ceased to rise and, though a barge of levee workers had just gone down with the loss of several lives, matters on the whole were as they should be under the conditions.

But the conditions themselves, all humane measures notwithstanding, were such as to make one wonder whether civilization had at all improved the status of the region's inhabitants above that of its aboriginal occupants. The latter could at least move away without much disturbance of their ways or destruction of their goods when the waters came up. The former must leave frequently their stock, farm implements and stored produce, but always their homes. Even if these managed to stay put, they would be ruined by the settling mud when the flood retired. Along the levees of the flooded basin I came across many little knots of somber-faced women looking at their rooftops out in the water. It is not difficult to imagine the desperate feeling of these women as they contemplated

the dreary mess and equally dreary labor ahead of them. Negro women, better conditioned to a philosophy of misery, took things easier than the white women and were capable of joking and laughing about their situation. No doubt the Army tents, which provided their flood refuge, and the Army food were for the colored women and their families an improvement on what they had been forced to leave. In fact I heard that a sergeant in charge of a relief mess had so overdone things in the matter of food that half his charges were sick from the unaccustomed richness of what they ate. The poor of the river basins are very poor and I have no doubt that they found even Army cooking far beyond their stomach's habits.

The roads of the flood country were full of movers. Wagons, trucks, and Model T Fords loaded with household goods, beds, stoves, etc., even with chicken coops full of chickens, even with pigs, wandered slowly away from the waters. Lord knows where they were going. Every once in a while seepage from under the levee would force evacuation of a house and you would see a great struggle to get animals and goods out of the rising water. I talked with the members of one such retreating family of six. They were tenants occupying a two-room shack and were leaving "this here place for good." They were going to stay with relatives in a hill county to the west until they could find a new place to work. Asking about the relative's family, I was told that it also had six members and that their house "wuzn't no bigger'n this'n." Wonderful prospects for children of the richest country in the world!

Along with and in sharp contrast to misery in the flood area, nighttime whoopee had its place. The night clubs did a roaring business, especially on Saturday nights. The Army boys, off duty, flocked into the joints, and with their proverbial attractiveness for the fair upset the run of country amours. In one of these places a young soldier, his service cap cocked at a jaunty angle over his ear, had managed—rather easily, I judge—to take possession of a curly-haired country girl all dressed up for Saturday night. He had

her over at a corner booth with a couple of bottles of beer and was stroking her neck, now and then making little accidental slips of the hand toward her breasts. Somebody put a nickel in the slot-machine phonograph, which furnished the music for the club, and the pair got up to dance. As soon as they had vacated their place, a big slouching country boy had had been eyeing them with obvious disapproval took possession of one of the seats in the booth. When the music stopped the soldier returned with his girl. "Don't you see them bottles o' beer," he said, sticking his face truculently out at the country boy.

"Yeah, Ah see 'um," came, with pretended indifference, the reply.

"Them bottles means this place is occupied," said the soldier.

"Yeah, who said it?"

"I said it and you git out o' there, pronto."

"You gonna make me git out," said the country boy, lounging back in his seat and raising two immense feet shod in metal-heeled boots. The soldier looked at the boots, at the long legs half-doubled behind them, at the narrowing eyes of the intruder. The girl looked also and plucked at the soldier's sleeve. She whispered something, probably a warning. But the soldier had started out as the forceful male and he didn't like to back down.

"Get up from there," he said, "I'm gonna show you something."

"Come an' git me," drawled the country boy.

The soldier moved his hand forward. One of the big feet rose a little and he drew back. He'd probably heard some stories of Missouri stomping and the prospect of coming into immediate contact with it was too much for his valor. The country boy caught his fear.

He straightened one leg out, his boot touched the soldier's rear. "Come on, just set a little on that, feller," he drawled, "just set a little an' talk to yer gal."

The soldier's truculence evaporated into loud talk. He gave up his seat and the country boy drank what remained in his beer bottles, while the crowd laughed. There was just a handful of soldiers

in the place or this little altercation might have had more violent consequences. As it was, the young soldier without support swallowed his pride and left. Later I saw the girl dancing with the big country boy. She looked, however, a little sad.

Nighttime gaiety in the flood country was pretty boisterous and loud, as if to make up for the silent misery out near the waters. It lasted late and though I saw but one actual fight they seemed to be always in the making.

The fight I did see offered a pretty picture of familial affection. A young fellow, mean with liquor, tried to stab his brother, who, saved by a leather jacket which turned the knife, promptly knocked him out.

Towns in the flood area endangered by the possibility of levee breaks had much the appearance of the deserted mining camps of the West. In New Madrid, Missouri, the windows of stores were boarded up and in some stores that were still open the goods were set up on high platforms near the ceiling. The river side of New Madrid was made of little islands of mud sticking out of lakes of seeped water. There above the dilapidated shacks and broken-down stores the levee rose, and above that as if ready to come down at any moment were the hulls and tall smokestacks of the government river boats. High water in the levee country produces a very topsy-turvy effect. It is difficult to get accustomed to seeing boats riding around above your head.

River exploration and travel have from the beginning of this country offered their most suggestive appeals in the downstream voyage. The particular lure of the float, mentioned before, has apparently always existed. For the Jesuit Fathers of New France who first recorded the white man's travels on our rivers, it was the downstream voyage which produced the most literary fervor. Accounts of theirs dealing minutely and glowingly with experiences on their way down the big rivers are cut to short statements of bare fact on the way up. Even today shanty-boat men, river roustabouts, and

poor dwellers on the flood banks have a kind of nostalgic lilt in their voices when they speak of down-river places. I have had no experience with people of the northern parts of our streams but from St. Louis and Cincinnati southward they look inevitably down the current.

New Orleans is the riverman's Mecca. Perhaps it is because New Orleans was for so many years the main outlet of Mississippi valley produce and that overglamorous stories of its civilized wonders, brought back by traders, were told on all the riverbanks, but whatever it is that provides appeal the southern metropolis still holds the imagination of river people. It has the largest shanty-boat colony in the country. For years these people, under the lure of the city, have floated down to it on the Mississippi. Unable to get back up the river without power they have, even with dispelled illusions, been forced to stay there. For steamboat crews, black and white, the place is a very haven of joy.

New Orleans is a great whore town and gamblers' resort. For ignorant river boys on the loose with a pocket of pay it offers the ultimate in gaiety. The city has always been lenient with her underworld and in the days of Lafitte, the pirate, even introduced its concerns into the affairs of the best people. Here of course the pirate and his companions with their comprehensible Latin ways were supported in a sort of mocking protest against Yankee meddling and moral hypocrisy. But open gambling and the flaunting of sexual divertisements have always been traditional in the city.

It must be said of New Orleans, however, in great contrast with other southern towns, that she takes her vices with an air. She is a fine lady and if her skirts are a little dirty she makes up for it with perfumed gowns and graceful gestures. Her nickel-a-dance halls are quite truly gay. The hard-faced but charming little sluts, who for the benefit of their pimps take the up-river boys, the sailors, and outlying parish sports, have manners and voices that are not found in other southern underworlds. Though viciousness is thoroughly developed in New Orleans, there is laid over it somehow

the grace of Latin friendliness and the flavor of catholic understanding. It is not repulsive as in the cities of the upper South, where a hypocritical Bible-belt denial of its existence, like the hard crust over a carbuncle, makes it fester and ferment into a stinking poison. The vice of New Orleans has been shown to me not as a snickering secret but as an open affair, recognized by everyone. Her periodic cleanups have been made with rakes of very widely set teeth and seem to have affected but little the normal run of her affairs.

Besides her world of vice New Orleans nurses also a Bohemia where the piquant and picturesque are cultivated. In the old French Quarter artists, writers, and southern girls with advanced notions of feminine liberty set up studios, contemporary clubs, and bookshops. These sanctuaries of the higher life exist in close proximity to other sanctuaries which are anything but high. You step into a little hole-in-the-wall under a porch of lacy ironwork and a young lady with brightly painted lips asks graciously what you will have, as she fingers a display of magazines and intellectually titled books. "We have the very best books in the city," she'll say, with just the proper degree of pride. Right around the corner you enter another hole-in-the-wall and another young lady with brightly painted lips will also ask you what you will have, while she fingers a blind of Coca Cola bottles. "Nicest girls in town, boys," she'll whisper, also with a certain touch of pride.

Elderly ladies with a yen for curios, accompanied generally also with a yen for tourist cash, run antique shops by the dozens. They put on teas and capture visiting celebrities, who have to bow and sweat and live up to their reputations. There are cliques and clans of superior people and warring battalions of convinced intellectuals which seem quite out of place in the easygoing town with its spice- and banana-smelling streets and its languid speech. The city's nests of refined cultivation are limited, however. It is easy to escape them. Walk around the corner and they are gone and culture becomes what it really is, a way of living, rather than a precious juggling of excerpts from half-read books.

Creoles, Mexicans, Portuguese, Italians, Filipinos, sea rovers, and American river wanderers mingle their various concerns, languages, and rivalries in the narrow streets of the old quarter. The Negroes with their calm, leisurely gaits give a tone of nonchalant ease to everything. Parties, ceremonies, all kinds of marriage festivals abound. I went to a prize fight one night, or rather to a series of them, for there were literally dozens of bouts. All races were represented in the ring and out. Young mothers, babies at breasts, came to egg on their kinsmen and screamed for blood with the best of the fans.

A few years ago, before the city fathers, under the pressure of business enterprise, put a modern dock in the place of the old river landing below Canal Street, the packet men of the lower river gathered there. The old boats which still survived, like the *Tennessee Belle*, tied up there and their crews and roustabouts, laughing and ragged, carried on crap games behind stacked bales of goods. All this is now gone. Steel and concrete shut the river from the town. From nowhere over the yellow water of the Mississippi is it possible to look into New Orleans and for the majority of the city's inhabitants the river, unseen, does not even recall a memory of its old significance as the artery of half a continent. The men of the river still look to New Orleans, but New Orleans, Pan-America-minded, looks southward to the Gulf and the sea. She has forgotten of what water she was the queen.

West of New Orleans, stretching out in curling lines from the lower Mississippi, are bayous, lakes, small rivers, and canals. Amethyst water plants line their shores. Little towns sunk in rich and heavy foliage rise on their sides. Old vine-covered and flower-encircled houses give an air of permanence to these towns. Out beyond them lie the sugar plantations and then farther on the rice fields. There is a great peace over this land. Misery, human misery and poverty, which is everywhere, is there also, no doubt, but it is not in evidence. People speak slowly in the dialect of the Cajuns.

Back under great live oak trees old monasteries and religious schools stand, their massive colonnades a rebuke to time. They seem older than they are.

As you run west this country changes from river country to prairie. To the north it merges into great pine forests, or rather what were great pine forests. Now there are unending acres of stumps encircled by belts of pine. In these belts the ground is clean and sweet-smelling. As the pine countries run toward the rivers, however, the ground gets muddy and black and soft and turns into swamp underfoot. Deadly-looking moccasins crawl around there, fat and evil. The swamplands that adjoin the rivers would seem to be the last places on earth where people would live. But they do live there, in rickety shacks and crazy cabins. They eat yams, pork, corn meal, and fish. What they do for a living I don't know. Occasionally there are jobs to be had in lumber camps, but most of these people, malaria-bitten and lazy, neither could nor would take on a day's heavy work. The only thing I've ever seen them do is fish. Out in the middle of gruesome and unearthly cypress swamps they sit in skiffs that are as thin as the lily pads growing about them. With willow poles in their hands, a can of worms beside them, they are immobile for hours at a time.

Nothing on the face of the earth has a more forbidding beauty than a cypress swamp. The trees with their fat curling bases rise out of the dark water like enormous fungi. As a rule they have little foliage, and that is transparent, fragile, and lacy. From their branches long whiskers of moss hang in gray veils. Sometimes a dead tree stands up stark, like a piece of white sculpture.

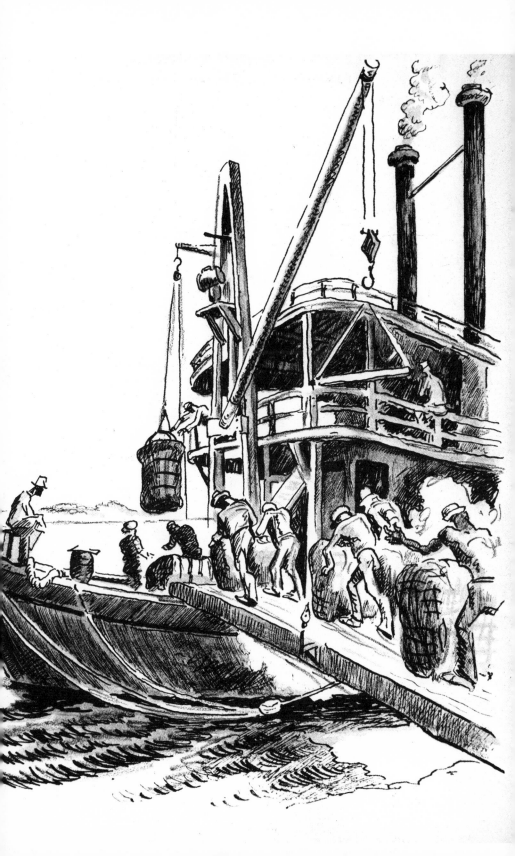

VI

The South

A SCREECHING yell split the hot dead silence of drooping leaves and was echoed in a clamor of excited voices.

"Maw, Maw, git th' sheriff, Paw's a-fightin'," and down the street a gangling boy went sailing, dragging a little baby behind him. One hand had the baby, the other went round and round at the end of his outstretched arm like a rock in a slingshot.

Paw was a-fightin' all right. Surrounded by a bunch of squealing women, two big hulking men, red-faced and furious, were flailing the air with great swings. One went to the ground, hit. With a splatter of blood on his mouth, he rose, grasping a big stone. His opponent reached instantly for a gallon jar that stood half-full of white corn liquor on the porch steps near by. The men stood irresolute for a second facing one another, blowing hard, sensing the possible deadliness, the finality of their next move. The fellow with the jar jumped suddenly back, and transferring his glassware to his left hand reached down into his overalls. There was a chorus of concentrated screams, "No, no, don't do it!" and a rush of women around him. The man shook them off cursing at the top of his voice.

Bill stepped on the gas and we made off. We didn't want to be held as witnesses to an affray that was beginning to look murderous.

On the edge of a little Georgia town we had stopped to consult our maps. Along each side of the shaded street were rows of little houses almost identical in shape. They were raised from the

ground on posts of brick. Miniature porches were tacked onto their corners. Hanging over them were big trees whose leaves were beginning to droop after the long hot summer. In the yards of the houses patches of wilted and drying grass alternated with bare spots of red earth and loose stone. The lower boards of the houses, once painted white but now fading to gray, were stained with the red earth blown from below in dust, spattered from below in times of rain. It was Sunday and here and there people sat on the little porches, the women in their Sunday clothes, the men in clean overalls.

Around the house before which Bill and I had halted, a considerable crowd was gathered. They sat on the porch and in the yard. They were mostly women and children, but holding the center of attention were the two big men who in the next minute were to go into battle. They were arguing boisterously, laughingly slapping each other on the back and knees, meanwhile. They took frequent swigs from the gallon jar of "corn" on the porch beside them. The women around were laughing. Bill and I noticed them as we put our maps away. Suddenly rising from mirth cut abruptly short by words that we couldn't hear, the men started slugging one another. They were tremendous fellows, both well over six feet tall and proportionately big around. They fought like prehistoric monsters with a lumbering viciousness.

A crowd of men and grown boys were pitching horseshoes in the shade of a big red cotton warehouse. I could see them from the window of the one-horse hotel where I sat resting my feet in a bowl of water after a long sweaty walk. They were playing in a sort of passageway between the warehouse and the town jail. On the bars of the jail windows above them were a number of black hands which moved up and down. Because of the angle of the jail, I couldn't see the faces behind the bars, but I could see the hands and I could hear mellow Negro voices come out of the windows in laughing commentary on the game in progress.

A horseshoe hit the iron of one of the stakes and settled neatly around it. A broad rich voice came out of the jail, "Tha's a good 'un, Mistah Bob."

As the game went on Mistah Bob kept making ringers and each time he did an applauding laugh came out of the jail.

When a final neat shot brought its echo of approval from the barred window an irritated voice rose from the crowd.

"Shut up, yuh yellow son-of-a-bitch."

"Aw, don' git mad jist cause Ah'm a-winnin'," came another voice.

The first voice again, "Mebbe you' a-winnin' but Ah ain' gonna have no yellow bahstahd of youahs a-commentin'."

The crowd laughed. Then the winner, "Aw, leave the niggah alone, he ain' mine no-how. He's too ole." And then as the crowd laughed again, "Ef 'at yellow boy wuz a little longah in the nose I'd say he wuz youahs. He sho' do look lak you."

Then in a flurry of dust and amid the yells of the crowd, I saw the two disputants rolling over the ground, their legs and arms flying. The crowd closed in. Drawing on my boots, I rushed downstairs to get a close-up of the fun, but by the time I reached the playing ground the sheriff had also arrived and was standing between the fighters, who turned out to be, now that I saw them close, full-grown men. Their faces, red with exertion and rage, were beginning to look sheepish.

The sheriff said to one of them, "You go on home, John. You ought tuh be ashamed of yo'self with Sally a-layin' sick in bed."

The crowd dispersed.

"Just the whisky, and a half-glass of water," I said. And taking my drink I went with my friends out of the little barroom to a table on the porch of the swanky country club. The barroom was furnished with tables but it was hot and crowded in there. Besides, a group of well-dressed and dignified southern gentlemen

were shooting dice all over the bar, relaxing after the long day at their offices in town.

My friends and I sat on the porch and looked out over the clean grass of the golf course, where a few players still walked about with their sticks in the approaching twilight. A handsome ebony-black Negro boy came out and turned on the porch lamps. Some rather overelegant southern ladies were playing bridge at a table a few feet away. Back of us, we could hear the bounce and click of the dice in the barroom. Then, with the unexpected sharpness of a bursting firecracker in a church, a roar of high controversy broke out. There was a tinkle of broken glass and from the barroom door came a wave of expostulating voices, "Gentlemen, gentlemen, this will nevah do. Remembah youah positions, gentlemen. Remembah, the'ah ladies present."

Looking around I saw two portly purple-faced men apologetically shaking hands. They were still ruffled. It was plain that their handshake was only a bow to convention and no sign of regained love for one another.

The faces of the ladies playing bridge were classics of horrified delicacy.

There was a camp meeting in progress near a town on the borders of two southern states. Across the street from where I was staying stood a row of unpainted, disreputable-looking tourist cabins. The camp meeting was just a short distance away and a lot of the people who had come to it were set up in the cabins. They were poor people. Their cars were battered and the blankets and quilts which they had hanging around to air were dirty. After supper, before night services of the camp meeting, the menfolks went over to town and the women washed clothes and towels and sheets in tin basins and buckets. They got their water from a pump out in front of the cabins.

Two young women with basins in their hands made for the pump and reached it at the same time. Both drew back a little

with polite gestures. Then both stepped forward and simultaneously grasped the pump handle. There was a sort of laughing struggle, then one let go. She said something at the same time in a low voice. I didn't hear what. The woman who had the pump handle looked up. She had stringy blonde hair and very pale blue eyes. Leaning forward she pumped a basin of water and without a word threw it in the face of the other.

The recipient of the water spluttered and blinked a second or two. Then with a squeal like a wild mare, she leaped on the stringy blonde. For a few furious seconds the pair stood toe-to-toe and slugged each other like men. Then the blond's hair got within reach of the other's hand. She grabbed it and started to jerk and twist, slapping and scratching with her free hand.

"Fight faih, fight faih, yuh bitch!" screamed the blond, digging her hands into her opponent's breasts.

The doors of the tourist cabins swung open and a flock of women and children jumped out yelling. A couple of big boys coming from behind one of the cabins grabbed the combatants and separated them. They'd had enough and broke easily. They stood back and berated one another with squeaky hysterical voices.

"Yuh ain' fitten to come to no meetin' of the Lord's."

"Yuh ain' fitten yuhself. A duhty 'hoah and ev'ybody know it."

They began to cry and were led back to their respective cabins. During all this I stayed safely across the street. I took little walks up and down waiting to see what would happen when the men-folks should return from town. I expected more fighting from husbands or brothers. When the men did come, there was a lot of serious discussion but no hot blood was raised. After a while the people began to trail over to the camp meeting grounds called by the mournful hymns of the southern poor. I followed them. As I went by the cabins I could hear one of the women still sobbing.

Here are four examples of southern irascibility. I could supply others, some involving people who are good friends of mine, some

seen from the outside as three of those above, some simply heard of. The four cited will suffice for the moment. They show plainly the chip that is so frequently on the southerner's shoulder. Almost everywhere you will find that chip and it is impossible to tell what accidental circumstances will knock it off. You never know, down South, when you are going to say something that will be offensive and which, though it may not occasion physical violence, will turn people away from you.

The southern temper is a strange thing. It is extraordinarily touchy but it is not passionately hot like the tempers reputed to Latin people. In spite of its readiness to flare, there is a kind of frigidity about it. It is the outcome not of hot blood but of a kind of fury of pride. Because of this pride, strange and incomprehensible attitudes toward themselves hang in the minds of southerners like brittle icicles to be broken by the slightest jar of a word or gesture.

Southern women are great gabblers. They talk incessantly, gesticulate, and explode in enthusiasms, but like their more reserved menfolks, they have highly strung sensitive souls which respond nervously and hysterically to the slightest awkward touch. Some responsibility for this touchiness may be traced to the Civil War and to the defeats, losses, and outrages which the South suffered at the time. Well-to-do people, habituated to positions of importance in southern society, had frequently nothing left but their pride when the Union hordes were gone. This they nursed and coddled inordinately even to the point of passing it on to those charming but highly self-regarding descendants of theirs (or claimants of descent) who paraded in the chorus lines and posed around the studios of New York just before the World War.

But it is not only among descendants of old southern plantation aristocrats that pride is sustained in the South. It is just as strong with the new go-getting business class, for the majority of whom the most venal work of genealogists would provide no very aristo-

cratic background. Further, it is a characteristic of the average southern dirt farmer and even of the lowly white sharecropper. It holds a place also among those reputed to be educated and informed. A few years ago on a southern lecture trip, I spoke rather disparagingly of a mural painting which decorated a hall in a certain well-known monument to the Confederacy. My disparagements, unavoidable because of some pointed and provocative questions, were given as gently as possible, and I thought with a proper acknowledgment of the value and importance of the mural's theme. The next day the whole press, not only of the city where I spoke but of the state, rose in a body to assail me with editorial comment in which I was treated as a bumptious and impertinent Yankee upstart who had put his meddling feet, unasked, on sacred ground.

The southerner colors all his interests, his concerns, habits, and belongings, with a furious sense of their rightness. Economic powers held by businessmen in the South are even more readily regarded as God-given prerogatives than they are in the North. This is saying a good deal but I think by and large it is true. Business go-getterism reached the South late. It has never spread so completely as in the North and Middle West or subordinated yet the better part of the whole population to its psychology, but where it has developed it has borne fruits of attitude which will be hard to handle when any serious attempts are made to set up more equitable economic arrangements for the underprivileged of southern society. Business practice, once looked down upon by gentlemen of the South, has redeemed itself and been made respectable by frequent grafting from the heavy growth of southern pride. This pride, as indicated above, makes "all that is mine" incredibly precious and above all criticism, open or implied. It makes of a suspected critic, or of one who has inadvertently commented to the apparent disadvantage of someone's situation, holdings, or beliefs, a deep-dyed malicious scoundrel. Assaulted southern pride was behind the incidents recounted at the beginning of this chapter. It will be something to

figure on in any administration's blueprinting of the southern future.

The green of the cotton plant leaves was slightly bronzed about the edges. The stalks stuck out with dry angular jagged turns. The pods were full, bursting with white fluff. The ground under the September sun was a bright gay pink color. It was cut and criss-crossed with narrow purple shadows from the cotton plants and with big shadows thrown from the bodies of the pickers. The field stretched out a long ways. A few feet from where I stood, the pink ground was lost in a spotted canopy, iridescent in the heat, of green, bronze, and fluffy white. Far away, beyond the field's end, a clump of dark tall pines stood against the sky. Behind me was the over-seer's house, a rambling affair of creosoted boards underneath which the chickens walked and the dogs rested. On behind the house, in a little depression of ground, a number of nigger shacks made a gray battered line. To the side of them were the barns and stables. Over the barn lot fence the plantation mules looked humorously and wisely on the world. Standing by the overseer, a kindly pleasant southerner, I was making drawings of the cotton pickers, men, women, and children, who, bending over the white-mouthed cot-ton pods, dragged their long canvas bags on the ground as they went deftly from plant to plant.

"These hyeh ah good wukkuhs," the overseer was telling me. "Ah've nevah had no bad trouble with 'um. Time uv th' Wah lots uv ouah niggahs tuk to goin' Noath to wuk aroun' Chicago. Lots uv 'um wuz bad niggahs that went up theah. They stayed. We wuz glad to get rid uv 'um. The good 'uns ah comin' back nowadays, back home. We got all we need but when a good niggah come back from Chicago, we tek an' fu'nish 'im agin. They's comin' back con-sidahbly now. It's goin' a come a time when they'll be moah nig-gahs then we kin tek in."

"What happens when the bad ones come back?" I asked.

"Oh, they genahlly ends up in the chain gang," the overseer re-

plied. "It's putty hahd to know what to do with niggahs when they git uppity. But the niggahs roun' this place has always ben putty good. No, Ah've nevah had no bad trouble with 'um," he concluded.

It is impossible to represent this middle Georgia overseer's dialect. It was not Negro, as the above attempt would indicate, but it was soft and slurred like a Negro's. He talked to me considerably about his workers, of the difficulty of keeping them properly "furnished," and of seeing that their work was done thoroughly. He told me he was a good cotton man and could get more out of the land than most. Overseers are generally represented as hard-bitten, harsh, yelling slave drivers. This man was soft-voiced, spoke to his Negroes quietly and pleasantly. There was in him, however, something that the plantation blacks never trifled with. In spite of his mild ways, he was unmistakably boss. He saw to it that the cotton pods were picked clean and that there wasn't too much boisterous play among the little pickers. He needed few words. What he said was listened to. He was well aware of the Negro problem of the South, and readily agreed that a sincere effort to educate the Negro was needed. He said it was impossible, however, to keep Negroes who could read and write in the cotton fields.

"Jist as soon as they luhn a little," he complained, "they run right off to Atlanta or Buhmin'am oah up noath somewheah." Although generally sympathetic toward the black man, he was quite convinced that a Negro with money would never work. Without his openly saying so, I got the feeling that whatever he thought about Negro education and improvement he would rather deal with just the kind of Negro he had on the plantation than with those who had had advantages. And I also saw that a bad Negro for him was simply one who didn't fit into plantation and cotton-raising methods as he practiced them. He was grooved to ways which, though he deplored them, he couldn't escape. I can imagine the scorn with which some of the cocksure social radicals of the big cities would regard him, but he was a good man and one who I am sure would not leave his Negroes in the event of any catastrophe to shift for

themselves. I think he would see them through. With what will probably be a continuous and yearly accelerated drop of cotton values in the world market and with the possible coming also of the new cotton-picking machine into general use his Negroes are going to need care. It was eight or ten years ago that I stood in this Georgia cotton field and talked about the Negroes. They have probably needed no small amount of care even by now. It is possible, of course, that my overseer, no more an overseer, is without power to help anyone. He may, like many others, have been sacrificed to the pressure of depression expense accounts and been left himself to shift as he might.

I made pictures all morning in the fields. There were quite a few pickers who did not belong on the plantation but who came from places near by. At noon they sat around the stables, eating, laughing, and talking. The young girls, as flashily dressed as possible, took the picking as a lark which offered other prospects than those of pecuniary gain. There were strange young bucks around, full of jokes and sly references. The crowd was a little suspicious of me. They had watched me out of the corners of their eyes all morning. I looked dangerous even though I didn't carry a camera. The country Negro is a little afraid of pictures. Hanging over in his mind, like a tribal memory out of the deep past, there is a vague fear of the evil that might be done him by the possession of his image. It is not quite a conviction that he has about this but just a kind of uneasiness. It can be overcome with friendliness. With the help of the overseer, whom all the Negroes trusted, and by a few presents of cigars to the boys and men and of nickels to the kids, I broke down the little barrier of fear that stood between the pickers and my pencil. They looked at my sketches and were soon full of hilarious comment.

"Lawd, ef dat ain' ah bunch ah niggahs!"

"Yah, look a' dat ole fat ass. Dat's you, sistah," and the young buck commentator, pointing to a big girl sitting in the splendor of new red calico, opened his mouth in a peal of laughter.

She came back with, "Shut yo' mouf. Wha's a black mule like you got to do wi' asses?" The crowd, getting the fine point, squealed with joy while the abashed buck retired, corked for good.

With a new shiny nickel I induced a little boy to pose. Though I had barely enough elbowroom to move, I finished him off.

"Yah, ha, ha, look-a ole Dime. Look-a 'at monkey face." Dime, so named I learned because he was a tenth child, ran off in confusion. Later he came back and wanted to see his picture.

"Is 'at me?" he queried skeptically.

"Sure, that's you," I answered.

"How you know is me?" he said seriously.

"Weren't you here when I made it?" I asked.

"Yeah, 'en Ah's still heah now too," he asserted.

Two Negro boys were walking along a dusty north Georgia road. They were barefoot. Their new pants were rolled up in fat cuffs below their knees. Both had shiny patent leather shoes hanging from their shoulders. One carried a bulging black paper suitcase, the straps of which were reinforced with strands of rope. It was a heavy load. They were sad-eyed and their lips drooped.

"Mistah," said one to me, "is it fuh frum hyeah to Noo Yauk?"

I sat by the curb of a broken-down street. Two little Negro boys were playing with a couple of old tires in front of a whitewashed shack which I was drawing. Some colored folks sitting on the porch went inside when they caught sight of me. Pretty soon a tall Negro with very much patched but clean overalls came out of the shack and walked over to me hesitantly. "Howdy," I said, seeing that he wanted to speak. "Sir," he said with perfect English, "I beg your pardon, but my mother thinks you are making fun of her house and wants you to please go away." I went.

It was in a railroad station. An elderly Negress rather flashily dressed came up to the ticket window. She was portly and dignified.

She stood at the window until the station master caught sight of her.

"What can I do for you, Auntie?" he asked pleasantly.

"My name is Mrs. Jefferson," she said.

The stationmaster missed it. "What's that, Auntie?" he queried.

"Ef you want to address me, do so with my correct name," said the woman, swelling up.

The stationmaster's mouth fell open. His freckled face flushed. His red hair stood up. His blue eyes popped out of his head.

"Wha'—what's that?" he stammered.

"When you speak to a lady, you must address her as such, sir."

The stationmaster got off his stool. Slowly he went over to a pile of mailbags. From under them he pulled a smooth shiny club about three feet long. He came over, opened the door from his office into the waiting room, and bending his lean body forward walked up to the woman. He stuck his fist in her face as she stood wild-eyed with fright, her dignity shattered, her pride suddenly gone.

"You God-damned black bitch, what's got into you?" he yelled. She was silent.

"You want to taste this piece of hickory?" he yelled again.

"No, suh," she replied humbly, with a broadened accent and a fearful look at the club.

"Well, you just let one more piece of that lip fall off your black mouth and I'll skin you." He turned toward the door of his office. Looking backward he paused, "You know what I mean, don't you?"

"Yes, suh, Ah does." Her accent was broader still.

He returned to his office. After puttering around awhile he sauntered over to the window again.

"What can I do for you, Auntie?" he asked pleasantly but very deliberately.

"Ah wants uh ticket to St. Louis, if you please, suh," she said.

It was Sunday noon and we were sitting down to dinner in my

old friend's house. From the little valley of niggertown below came the loud clear sound of a bell. It had been ringing steadily since eight o'clock.

"What's the idea of that bell?" I asked, beginning to get weary of it.

"Can't do anything about it," my friend said. "The Baptist niggers down there saved up their collection money for years and bought the best church bell in this whole country. The white people tried to buy it from them but they wouldn't sell. Then they attempted to get up some kind of injunction, to declare it a nuisance and keep the niggers from using it, but it was no go, and ever since the niggers found they were safe, they've been splitting the heavens with their bell. They'll get tired of it after awhile but now they work in relays. It's about cleaned out the Methodists down there. Every darky wants to belong to the church with the big noise."

A black boy sat on a pile of loose boards by the side of a vacant lot. He had a derby hat cocked on the side of his close-cropped head. He wore a flamboyant pink shirt. His suspenders were black. His light gray pants were creased. His yellow shoes were shiny. He was a grand young dude. I itched to make a drawing of him, but having seen his kind before I knew the chances were slim that he would pose. Nevertheless I thought I'd try it. I walked slowly up to him, working up something to say. As I got near him he jumped up and started running toward some bushes in the vacant lot. Two white men appeared at the same instant with revolvers in their hands. One had on a police uniform. They called to the boy to halt but he rushed into the bushes. Then in some frenzy of fear, he turned back again. He stumbled and there was a shot. A crowd gathered. I pushed over to where they were closing in. The boy lay on the ground, propped a little by a piece of curbstone. His derby hat was gone. In the top of his cropped head was a hole with blood coming out. He was calling, "Mammy, Mammy," in a faint pitiful voice. Dead sick, I turned away. I heard a man say softly to another, "Shootin'

the pore nigger fer sellin' a little whisky. Them damn bastards ought to be hung."

The garageman was fixing our tire. He sent his helper, a colored boy, for a tool. The boy was a little slow. "Step on it, you God-damn black ape," he yelled after him. Winking at me, "We handle our niggers right, here," he said.

Old Man Carney's dad had a slave. The slave had stuck with him after the Civil War. The Negro in his old age found a loose girl and got a boy-child from her. When Carney's father died he left him a little farm on the outskirts of town, and the three Negroes who worked it. Carney was about forty when he got the farm. The old Negro died and the girl, now a woman, went off. The boy stayed with Carney. When he was about twenty-five and Carney about sixty, they were hoeing cotton together and got into an argu-ment. Carney, now Old Man Carney, got mad.

"Joram," he said (Joram was the boy's name), "come on ovah hyeah in this cleah space. Ah'm gonna beat the hell outta yuh."

Joram, however, was a strong young buck and he smacked old Carney all over the place. Some white men coming along in a buckboard saw the affray. They ran over and grabbed Joram and were for taking him out and stringing him.

Carney interposed, "You all git to hell out frum hyeah," he said. "This hyeah boy is mah niggah an' ef Ah wants him to fight with me it ain' nobody's consuhn but mine."

He and Joram went back to hoeing.

I got this story seven or eight years ago from a bunch of yarn spinners waiting for a ferry over the Tennessee River north of Huntsville, Alabama. I don't know whether it's true.

On a ridge of red clay stood a crazy church. It was night and the light from the kerosene lamps within came out through yawn-

ing cracks as well as through the windows. The tower of the church
stood over at a dangerous angle.

> De Lawd mah pastuhe will pruhpeah
> He feed us wif a shepahd's keah—
> Oh de blood of de lam'—

The deep beautiful tones came out, cut here and there with the
lilting wail of a high soprano, so high that it was truly like an
angel's voice. If anywhere in the world the Christian faith is still
touched with the hand of God it is among the southern Negroes of
the back country who cling to traditional ways. They alone set it
in unstereotyped beauty. In the old-time services the shouts of the
faithful, punctuating the hymns, are pure unpremeditated cries to
God.

The new religion of Holiness, to which the Negroes are rapidly
succumbing, puts a certain kind of gross merriment into faith with
the fast jazzy tempo of its hymns. While it loses no fervor, the
solemnity and mystery of belief is shot through in the new religion
with exhibitions of physical prowess which tend to reduce heavenly
aspiration to a mundane whoopee.

A little round preacher, whose smoky gray wool surrounded his
shiny black pate like a halo, was carrying on a Holiness revival
service under a tent near a large southern city. He was a fervent
missionary. Standing on a loose plank platform above his audience,
he described the Holy Temple of David.

"An' roun' outside uv it wuz a great wall. An' inside o' dat wall
wuz a great cou't. An' they wuz a wall roun' dat cou't too, an' in-
side dat wall wuz a innah cou't an' they wuz a wall 'roun' dat
innah cou't too, an' inside dat wall wuz anothuh innah, innah
cou't, and theah wuz the Ho-o-o-oly Tabernacle wid a open space
front of it fo' a sanctified man to DA-A-A-nce in." Shouting his
conclusion he began cavorting like mad on the platform, whooping
and jumping up and down. "Don' cross yo' feet foah de Lawd, don'
cross yo' feet foah de Lawd." The planks rattled and the jazz boys

of his congregation set up a fast racket, with two battered saxophones, a banjo, and a drum.

The audience began to jump. In two seconds the whole tent was a mad house.

Down in the sea-island country at Beauford, South Carolina, back of the old water-front mansions of slave days, there is a church of the Sanctified. It is not really a church but an old ramshackle dwelling house used for the purpose. The Sanctified shout and whoop and dance but so far as I have seen they do not roll. In all other respects they are like the Holiness people. Their musical instruments are a guitar and a pair of cymbals. Also their feet should be considered as instruments, for with them they beat out incredibly subtle variations of rhythm. In a simple four-four hymn, they develop the most intricate patterns of beat with their heels and toes which never break the basic time of their music and which put the tricky decorations of eighteenth-century dance music to shame in so far as variety is concerned. There is no solemnity about the services of the Sanctified. Like other Negro religious beliefs which have been subjected to modernism, they are uproarious rather than solemn. Negroes, and for that matter, the whites of the South, have always been given to taking their religion with fervor, to whooping things up, but it is only in late years and mainly through Holiness and other similar sects that the rapid syncopations of jazz have set the patterns of profane music within the churches. When the new Negro sects get hold of *Swing Low, Sweet Chariot*, it is something to dance to, not to worship with. This is true of other old songs. *The Old-Time Religion,* which used to be a slow, mournful sort of dirge, is given now in a way to raise the dead with a mighty and complicated foot stamping and dust raising. The pace of all things in this new day is accelerated. God, with the rest of us, has to hurry.

However, across the water from Beauford, on the sea islands proper, a certain dignity is retained in religious service. A careful

traditional ritualism survives there. Services are carried on in white robes and with a measured and solemn pace.

The Negroes of the sea islands are very black. They are long-headed as a rule. Their features are clean-cut, like beautiful ebony carvings. They speak rapidly and with a dialect hard to understand. They live on little farms and do their plowing with tiny horses of a special sea-island breed, or with oxen. A lot of them are quite shrewd. Their islands are becoming something of a winter resort. Well-to-do white strangers with a high appreciation of the picturesque wander on the little narrow roads of their pine forests. A friend of mine, coming on an unusually entertaining white-washed cabin outside of which an old kerchiefed mammy was working with her soap kettle and her tubs, leveled his camera at the scene.

"Hol' on, mistah," she called out, "wha's you all gon' gi' me fo' dat pictuh?"

"Give you—?" said my friend. "Why, what do you want?"

"Well, s'like dis," she said, "white peepul as teks mah pictuh gen'lly gi' me somp'n. Dey gi' me cloes or dey gi' me money."

She had shrewdly fixed up herself and her place with all the accouterments of picturesque southern darkeyism, and was making it pay.

The Negroes, Gullahs, of the islands get their cash money at seasonal work in the oyster- and tomato-canning plants of the islands. They come in at working periods from all the outlying places and camp out in the rows of shacks by the plants. They have hilarious doings here. They meet friends. As among the cotton pickers, the seasonal work here provides opportunity for courtship, and at night after work the girls dress up and parade about, swishing their tails and rolling their eyes. The boys close in on them and nudge them and pinch their buttocks while they squeal with pretended anger. They edge off in pairs toward the palmettos or moss-draped live oaks. An anxious black mamma steps out of a

shack door with bulging dignity to command, "Come on back hyeah, gal. Don' le' me ketch you traipsin' off wi' dat no-'count."

The sea islands were captured early in the Civil War by Union forces. It is said that when the war ended the Federal Government, having well established itself, fulfilled a promise made in the islands to give every emancipated slave a mule and ten acres of ground. Maybe this is true. The mules I have seen down there were certainly living when Lee surrendered. I judge that whether or no the land was allotted, the mules were.

At Beauford I have a friend named Adam. Adam is a southerner who after years of business life in the North came home again. When I went to see him he lived in a large house with marble stairs and great columns. The house was surrounded by live oak trees draped in hanging moss. It looked out over the water and was cooled by sea breezes.

To make up for his years of hurried northern activity, Adam set about establishing an atmosphere of perfect ease. He manufactured a bookstand, which made it unnecessary to expend effort in holding up his books when he wanted to sit under his pomegranate tree in the back yard and read. Finding the business of turning the pages something of a chore, he was at work when I visited him on a foot lever designed to eliminate the difficulty. This contraption when perfected would not only give him a perfectly relaxed position but would leave his hands free for the making of juleps, iced toddies, etc.

It would be an hour before the car could be fixed. We sat in the shade behind the garage near the entrance to an unpaved alley. From up the alley came the sound of a lot of boisterous rooster crowing. People talking and laughing kept coming in the alley. In its shade they would remove their hats and wipe the sweat from their foreheads. There were red brick buildings on each side of the way. There was a lot of cast-off junk underfoot. People kept coming, whites and colored people. We got curious and followed.

At the end of the alley as it rose abruptly to meet a street on a higher level was a brick jail. From behind the window bars of the jail black faces looked out. At one window, however, there were two white faces. The jailhouse had a back yard on the alley. The yard was surrounded by a high wire fence. The people we had seen come up the alley were standing around the fence. Edging in we saw a dozen or more fine-mesh chicken coops with handles and sliding doors. In each coop was a fighting cock. Within the limited boundaries of their cages, they strutted proudly. Their hard eyes, yellow in the sunlight, glittered fiercely. Every once in awhile one would stretch his neck and challenge the world with an exultant crow. They had been arrested along with their owners.

I was walking one Sunday along an Arkansas highway with a boy I had picked up just out of a town. He worked in a little sawmill out in the country and had been in town over Saturday night with his folks. He was going back to the country so that he might be at his job early Monday morning. It was afternoon. We plodded along a couple of miles talking about this and that. In the distance a line of hills rose up, green, blue, and violet.

"I'm turnin' off come the next fork," the boy said.

Just then a car passed us. It went around a bend ahead. We heard it stop and then go on. When we turned the bend the road stretched out a straight line clear to the hills but there was no car in sight.

"That's funny. Musta gone up my fork," said the boy. "Seems to me I seen them fellers in that car up round the mill las' week. Yep, that's where they went."

A little farther on we came to a narrow road that branched at an oblique angle from the highway. A split rail fence ended in a sharp corner where the rails were bound with barbed wire to a tree stump six or eight feet tall. Hanging to one of the rails which projected beyond the stump was a small bundle of straw tied around the middle with a strip of white cloth. The end of the cloth was tied to the rail. The boy saw it immediately.

"I thought so," he said. He looked at the straw meditatively.

"What is it?" I asked.

"Fightin' chickens," he replied.

"What's that?" I asked.

"Them two fellers in that car has been round here for a week," the boy explained, "and las' night I seen 'em in town talkin' to a feller I knows has chickens. They's a lot of fellers has chickens out this way too. They keeps 'em hid out in the woods."

"What's that got to do with the straw?" I asked.

"Them fellers gets up signs when they's gonna be a fightin'," he replied, "an' this is likely their sign. Somewheres up the road there'll be another one. I don't need no more signs though. I betcha I can find any chicken fight in these woods. They ain't but three likely pits no-how."

"Are you going?" I asked.

"Course I'm goin'," he replied.

"Say," I said, "I think I'll go with you—think they'll let me in on it?"

"Ev-body knows me here, so I reckon ef you come with me they won't nobody bother you."

We walked up the road briskly. Two cars full of men went by. We passed the sawmill where the boy worked. It was a rough board shed covering the saw and an old threshing engine which supplied the power. On to one side were a couple of board houses with unpainted picket fences. One house was covered with yellow roses. On its porch a young woman sat holding a sleeping baby. My companion addressed her, "Anybody been roun', Flora? Seen any people roun' today?" I stood back by the fence while he went up to her.

"I seen enuf people roun' here today to know that some meanness is up," the young woman said. "I seen that Jake Fletcher round here an' when he's roun' people is doin' things they ought not to. They's a-fightin' chickens somewheres in the woods. Can't fool me. That's what you're lookin' fer, ain't it? That's why you come out so early, uh?" She leaned over. I heard her whisper to the boy,

"Who's with you?" I didn't hear his reply but Flora looked at me questioningly.

The boy came back to me, "We'll go up the road a piece," he said and took the lead. On both sides of the way was a thick growth of scrub oak and underbrush. We came to a clearing, a stumpy field full of the stalks of last year's corn. There was a two-strand barbed-wire fence between it and the road.

"We'll cut in here," said the boy and climbed through the wire. I followed. There was a faint path leading over and down the field to a heavy patch of timber that I knew must be a creek bed. About halfway across the field we heard a prolonged whistle coming from below in the woods.

"I wuz right," said the boy and started to trot.

We got to the edge of the timber. Just as we were about to enter the shade of the big trees, we saw two men bent over and running fast between the trunks of the trees. They made the underbrush crackle. They were in a hurry.

"This ain't healthy," my companion remarked and stood still.

"What do you think is up?" I asked.

"Like as not the sheriff's out here," he said.

We waited. Far off somewhere we heard the engine of a car starting up.

"Let's go see," my companion suggested. "Nobuddy's got anythin' on us." He moved ahead. "I know where they were," he said.

Stooping under the dense brush we made our way with difficulty. We crossed the creek, a slow muddy little stream, on a fallen log. Climbing up the other side we got into pine. The ground underfoot was clear. We went at a fast trot.

"Here 'tis," said the boy and he climbed over a little knoll. The knoll was circular. Down in its middle was a place some eight or ten feet round. It was clear of grass and packed hard.

"This here's the pit," my companion said. "I seen a five-hundred-dollar fightin' here two years ago."

There wasn't a soul around. The only sound was the rattle that a light breeze made in the pines.

About two hours later, after leaving the boy, I crossed a bridge on the highway a little beyond the place I had turned in. Four men were standing at the entrance of the bridge talking. Their heads were close together. On the farther side were two cars. Hoping to pick up a ride, for it was getting dark and I had a long ways to go, I greeted them.

"Howdy, gentlemen." They looked at me but didn't return even a nod. They simply stopped talking and stared at me.

Two or three minutes later they passed me on the road. The two men beside the drivers had cloth bundles in their hands. One of the bundles seemed to be very animated. The man who held it moved his hand over it rapidly.

I walked over the concrete way that led across the lawn. The lawn was luxuriant except where the shade of the magnolia trees kept the sun away. In the middle of the lawn were beds of flaming canna lilies. I went up on the white porch and knocked. A bearded and dignified gentleman came to the door.

"I'm Tom Benton," I said. The gentleman in the door looked at me a little surprised. I had on walking boots and I was sweaty and dirty. I had come into town in the caboose of a freight train. The railroad bed had been full of dust, and after the engine and forward cars had worked it up, the caboose traveled in a regular dust storm.

"Tom Benton!" exclaimed the gentleman. "Why, come in, sir."

He looked me over in an imperial sort of way. I took a letter from my pocket which he had written me inviting me to stay with him if I ever came to his part of the country. He beckoned it away. "Oh, yes, I know," he observed. He led me into the library. "Sit down," he said, "and wait a few minutes. I'm in the middle of an important bit of correspondence."

There was just the faintest suggestion of the southern drag in his very authoritative voice. He stepped over to a desk, sat himself down,

and began to write. A clock ticked in the silence. I watched it. The hands moved slowly for half an hour.

"What a hell of a way to greet a new guest," I thought. I began to itch and get fidgety.

The bearded gentleman bent over the desk. Finally he laid his pen down. "Lord, I thank thee for Thy help in this case. I hope I have taken Thy instructions well." He spoke aloud. He got up and folded his manuscript. He walked over and stood above me. "I knew your father well," he said. "He was a God-fearing man, one of Christ's servants on earth."

"Holy Christmas!" I thought to myself, "Is he talking about Dad?" But I assented. He saw a touch of amazement in my face, however, and went on, "Your father's work in the world took him away at times from his brethren in Christ, took him away from God's work, but our Church was proud of him, for he was a good man and a faithful one."

"Of course," I said. He paused, looking at me closely.

"You will have lunch with me here?" he questioned.

"Certainly," I replied. I was a little taken back, for the letter he had written me contained a hospitable invitation to spend a week in his house. In a moment, however, I was relieved on that score.

"Tonight, God willing," he said, "I shall have a room ready for you here. This is a very busy day for me. I am arranging for our great conference which begins next week. I shall be able to give you but little time. One of our young men, a sincere and happy Christian, will take care of you this afternoon. Tomorrow I may perhaps have the opportunity to explain fully why I wrote to you. Your art I believe may well have a place in the ways of God in our community. I wrote you about our interesting people as subject matter for your pencil, but I was thinking in my heart of how you might help them with your message of beauty."

About this time he must have got a whiff of the sweat under my arms, for he said abruptly, "You will want to clean up." It was nearly

a command. "You have a change?" he questioned, eyeing my knapsack doubtfully. "Yes, I have what I need," I replied.

He ushered me into a room and closed the door on me with a neat bang. There was a wash basin and pitcher of water there. I cleaned up as best I could, put on a clean shirt, and came out again into the library. Two ladies had arrived in my absence. They had pinched, weazened faces and an indrawn look in their watery eyes. My bearded friend introduced them. They barely noticed me.

"Sisters," he said, "sisters in Christ, Mr. Benton is the great artist I have spoken to you about. He will talk to us later about God's beauty in this world." He turned to me, "Mr. Benton, God has told me at this very moment what your course is to be with us. God has made it clear that your steps were directed toward us at this time that you might speak to our brethren in conference. And that they might speak to you about the beauty which He has put in this world and which He has given you the talent to imitate."

"The hell He has," I thought, and I felt the sweat begin to run under my clean shirt. I had visions of the conferring brethren lecturing me on beauty.

About this time a young man entered. He was skinny and pimply. His sandy hair was parted in the middle. His lips made a prim white line. He looked like a Y.M.C.A. secretary that had indulged too much in secret practices. I was introduced.

"Mr. Sanford, here is the young gentleman I spoke of, Mr. Benton," said my host. "You will have much in common with him, I'm sure. He will take care of you this afternoon."

Lunch was preceded by an inordinately long blessing. Each individual had to give thanks for the food. It came my turn. I lowered my head and tried to think of the perfunctory blessing with which my Dad used to open our meals when we had company, but I couldn't remember it so I mumbled along and ended with an emphatic "our Father in heaven" which came to me opportunely. The pimply fellow, who was to be my afternoon companion, eyed me with a touch of disapproval as I finished my prayer and raised

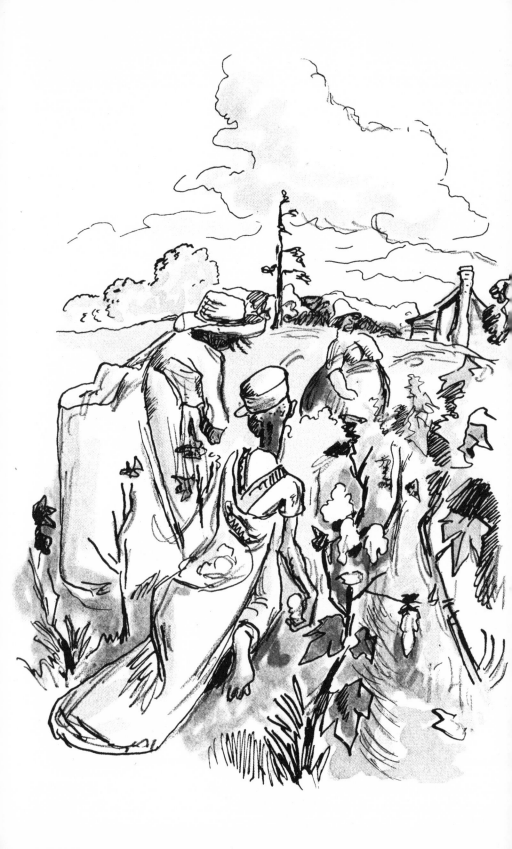

my head. He wasn't sure of me. The meal was good but the heavenly frigidities of the conversation took the steam out of it. It froze in my mouth. I swallowed chunks of ice.

After lunch I started to light a cigarette.

My host touched my arm, "Not here, Mr. Benton," he said. He was kind but firm. The ladies and the young man looked horrified. I started for the porch. My host, catching my intention, followed. "Mr. Benton," he warned, "we try to make this house an example for the Lord, outside as well as in. While you are with us I must ask you not to indulge in questionable practices."

"Yes, sir," I said humbly.

The pimply guy and I went out later. When we got around the corner I lit a cigarette. He said nothing, but his lips tightened and his eyes narrowed. I started to make conversation.

"Mr. Mareham wrote me that I should find very original people in the country around here," I said.

"Dr. Ma'eham is himself the most original man Ah know," he replied. Unlike the Doctor's, his accent was broad.

"By golly, that's right, he's a card for sure," I agreed enthusiastically. The pimply guy turned on me.

"Dr. Ma'eham is a gre't man," he said. "He's one uv the gre't men of ouah day." He looked at me with the air of one who has been grossly affronted. Then he went on:

"Dr. Ma'eham has checked the fo'ces of evil in the legislatuah uv this state foh twenty yeahs——"

"God's lobbyist," I thought.

"He's cleahed all the bad books out of ouah schools and libra'ies and book stoahs. He's closed all the bad dance halls and bad houses in this city too——"

That's why you have to play with your own self, Pimples, I thought; no girl out of a whorehouse would.

"And he's stopped mos' of the cyard playin' hyeah. He's done all uv this by himself," he continued. "Singlehanded he's fought

foah God and foah what is right." He paused to let the magnitude of the Doctor's greatness sink into me.

Then again, "He's the most leahned man in the countrah."

Another pause.

"And he knows moah about beauty than any man alive," he ended emphatically.

"Where are we going?" I asked to get my comapnion away from the supreme Doctor.

"We ah goin' now to ouah printin' shop," he replied. "Ah've got to look ovah the proof of ouah new messages. Brothah Mahion, ouah printah, will be able to tell you a lot moah about Dr. Ma'eham. He's been with him since the Doctah first came hyeah frum the No'th."

Good Lord, I thought, and I'm to stay around here.

We walked down the hot street. We passed a telegraph office. A hundred feet beyond a thought came to me. I said, "Wait a minute, friend. I've left word to have my messages held for me at the local telegraph office. Maybe I'd better see if there's anything for me here." I ran back. Slipping in the door I dug down in my coat pocket for an old telegram that I'd received a week or so ago. I waited a minute. Then I rushed out waving it. "Say," I said, "this is terrible. I have a hurry call from my brother. Where's the railroad station?"

Pimples eyed me in amazement, with his mouth open. I knew where the station was and I made for it. Pimples was way behind when I got there. I said to the agent, "Give me a ticket on the first train out of here."

"Where to?" he asked.

"Any town fifty or sixty miles from here," I replied.

I got the ticket.

"How much time have I got before she goes?" I asked.

"Twenty minutes," he said.

I ran out and chased back to the Doctor's. He had departed for his conference. I grabbed my knapsack. I met Pimples, puffing from

his chase after me on the steps. "Tell the Doctor," I said, "that my brother that lives up in Missouri has had a terrible accident and I have to go."

I started for the station.

"Ah you takin' th' next train!" exclaimed Pimples.

"Yes," I said, "she's due now."

"Tha's a westbound train," he said putting his hand on my arm. "It don't go to Missouri."

"I know," I said. "My brother was hurt in Texas."

I opened the rickety gate and walked into the packed dirt yard, bare under the deep shade of the magnolias. The long two-story house with its upper and lower galleries had never been painted. An old fellow in faded overalls sat with his chair cocked against the side of the front door. He held a fly swatter in his hand.

"Is this the hotel?" I asked.

"Yes, suh," he said.

"I want a room for the night."

He got up, breathing asthmatically, kicked a pair of old bedroom slippers off his feet, and hobbled into the house flapping his toes. He went upstairs beckoning me to follow. He led the way into a big room. There was an iron double bed in the corner from which the enamel had been chipped. The yellow wallpaper was peeling here and there. Mosquito netting was tacked over three windows. On one of the windows it was badly torn. Though it was getting on toward evening, the room was hot as hell. I threw my knapsack on the bed and looked at the wick of the kerosene lamp on the table.

"This is fine," I said. "How much?"

"Et'll be six bits with yoah suppah en brekfus'."

I went back with him downstairs and sat on the gallery. He put his slippers back on.

A couple of slouchers in dirty overalls opened the gate and came

in the yard. They ambled up to the steps of the gallery, sat down, and took off their shoes.

"Howdy, gentlemen," I said.

"Howdy," they answered.

They went in the house and got chairs. They leaned back against the gray boarding and aired their feet.

"Wa'll, Uncle Whea'ley," one of them began, "it's a-ben a hot day on thuh road."

"It's ben a hot day heah," the old man said.

"They got 'at niggah, Uncle Whea'ley." The speaker leaned over and looked at the old man.

"Wheahs he at?"

"They tuk 'im en town. He's in thu jailhouse." The speaker looked closely at the old hotel keeper.

"They wahn't no vi'lence?"

"He got rustled a li'l but they wahn't none to speak of."

"Tha's good," said the old man. "They ain' nobuddy got no right to be vi'lent to one uv God's peepul even ef he's black. They's law in this country foah evildoahs, black an' white both. We kin fin' out in the law who's been evil an' who's done wrong."

There was a pause.

The new arrival who had been speaking rose up slowly. He took his chair and put it alongside the old man's. He worked his bare toes deliberately.

"Uncle Whea'ley," he said, "we ben a-talkin' 'bout this evah since that niggah stole 'em traps. Now Ah think yo' principles is all right and Ah knows you is a well-meanin' man but a niggah at'll steal'll do wuss, an' Ah'm one 'at says yuh cain't encourage 'em, law or no law. The law takes a long time an' we has to pay fer keepin' peepul in thuh jail till the law gits to 'em. 'Tain't no use fuh a niggah."

"Did they find 'em traps?" asked the old man.

"They ain' foun' 'em yet," was the reply. "But they ain' nobuddy roun' here what ud take em but dat strangah niggah. He ain' even

got no right place to stay. They caught 'im sleepin' in 'at ole saw-mill shed down in Meekah's bottom. None of ouah niggahs even knows 'im. He's jist a vagrunt."

"Ef you ain' found them traps, you ain' even got no right to take that niggah to jail," said the old man emphatically.

"Ah didn' wan' a put 'im in the jailhouse," was the reply. "Ah jist wan'ed to give him a lickin' to fin' out what he done with 'em traps. Them traps cos' Uncle Al a lot uv money and he got to have 'em come fall. The sheriff put th' niggah in jail. Wahn't me."

"Well you ain' got no call eitha' to beat that niggah," the old man said. "You ain' got no call to do nothin' to 'im. We got a law in this lan' an' I tell you, even ef you is mah own brothah's son, that it's fellahs like you that's a disgracin' the whole South in the eyes of good people. You cain't disremembah the law, jist whin you got suspicions. You cain't disremembah it *whin yuh got facts.*"

The old man got up, hobbled out in the yard, and began knocking dry magnolia leaves over the bare ground with his fly swatter.

The fellows turned to me. "He's a ole man," they said.

After supper I went upstairs and lit the lamp. I wanted to look over my drawings. In two minutes the room was full of a swarm of night bugs. They flew around the room making a noise like a bunch of trimotored battleplanes. They smacked against the light and against my neck. I turned the lamp out and when the bugs settled I went to bed.

I sat in the Pullman car smoker on my way from Memphis to Jackson. My seat companion, a well-dressed, smooth-shaven, well-spoken man of middle age, was talking.

"No, suh," he was saying, "this new litahtuah comin' out of ouah South today is a disgrace. Ouah young men have been corrupted by readin' vile trash and by listenin' to the outrageous doctrines of Socialists and Communists and otha' distu'bahs of the Noath. They have lost the puhspectives of right thought. They sea'ch out the vile and the mean in actual prefehence to the good and the beauti-

ful. These ah hahd times foh ouah South, an' ouah young people in the colleges need the good and the beautiful moah than evah. They need hopeful things so that when times get bettah they will be ready foh a good life. We mustn't let them lose ouah southern traditions. We mustn't let them fo'get the dignity of ouah past. We need writahs now who will make ouah chil'ren remembah that we in the South come from gentlemen."

The table was beautifully set. In the clear light of the wax candles the silver shone and the intricate patterns of the linen tablecloth were like cobwebs in the morning dew. My hostess was very pretty. She fingered her wineglass and looked at the fat beaming dowager across the table.

"Oh, Mothah," she said, "isn't it mahvelous, isn't it gohgeous, isn't it just unspeakable that we have a real great ahtist with us, right hyeah in ouah ahms."

A lecturer sure has to take it at times.

The black chain gang was stretched out along the orange road. Where the road dipped ahead the Negroes were silhouetted against the sky. Their striped pants flopped as they moved their hips. They swung their picks for short sidestrokes on the red clay roadside. They worked slowly, with as little effort as possible. At the end of the row a big strapping husky was singing while he swung his pick. I slowed down to hear what his song was.

"Move on, you," the guard said. "Git outta this."

All over the South men dressed like clowns, black men and white men, are to be found strung out along the roads with picks and shovels. Tight-lipped men guard them with sawed-off shotguns. Much has been written of the evil of southern chain gangs and of the abuse of power by officials in charge of them. A great deal of it is true. It has been properly documented. Nevertheless, I suppose it is better to work men in the open air than keep them cooped up in jails where they have nothing to do but yowl. No doubt there

is much to say in defense of the southern penal system if it is frequently and openly investigated, and kept out of the hands of profiteering individuals. But punishment of any kind is horrible. Nothing is sadder than a gang of men under forced labor exhibiting their punishment to the world. They seem doubly sad in the ludicrous striped suits of the southern chain gangs.

I have seen many gangs in the South. The Negroes always look curiously at passers on the road. Quite frequently as they work, they sing with low voices some repetitive phrase. Because of the watchful guards, I've never been able rightly to hear what they sing. They look mournful but not exactly miserable. The white prisoners do not, as a rule, pay any attention to people who pass. They are apparently without curiosity. They are a harder lot than the Negroes, a meaner lot. At least they appear to be so.

Coming abruptly on a chain gang around some bend in the road, you get a sort of sinking feeling in the chest. It is as if you yourself were under sentence and about to be put in line without hope of appeal or escape. The guards with their guns have a menacing air. They look dangerous and merciless. The only guard I ever knew, however, was a loose-jointed cracker, who on a day off shot marbles in his bare yard with his towheaded kids, laughing like a boy. He was a good-natured fellow, apparently afraid of his wife, who ordered him about as if he were a nuisance around the house. Lounging on his porch step, he was the last person in the world to be afraid of. Yet out on the road with a gun in his hand, I suppose he would look like the rest of the guards, hard-bitten and cruel. There is something about a firearm that completely changes the character of even the best-humored man who grips it. Its deadliness is transferred to him. The guards of the southern chain gangs are for the most part, I suppose, just ordinary men, neither good nor bad; but in their capacity as guards when they eye you as you drive through a working outfit, they have a forbidding aspect. When they say, "Move on, you," you don't trifle with the order; you move on as fast as you can.

There is a tradition of black chain gang song. A few years ago collectors found the songs more or less humorous in their content, as they did all the secular songs of the Negroes. The various "John Henry" songs transferred from the railroad to the chain gangs carried lines of laughter and the comments in them on "the captain," the work boss of the gang, were always funny. Recent investigation indicates that there is more lament than humor in the genuine Negro work songs. It seems probable that the humor in those songs which have been popularized has been injected by Negroes who were clever enough to escape work and who could pick up an easy living in the Memphis or Birmingham "joy joints," or in the service of white exploiters of Negro music in the North. Negroes who sing at work sing mournfully. It is true that some of the words they put together suggest laughter. It is also true that the singer will laugh if you ask him what he is singing. But if you watch silently while he works, you will find a serious, sad expression.

> Dem ole duhty shoes
> Dem ole duhty shoes
> Who se-e-ehd dem shoes—

This refrain was repeated over and over again on the back stoop of a southern hotel by a Negro boy cleaning the riding boots of some of the guests. He sang with a funereal solemnity. The words of his song meant nothing funny. They just happened to come to his lips as he set about relieving the monotony of his task with rhythmical cadences.

The songs of the chain gangs of the South are, I imagine, much like this. They probably have no definite content of any sort. The words of their songs are more likely than not mere accidental phrases suggested by the matter of the task in hand. The words come from the material objects connected with the task just as the rhythm of the songs comes from the task's pace and the muscular stresses it involves. This is true of the ordinary work songs I have heard, and southerners long familiar with the chain gangs tell me it is true

for their songs also. I don't believe any work songs, chain gang songs or others, are intentionally funny except when sometimes a Negro scenting favors makes them so deliberately.

They are not, on the other hand, songs of bitter revolt as is claimed by some of our forward-minded young radicals who after making a running trip to the South come back to New York with the wonderful discovery that the Negroes are natural Marxists and that their songs express a genuine sense of the colored man's place in the class struggle. These discoveries are, of course, nothing but figments of wish. I have seen lately some revolt songs of a proper proletarian pattern set to characteristic Negro blues cadences, but they were shown me by men whose wishes were strong enough to allow them to make an unconscious substitution in the matter of content. No dishonesty was involved. A deep conviction of what ought to be will lead easily to illusion. People who believe in God with a firm faith are sure to talk to Him and bring His words back to earth. People who believe wholly in the Marxist class struggle pattern find evidence of its existence in places as unlikely as are those where the Holy Rollers find the words of God.

The Negro of the South is not stupid. Under the lash of difficulty to which he has been submitted for a long time he has learned how to adapt himself to the drolleries of the white people. He is quick, notoriously quick, to find the pattern of his white brother's wish whether that brother wants to embrace him or kick him in the buttocks. He knows how to move and what beliefs to have. He knows how to turn a tory's anger into laughter and a reformer's love into a dividend. The Negro is not stupid but, on the other hand, he is not farseeing. As a rule he is ignorant. The ignorant are often quite able to take advantage of the good in a momentary situation but are rarely able to foresee the possibility of evil consequences which might arise from that situation's further development. A number of young Negroes about the cities of the South have been instructed in the doctrines of Marxist communism. Their instructors are no doubt sincerely interested in the Negroes' welfare.

Sincerity is a deeply persuasive weapon where the inculcation of doctrine is concerned, and where full social equality before the tenets of doctrine is indicated, it is well-nigh irresistible for the Negro. Quite apart from the matter of social justice involved in Marxist doctrine, it is, or has been, devoted technically to violence in acquiring that justice. The young Negro seeing the immediate values of equality overlooks the action strings tied to its Marxist aspects. He accepts the immediately desirable. He is a Communist just as his pappy was a Baptist because his emotions are stirred by its tenets. This is as harmless among young educated Negroes as it is among the young white fellow travelers of the northern cities whose beliefs are verbal and who spit their convictions over the cigarette smoke of cocktail parties. When, however, Marxist doctrine sinks into the uneducated colored sections of the southern cities where the Negroes, because of their isolation, can nurse illusions and hopes unaffected by disruptive white criticism, the matter is not harmless. Unable to see the consequences of beliefs, the concomitants of which they do not fully grasp, the Negroes are led to declare allegiance and assume attitudes which are likely to produce some bitter fruit in the near future. The whites of the South are likely to see the innocent Negro Communist as a full-fledged militant revolutionist, thoroughly aware of the meaning of his party affiliations. They are likely to take repressive steps far more violent than the actuality of the situation calls for, and slaughter a lot of poor black boys who are simply enjoying the emotional values of a new religion. When this moment arrives the young white instructors of Communism will have evacuated the ground. They will have scented blood and after telling their black adherents to defend their principles to the death will have retired north where their services to the cause will take the safe form of vigorous protest.

A realistic view of the actual disposition of powers in the South and of the tie of these powers to deep-set prejudices would, it seems, put a little humanity into even the most frenzied followers of doctrine. The Negro is not stupid, but because he is ignorant, he is

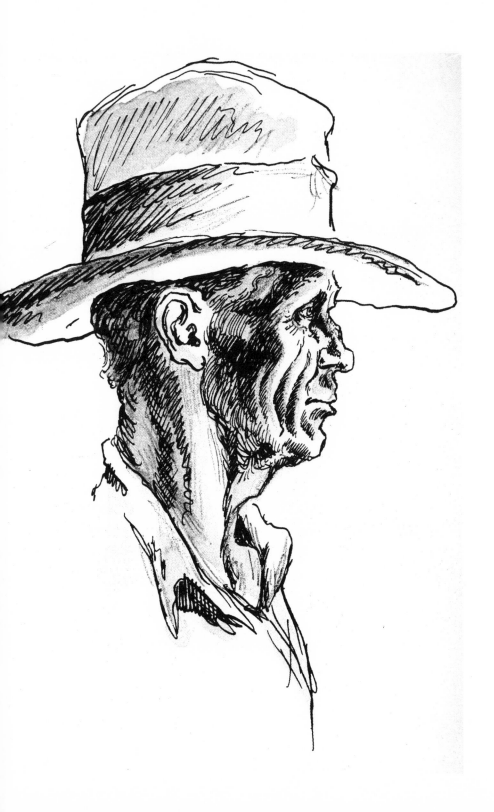

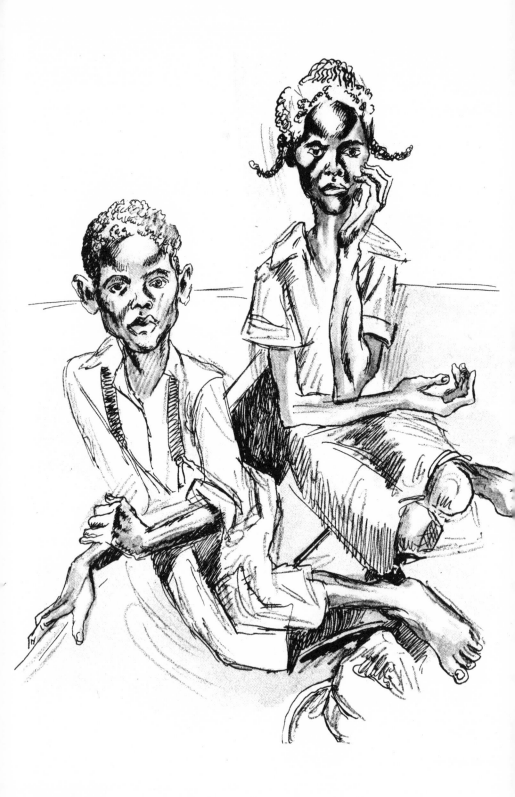

naïve. It seems a vile thing to me for men to use that naïveté in the interests of any ideal the full consequences of whose acceptance is not candidly presented. There is plenty of ground for Marxist attention to the Negro. He is as near a genuine proletarian as anyone in the country. He is really a part of a submerged and oppressed *stationary* class. It must not be forgotten, however, that he and his brothers form a relatively small part of our one hundred and thirty-five million people, and that though he is technically a proletarian, his class solidarity is ephemeral. This means that it doesn't exist politically. If it did exist to its fullest extent it could and would be squelched the moment it showed its hand in the South. Should a militant and solid proletarian black class under clever agitation manage to get strength in the colored pockets of the southern cities, it would precipitate a prompt race war which designing individuals would use to the end of crushing the civil liberties, not only of blacks but of whites as well who were not plainly tied to the proper-tied groups in power.

The racial situation in the South is explosive. The economic situation of the South is not permanently tenable. King Cotton is going the way of other kings. Some three million of his dependent subjects looking around for their bread and butter are going to put a heavy strain on resources that are already strained. The southerner is irascible. He runs easily to the sort of violence indicated at the beginning of this chapter. Let him see his difficulty as one of class conflict with a racial base and he will rise to the occasion in a way that is far from being socially desirable.

I should like to recount here two experiences touching on the question of class which I had last summer when I took a few days off work and went down into southern Missouri. Although Missouri is properly in the Middle West, it was settled mainly by southerners, and the southern psychology with its thread of uncontrollable temper is in frequent enough evidence.

The Roosevelt-Landon campaign was at its height and the polit-

ical atmosphere was as well-charged in Missouri as in other places. The press, in full blast for the protection of American liberties against Rooseveltian radicals, had quite a number of nice people pretty well stirred up.

I visited the house of a retired banker, one of those Missouri southerners whose family traditions went far back into the history of the state and who had therefore a rather highly developed sense of natural right in the matter of standing and prerogative. The house was a charming one. The cocktails were good. Everything was as it should be on a lazy summer afternoon until politics, an almost unavoidable subject at the time, was injected into the conversation. In a very few minutes my host forgot that although he was a banker he was also a southern gentleman, and about some mild remark of mine on the probable necessity of increasing federal regulation of private enterprise, completely lost his head and attacked me with a perfect tantrum of abuse. He called me a traitor to my kind, to my name and my traditions. He harangued me for ten or fifteen minutes, and ended with the following red-faced declamation:

"The class of people who run the business of this country are the ones who know how to run it. They have the right to run it because they know how. It has come to an awful place when a lot of incompetents who won't work when they have a chance can get up the nerve to insist that those who do work should divide with them.

"What's all this business about the rights of the masses? If the masses would work they'd have all the rights they needed. There is nothing the matter with this country except the dissatisfied people who want something for nothing. I've got no bouquets for you artists either. You're worse than the rest of them. You refuse to work in the way this country wants you to work and you help stir up trouble with those who would work in the proper way, if you'd leave them alone.

"Let me tell you something," he said, warming up, "there's three things in the world I like, flowers with perfume, ladies with virtue—"

here he looked questioningly over the women present— "and men who are loyal to their kind." Here he looked at me.

"And let me tell you something else," he went on, "you have no respect for the traditions of your country but when the time comes you are going to learn, you and all your dissatisfied friends, that there are machine guns in the hands of the right people here to bring you back to your senses."

Of course this tirade was let loose in heat and the latter part instantly regretted and apologized for, but it pictured in plain terms the growth of a very un-American class state of mind. It was apparent that my banker was looking for a class enemy on which to blame the economic difficulties of his kind.

What struck me about this conversation and what struck me at other times during the Roosevelt-Landon campaign was the rapid growth of a marked class-conscious language among the well to do. The class solidarity regarded as such a desideratum by Marxists was getting its American demonstration at the wrong end of society. In many polite houses during the summer of 1936 as in the houses of genteel Philadelphia during Hamilton's day, the voice of suspicious hate was directed toward the riffraff. Appeals for class solidarity, though couched in different terms and idealistically disguised, were constantly made that this riffraff might be defeated.

Against the story of my banker and his growing sense of class I want to put another story.

I was sitting in a garage in southeast Missouri on a Saturday afternoon. While my car was being greased I talked with the loafers. A farmer told a story about his brother who lived over in Arkansas. Rather it was about his brother's wife.

It appears that some young organizer or socially-minded college boy working in the field of the northeastern Arkansas sharecroppers had paid a visit to the brother's house and had started some kind of discussion on the question of class. I imagine that the young man was pretty inexperienced and that he was wholly unfamiliar

with the language habits of those with whom he was dealing. Anyhow, the farmer telling the story said this:

"The ole woman didn't like that young feller an' she tol' him he was meddlin' in things he didn't have no business about. He tol' th' ole woman she didn't understand anything cause she didn't have no class. This got th' ole woman mad an' she said, 'You young smart aleck, I maybe ain't got much class but I betcha I got a sight mor'n you have. I got class enuf inyhow to own three dogs an' ef you don' git out o' here right now them dogs is goin' to fin' out whut is the class of yer britches.'"

This tale made a great hit in the garage. It went right to the funny spots of men who by tradition and habit and in spite of the fact that they are the victims of marked economic class divisions repudiate and scorn the whole idea of class. In view of the fact that these Saturday hangers-on around the garage represent a very heavy percentage of lower-middle-class and farmer psychologies and will have to be counted on in any large-scale class movement, there is an inference to be drawn from my two stories which every Marxist revolutionist should consider.

Today the plight of the southern sharecroppers and tenant farmers is very much in the air. So much has been written about them of a documented and exact nature that what I have to say will seem pretty old stuff. In my rambling journeys about the South I have seen much of the southern feudal system and of the kind of humanity for which it is responsible. I agree with the more scientific reviewers of our social order that it is one of the major sores of our civilization.

For years in the back roads of the South I have come across the croppers and tenants sitting listlessly around their shacks. These slaves of an outmoded land system live a dull existence broken only by shouting camp meetings and for the whites by the occasional hullabaloo of a lynching party in which race hatreds and economic jealousies find awful satisfactions. The deep suspicions which have been developed in the South by playing the Negro

against the poor white in the economic struggle are easily inflamed. The poor cropper or tenant farmer, irascible as other southerners and grossly ignorant besides, finds no difficulty in working up violent compensatory rages against the blacks. In southern lynchings the greater number of participants are the very poor who find in the fierce excitements of illegal execution all sorts of strange releases. I have been told that in an alleged rape lynching in Texas, where the poor Negro under torture made confession, that the participants in the business were plainly under sexual excitement throughout the whole horror of the affair. Explosions of racial hate may cover many things.

Lately, it is said, some of the racial prejudice among the poor whites is being broken down by the work of such organizations as the Tenant Farmer's Union. I hope that this is true but it has been my experience, although of some years past, that the major part of the poor whites, croppers and farmers, nurse their racial superiority with even more intensity than the average southerner. It is in fact the only superiority they have, for they live like the Negroes on the miserable "furnishin's" of the plantation stores where prices are generally manipulated so that the value of the cropper's share may not exceed his indebtedness to the furnisher—either that, or they live upon a yearly cash return that is too small to provide even the bare necessities of life. Those fortunate croppers and tenants who do get above the general dead level of their kind and have a few dollars a year with which to trade in town do not actually live much the better for it. While their overalls may not be so heavily patched or their daughters be forced to outright whoredom, their quarters are as dilapidated and their living habits as low as those of the majority of their sort.

The Negroes, with the resilience of their race, take the southern system with no very marked effects on their humanity. They are able to maintain a certain kind of happiness in the face of the world. For the whites, however, the endless grubbing servitude, the vile living, produce devious gloomy and frequently hysterical

psychologies. Rape, incest, and religious ecstasy of the Holiness variety go hand in hand in their hopeless and ignorant lives.

A case brought up in court a short while ago in one of the counties of the border South revealed an old gnarled cropper of eighty-three doing violence to a grandchild of thirteen and getting her pregnant. The girl's parents, unable to support her, had sent her to live with the grandfather in a cabin on the edge of a swamp. The child cooked for the old man. She did not go to school and had no children to play with but passed her days in loneliness while her grandfather was out cutting wood. At night the old man was always wanting to touch her and she in fear kept running away from him and dodging him. These nights of horror finally ended in rape and the courts.

In the promiscuous living of the southern poor whites the question of sex undergoes constant agitation. Sexual comment runs frequently into the vilest forms. I was talking with two farmers on a store front during one of my walking trips in Arkansas when an aged woman came into the store. She was wrinkled, bent, and dirty. As she went in the farmers laughed.

"Ole Aunt May jist about passed her time," one said.

"Naw," said the other, "her ole fiddle is still purty good to play on."

A friend of mine was sheriff in an up-and-coming town in the southern part of Missouri. I dropped in to see him one afternoon just as he was going out on a murder case. He asked me if I wanted to go along. I did. We drove out in the country about fifteen miles and up a rocky, poorly kept country road to where there was a straggling line of tenant shacks. The people living in this community were closely interrelated and had as well all the characteristic secretiveness of poor whites. It took a great deal of questioning to get at the facts of the case in hand but the story that developed was as follows.

The murderer, about forty or forty-five years old, married and with three children, did a great deal of talking about the women

of his community. His main interests in life were apparently cen-
tered on sex, and his tongue was constantly wagging on the matter.
No doubt he had plenty of facts to embroider but he overdid the
business publicly and the husband of one of his subjects took of-
fense. This husband was a cousin of the talker's and I believe the
wife in question was also related. In any case a feud developed
and there were hard words and some rock throwing.

The offended husband owned a rickety Model T truck and he
would drive up every day in front of the tongue wagger's house
and curse him at the top of his voice and challenge him to come
out and fight. The offending gossip didn't fancy a showdown battle
and kept close to his house. His challenger, seeing how matters
stood, increased his taunting. This had gone on for weeks until one
day the gossip, against the prayers of his wife, loaded a shotgun
and took it out in the field before his house. There he was cutting a
crop of horseweeds when his enemy drove up in the Model T truck.
The usual taunts came. There was an exchange of words. Evi-
dently the taunter scented danger for he started to drive off when
the other picked his shotgun out of the weeds and fired. The slugs
took the back of the challenging husband's head off and as his car
ran into the weedy ditch by the road he died.

There was a fellow named Frank in the truck with the murdered
man. He jumped out when the shot was fired and stood looking
at the murderer.

"You done played hell, Elmer," he said.

"You git out o' here," the killer, full of blood lust, replied. Frank
started to walk away.

"You run, you son-of-a-bitch," the murderer yelled.

"What did you do then, Frank?" the sheriff asked when the mat-
ter was being investigated.

"I ran," said Frank.

"Did he leave you alone then?" asked the sheriff.

"Naw, he hollered, 'You ain' runnin' fast enuf,'" Frank replied.

"What did you do then?" asked the sheriff.

"I didn't do nuthin'. I wuz runnin' fast as I could inyhow," said Frank.

We went into the murderer's house. It was better than the average tenant farmer's house. The walls were pasted over with newspapers and the covers on the beds were fairly clean. There was an old woman in there sitting by the stove. There was the man's wife, secretive, dumb, suspicious, unwilling to talk, and there were three little children. One of the children, a little boy about eight years old, had an intelligent, bright, sensitive face. His eyes were big and clear. I thought what a hell of a world he had to look upon.

The tenant and cropper system of the South and of the border states like Missouri, Kentucky, and Oklahoma has bred a race of people who are without the slightest conception of consequence. There are about ten million people living in or near the cotton belt who rarely or never see a dollar and who live in a poverty which makes any cultivation of the sense of responsibility impossible. The whites of this class exist in an atmosphere of gloomy prejudice, animal-like sexual imagery, and clannish hate. Their children grow up like them. Grandfathers rape their grandchildren, brothers stab each other, and violence of all sorts comes continually over obscure and meaningless words. The well-to-do of the South sit on this condition and lift the voice of hate against those who are making some effort to remedy it. I am not sure but that some of the expressed policies of such organizations as the Southern Tenant Farmer's Union are politically quite as unintelligent as are the Marxist efforts among the Negroes, mentioned before, but I am certain that it is only in such movements that we can look for remediable action in the South.

Planters who live on their land and absentee owners living in the cities and large towns complain of the complete lack of responsibility among the tenant and cropper classes. The answer to that is that no opportunity to develop responsibility has ever been given these people. They have no opportunity in many places even to vote. They have no loyalties to society because society has given

them nothing to be loyal to. Some sense of social responsibility is bound to develop from unionization, and thousands of men who have had nothing to live for may find something in the economic ambitions which a union must develop to give them a grip on life. Those who control the South, grooved in habit and prejudice, have a thousand defenses for their system. They look upon all efforts to better it as subversive. They point out some of the undeniable human values that are a part of their ways as if they represented the whole of them. I myself have seen the cropper system work beautifully. I have seen cases where owner and tenant shared not only crops but everything else as well. These were mostly cases of poor farmers who took on tenants, not to squeeze profits from them but simply to keep their land in running order. But I also know of cases among well-to-do landowners where, in spite of heavy economic pressures, humane and decent conditions are prevalent. The men of the South are not evil any more so than they are in other places. They are simply tied to habit. Because, however, of their pride and irascibility, their habits are difficult to deal with and I expect the particular land habits of the South are going to cause some very difficult moments in our American tomorrow.

"What," a southerner one time asked me before I went on the lecture stand in his town, "do you think is the most important cultural factor in the South?"

"The niggers," I answered.

"What do you mean?" he said.

"Just that: the colored people by what they could do in your climate determined your way of life," I replied. "In your childhood they taught you the language by which you express yourself, they made your songs, your jokes, and all else that will stand in your civilization as unique and characterful. They made your political theories, in that it was their peculiar position among you that was responsible for them. They are responsible for the tradition of 'good life' which you have, for without them to do your

work you could not have had that life. Nearly everything you have can be traced to their influence except your architecture, and that is borrowed."

"Don't say that in your lecture," my questioner said.

Who knows the South?

It is a land of beauty and horror, of cultivation and refinement, laid over misery and degradation. It is a land of tremendous contradictions. Southern chivalry is proverbial, but the prewar chorus girls coming back to New York from southern tours spoke of it with contempt. They invariably asserted that the dirtiest and most impolite men on earth were the southern gentlemen who tried to entertain them. Southern whisky is famous over the world, but the majority of the people in the South drink rotgut and like it. The beauty of southern homes has filled both song and story for years, yet the greater part of the houses of the South are dilapidated shacks with no grass in the yards and no flowers within miles.

In spite of the above the South remains our romantic land. It remains so because it is. I have seen the red clay of Georgia reveal its color in the dawn, and the bayous of Louisiana glitter in magnolia-scented moonlight. There are no crude facts about the South which can ever kill the romantic effect of these on my imagination.

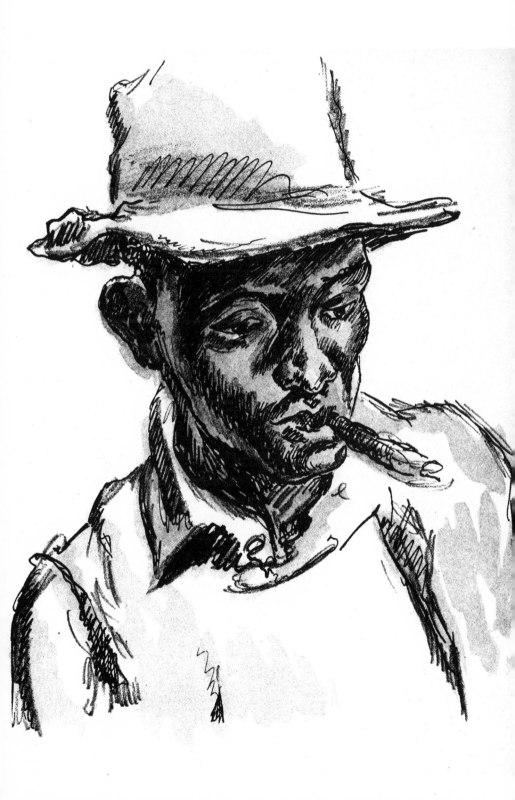

VII

The West

WHERE does the West begin?
Strung in a zigzag pattern up and down the ninety-eight-
degree line, there is a marked change of country which is observ-
able wherever you journey westward, whether in the North, the
middle country, or the South. About this line, though the exact
distance from it is highly variable, the air becomes clearer, the
sky bluer, and the world immensely bigger. There are great flat
stretches of land in Louisiana, there are prairies in Illinois, Iowa,
Missouri, but the experienced traveler in the United States does not
confuse these with the West. Even though these more eastern
prairies may present the same great vistas which are connected in
our thoughts with the West, they lack the character of infinitude
which one gets past the ninety-eight-degree line.

In the prairie lands, coming between the old forest country of
the Middle West and the plains, one is able at times to see for
great distances, but it is as if one were set down in the center of
a big plate with elevated edges. There are definite ends to the
horizon, which acts as an enclosure and sets a limit to things. In
the West proper there are no limits. The world goes on indefinitely.
The horizon is not seen as the end of a scene. It carries you on
beyond itself into farther and farther spaces. Even the tremendous
obstructions of the Rocky Mountains do not affect the sense of in-
finite extension which comes over the traveler as he crosses the
plains. Unless you are actually in a pocket or a canyon, the Rocky
Mountains rise in such a way, tier behind tier, that they carry

your vision on and on, so that the forward strain of the eyes is communicated to all the muscles of the body and you feel actually within yourself the boundlessness of the world. You feel that you can keep moving forever without coming to any end. This is the physical effect of the West.

There are many people for whom this effect is unbearable, especially as it is manifested on the great plains. Cozy-minded people for whom life's values reside in litttle knickknacks which must be kept within easy reach, people for whom the sense of intimacy is necessary for emotional security, hate the brute magnitude of the plains country. All their familiar urges are inhibited by the great empty stretches of land and sky, by the immensity which reduces even a city to an anthill. Time and again on motorbusses and trains I've heard people complain of the monotony, the weariness, the oppressiveness of the plains. I've heard them groan over the misery of their journey.

For me the great plains have a releasing effect. They make me want to run and shout at the top of my voice. I like their endlessness. I like the way they make human beings appear as the little bugs they really are. I like the way they make thought seem futile and ideas but the silly vapors of the physically disordered. To think out on the great plains, under the immense rolling skies and before the equally immense roll of the earth, becomes a presumptuous absurdity. Human effort is seen there in all its pitiful futility. The universe is unveiled there, stripped to dirt and air, to wind, dust, cloud, and the white sun. The indifference of the physical world to all human effort stands revealed as hard inescapable fact.

Always stewing somewhat over ideas that dissatisfy me, over techniques that fail me, over all sorts of undefined or vaguely sensed human urges, the plains afford me an immense freedom of spirit. Contrasting what is within me with the immensity outside, I get a proper sense of the consequence and significance of my concerns. I am not sure that I should like to live on the plains, that is, in one place. The great reaches of land bring out my nomadic

urges and make me want to keep moving all the time. An active physical life would be necessary for me out there.

The people who make their living on these open lands have in their characters something of the largeness of their surroundings. The plains farmer does not raise his crops under his back doorstep but on the great curve of the world. His manners and physique reflect his environment. Your true plainsman is sparse of words, as if he sensed the futility of talk in the face of the infinitude about him. Cowboys, sheepmen, and the workers on the tractors and combines in the wheat country speak little and enunciate slowly. They are big, silent fellows for the most part. It is true that they are capable of yelling in pure physical exuberance and of making a lot of noise on a day off in town when they have access to a bottle or so, but they are not wordy like city people. They are not given to chatter or to playing with ideas. On the other hand, they are not dour. They are ready with friendliness. They greet you easily and without reserve.

Where industry has sunk its steel into the plains country as in the Panhandle of Texas, there is a change in the character of the people. This is inevitable because industry develops its own particular psychologies. But even on the industrial community, the wide environment has its effect. There is a great difference between the oil towns of Pennsylvania and those of Texas. There is a great difference even between the oil towns of east Texas as compared with those of the Panhandle to the west. This difference is beyond accurate description. The industrial equipment is the same. The people who work do similar things. And yet they are not the same. They act differently. Even their vices have a different flavor.

I was in the Texas Panhandle when Borger was on the boom. It was a town then of rough shacks, oil rigs, pungent stinks from gas pockets, and broad-faced, big-boned Texas oil speculators, cowmen, wheatmen, etc. The single street of the town was about a mile long, its buildings thrown together in a haphazard sort of way. Every imaginable human trickery for skinning money out of

people was there. Devious-looking real-estate brokers were set up on the corners next to peep shows. Slot machines banged in drug-stores which were hung with all the gaudy signs of medicinal chicanery and cosmetic tomfoolery. Shoddy preachers yowled and passed the hat in the street. Buxom, wide-faced, brightly painted Texas whores brought you plates of tough steak in the restaurants and said insinuatingly, "Anything moah I c'n do foh you all? Ah'm here to ple-e-eaze, boys."

The Texas rangers had charge of Borger when I was there. It was too tough for local government. Whenever any elected officer attempted to attend to his duties, he got shot. The day before I arrived in Borger there had been a cleanup of the town. Several hundred whores, bootleggers, gamblers, and rough characters had been chased out on the plains. Every unattached person was questioned. Among adventurous girls whose business in the town was open to question, there had been a wild scramble for waitress and chambermaid jobs. Several of the rough board hotels carried suggestive appeals: "Nice girls wanted here as helpers." This was an indirect indication of where complaisant girls could be found.

The hotels that had bathtubs advertised the fact. They charged as much for a bath as for a room. Most of the people around Borger didn't take baths. It was useless anyhow, for the wind was liable to come up at any minute and blow all the dust of the unpaved rutty streets down your neck.

Out on the open plain beyond the town a great thick column of black smoke rose as in a volcanic eruption from the earth to the middle of the sky. There was a carbon mill out there that burnt thousands of cubic feet of gas every minute, a great, wasteful, extravagant burning of resources for momentary profit. All the mighty anarchic carelessness of our country was revealed in Borger. But it was revealed with a breadth, with an expansive grandeur, that was as effective emotionally as are the tremendous spatial reaches of the plains country where the town was set. One did not get the feeling, in spite of the rough shacks and dirty tents in which

people lived, of that narrow cruelty and bitter misery that hovers around eastern industrial centers. There was a belief, written in men's faces, that all would find a share in the gifts of this mushroom town. What if evil and brutal things were being done—people forgot them quickly and laughed in an easy tolerant way as if they were simply unavoidable and natural hazards of life, as inescapable as a dust storm. Borger on the boom was a big party—an exploitative whoopee party where capital, its guards down in exultant discovery, joined hands with everybody in a great democratic dance. Rich and poor whooped it up together over the crowded oilcloth table covers of the "beaneries."

The road to Borger from Amarillo, the metropolis of the Panhandle, had no definite edges. Whenever the rains fell heavily and bogged the commonly used road, the traveler simply moved his car over on the grass and went ahead. A few months of this had worn a path a quarter of a mile wide. When the winds came up on this path you simply had to stop driving, for they raised a blinding and impenetrable dust which made every turn of your wheels a hazard. After the whores were run out of Borger they patrolled this road in carlots. They were in hilarious spirits, as if their forced evacuation of the oil town were just a playful thing of no consequence. They had high, slightly nasal voices. They waved and greeted the male traveler with a "Hi, boy! Whe'ah you all goin'?" They were powerful-looking gals for the most part. From their general appearance I surmised that no one but a big Texas buck could ever hold one of them down on a mattress. They were built not for sexual play but for roaring battle.

The women of the western plains, like the men, run frequently to bigness. They are strapping. In the cities and towns they use an incredible amount of face paint. In the days of short skirts they wore them shorter than anywhere else and displayed an awful amount of beef. When things first began to boom in the western oil countries, the population was predominantly rural and old-fashioned, and women were always months or even years behind

the fashionable styles. With the rise of the parvenus of the new industry, stories of the grand flow of loose change in the mushroom cities came to the ears of the loose and adventurous all over the country. Along with gamblers and shysters there was a rush of painted and blondined girls to the scenes of the pickings. A lot of them were smart and attractive. They were the models on which the native girls of the oil countries first patterned themselves. Something of the character of these first models still hangs to the appearance of the flappers of the West. They run to gaudiness whatever their social stratum.

I was riding around a certain western city with a friend in the employ of one of the big oil companies located there. It was late evening and the streets were full of people—men, women, and girls. We were stopped by traffic at a crowded corner. A particularly good-looking young woman, painted up like a barbershop pole, stopped alongside us. This girl was not mammoth, like so many of the others about. She had reasonable and pleasant human proportions. Through her transparent short skirts silhouetted against the bright lights of the stores, you could see everything she had. In a spirit of fun and show-off, I leaned out of the car.

"Hello, Honey," I said.

She gave me a shocked, offended stare and turned on her heel.

"For God's sake!" my companion exclaimed, "that's my boss's daughter."

From her appearance I judged she was just one of the girls of the town, though more appetizing than the usual run.

The Indians of the great plains were nomads. The cattlemen who followed them were restless fellows who lived mostly under the open sky and made long yearly treks to market. The Indians camped out in tents. The first cattlemen camped also for the most part in long one-story mud-and-log shacks. Later they made more substantial dwellings but these kept the character of their first rough shelters. They rambled along next to the cattlesheds, stables, and

corrals in an unkempt loose fashion. Even today the majority of
dwellings on the plains have the character of mere windbreaks,
mere covers to keep out the worst of the elements. Their gray
warped boards set on fragile posts have a puny unsubstantial ap-
pearance. Even the houses that are painted to make a sort of brave
showing rarely look finished. They never seem nearly so complete
as the Mexican or Indian mud dwellings of the far Southwest which
cling to the land and seem to be a lasting part of it. About most
of the houses of the great plains a makeshift character persists as
if people were never quite sure that they would remain planted.
Hopeful women set out flower gardens under their front doors
but the wind comes along and makes a mess of their efforts. The
dust of the fields is blown against new paint and the lower halves
of most of the houses are dirty brown or red, so that they look
like soiled bedraggled bedclothes hung out to air.

The most substantial things in the little western towns are the
grain elevators and water tanks by the sides of the railroads. These
stick up and face the open land with the hard defiance of their
utility. In the centers of the larger towns, by constant watering and
care, shrubbery is made to grow, and intimate greeneries are suc-
cessfully propagated, but once on the edge of town the sense of
impermanence in man's settlement is felt again.

In tune with this impermanence, especially in the southern part
of the great plains, in western Oklahoma and Texas, there is a
great drift of nomadic people, of wandering workers who amble
from place to place looking for the wherewithal to live, much as
did the Indians in the old days. Even in the late twenties, in the days
of prosperity, these western wanderers were plentiful. With their
bedding and baggage loaded on an old Model T car, whole families
could be seen chugging along the road throwing dust into the wide
staring faces of the sunflowers lining the way. These nomads of
the plains run north in the summer and south in the winter. Fre-
quently they are in great demand in the cotton picking season.
Seven or eight years ago cotton farmers were waylaying them on

the road trying to outdo each other in offering accommodations. There was a dearth of the nomadic pickers.

I was stopped on the road myself by a farmer one hot September afternoon. He came out from the edge of his field when he saw me coming. He was picking his cotton by himself. He was a tall fellow in his early forties. He had pads sewed on the knees of his faded overalls to protect him as he knelt in the squat rows of the plains cotton. Without asking me whether I wanted to pick or not, he began reciting the advantages of working on his place.

When he saw that I was not a field worker he began to cuss. "They's a-bin twenty outfits come by here today and I ain' bin able to git a one of 'em to put up. I got as good a bunch of cabins as there is in the country. I got good water and I'm a-offerin' more per hundred than I ever did before. This is the best crop we've had here in years and jist when we git a crop, them damn tramps won't work. I don't know where they think they're a-goin'." He climbed back across the road ditch, adjusted his picker's bag to his shoulders, and knelt down in his cotton. He was all alone in a field that stretched on and on until it faded into a lake of distant heat waves where some houses and a grain elevator floated in shimmering illusion. The magnitude of his task was appalling.

Out in the extreme western part of Texas, north of the Pecos country in a shady pecan and live oak grove, I once met an entertaining western wanderer. He lived in a delivery truck in which he had set up a stove and bed. He had a gun and a dog. He was about sixty-five years old, and was hale and hearty and full of broad laughter. He never left the state of Texas but wandered about following the sunshine. In the winters, he camped out along the southern Rio Grande, and when spring came he traveled north into the highlands. He fished and loafed. His history was interesting. All his younger life he had lived on the Atlantic Ocean in boats and ships. He had been a sailor in the Navy. When he was too old for service he was discharged with a pension. Wanting, for

some obscure reason, to get rid of the sight and thought of salt water, he had drifted out to Texas to spend his declining days as a land wanderer there. I asked him if he ever got lonesome.

"Why God damn it, boy," he said, "I lived the most of my life with sons-a-bitches orderin' me around. I'm so damn glad to be by myself that I can't speak it. When I go to bed at night I don't have any slobber-lip snorin' in my ears and in the mornin' I get up if I want to an' I stay abed if I want to. Lonesome—they ain't no such word for me. I've ben close to all the people I want to in my life. I got enough of 'em fer good.

"Besides," he went on, "there's plenty on the road like me to talk to if I wanta talk. Inside a week this place here'll be full of travelin' people. It'll be so full I'll have to move on. This is a nice place to camp and others but me know about it. Why last year they was a thousand or more Methodists come out here from all over Texas to a camp meeting. You'd a thought all the coyotes in the country had got together. God, boy," he ended, "I don't have to be lonely out here. I wanta be."

Bill and I drove into a little one-horse dust-blown cattle town at noon. There was nothing there but some cattle pens by the railroad track, a row of battered false fronts, and a few warped gray dwellings. There was a sign hung up by one of the false fronts on which was printed amateurishly, "Pete's Lunch." We went in there. There was a pasteboard card tacked up on the wall behind the board counter. It said in big letters at the top, "If your wife can't cook, come here—We can." The menu was printed below. It listed "Ham and Eggs," "Fried Oysters," "Hot Tamales," "Steak and Onions," and "All kinds of Pies."

A big fat man with a dirty apron tied around his middle sidled out from behind a curtain that led to the kitchen. He looked at us questioningly.

"What'll you have?" he said.

Bill looked at the menu. Perversely he ordered fried oysters.

"We ain't got no oysters," the man said.

"Well, I'll take some fried ham," said Bill.

"We ain't got no ham," the man replied sharply.

"How about frying me a couple of eggs?" Bill ventured.

The big fellow assented with a contemptuous grunt.

I ordered fried steak.

We heard him out in the kitchen. Pretty soon a strong sulphurous rotten-egg odor pervaded the place. We heard a muttering curse and the man came back. He looked at Bill menacingly. "Young feller," he snapped, "we ain't got no aigs."

"Well, I'll take a piece of pie and a glass of milk," said Bill.

"Young feller," said the man, "ef you wanta eat here you'll take fried steak."

Bill took the steak.

During wartime, the demand for wheat put the plow on a lot of new land in the west of Texas. Ambitious young farmers took up holdings in outlying places. I heard a terrible story about one such venture from a filling station keeper near Dalhart, Texas.

A young man with a wife and two children located way out on the open plain in a lonely spot reached only by a dirt trail from the highway. They were far away from any other people, fifteen or twenty miles if I remember correctly. The land where they located had never been broken. It was as wild as in the days of the Indians. There was nothing but grass and mesquite as far as you could see. The young farmer built a one-room house to live in. He set it about six inches off the ground.

After he got his house built, he would crank up his old car and go away to work at odd jobs around already established farms. He did this in order to accumulate enough cash to get the implements he needed to start life on his own. He would leave his wife and children at home. One of his children was a nursing baby, the other a couple of years old. The woman would get terribly

lonely in her house. She talked to her babies and listened to the winds. That was all she had to do.

One time the husband was kept away for a considerable period. Days went by and he didn't come home. The woman always closed her door tightly as soon as the sun touched the horizon, for in the cool of the evening the prairie rattlers came out and crawled in the grass around the house. They commenced going under the house. Their dry sharp rattling could be heard under the single-plank floor whenever the woman moved about her work. She became obsessed with snake fear. Her evenings were terrible.

One day, when she went out to spread a washing in the sun, she let go the door and the wind caught it, slammed it briskly against the house, and split off the plank to which the upper hinge was screwed. The door hung crazily. The woman ran to hold it but the wind caught it again and twisted it off the lower hinge, which wasn't strong enough to hold the weight of the heavy planks of which the door was made. The door fell down. The woman looked for a hammer and nails to try and fix it. She found that her husband had taken all the tools in his car. She lost her head and couldn't think of any way to barricade her door against the snakes. She was mad with the fear that they would come in the house when the sun went down and strike the babies. She had an ax handle and when evening came she got it and sat in the open doorway. That evening she killed a dozen snakes. She was frightfully afraid but she gritted her teeth and went after them. She sat up all night. The next day she squatted in her doorway and looked at the snakes she had killed the evening before. When night came her fear of the reptiles was so great that she took her children in her arms and with her ax handle started for the dirt road that led to the highway. She must have met rattlers on the way for she went completely crazy about her direction and turned off on the open plain, where a farmer found her the next day in a state of utter collapse. She never remembered what she did that night. Her mind went blank after she left her door and fled from the rattlers.

I believe this story. One time, some eight or ten years ago, I drove from Amarillo, Texas, with Larry Olds, a geologist employed there, to visit a wildcat well situated out on the plains some eighty or ninety miles from town. The cook who had charge of the camp at the well said that when they first set up their quarters, the rattlers were as thick as ants. He said they killed them by the gross lot. About sundown, as we started to go back to town, we found a rattler within a few feet of the car. The camp boys cut off a piece of mesquite and kept him occupied while I made drawings of him. The prairie rattlers are not big like the southern species of Georgia and Florida but they look just as mean. They coil and snap like lightning. We saw a dozen that evening right in the way of the car. We could have found enough to start a snake farm without half trying. These snakes seem to bank together in tribes. They are not to be found everywhere but you can be pretty sure that if you find one there are a lot more about.

There are dozens of legends about the rattlesnake among the cow hands and farmers of the West. One fellow said to me, "There ain't nothin' on the livin' earth as fast as a rattler. You know why you always hits a rattler in the haid whin you shoots 'im?"

"No," I said. "Why is it?"

"Well, I'll tell you what's the fact," he replied. "The rattler sees the bullet a-comin' an he strikes it. He hits the bullet. The bullet don't hit him."

There's a crazy, farfetched tale of an old cattleman who bought a new pair of boots. On his way home from town he got off his horse for some reason or other and was bitten by a rattlesnake. He died. Some time later his son, seeing the old man's boots in a corner, put them on and went to work. That night he got sick, swelled up, and died. There was a scratch on one of his legs. Nobody knew why he died. A little later another member of the family put on the boots, which were still new. He died also with a scratch on his leg. I've forgotten how many people died from wearing the boots, but the tale has it that the mystery was finally solved by dis-

covering a couple of rattlesnake fangs in the boots. They had broken off there when the old man had been bitten and had continued to bite all those who wore the boots later!

They say that rookie brakemen going to work on the plains' railroads are given those whirligig rattler toys which are used for noisemaking at carnivals and fairs. They are told to whirl them before they approach a switch because a rattlesnake might be coiled up there. The new brakeman is led to believe that when he sounds his toy loudly the rattlesnake in the switch will think a bigger snake is near and will evacuate his post.

A generally prevalent story about rattlesnakes says that when they are close to death, they will strike themselves. I don't suppose there is any real basis for believing that a snake in extremity will commit suicide, but of the dozen or more rattlers I have seen killed most of them actually did bite themselves. They may simply have mistaken their own bodies in a mad rage of pain for the stick or stone that hit them, but they appeared to be deliberately putting an end to themselves.

The pioneer West has gone beyond recall. The land is largely fenced. There are no more great cattle treks. Solemn Herefords have taken the place of the wild-eyed longhorns of the old days. There are no more six-shooter belted cowboys. The tough work of the cattle business is done by plain cow hands and fence tenders. On the trails to Wichita and Dodge City, where the hard-riding boys of the old days used to drive their long strings of cattle, the tractors and the combines are chugging.

But the West clings to its past. It does not acquiesce in the official ending of the frontier in 1890. It does not readily let go of the drama of its first wild days. Every dust-blown town that can rake up the money has its yearly rodeo and wild West party where mighty and brave efforts are made to resuscitate the glamour of yesterday. The big doings of these parties center around the cow business, many of whose common chores have been ritualized and

made into well-patterned and exciting competitive games. The western country supports a large number of men whose main business in life is to perform in these games. They are the cowboys of today as distinguished from ordinary cow hands. They are tough birds. Let no one get the idea that the cowboy of the rodeos is just an actor dressed up and playing a part.

Once during prohibition days I went with a party of Texans over to Jaurez, across the river from El Paso. In one of the honkytonks I met the champion broncobuster of Montana, who had been a goodly prize winner in the El Paso rodeo, just terminated, and who was out celebrating with the proceeds. I made two sketches of him and gave him one. He took a shine to me and insisted on buying me drinks whether I wanted them or not. The Mexican whisky sold over the bars was all dressed up in labeled bottles, but it was the worst sort of tobacco-juice corn and hard stuff to down.

After swilling a couple of Montana's treats, I began shooting the others in a spittoon on the sly. I didn't want to get drunk on the stuff. But Montana drank his whisky and in about ten minutes got roaring tight. The tighter he got the more love he had for me and I couldn't get away from him. He was a thick fellow, one of the kind that country boys call stout. He didn't look like an athlete but when he put his arm around me in a drunken embrace I felt that I was in a trap. He was as hard as steel all over. Every once in a while when he'd let go of me, I'd make a move to get away. But quick as a flash he'd have one of his arms around me again and insist on another drink. My friends sitting at an adjoining table were having the time of their lives laughing at my predicament but they made no move to help me.

This joint was full of representatives of the border demimonde. Montana invited an immensely painted and perfumed pair of them to sit at our table. "I'll buy the drinks and you'll feel up the gals," he whispered. When I declined the job he hit me a mighty slap on the back that nearly busted me. The minute, however, that the

girls sat down he got tame as a lamb. He was afraid of them. While he was trying in an abashed way to make talk I slipped away.

Later in the evening he found me again in another place. When I came in he jumped on my back. He it was I bucked off, as told before, in a beer-throwing lady's lap. This, however, was just a piece of blind luck for his agility and his strength were unbounded. He must have been absolutely tireless for he had ridden wild horses all day and yet was capable of carousing as actively all night as if he had spent the day in bed. He was as tough as they come. The last I saw of him he was in the hands of a couple of pals who were trying to get his lurching body over the Rio Grande bridge before closing time. A few years later I heard he was in some penitentiary in the Northwest for killing a man in a drunken bout.

All of the fellows who do the hard riding and pull off the dangerous stunts of the rodeos are tough—not vicious, but just physically tough. As experts, they are also in a class by themselves. They are artists of a kind, and they have all the vanity of the performing artist. Like boxers, wrestlers, actors, and others whose arts involve personal display, they are highly self-regarding and inclined to give much attention to appearances. The cowboy performer is particular about his shirt, his boots, his spurs, and his saddle. During the rodeo season, he is in the spotlight and must live up to his part. The big shows like the Cheyenne rodeo in Wyoming attract thousands of visitors. They are well-organized affairs and offer big prize money as well as much publicity for the winners of the events. From all over the West, young men come to compete before the crowds that gather. After a while, if they are good, they become thoroughly professional and live for and by their performances—like circus people.

Beside the big nationally advertised rodeos, the small-town ones seem amateurish. But for me they are vastly more entertaining. Most of the performers are local boys who are still actually in the cow business. The competition for prizes, even though the prize money be small, is just as strenuous as in the big highly touted af-

fairs. The riding is just as wild and the enthusiasm of the people in the audience is intensified because they know all the contestants.

In 1930 I went with Glen Rounds to a Fourth of July rodeo in a small town in the middle of Wyoming. Glen and I were riding around the back country making drawings of the West. Glen, like Bill, was an old student of mine. He came from the Dakotas but he knew the ropes in this Wyoming country. He knew where to find a good thing. We got into the rodeo town on the day before the show, on the third of July, and located a cabin which we rented for two bits a night.

There was a cowboy in the cabin next to us, a fellow named Tex something, from Fort Worth, Texas, who was a professional horse-buster and rodeo performer. He and a pal of his from New Mexico were the only professionals in this back-country show. They were limbering up for the Cheyenne games after a winter of loafing down in the Rio Grande country. Tex had a split lip and a wife. (I have a picture of him in the Whitney Museum murals. He's the fellow in the big hat rolling a cigarette.) When we unloaded at our cabin, Tex, his wife, and his pal were playing cards on their doorstep. We made friends with them. I told Tex that we wanted to have the run of the field when the rodeo started so that we could make drawings. He said it would be easy to arrange and directed me to a hotel where he said "the boys" running the show had a room for the registration of contestants. I went to the hotel. It was the regular frame hotel of the western town, a square box with a porch in front and a lot of old barrels, tin cans, and junk in the back.

I found the boys who were running the rodeo established in a front room overlooking the street, where a traveling carnival was just finishing nailing up its booths. They were all hanging out the windows looking at the activities below. I had to yell to get their attention, for people were beginning to shoot off firecrackers and a brass band near by was making bitter efforts to get tuned up. The directors of the rodeo were young. They had on ten-gallon

hats, the first requisite of cowtown officialdom, and gaudy shirts of explosive green and cerise.

"Howdy-do, gentlemen," I said when I got their attention.

"Hello, boy," they replied. "Whatcha want?" They looked me over with broad patronage, trying to size me up.

I explained that I was an artist and that I wanted the run of the rodeo grounds in order to make pictures of the events of the morrow.

"A artist—" said one, "are you a perfessional?"

"Sure," I answered.

"Whut paper you on?"

"I'm from the Denver *Post*," I lied, sensing that they would only recognize professionalism with a publicity value.

"By God—are you, mister?" they chorused. Their patronizing airs evaporated and they turned very suddenly respectful.

"Yes," I said, "I've been sent out to find a good typical western rodeo. We're going to play it up in a Sunday edition. I heard that you were going to have a good show here."

"By God, mister, you're right. You come to the right place," one said.

"Yes, and by God, you're gonna get treated right," said another. "Say, Jim, git it out."

Jim went down under the bed and hauled out a gallon jar of bootleg. He filled four dirty glasses on the washstand about to the brim.

"Well, boys," he said, raising his glass, "this here's a break for us." Turning to me, "And it'll be a break fer you, mister, 'cause we shor'll appreciate you. We're havin' a big-time rodeo an' we'll fix it so you can do big-time stuff fer yore paper."

After some wrangling as to the proper procedure, they wrote me out a slip of paper which said, "The bearer of this, Mr. Thomas H. Benton of the Denver *Post*, is the official artist of the day. Every courtesy given to him will be appreciated."

They all signed it.

I said, "Say, I forgot to tell you there's another artist with me. He's working on this job too, and'll have to come with me."

"Oh, that's all right," they replied. "He don't need any paper. We're just givin' this to you to make it official. You and yore pardner just go anywheres you want to. We'll know you."

"Say, boys," said the fellow called Jim, "these boys ain't likely got no horses. Do you need a horse, you think?" He turned to me.

"No, no," I said, "we don't need horses. We couldn't work in the saddle." I was a little uneasy. I knew I couldn't ride the Wyoming cow ponies these fellows were used to, and I knew they would think I was a dude and a sister if I couldn't. "No," I said, "we've tried that—working from the saddle before. It don't go. You've got to have your feet steady on the ground to do our work."

"Yes, guess that's right," they agreed. My mind was eased.

That night there was a big to-do in the town. The band got tuned up and marched around the street playing as loud as it could. There was a crowd. All of the country farmers and ranchmen who could find a place to stay were in with their families. The carnival barkers whooped up their wares and games. Little girls and boys from outlying places looked wide-eyed and scared. The metropolitan din was too much for them and they clung together in little knots for all the world like scared calves. Their folks walked solemnly around the carnival booths. Occasionally someone would take a chance throwing a ring or a ball. They were curious but not very free with their dimes. The carnival made a lot of noise but so far as I could judge very little money. These country westerners were skeptical and cagey. I heard one fellow say warily, "They ain't no use playin' them bingo games. They's all ribbed up to take you."

Glen and I got up early next day and went out to the fairgrounds where the rodeo was to take place. We followed a string of people who were out to get good places. The fairgrounds were not fenced but there was a little grandstand there. An old-fashioned starting tower faced it across the race track. In the center of the field the

corrals were located. The rodeo impresarios in their cerise shirts were already out. So was Tex, our cabin neighbor, and his pardner. They and a crowd of yelling cowboys were busy trying to round up a bunch of wild horses that had broken out of an enclosure in a field adjoining the fairgrounds. It looked for a while as if a good part of the animals were going to get away and make a run for the mountains. There was nothing to stop them if they broke the loose encircling cordon of cowboys. The situation was precarious and our impresarios were obviously uneasy. They didn't dare let the main part of the show get away.

As people began coming into the grounds by horseback and car, they were ordered to take places in a great half-mile circle around the horses. After a while it looked safe to start the arrivals toward the fairground corrals. When the boys got them started I climbed up on a post near one of the corral gates. The cowboy who opened the gate yelled at me, "Git off, there!" I didn't pay any attention to him. I was too interested in the oncoming horses. The whole herd in a close, turbulent knot came pounding toward me raising a cloud of dust. About a hundred feet from me they broke and began turning and milling in all directions. A voice yelled, "Git that son-of-a-bitch off the fence. Ain't he got no sense!" Realizing suddenly that I was scaring the horses, I climbed down and got out of the way.

It took three-quarters of an hour to get the herd corralled. There was one handsome black pony that kept breaking away. He'd light out through an opening in the crowd and start for the mountains. My neighbor Tex finally lassoed him and he was shut up with the others. I climbed back up on the corral gate and started to draw some of the horses. A truculent cowboy rode up to me. He shouted, "Git off'n that fence. You done caused us enough trouble already. Who the hell d'you think you are?"

"I'm the official artist," I shouted back, dragging out the paper confirming it.

"What the hell is that?" he yelled.

"Leave 'im alone, Pat, leave 'im alone." Jim, the impresario, rode up and saved me. His cerise shirt was streaked with sweat and dust. "That's the artist from the Denver *Post*. He's a-makin' hand pichures fer the paper."

The crowd on the fairgrounds got thick. Some of them began piling in the grandstand. Nobody was taking tickets. The rodeo managers got together to consult on the matter. They hadn't counted on so many people coming out before noon. Spectators were supposed to pay twenty-five cents to come on the fairgrounds and fifty cents to sit in the grandstand. The managers and some extra helpers who had long yellow ribbons tied to their hats went over to the grandstand.

"You fellers got your tickets?" they yelled. "If you hain't, git out yer money. We're comin' to collect."

The grandstand sitters rose in a body and fled. They swarmed across the field and perched on the supporting fences of the corrals, where a big crowd was already roosting. The managers followed them.

"Say, you fellers can't get away with this," they said. "You got to pay yer two bits fer this show. This ain't no free show."

"We're payin' this afternoon," someone yelled. "This ain't no show this mornin'. We ain't payin' jist to see you fellers run them ponies in."

Jim, who was apparently the leader among the managers, made a conciliatory speech.

"Well, that's right, boys," he said. "That's right. But after dinner it's a show and you fellers must pay yer two bits fer comin' on the grounds. We been at a lot of expense gittin' up this show an' had plenty trouble gittin' the prize money donated. You fellers got to help us pay what we owe. Now if you fellers'll go out of the grounds and come in by the road an' pay yer two bits before the show begins after dinner, we'll be obliged to you. Now I'm jist a-thankin' you fellers beforehand fer the way you're gonna help us."

Most of the crowd got off the fence and scattered toward the edge of the fairgrounds. Glen and I went to town to get something to eat. Hundreds of people had come in from the country during the morning and the one restaurant of the town was jammed with an impatient army trying to get waited on. The hotel dining room was full also. Ranch people sat on the street curbs and in their cars and ate their lunches out of shoe boxes just as the Missouri farmers used to do in Neosho when I was a kid. Glen and I bought a can of beans at a grocery and some cookies at a lemonade stand and ate our lunch in the middle of the street.

The rodeo was scheduled to begin at two o'clock. By one the road to the fair grounds was jammed with a string of halting sputtering cars and farm trucks. Five or six hundred people were strung out walking on the side of the road. When we got out to the grounds, we found a line of men on horseback collecting tickets and quarters. A lot of the people on foot would slip past them without paying anything. The collectors would try to catch them.

"Now, boys, you gotta do your part. Come on, pay up yer money." Sometimes they were successful in collecting a quarter or so, but in the confusion of cars, horses, people, and dust, most of the shirkers got by.

Jim, the impresario, in his sweat-streaked cerise shirt was trying to be everywhere at once. His temper was getting short. A sudden rush of boys and men in overalls down beyond the line of admission collectors raised his ire.

"Head off them damned sheep herders," he yelled. "We ain't gonna let everybody in here fer nothin'." A couple of horsemen tried to head the gate rushers off but they dodged around the crowded cars and trucks and were lost. By two o'clock there must have been between four and five thousand people scattered over the fairgrounds. They perched all over the corrals and all over the race track fence in front of the grandstand. They stood up in trucks. The grandstand with its fifty-cent seats was guarded by a row of ticket collectors. It was about half-full. Half a dozen eastern people

from a dude ranch somewhere about were grouped in a knot off on one side of the grandstand. They were about half-lit and were in a hilarious mood. They cheered everybody that came in the stand.

About two o'clock a fellow in an A.E.F. suit climbed up in the starting tower and blew on a bugle. Then the three gaudy-shirted impresarios pranced their horses out in the track before the grandstand. The fellow named Jim had a megaphone.

He said, "Ladies and Gentlemen, we're all ready here to start our show. We've got some fine workers here and the boys is rarin' to go. But we ain't gonna make a bit of a start till the corrals is cleared and the track is cleared. Now," and he turned toward the corrals whose fences were lined with grinning men and boys, "if you sheep herders want this show to start you git out of the field on the other side of the track. About half of you sneaked in here anyhow. If you can't pay, at least git out of the way so the people that has paid can see."

A bunch of cowboys began riding around in the crowd urging the sheep herders across the track. Only contestants were allowed to stay about the corrals. As official artists, Glen and I were permitted to remain on the fence by the main chute through which the bucking horses were to come. When the way was partially cleared, for it was impossible to get all the crowd across the race track, the rodeo started. First a Senator Something-or-other made a Fourth of July speech, then the band marched around the field and filed up on a platform in front of the grandstand. The grandstand itself began to fill up.

Jim got out his megaphone again and addressed the crowd. He thanked the senator for his fine speech and then said he had a special announcement. "Ladies and gentlemen," he shouted, "after the contests in the field is over, right here in front of this grandstand where the band is, we're going to put on a boxing bout between the Butte Wildcat, that famous Montana boxer, and Wyoming Jack Sullivan. These are famous boys, as you all know, and this here is a

grudge fight an' it'll be a good 'un. All of you that wants to stay can pay a dollar extra for your seat and just stay where you are. Ticket sellers will be around after the field contests."

There was a great cheer. The bugle blew and the rodeo was really on. It was the usual thing—calf roping, steer riding, bulldozing, and broncobusting. The contestants wrangled and quarreled, the crowd cheered their favorites and roared at every mishap. A couple of boys got badly thrown in the broncobusting contest, but they came to after a sponge of water was squeezed in their faces by the "official" doctor. They limped off the field under the plaudits of their friends and kinsmen. The crowd of sheep herders had all swarmed back toward the corrals during the progress of the show, and when it was time for the wild horse race, the last event on the program, the business of getting them off the track had to be gone through with all over again. A wild horse race is exciting even in the big standardized rodeos. Here it was an elemental battle. There were ten riders and only one got his horse clear around the track for the prize. The rest were bucked all over the field in and out between scattering sheep herders. It was a good rodeo.

When it came time for the fight only a dozen or more paying spectators remained in the grandstand. The band filed down from the ring, and Jim got up and announced that the boxers "wuzn't gonna fight for two bits and if more folks didn't come through, he didn't think they'd be any fight." He appealed to the sporting instincts of the people, who were hanging around thick as bees, but it didn't do any good.

That Wyoming crowd hung onto its pocketbooks and in the end the fight was called off and everybody went home. I saw the Butte Wildcat that evening in town when they were having the fireworks. He was as fat as a hog, so I judged the crowd knew what it was doing when it refused to disgorge to see him perform.

Glen and I beat it at sunup the next day. We didn't want to an-

swer any questions about when our feature was to appear in the Denver *Post*.

In the southwestern part of New Mexico there is a great and extensive forest. The forest land is mountainous and rugged. It lies northeast of a mining town where there are hotels, beaneries, stew joints, and waitresses. The way into this forest when Bill and I went there led over a narrow rutted road just wide enough for a car. We went to camp out and take it easy after some eight thousand miles of driving. We had heard about a certain gorge in the forest where there was a cabin used by hunters and fishermen. A fellow in a Silver City beanery told us about it. He said that was where the town boys went when they stayed overnight on hunting or fishing trips. We had a couple of thin mattresses and some blankets. We stocked up with groceries and started out one morning. Our directions were faulty and we kept driving off on blind trails.

We spent the whole day without locating our camp and when night came and we couldn't go any farther we threw our mattresses down by a stream in a narrow canyon and prepared to sleep. We were too tired to cook anything to eat. For two months of steady driving our kidneys had been pounded by the vibrations of the car seat and we were just about done for. It was September. September nights in the mountains of New Mexico are cold, so we had to drag out everything we had to cover us, even our tarpaulin. We lay on our backs and looked up into the sky. The stars seem unusually bright and clear from the bottom of a canyon. We remarked on the matter. We talked a little now and then. The intervals between our words lengthened and we began to doze.

I don't know whether we got to sleep or not but suddenly we both sat up with the sound of a wailing screech lingering in our ears. The screech echoed in the canyon sides and hung in the tops of the tall pines. Even when it had completely ceased it caused vibrations in the chilly dark air. Bill and I looked at each other. We

were scared. We had both heard the sound so we knew it was no dream. We were also pretty certain from what kind of a throat it had come. The talk of mountain lions destroying the sheep of the country had been one of the main subjects of conversation in the beanery where we had heard about the forest and its empty cabin. The fellow who had directed us had said the government lion hunters were preparing to go into the forest soon to clean the beasts out. He had said the place was full of "varmints."

Bill and I had listened with our tongues in our cheeks. We had heard too many tall western stories to put much stock in loafers' gossip. So little credence did we give their tales of lions that we were perfectly content to go into the forest without arms. I have never believed in traveling with firearms. The temptation to use them in some supposed emergency is too great. Bill and I, as a consequence, were without even a twenty-two rifle. We were without even a knife that would cut anything. All we had was a short-handled ax and a shovel.

Anyone who has been in a deep and mountainous forest at night will know the feeling of scariness that one has there even on ordinary occasions. There is something about night and the forest that throws people back into a primal emotional state. You sleep lightly. You are wary and wake up wide-eyed. You stare into darkness as if you saw things there. You are in a state of nervous readiness as for a dread emergency of some sort.

When the last echo of the screech that had brought us up from under our covers had died, Bill and I got up and threw our stuff in the car. We turned on the car lights. They shone far up the canyon. The rocks and tree trunks under the beams of the lights were like a stage set. We sat on the running board of the car and listened. Pretty soon from way up the canyon the screech came again. It was decidedly human in its quality. It began sharp and loud and died off in a long wail. It had a sort of hilarious character. This fact, however, didn't ease us for we had heard that mountain lions often made noises like people crying or calling.

There was no use getting in the car for it was open, so Bill got our shovel and I grasped our ax. With these weapons in hand we scoured the immediate vicinity for brushwood and made a fire. We made a big one. When the flames began to leap up, the screech came again. In the glare from the car lights and the fire, it did not seem quite so terrifying. We listened intently as it died down. I moved away from the crackle of our flames so that I could hear better. There was a faint clickety-click sound distinguishable in the silence of the canyon. For a moment or so it would be fast and even, and then it would become irregular as if interrupted by something. It was very faint. It continued intermittently for some minutes after the wailing screech had passed into silence. Then it ceased. Bill and I couldn't make it out. Some ten or fifteen minutes passed. We gathered a lot of wood. Then we spread our things out on the ground again. The fire warmed us up. We lay on our mattresses with our heads propped on our elbows. We were still too uneasy to go to sleep, but we didn't talk. Suddenly, with a loudness that brought us both to our feet, the screech came again, and around a bend of rock up the canyon just touched with the last of the car's lights, two horsemen came clickety-clicking down the canyon yelling like a couple of lunatics. They were quite a ways off. When they hit rock their horses' shoes would click sharply, when they struck a grass patch or went under the pines there was no sound but a dull rapid thudding.

"Here come the mountain lions," I said, and Bill and I laughed. The horsemen were on us in a minute.

"Hi, boys," the forward one said. He was a thickset fellow with a spray of curly hair shooting forward from under his big hat, tipped at a cocky angle on the back of his head. "Hi," his companion said too. The second fellow had on overalls and a red shirt. He was hatless and his long front hair, parted in the middle, flopped down to his neck which was shorn to the middle of his ears so that nothing but bristles were to be seen. He looked like some crested bird. Greeting us he fell off his horse. As he hit the

ground, he let out the mountain lion screech that had scared the wits out of Bill and me. His horse jumped, but he held onto the bridle and the animal quieted down in a second. The first fellow, reeling in his saddle, roared with laughter.

"Slim's kinda full," he said. "We're all full," he added. "We heard ye all comin' down above the canyon this evenin'," he went on, "we seen yer light here. We come down to git yuh. We're doin' whoopee up to th' cabin and we wants yuh to come up and jine us. We got a good party and a barrel uv good corn. Here, taste this."

He pulled a pint bottle full of faintly brown bootleg out of his back pocket. Bill and I drank a couple of little swigs. It was hot fire and it stunk like gasoline. Slim with his long front locks hanging over his eyes like a drunken Indian crawled over to us.

"Drink it all, boys," he yelled. "It's fer you. It's whoopee stuff." He screeched again his imitation of a lion and rolled over laughing.

"Slim's full," said the curly-haired fellow again. "We're all full," he yelled and let out a bloodcurdling whoop. His horse reared and began side-stepping. Drunk as he was he kept his saddle and held the animal in.

Slim stuck his finger in my rear. "Are you goosy? Come on up an' see the gals," he said.

"You got girls with you?" I asked.

Slim whooped again, "An' how, boy!"

He staggered up on his feet, shook his forelocks, took the bottle from which Bill and I were pretending to drink and poured about half of it down his throat. "Finish it up, boys," he said as he turned it back.

I shut my eyes and drank all I could. Bill followed me and handed what was left to the horseman.

"What's your name?" I asked him as he took the bottle.

"Lem," he said. "What's yourn?"

I introduced myself and then Bill.

"Lem," I said, "we're too damned tired to come to a party tonight. We'd go to sleep. How long are you going to be up the canyon?"

"Till the likker and the beef is finished—come on an' go up. You can sleep up there. The gals is jist cookin' supper. You can eat and then sleep all you wanta. They's six bunks. We ain't gonna sleep."

"How do we get there?" I asked. "Can we drive the car up?"

"No," he said, "car can't get up there. Git up behind us, we'll ride yuh up. Yore car's all right here. Ain't nobody out here but us, an' even ef they wuz they wouldn't bother nothin'."

Bill and I considered the invitation a moment but decided against accepting.

"Lem," I said, "we're too tired. Why don't you all come down in the morning and get us? We'll be all right then."

"We'd shore like to have you tonight," said Lem, "but you're the boss."

"We'd like to come but we're too tired. We wouldn't be any good," I said.

"You don' hafta be no good," said Lem. "If you're a-thinkin' 'bout the gals, they ain't no tail there fer none of us. Yuh won't hafta do no work." He laughed. "Them gals is jist out fer a whoopee. They ain't givin' no tail away to nobody. They's jist up here a-whoopin' with us and a-cookin' fer us."

"Who all is up there, Lem?" I asked.

"They's five of us," said Lem, "five of us and ole Shack but he don' count."

"Where you from?" I asked.

"Slim and me's from Doc Frenner's ranch over west of town. Shack come from there too but he's ole and don' count. The two gals is from town. One uv 'em works in Jack's restaurant. The other one is taken' care of a soldier. She's his wife. Soldier came out from the East and married a gal here. He's sick, been gassed in the War. He's out here to git well. Good feller. Jim's up there too. He's goin' with the other gal, the one that cooks in Jack's restaurant in town." Lem scratched his head.

"Say, how many of us is they?" he asked.

"You said five but it sounds like seven to me," I answered.

"Well Shack don' count," he said. "So it's six."

"Say, Lem," I said, "why don't you fellows come down and get us tomorrow? It's getting late and we're tired."

"Yore th' boss," said Lem.

At this moment a huge retching sound came from Slim, who had been silent during our conversation. We all turned to see him on his hands and knees puking like a fountain. Lem roared with laughter. Slim stuck two big dirty fingers down his throat and with a bellow like a mad bull emptied his evening's entertainment on the ground.

"Slim's full," commented Lem again.

Slim went over to the stream washed his face and drank. He staggered back. "Gotta go home," he said. "Stummick's out o' order. Somp'ns matter with me."

He went over to his horse and flung the bridle back over the animal's neck, but when he put his foot up in the stirrup he fell over flat on the ground. The horse reared but Lem, adroit as if he'd had nothing to drink, had his own mount alongside in a second and grasped the bridle.

"Help him up, boys," he said.

Bill and I dodging the horses' hoofs managed to get Slim up and in the saddle. Once there he was all right. He seemed perfectly sober.

"We'll be down to git you all in the mornin'," said Lem.

"Git yuh fer breakfast," said Slim. "Git up early."

They cantered off, waving back to us as they went up the canyon in the beam of the car lights. With the intermittent clicking of their horses' hoofs, they disappeared in the dark beyond.

Bill and I moved our beds away from the smell of Slim's vomiting and went to sleep. We slept without fear of mountain lions.

In the morning we got up and made coffee. The sun had not come into the canyon yet and it was still cold. We sat by the fire

and watched the smoke rise straight up in air to where the sun caught it and turned it from blue to orange. After a while the sun got down in the canyon and warmed it. We explored our immediate vicinity while we awaited the return of Lem and Slim. It was midmorning before we heard them coming. Their horses' hoofs echoed in the canyon long before they came in sight. When they finally appeared we saw that instead of Slim, a girl rode one of the horses. Lem led the way and kept looking back at the girl solicitously.

When they arrived at our camp, Lem took off his hat with a flourish. "Boys," he said, "this here's Pearl."

Pearl was a buxom dame, a peroxide blonde with a wide face and a big wet mouth. Her face was powdered and her lips were painted a bright glaring impossible orange. On her cheeks were two bright spots of rouge about the size of a silver dollar. She had on a pair of blue pants, overall pants without the bib, and a white ruffled shirtwaist which pulled tight around her plentiful breasts and showed her nipples underneath.

"Howdy-do, Miss Pearl," I said.

"Hi, feller," she said. "Who's yer frien'?" She looked at Bill intently. Bill is a good-looking fellow, and at the time of this occurrence he was young and fresh. He had a little go-to-hell mustache. He was slim and his dark eyes looked good to Pearl.

"This is Bill," I said. "He's a good guy."

"I see that fer myself," said Pearl.

She turned to Bill, "Hello, Honey," she chirped. She had a high voice. Bill didn't like her but he returned her greeting.

Lem spoke up, "Well, let's git goin', Slim and Minnie's a-cookin' breakfast."

"How'll we ride?" I asked.

"Climb up behind Pearl," said Lem. I was standing near her horse.

"No, I'm takin' him," Pearl trilled as she beckoned Bill over with a meaningful and voluptuous ogle. Bill blushed. He used to

blush easily in those innocent days before he got used to the antics of girls who were out to take his pants off.

"All right, Pearl," I said, "I get you," and I helped Bill up behind her. Bill tried to get a grip on the saddle. He knew as if by instinct that he'd need something to hold to.

"Not there, Honey," said Pearl. "Hold on here," and she reached back, took Bill's hands, and clamped them over her fat breasts. Bill was hot with embarrassment but he made a sturdy effort to laugh.

"Git in close, Honey. This saddle's big enough fer the both of us." Pearl reached back and edged Bill's legs over the saddle back. It was a tight fit.

"What'll my husband think of this, Lem," she cackled as she threw her frizzy blond hair back in Bill's face.

"He'll shore oughta shoot that guy—Bill," Lem laughed back. Bill looked decidedly uncomfortable. He squirmed a little, Pearl squirmed back.

"Oh, you bad boy," she gurgled. "An' my husband a wounded soldier, too."

I got up behind Lem.

Pearl started up the canyon at a sharp pace. She was a poor horsewoman. At the first rough spot her buttocks went up in the air two feet. As she came down she forced Bill out of the back of the saddle. He lit on the horse's rump, holding on to Pearl's breasts with all his might. His legs and coat flew up in the air as he struggled to keep the place he had.

"Not so tight, Honey," squealed Pearl. "Don't squeeze 'em, Honey." Bill grabbed her lower down about the waist and they went bouncing up the canyon. Bill hit one side of the horse and then the other.

Lem was a good rider so I had an easy time. All I had to do was laugh at Bill. Lem and I split our sides at the pair. After two miles of joggling we reached the whoopee camp.

Up the side of a little grassy plain just before the pines began climbing the mountain side lay a ramshackle log cabin. It had

been chinked with moss but a good part of this had dried and fallen away so that there were gaps between most of the logs. As we came up Slim popped out of the door waving a slab of red meat in his hand.

"Hi, boys," he yelled. "We're up an' a-goin'." He was drunk again.

We climbed off the horses and went in the cabin. The girl Minnie was there making biscuits. She wore the short skirts of the times well above her knees. She was thin, dark-eyed, rather pretty but painted up quite as barbarically as Pearl. A fat puffy fellow in an A.E.F. hat sat in a chair blinking. He was drunk like the rest of the men. The boy called Jim was there. He was cutting little square chunks of meat from a slab like the one Slim waved his greeting with. Slim joined him and the two, after putting out a pair of meaty hands to Bill and me, kept cutting little chunks of flesh into a frying pan already full of pieces of onion and potato. They were making a hash for breakfast. Every once in a while a chunk of meat would fall on the dusty floor. The boys would pick it up and throw it into the frying pan just the same. Everybody but the soldier was talking. He was too drunk.

"Say, I thought you all was goin' to have breakfast ready," Lem complained.

"Aw, Jim and Minnie wuz in there a-horsin' an' wouldn't git up," said Slim.

Minnie's eyes opened wide. She picked up a hunk of biscuit dough.

"You're a dirty liar," she said. "Take that back er I'll sock yuh. Nobody ever caught me horsin' in public." She drew back with the hunk of dough.

"I'll take it back," yelled Slim. "I only meant you was 'powderin' yer nose.' I guess Jim wuz jist a-helpin' you."

Pearl piped up. "I'll bet he was helpin' her all right," she squealed. "Look at her stockin's!"

The cabin shook with peals of laughter as Minnie looked down

at her wrinkled stockings. Slim let out his mountain lion yowl. The cabin rocked with its vibrations.

"Aw, to hell with all of yuh," laughed Minnie. "Yuh don't think of nothin' decent ever. You're a lot of cow-chasin' bums. You're jist natcherly low-down, all of you."

Minnie rolled out her biscuit dough and began cutting out biscuits with the top of a baking powder can. The table where she worked was covered with a wrinkled piece of oilcloth which hung down to within a foot of the floor. From underneath this oilcloth a hand appeared. It was a knotty wrinkled hand. It edged over toward one of Minnie's ankles. Suddenly it shot up her leg and grabbed her above the knees. Screaming and kicking, Minnie jumped back. The oilcloth bulged and Minnie kicked again. As she kicked a howl came out from under the table.

"Let up thar, gal, I ain't meanin' no harm."

The oilcloth bulged out more and an old fellow on his hands and knees squirmed from beneath the table.

A yell from Slim greeted him. "Hi-e-e-e! Look at ole Shack."

"Ole Shack," everybody chorused, hilariously.

"What yuh up to, Shack?"

"What you doin' under that table?"

"Is that where yuh slept, Shack?"

Minnie looked down at him. He had his hand on his nose, from which a little trickle of blood came. It ran over his curled knuckles.

"Say, gal," he whined, "they ain't no call fer kickin' me in the face like that."

"The hell they ain't, you ole son-of-a-bitch," said Minnie. She glared at him. "What ya think I am, you stinkin' ole end uv nothin', runnin' yer paws up me like that?"

She drew her foot back as if to aim another kick.

"Aw, let up, Minnie," Lem and Pearl interposed. Old Shack staggered to his feet. He was blear-eyed from drink and sleep. His bald head fringed with graying hair was covered with brown spots like big freckles. His long gray mustache drooped. He stank of whisky.

"You're a good 'un, Shack," Slim hit him on the back. "Eighty-seven year ole and still a-feelin' up the gals."

"You still know what's good, don't yuh, Shack?" Pearl trilled.

"He got to dreamin' he wuz a colt agin," laughed Slim.

"Yeah, but don't you colt me no more, you ole fool." Minnie rubbed her hands together briskly and slammed a pan of biscuits in the oven. She was riled.

The soldier woke up. "Gimme a shot," he said.

"Hey, look at the army," Pearl gurgled. "You better wake up, Honey, I'm gettin' me a new beau." She moved over next to Bill. The soldier only blinked. "Gimme a shot," he said again.

On a shelf in a corner of the room was the keg of liquor. Lem went over, removed a plug of wood, and tipping the keg very carefully poured out some of the drink in a saucepan. He took a hearty swallow himself, and then gave the pan to the soldier, who drank and passed it on. We all drank. Bill and I did the best we could.

After a while the hash was cooked and the biscuits made. We ate breakfast and washed it down with the whisky. By one o'clock the whole crowd was getting high. The boy, Jim, silent up to now, suddenly burst into speech. He got up from beside Minnie, lurched over to the cabin door, and then turned facing us. He addressed Bill and me.

"Say," he asked, "are you fellers in here to hunt?"

We told him we were not hunting.

"Then ya ain't got none of them red hats?"

"What red hats?" we asked.

"Them red hats that tells people ya ain't a deer."

"That tells people what?" I exclaimed.

"Sure," he said, "that tells people ya ain't a deer. They's a law been passed in the state that says ye can't hunt without ye wear a red hat 'cause you might get shot fer a deer." He laughed. "Red hat," he went on contemptuously, "red hat, think uv me a-wearin' a red hat, and lookin' like them nuts up in Santy Fe." He pointed

suddenly at me, "You ain't one uv them nuts from Santy Fe, are you?"

"God, no," I replied.

"Is he?" he pointed to Bill.

"No," I said, "he's my buddy."

He came over and drunkenly shook hands with us.

"'Scuse me," he said, "I jist wanted to be sure."

"What have the Santa Fe nuts got to do with the red hats?" I asked.

"Well," he said, "them fools up there goes out a-huntin' with a lot of dudes they brings here from the East. Them dudes shoots each other an' the Mexicans, so the state had to make a law makin' them red hats a law durin' deer season. I ain't wearin' no red hat though. I ain't no nut and I ain't no dude."

Muttering, he picked up the saucepan and ambled over to the whisky keg in the corner. He tipped the keg and filled the pan.

"Say," he said, "what you think all them nuts come out to Santy Fe for?"

"Yeah," Slim joined in, "what's all them nuts up there for?"

"What nuts do you mean?" I asked.

"Aw, you know," Jim said, "them God-damn funny-lookin' women and men."

"You mean all those artists and writers around Santa Fe and Taos?" I asked. "Do you mean the artists that come there in the summer?"

"Yeah, them's the nuts. What ya think they come out here for?"

"I guess they come out for the scenery," I replied. "They come out to make pictures of it and write about it."

Jim was silent. Shack and Lem, propped up in their chairs, began to snore. Pearl and Minnie got up and went out the door to the brush. The soldier lay on the floor looking at the ceiling.

"That's funny about them nuts," Slim said. "Yuh can tell them artist nuts right off without knowin' 'em. Yuh jist have to see 'em."

"Can you always tell them?" I asked.

"Ever' time," said Slim.

Bill and I laughed. I thought it was about time we admitted our relationship to the nuts. I said, "Say, boys, before we go any further I'd better tell you that Bill and I are artists too."

"By God," Jim brought his hand down on the table. "I seen it. I knowed damn well that you all was somp'n funny. Didn't I say it, Slim? Didn't I?" he questioned.

"Are we so funny as all that?" I asked. "Do you think we're like the nuts from Santa Fe?"

"By Jesus, ye ain't so nutty," Jim admitted. "But jist the same I knowed damn well I seen somp'n was funny 'bout you all."

"Can ye take pictures by hand like they do in Santy Fe?" Slim asked.

"Sure we can and tomorrow just to prove it we'll make some pictures of this outfit," I said.

Lem, Jim, and Slim were familiar with Santa Fe. They had been there many times on trucking journeys. No doubt in the garages and speak-easies where they hung out they had heard a lot of talk about the people of "nut row." "Nut row" is the name popularly given to that section of Santa Fe where the artists have built their bungalows and their cute adobe houses. I gathered from the boys' talk that the row had quite a reputation for high-toned whoopee and for a plentiful amount of snootiness as well. There seemed to be no small amount of feeling against the artist tribe. Slim said the artists had got it in their heads that they owned the town.

I can sympathize with fellows like Slim and Jim. There is nothing quite so offensive as a clique or colony which, living economically independent of people, takes superior or patronizing airs toward them. During the twenties, when eastern artists began coming in great herds to New Mexico, they were under the influence of an exotic purism which was calculated to set them off and keep them off the ordinary behavior patterns of New Mexico society. Their productions were wholly incomprehensible to plain people and their talk borrowed from the jargon of Parisian aesthetes was

outrageous in the environment. Lots of the artist emigrants were to my knowedge perfectly sane democratic-minded fellows but they were under technical and aesthetic influences which worked against their participation in the normal activities of their new background. The prewar "genius" complex was still very strong among them and that alone would be sufficient to provide a marked queerness of character. It is no great wonder that the ordinary run of New Mexico people lumped the artists all together as nuts. I imagine it will be quite a time before artistic New Mexico lives down the influx of gabbling and vain women, of priggish aesthetes, minor poets, and fairies which followed the War. It is a sort of pity that the people of the most beautiful land on earth should have been inflicted with all the artistic drolleries just when western America was ready to take some interest in the social place of the arts.

Art to function healthily must have some significance for a whole society and if the artist and his art are nutty for such fellows as Slim and Lem and Jim, they are likely also to be nutty for the better educated average of society.

Bill and I returned to our car in the evening. We walked. No one was sober enough to ride us down. Next day we came back and made drawings. The boys were getting ready for another night of it. The girls slept most of the day. Bill and I stuck around till the middle of the afternoon when things got dull. We slipped away and went back down the canyon to the car. We had had enough of the whoopee party.

"Let's pull out of here before they come after us," Bill said.

"Suits me," I replied.

We decided we had better not return by the way we had come. We had found that the road by which we entered the canyon ran along a ledge just above the whoopee cabin. The boys would hear us going out just as they had heard us coming in and they might think we were trying to dodge their company. In the course of talk at the cabin we had learned that a forest trail ran northeast

from the forest into sheep land and that a seventy-mile drive over it would get us to a highway. We could see the trail plainly. Sheepmen used it for their supplies. We drove out over it and camped at night in the woods. The next morning we got out of the trees into upland grass country. The trail was staked there or we shouldn't have been able to keep it, for it was barely touched with wagon tracks. We passed a mud ranch house. Some chickens were in a pen at the side but no other sign of life was there. The land stretched out in great silent rolls of gray-green.

Bill said, "We're going to be out of gas in a little while."

I said, "How about the can?" I was thinking of the five-gallon can of gas we carried for emergency.

Bill said, "I put it in the tank before we started this morning."

This was sort of serious. We decided to wait at the ranch house for someone to come home. In midafternoon a big tall squint-eyed Swede drove up a truck and got out. We told him we needed gas.

"Hum, so you need is gas," he said, "hum, gas he cost money so far."

We saw we were in for it.

"Have you got any gas?" I asked.

"Hum, maybe got leetle gas," he said. "Cos' one dollar gallon."

"How far is it to the highway?"

"Hum, 'bout fifty mile."

We knew he was lying for we had already come over sixty miles since leaving the canyon but we bought five gallons of dirty gas from a drum he kept in a shed. There was no use kicking about the price, the Swede had us and knew it.

The road was bad. We drove slowly. When night came we were in flat desert country with no highway in sight. We drove for a while with our lights but finally when the road got too hard to keep we stopped. We ate bread and cheese and went to sleep.

The next morning I woke up before dawn. Against the whitish sky to the east a chain of black mountains rose. As the sky turned pink the mountains became blue. There was a bright star hanging

in the sky above them. This dawn on the desert was the most beautiful thing I have ever seen. It was moving. It was like the music of some old chant of the early Church, delicate, exquisite, and sad. I walked away from the car. I cherished the sense of great peaceful loneliness the scene gave. I felt like wandering off into the blue, violet, and orange-pink planes that hung in transparent sheets from the top of the sky to within a few yards of my feet. The earth and the sky were as one. There was no distinction between what was solid and what was not. The universe stood revealed to sense as a great harmonious unity, as one thing.

When the sun came over the mountains to the east, the world became what it is. In the place of the one thing there were many things big and little. There were ants at my feet, there were yucca plants and clumps of sparse grass. Way over on the side of a hill, little round bumps of piñon pine squatted in black irregular rows. Beneath another hill about a half mile ahead was a ranch house with a windmill. A scrubby cottonwood tree grew by the windmill. I got out our water cans and walked over to the ranch house. The door was boarded up. No one lived there apparently. It was an utterly silent place. It seemed especially lonely in the new white light of the morning sun. The cattle tank by the windmill, however, was half-full of water and there were fresh marks of cattle in the wet ground beside it. Looking at the cottonwood tree I saw that its leaves were moving. A slight breeze was up. I released the catch on the windmill and waited for the blades of the wheel to turn. After a while the wheel spun, the pump began to work, and a thin stream of water played into the tank. I filled our cans and went back to the car. Bill was up. We gathered a pile of dried yucca stalks and made coffee. The car needed water so we drove over to the ranch house and I turned on the windmill again. Bill and I talked very little. This was a valley of silent loneliness. The human voice seemed out of place, a futility in the great stretch of white land. We felt as if we were utterly removed from the possibility of further contact with civilization. Yet the highway from Albu-

querque to Gallup was just the other side of the hill below which the ranch house lay. We found it in fifteen or twenty minutes after we started. Where our trail joined it there was a store and a gas station. The boy in charge there was from Newark, New Jersey. He hated the country.

"This place is too lonely for me," he said. "There ain't a damn thing to see." I judged he had not been up in the dawn of that morning.

Ten years ago my old friend Mike Robinson took his whiskers and his eyebrows and moved out to Colorado Springs. I went to see him out there. It was during the Hoover administration at the time when "prosperity round the corner" was manifesting itself in bread lines and other similar indications of the fundamental soundness of the country. Mike is a great artist but he lives with the socially elite, with those well-to-do people of advanced ideas, liberal opinions, and talkative habits who make up for the social differences between themselves and the "have nots" by maintaining a great deal of heartfelt sympathy for these. They are nice people but rather tiresome when they're sober. Fortunately, they serve excellent drinks and when they don't drink sufficiently themselves to be entertaining, you yourself can have enough to see them in a rosy light. They dwell in beautiful houses on beautiful estates where immense and stirring vistas are obtainable. These people, who are for the most part better fitted to the atmosphere of Long Island and suburban Philadelphia, are located in Colorado Springs generally because some member of their families is a lunger.

When I went to see Mike the season was at its height and there were many parties. My clothes were not the most presentable, for I had on my touring outfit of boots and khaki, but I was received everywhere just the same and most royally treated. By the time I was ready to leave, the luxurious houses, the good drinks, the general atmosphere of ease and security had put me in such a frame of

mind that I was about ready to believe in the administration's idea that the depression was mostly psychological.

I took a bus south for Trinidad intending to walk from there over Raton Pass. Trinidad is an interesting place and I hung around for a couple of days making drawings. There I got right back into the very center of the depression's effects. Every freight train that came in town had a big cargo of bums. These bums were not ordinary tramps but workers of all sorts who had lost their jobs and wandering boys for whom depressiontime life at home had become unendurable. There were so many of these hard-times floaters on the trains that the brakemen didn't try to put them off. I talked with a lot of these fellows and heard some pretty hard stories. I was told that in many places deputized citizens kept a permanent vigil in the railroad yards to keep the job hunters from getting off the trains. The towns didn't want them. I suppose that driven by hunger these poor fellows would leave the boxcars and beg at the houses until the common citizens, depression-ridden themselves and unable to provide enough charity, would grow afraid and take measures to shut them out. I had plenty of evidence right in Trinidad of the attitudes which people held toward the depression wanderers. With my old khaki pants and boots and my knapsack to mark me I found people avoiding contact with me. Ordinarily broad good-natured western folks developed suspicious feelings toward strangers. As I went into a little restaurant in Trinidad, the proprietor, seeing my clothes, leaned over the counter and said, "Git out, you." He didn't even ask me if I had any money.

I walked over Raton Pass and then over Eagle Nest Pass to Taos. Later I started back east by bus, stopping overnight in different towns. Pretty soon I got tired of this slow journeying and looked for a train. At a certain railroad junction on the plains I found that I could make good eastern connections. I went over to the station, an old-fashioned affair with a big potbellied stove in the center of the waiting room, and discovered that my train left at night. I waited around town all afternoon and saw a lot of the wandering depres-

sion tramps begging about the place. They were an unwelcome lot and people, though they did it in a sort of shamefaced way, were pretty short with them.

When night came, after a beanery supper I went over to the station. It was around the first of September. There was a stiff wind blowing and it was quite chilly. A fire was in the station stove and the waiting room was warm. There were quite a number of people, men and women, in there waiting for the train.

Over in a corner where the station benches made a right-angle turn, a boy of seventeen or eighteen years was curled up asleep. He had on dirty overalls and a flimsy shirt. He had no coat. He slept with his mouth open. In his sleep he kept shifting a little and his limp body finally hung over on the very edge of the bench. With every intake of his breath he came precariously near to falling. Some of the people around began laughing at his position. Pretty soon everybody was watching to see when he would fall. There was a good deal of humorous comment. Suddenly there was a sharp slam of the ticket agent's window. The door from the ticket office into the room opened briskly and the agent strode across the floor. He was a tall angular man, narrow-eyed with a big hooked nose. He reached over the sleeping boy, got him by the back of the collar, and jerked him sharply to his feet. With a quick run he propelled the lad to the station door and with brutal efficiency kicked him into the night.

It was all done in two seconds. There was an outraged gasp from the women in the station. A couple of men got red in the face. A man said, "By God, that's too hard on the kid." Another, "Somebody ought to knock the —— out of that guy." I thought for a moment the agent was going to be in trouble. A kind of menace charged the warm air of the room. It was broken by the bell of the approaching train and the people moved out on the platform.

The West, like all other parts of our country, is in a state of rapid change. There are no people or places there which anyone would

dare to call typical. A great number of people in the West, as I have indicated, cling to the bucking, shooting, yelling glamour of their past. Even in the society grooves of the new western cities the older male members hanker for the tough days that are gone. The virtues of yesterday's rough-and-ready individualism are contrasted in their minds with the petty trickeries and polite rules of the modern world which has grown up around them. They seem to be slightly ashamed of their ease and of the lack of genuine fighting enterprise in their lives. It is not only among the old boys either that this condition holds. Every true westerner likes to think of himself as a fellow who could nonchalantly guide a hot stallion to a skittish mare or perform adequately with a herd of fear-stricken cattle. In the minds of many of the boys who sit around western country clubs in dinner coats, there is a persistent admiration for the Lems and Slims and Jims of my stories—there is more than admiration; there is a sort of envy. Still in secret vision, sentimental if you will, the boys of the open country represent full manhood. They have the kind of wonderful physical readiness which goes with the western tradition of manhood. The fellows in the clubs, fat around the middle, saggy around the jaws, look on them feelingly as if they were memories of their own lost youth.

Accompanying and in direct contrast to this itch for untamed and unconventional hang-overs of the past, another itch is much in evidence in the West. In the new cities with their shiny skyscrapers, their golf clubs, community churches, and cultural forums, an intensely cultivated feminine gentility expresses concern with another kind of past. Socially ambitious women take aggressively to establishing the respectability of their backgrounds. No hot stallions or smelly cowboys for them.

One thinks mainly of New England and Virginia as centers of ancestral concern, but out in the suburbs of the plains cities, ensconced in bright new homes made nearly always in some wholly inappropriate old English or Continental style, innumerable ladies

are found whose main business in life seems to be the watering of their family trees. There is an odd sort of dissatisfaction among the women of those groups who have come to the top in western society. After the long struggle of arrival they seem to feel compelled to justify their positions. It is as if they needed to make some account which would establish other rights than economic ones to the privileges of their menfolks' success. They keep the genealogists busy tracing out lines of descent and digging up ancestral coats of arms. Some of the ladies have to struggle desperately to keep their aristocratic pretensions on a plausible basis. It is often pretty hard to make some shrewd and skeptical old frontier grandfather who never took his boots off look like the sprout of a noble tree. But in the devious alchemic cookeries of socially ambitious women, much of the sort is attempted and to their own satisfaction frequently done.

In the colleges and universities of the West, studies of the cultural accomplishments of mankind take an increasingly important place. The arts are assiduously cultivated. Down in the University of Oklahoma, in what used to be "injun land" when I was a boy, much attention is given to painting and sculpture and music. The business is yet a little exotic. Stravinsky and Chinese pottery are hard to reconcile with the dust-blown realities of Oklahoma. It occurs to some of the more intelligent instructors that perhaps they never can, but university habit is strong and "art is art" all the more when it has no relation to the particularities of place.

I went to a cultural symposium in Oklahoma. It was a considerable affair, full of governors, college presidents, and preachers in full dress. The talk was full of intellectual ideals. There was an irascible poet there from the wilds of Arkansas who had lived in aesthetic Europe and been educated out of his environment. He got up and made a speech about the low cultural status of the community. He was particularly sharp with the fellows who clung to the frontier idealism of the West. He was tired of hearing of the

tough virtues of the covered-wagon forefathers. He was sick of the shoddy folklore of the pioneers—

> Them hardy sons a' bitches
> That —— through leather britches.

He didn't quote the poem, but it was easy to see he didn't like it or anything it stood for. He was out for some kind of higher life. I couldn't make out what it was but it sounded like something to be read out of the back of the *New Republic* in a Greenwich Village tearoom.

Right next to the crudest sort of physical reality, the cultural leaders of the West nurse an extraordinary idealism. The spirit of the Daughters of the American Revolution has got mixed up somehow with the dust of the combines, the stink of the oil wells, and the smell of the cattle trains, and has produced an atmosphere where the values of things as they are cannot be faced. There is no land on earth where the great and harsh drama of reality is more transparently exhibited than in Oklahoma. Yet it was out of Oklahoma that this tribute to the realism of my Missouri mural came.

SHAME ON YOU, MR. BENTON

A great state is grossly libeled by its own official order else how could such a picture as so-called artist Thomas Hart Benton has painted be fastened to the walls of the House of Representatives lounge in the Missouri state capitol at Jefferson City?

In this mural the artist professes to have recorded the social history of Missouri. In that picture we find delineated life in the lowest dives. That is not Missouri.

Conspicuous in the picture is the acknowledged portrait of T. J. Pendergast, the Democratic boss of Kansas City whose organization votes dead men, who manipulates to steal government itself. In the picture Pendergast is seated at a table with representative citizens who are taking their orders from this hyjacker of government.

We have asked before: What is this new Governor Stark going to do about this outrage? He professes to be devoted to the highest political and social decencies of his commonwealth. Unless he at

once, demands the removal of this libel upon Missouri he dishonors
the state that has honored him by the elevation to its highest office.

It is bad enough to have a chap like Thomas Hart Benton who
professes to be an artist accepting a $16,000 commission to libel his
own state. But Benton by his labors repudiates all the integrities
and all the decencies of Missouri's fine social history.

Shame on you, Thomas Hart Benton, shame on you. You have
disgraced your art as you have disgraced your state.

Professing to picture in this mural the "social history of the state"
this callous Benton has pictured the degradations of society. Missouri
is not degraded. Missouri cultivated no degrading social history. This
most central of all our states is typically American in its principles,
practices and performances. It has a noble and heroic social story.
It has produced great, high-minded governors, men who became
eminent in the national councils in our country. It produced the
earliest commonwealth college west of the Mississippi river.

Where is the story of the beginning of Washington University
in the basement of a church? Missouri has reached the nobilities and
the altitudes of a social history that are characteristic of and in
keeping with the finest civilization which any nation has ever pro-
duced. Benton has not pictured the social history of Missouri. He has
used his brush to broadcast falsehood, to bear false witness against
a glorious star upon our flag's field of blue.

Shame on you, Thomas Hart Benton, shame on you, and shame
on whoever, representing Missouri's government, paid $16,000 to
buy this picture of infamy. Shame upon the people's representatives
in the capitol from Governor Stark to every member of the state's
legislature who will allow such a picture to remain brazenly ex-
hibited on Missouri's capitol wall.

Missourians, loyal to the integrities of their state which with
infinite propriety they love, are beginning to express the outrage
they feel against this bold, base insult. The whole nation is just be-
ginning to realize that the forces of evil in Missouri are evidencing
a boldness which the country can view with alarm. If the under-
world is to decorate our capitols and set up their law-defying per-
formances as worthy of emulation then it becomes high time for
decent citizens from coast to coast to protest the Benton picture in
Missouri's capitol as every decent citizen of Missouri now is doing.

The decent people of Missouri, not the Missourian Benton pic-
tures sent the father of this painter to the national House of Repre-

sentatives at Washington. If we are not mistaken this so-called artist's grandfather was Thomas Hart Benton who for thirty years represented Missouri in the Senate of the United States. Would they have admitted that they were elected to represent the "Social History" this Mr. Benton has painted for Missouri's capitol?

Or is this Mr. Benton's and Mr. Pendergast's and Governor Stark's little idea of a practical joke on the fine people of Missouri? A tragic sense of humor, if this be it.

Mr. Benton has lied about Missouri. He has desecrated its capitol walls declaring that Missouri's social history is one of utter depravity. That is a lie. Missouri's social history is a story of growing refinement and nobility.

(Editorial from the *Tulsa Tribune*, January 27, 1937.)

Of course it is to be remembered that it was a Democratic administration that sponsored my job in Missouri and that the paper from which the above quotation comes was a Republican paper. "East is East and West is West," but there are some grounds on which the "twain can meet."

VIII

Back to Missouri

IN THE spring of 1935 I emptied out my New York studio
and apartment, packed my goods in a truck, and sent them to
Kansas City with the intention of settling permanently in my home
state. The thing immediately responsible for returning me to Mis-
souri was the mural which drew the appreciative column quoted
at the end of the last chapter. There were other reasons which I will
deal with later but this first one calls for a little explanation. I have
so far neglected in this writing to make any account of the kind
of painting on which the better part of my public fame rests. I came
to Missouri as a muralist because I carried the reputation of a mural
painter. I got this reputation by painting murals.

In the chapter called *Art and the Cities*, I touched upon a project
I entertained after the War for a history of the United States in
paint. Some of this history I completed and exhibited, season by
season, at the Architectural League in New York. After a few years
of showing my studies, I began to be written about as a mural
painter. I had never painted on any actual walls but the character
of my work and perhaps its association with the architectural shows
led the critics to treat me as a wall painter. After reading about my-
self as a muralist, I began to think of myself as such and to com-
plain because there were no architects who would give me a wall.
I enlisted the sympathies of Lewis Mumford and Joseph Urban
and of quite a number of young architects who were safe with their
sympathies because they had no walls to risk.

A wall, however, did finally come to me. When Urban built the

New School for Social Research in New York, he welcomed me along with the Mexican, Orozco, as a decorator. Alvin Johnson, director of the school, had no money to pay for what art Orozco and I might produce, but he agreed to defray all our material expenses. Itching to get a crack at a real mural, I set out. The subject on which Dr. Johnson and I agreed for the room allotted to me was contemporary America.

My travels and sketching trips over the country had by this time produced an immense amount of material. I had to do very little research work for my subject. All that was necessary was that I organize what I had on hand. I worked six months preparing my scheme and three months in actually painting it. My finished job drew down a storm of criticism. It was called "tabloid art," "cheap nationalism," "modernist effrontery," and a lot of other nice things. Practically all those tricky word combinations for which New York critics are so justly famous were hurled at my work. Conservatives whaled me for "degrading" America, purists for representing things, and the radicals were mad because I didn't put in Nikolai Lenin as an American prophet. The painting, however, had its defenders. It was also good "news" and was written about and reproduced extensively all over the world.

Mrs. Force, who runs the Whitney Museum of American Art, was one of those who thought I had done a good job. She was also horrified to learn that I had received no money for it and was outspoken in her condemnation of people who would let an artist do such a work for nothing. She made up for the matter somewhat by purchasing a lot of my preliminary studies for the Whitney Museum, paying a good price for them. Alvin Johnson, though he couldn't actually pay for my wall, offered me a lecturing contract with the New School which would provide a sort of indirect compensation.

I hadn't done much lecturing then and was pretty innocent about it. I was introduced to the various professors of the school. Each one of them welcomed me and expressed happiness at the opportunity afforded of being able to attend my lectures and discuss art

with me. I began to think that I was going to have an audience of learned men, so I lit into the libraries and got all my historical sequences and dates worked up in detail. I didn't want to get caught on my facts. I was scared stiff the night of my opening lecture. I had visions of a row of informed professors who with notebook in hand were going to nail all contradictory utterances. My audience turned out to be a lot of timid schoolteachers and innocent art lovers who felt bad about the way the critics had treated me. I could have told them anything and it would have gone down.

But I learned something from this about professorial etiquette, and nowadays when a professor greets me on my lecture tours with the statement that he is glad of the opportunity to hear me, I know he means "Thank God I don't have to." I understand and sympathize with him. The only thing worse than having to listen to someone talk about a specialty which is not yours is to have someone beside yourself talk about one that is.

The New School murals put my reputation up. If I wasn't famous in the way the critics thought I ought to be, I was at least notorious. The value of my pictures took a jump, and Rita, always a good hand at the selling business, disposed of the better part of our stock of pictures. I had a dealer at the time but it was Rita who did the real selling. She and I began to live higher than we had since the days of Denny and his gang. We rented a swank apartment and gave parties. I improved my brand of whisky. The freedom with which it was served became famous and Rita and I, taking stock one early morning of our more or less inebriated guests, discovered we had never met a damned one of them before. After that we shut down on the parties.

A year or so passed after the New School murals and my new reputation began to fade. I went broke. I had a three-thousand-dollar payment to meet on some property and didn't know how I was going to get it. Rita thought of Mrs. Force and the Whitney Museum and the generous price that had been paid for my New School preliminary studies.

Several years before, I had made a set of four panels representing a history of New York. They were made one-fourth the size of some arched spaces in the New York Public Library. A number of my friends had the idea that if I showed complete renditions for these spaces that the job of filling them could be obtained for me. It was no go, and the paintings, six feet high, were on my hands. (They still are.)

Rita had the idea that maybe the Whitney Museum would buy this New York set for the needed three thousand dollars. She went to see Mrs. Force, who decided that if the Whitney Museum was going to buy murals it should have them specially made. The upshot of the matter was that the three thousand dollars I wanted was paid me with the understanding that it was to represent a down-payment on a mural which I was to make for the museum library. At least that is the way my wife and I understood it. I went to work on my designs and was at it a whole winter to the exclusion of all else. In the spring I got a further advance under a protest which made me wonder whether I had understood what the three thousand dollars first advanced really represented in the matter of payment for me. Mrs. Force had gone to England so I couldn't see her to talk the matter over. I consulted my lawyer, Hymie Cohen, about my status. I had nothing in the form of a written contract. He asked me what I expected out of the work. I said I ought to clear five or six thousand dollars. He told me I was a fool to put such a price on a big job like the one I was doing. He reminded me of the known generosity of the Whitney Museum toward artists, of the price Mrs. Force had paid for my New School studies, and told me to go on and be confident that in the end I would get the value of my work. I itched to do the mural, and glad with Hymie's advice, went ahead.

When I got through, the following autumn, the paintings were unveiled at a great party. Parties at the Whitney Museum are thoroughly taken care of. Before this one was half started I was thoroughly taken care of myself. I was tight as a jay bird in black-

berry season. Mrs. Force came over to me. I recognized her even though she had several heads and seemed to be dancing some kind of shimmy. She held out a slip of paper. I knew it was a check and took it. I couldn't make it out for sure but it looked like ten thousand dollars. I nearly fell over. I controlled my impulse to shout and sticking the paper in my pocket proceeded to get as tight as I could.

Somebody was giving a supper party for me that night. I discovered when I started out to it that I couldn't make the grade. I went into a drugstore, got a zinc emetic, and spilt my mural party in the gutter. When I could see clearly I looked at my check again. The check was for one thousand dollars. The sight of it ruined my supper party. The next morning I sent the check back to Mrs. Force with a note to the effect that I would feel better in making my mural an outright present to the Whitney Museum. This was rather an extravagant gesture but I was in an extravagant mood. Mural paintings have a way of putting me in such moods.

My new painting, like that in the New School, received its full share of comment. The critics laid into me again and told the world about all the different ways in which I failed to be an artist. When the furor was at its height, an architect friend of mine, Tom Hibben, showed up at my apartment with the story of an Indiana mural job. He wanted me to come directly out to Indianapolis and tackle the proposition, which was an affair to be rushed for the 1933 World's Fair at Chicago.

Murals are not done without a considerable expenditure of energy. I had just finished the Whitney Museum mural after a year's steady work and I was tired. But I was just as broke as when Rita went down and got the three thousand dollars from Mrs. Force. The year's labor hadn't profited me anything. I listened to Tom Hibben's story of a ten-thousand-dollar clearance to be had in Indiana. Tom knew about my United States history project, then abandoned, and inflamed my imagination with the suggestion that

here was a chance to do that history and get paid for it as well. I went out to Indianapolis.

The state of Indiana is proud of its cultural achievements. It is proud of its writers, its history, and its society. Some three years before my entrance into Indianapolis it had been decided among those in charge of the matter that if the state was to be represented in Chicago at the fair, it would be with something different from the usual state show of pumpkins, ears of corn, and photographs of pigs. Indiana decided to have a mural. That was all right but the World's Fair commission, the Indiana artists, and others involved in the affair could come to no agreement on what kind of mural. They debated the business up to within six months of the fair's scheduled opening.

Then Colonel Richard Lieber, head of the Indiana Conservation Department, was named virtual dictator of the fair commission. He consulted with Tom Hibben, then designing for the Conservation Department, and asked him if there was a man in the country who could do a mural over two hundred and fifty feet long and twelve feet high in the time that remained before the World's Fair was to open. Tom said he thought he knew of the man. He came to me, as told.

Using the time factor to exert pressure, I persuaded Colonel Lieber and the World's Fair commission to give me complete freedom on the job, to let me make a social progression rather than illustrate a series of noble state incidents, and to give me a contract which would allow me to deal realistically with social facts. These political Hoosiers liked me. Somehow or other they saw I was no nut artist and they had confidence in me. They turned me loose to work as I pleased.

Six months is a short time in which to do a two-hundred-and-fifty-foot mural. I started out inauspiciously by going down for a week with a cold. Lying in a hotel bed I worked out my preliminary plans. I read Indiana history, everything that was to be had in the state library, letters and documents included. When I could get up I

made sketches, indicating the general material organization of my conception. Colonel Lieber and the commission were pleased with the project, and I started elaborating my plans.

I was always talking with people and asking questions to improve my familiarity with Indiana. It wasn't very long before important things cropped up that had not been included in the texts and letters on which I based my original conception. Among them was Indiana's Ku-Klux Klan episode. In my second mural plan I included the Kluxers.

I didn't give them any more importance than they deserved in the total of the state's history, but when Colonel Lieber saw their shrouds he balked. He claimed they had no significance in the state and should be left out. Well, I had found out all about the extent of the Indiana Ku-Klux regime, and I differed with him. We argued a little and then put the matter off for discussion the next day.

I had been in Indianapolis about a month by this time and had made friends. Tom Hibben and I along with some cronies conducted what we called a "children's hour" in the hotel where we lived. From five to six in the evening we drank Brown County whisky with all comers. I used to work all day, get drunk during the children's hour, then jerk myself sober by a walk out of doors and work again at night.

I discussed the Ku-Klux matter with Tom and the "children" and we cooked up a game. One of these children was a great long Hoosier bean pole named Bob. We fixed it up with Bob to invite a few important senators and representatives over for a drink and to have Colonel Lieber in at the same time. When everybody was assembled Bob asked me, according to my plan, whether I thought the Ku-Klux Klan episode was of any importance in the state's history. I said I was doubtful about the matter and appealed to the politicians. They being newly elected Democratic politicians, while the Klan business occurred under Republican auspices, promptly informed me that it was of immense importance and had nearly

ruined the state. When they got through airing the importance of the Klan, I shouldn't have dared leave the organization out of a factual history of Indiana. As Colonel Lieber went out he winked at me and said, "You win."

The inclusion a little later of a strike episode in the Terre Haute mining field in which I pictured a miner throwing a rock at a soldier promised another flurry. It was feared that the newly elected governor, Paul McNutt, former Legion Commander, would take offense at this. When, however, he was invited out to survey the progress of the work and failed to see anything inappropriate, I was left undisturbed. The only other objection I faced was that of a prize hog raiser who didn't like the common run of Indiana pigs I put in my picture.

I spent a month traveling about the state making drawings of people, buildings, animals, machinery, landscape, etc. When I had everything assembled, I made a clay model of my whole scheme. After that I made sketches in color and then a final scale cartoon. By this time it was past the middle of March and though Tom Hibben had constructed the heavy panels on which I was to work and the panels had been coated with gesso and set up in a great barn-like building, there was not a line or a spot of paint on them to indicate that the mural might be finished by June. Colonel Lieber was nervous but he didn't say anything to me. He saw that I was working all the time and doing the best I could.

Finally when I was ready I got some students and friendly artists to help me "square up" my cartoons. Then I lit into the painting job, doing all the work myself. In sixty-two days I finished the task. I hardly know how I did it. Once I got going I never seemed to get tired. I worked from early morning till dinner. Frequently I went back at night. I made no changes or corrections nor ever went back over anything. When I finished and looked over what I had done, I knew I had produced the best work, so far, of my life. I knew it would get a critical whaling but I didn't care. There was a lot of protesting, meetings of resolution-passing clubs, and

condemnations by artists and aesthetic-minded gentlemen of leisure, but the work went up in Chicago and became one of the main points of interest at the fair. With the plain people of the Middle West, it managed to certify me as one who knew my stuff. It was popular. Common folks saw themselves and the world they lived in, and liked my job.

What with the children's hour whisky, the entertainment of friends, and the thousand unforeseeable expenses of a mural, I didn't come out with any clear ten thousand dollars. But I did better than with the other jobs. I came out with something.

To calculate profits on a mural of my sort is impossible. There are a thousand expenses that are unavoidable. In my paintings I use real people as models. When I represent a farmer I get a farmer, when I represent a night club girl I get one of them too. The farmer doesn't cost more than a ten-cent cigar generally, but the girl is likely to be more expensive. She has to find it entertaining to pose or she won't do it. Now while some of my mural expenses come pretty easy because they have other than strict working values, they are nevertheless expenses. You can't exactly charge them up against anything when you make out your income tax, but they cut down profits just as do other more generally recognized items of expense. In addition to such costs, my strictly material costs run high—my methods are expensive. When I start a mural I have come to expect to be constantly shelling out money for this, that, and the other.

In addition to the representational and material assaults on profits which mural making occasions for me, there are also assaults on my psychology which have effects. A mural is for me a kind of emotional spree. The very thought of the large spaces puts me in an exalted state of mind, strings up my energies, and heightens the color of the world. After I have gone through with my practical preparations, which are elaborate and occupy the major part of the time spent on any job, a certain kind of thoughtless freedom comes over me. I don't give a damn about anything. Once on the wall,

I paint with downright sensual pleasure. The colors I use make my mouth water. The sweep of my brushes, after I get really started, becomes precise and somehow or other beyond error. I get cocksure of mind and temperamentally youthful. I run easily into childish egomania or adolescent emotionalism. When the mural is finished I have a letdown.

After the Indiana painting, I returned east like an empty sack. With the Whitney Museum and Indiana murals, I had had two years of excited concentration, of constant overstimulation of all sorts. I had milked every emotional possibility out of myself and was good for nothing. I sat around for months without ever touching a brush. All I could do was play the harmonica. With this I nearly drove my wife mad. I took to playing some of the Bach suites and in order to memorize them I'd go over the different phrases time after time. I loved to squeak them out note by note and I'd keep it up for hours, beating time with my foot.

Music, or perhaps I'd better say the noise which represents music for me, has been one of the strange late passions of my life. In my youth I never knew anything about the personal satisfactions that come from making sequential sounds. I never could sing or whistle a tune of any sort or cared to try doing so. I went frequently to symphony concerts, I knew musicians and discussed theoretical matters—like the relation of painting to music, etc.— but I couldn't read a note or do anything by ear. After the New School mural was finished and while I was in a little emotional slump that forbade painting, I picked up a two-bit harmonica that someone had given T. P., my kid. I began to make noises on it, and discovered that its tones were regularly arranged in scales. This naïve discovery was like a revelation from heaven to me. I got so excited that I ran all the way home from my studio to tell about it. Rita, who played the guitar and sang, took the toy and made out a tune on it. Later other people came in and played tunes on it also. We had a friend Jagey, a dentist, M. A. Jagendorf—he was a literary dentist who got you down helpless in his operating

chair with your mouth propped open and read his poems to you. Jagey played on that harmonica in a way I thought marvelous. Secretly I said to myself, "If that literary nut can play on that thing, I can too." But I couldn't do it. I was good for the scale but no more. I stewed over the matter for some time to the neglect of all else and finally made up my mind I'd have to learn to read music. I got an elementary book and started in. For weeks I forgot everything and sat in my studio playing nursery songs and simple folk tunes. In my enthusiasm for my new art, I didn't give a whoop about painting. After a while I got pretty expert and bought an expensive harmonica that allowed me to play half notes and make key changes. Rita and I began playing the guitar and the harmonica together at night. Pretty soon we had recruits. Some of my students got interested in the harmonica and we began meeting every Monday evening. After a while we attempted part playing. I worked out a notation scheme for reading music with the harmonica, and we commenced charging a nickel when anybody missed a note. That became rather expensive as we increased the complexity of our music and we had to abandon it, but after months of trying we managed to get our squeaks into some relation to one another and to perform pretty well. During the winters of five years, the harmonica occupied no small part of my time. I was always looking up suitable music, digging around in the libraries for early forms, for stuff which fitted our capacities and which would sound well on our thin-toned instruments. Our orchestra attempted Bach, Purcell, Couperin, Thomas Farmer, Josquin Desprez, and others. My ear improving, I picked up American folk tunes on my summer travels. I played my harmonica in farmhouses and at country dances, and had an immense amount of fun with it.

My three murals continued to excite a lot of controversy. They put me pretty sharply in the public eye. I was constantly called on for lectures and began adding polite winter travels to my rough

summer ones. In all places I was heckled when I got up to talk, but when I rose in New York I could count on a raging torrent of opposition. I gave as good as was given me, sometimes a little better, and an incredible number of people got to disliking me. Down in the streets of Greenwich Village where I lived I used to overhear the young radical artists say, "There goes that son-of-a-bitch Benton." In the course of time I began to see that I was doing a lot more talking than painting and that I was making more enemies than friends. I began to wonder whether the big city wasn't getting me down again.

In the early winter of 1935, I came into the Middle West on a, lecture tour. I went to Iowa and saw Grant Wood. Grant said, "Why don't you come out here and live where you belong?" I thought about that but didn't see how I could do it. Later I gave a lecture in Kansas City and my brother, Nat, then prosecutor in Greene County, Missouri, came up and induced me to take a trip to Jefferson City, the capital, to meet some of the Democratic boys. In Jefferson City I ran into some old Missouri acquaintances and we had one of those regular hotel room parties where you pour liquids down you and stories out of you until the world begins to spin. When the world was spinning pretty well for me, Ed Barbour, the senatorial incumbent from Greene County and an old friend, said with his good Missouri drawl:

"Sa-ay, Tom, you did a picture there for Indiana. Why don't you do one for your home state?"

I replied that I was willing and Ed said that he'd get up a bill on the matter for the legislature.

Now the world was spinning for me and I took Ed's proposition just to be a part of the spinning and forgot about it. I went back to New York and fell into a lot of wordy controversies again. But it seems that Ed and my brother Nat had talked over the business of a Missouri mural before the hotel party, that they had made rather extensive plans which I knew nothing about, and that Ed's question to me was no mere party question but one that had sub-

stance to back it. Anyhow, in a month or so, I got a copy of a bill that was up before the Missouri legislature which recommended that I be hired to do a painting for the state capitol on the history of Missouri. There was an awful lot of whereases in the bill but I managed to understand it and sent a telegram of approval to Ed and my brother Nat. A few weeks later I heard the bill had passed and that I had another mural commission. On the very day I received this information, I opened a letter from Ross Howard, director of the Kansas City Art Institute, asking me to teach there. I made up my mind suddenly to leave New York and go home to Missouri for good.

I said in the beginning of this chapter that there were other reasons besides that of the Missouri mural which caused me to leave New York and return home. These reasons grew slowly over a number of years and prepared the ground for a decisive move. In my travels, both for pictorial subjects and for lectures, I had come to see that since the financial collapse of 1929 there had grown throughout the United States a sort of distrust of our great cities which coincided with something I felt within myself about them. I saw that the potentates who owned the towering skyscrapers of the big towns and who ran the country in the days of mounting prosperity and boom had lost their reputations for infallibility. Their immense practicality had turned out to be not so practical after all, and throughout the country, from backwoods stores to the halls of legislatures, derisive jokes about "their majesties" were becoming more and more frequent. I saw that political affairs were taking precedence over those of business and that ideas were beginning to dominate the reports of stockjobbers' moves.

Though politics remains in practice a trading game directed to the shrewd balance of economic interests and the maintenance of the status quo, it has been, nevertheless, making theoretical excursions into what a few years ago was considered the realm of impractical professors. This is a significant matter, for ideas held by

professors are just ideas, but when they get into the heads of politicians, they have the potentialities of sticks of dynamite. They may be dropped accidentally and they may explode in extremely crucial places. Such explosions, quite against the conscious wills of those responsible, may generate changes of unpredictable magnitude. Things of this sort happen. Lincoln was not an abolitionist when he came to the defense of the Union. He had no notion of clearing the land of chattel slaves to the end that wage slavery might progress more freely. He was not a revolutionist. There are no revolutionists among our political powers today, but in the body of ideas with which they are flirting there are notions far more menacing to our present social structure than were those of the abolitionists for theirs.

Seeing the country's ferment and prospects of immense changes in its allegiances, I had the desire to escape the narrow intellectualism of the New York people with whom I associated and to get more closely acquainted with the actual temper of the common people of America. I had no way of doing this in any permanent manner and at the same time be sure of making a living, but I considered the matter extensively. I lived much with those who under the illusory sway of their own logical structures ventured to predict our American future. I didn't believe them. I didn't believe they knew what they were talking about. I had myself no certitudes about our future. I could foresee nothing. I was aware, however, of the changes coming over the political psychology of our country, and I hankered to be close to the soil on which these would be most clearly operative.

In addition to politics, other things were taking my mind away from New York and toward the West. In my lecture tours I had seen that along with what appeared to be a reaction against metropolitan economic dominance, there was rising in our smaller cities a marked sort of cultural consciousness. I had large and friendly audiences in my western talks and while I did not lack hecklers, the majority of these seemed to be better informed and to be more

sincerely interested in getting at my meanings than did those of
the big cities. Everywhere I found what appeared to be a genuine
interest in the expressive arts. Some of this was pretty naïve, but
it was strong enough to make me think that perhaps the end had
come to that peculiarly brittle, dry, and empty psychology which
had grown up with the great exploitative possibilities of the Re-
construction period, where all effort was directed to immediate
monetary profit. I felt that whatever forces were at work, there
was growing, particularly in the Middle West, a belief that values
could exist in things beyond immediate usage and that these values
should be nursed and cultivated. Looking about I saw museums,
big and little, springing up all over the land. I saw that universities
were inaugurating extensive art courses and that small-town news-
papers were commenting on these projects without satirical inten-
tions. This was a revolutionary change from my boyhood days in
the West when the word "art" was mentioned only self-consciously
in the obscurity of ladies' clubs, and when the few art schools that
existed away from the big cities were regarded as the resorts of
nuts and cranks.

With all this I began to feel that I, a western artist, the better
part of whose work was motivated by western subject matter, should
find a way of being part of the change that was coming in my home-
land. When the opportunity came to return to Missouri with some
prospects of making a living there, I jumped at it.

While the truckmen were loading my household goods in their
van for my westward trek and the boys from the newspapers were
having fun with my farewell to New York, making considerable
to-do over the difficulties the big town would have in surviving
my departure, I sat down and wrote the following essay:

> The great cities are outworn. Humane living is no longer possible
> within them. The grand skyscraper-monuments of New York,
> while they were exulting proclamations of dominance and power
> were at the same time harbingers of distress. They brought on such

a concentration of population that elbowroom for decent living was extremely difficult, except for the very well to do. In addition to the physical conditions set up by overcrowding, there is evidence that mental processes are undergoing marked stultification in the shadows of the great buildings. I do not mean that our cities do not harbor minds of vigor and intelligence or that a superior person living in them may not rise above the prejudices and habits of the streets. Individuals of power and initiative are finally stronger than any environment, though they may carry its effects. I do mean, however, that but for a few people, the confining walls of the great city, because of their very extent and because of the manifold activities going on within them, tend quite unconsciously to set the measure of the world. It becomes, in a city like New York, very easy to believe that the beginning and end of all things lies within the subway lines.

New York, stacked up against the rest of America, is a highly provincial place. It has such a tremendously concentrated life of its own that it absorbs all the attention of its inhabitants and makes them forget that their city is, after all, only an appendage to the great aggregation of states to the north, south, and west. New Yorkers have a tendency to mistake their interests, wishes, and hopes for those of the whole country. The city, besides being geographically and economically a province of America, though an independent-mannered one, is also provincial in another sense. It, more than any city in our country, harbors the attenuated political, artistic, and economic ideas of Europe. I should say, rather, that it harbors the largest class of people who are dependent-minded and for whom such imported ideas are the only ones cherished. This is natural, because its population is very heavily bound by ties of blood and habit to the ways of Europe. The attachment to European imports is strengthened by the existence of a great parvenu class composed not only of the newly wealthy who look to Europe for the paraphernalia of their pretensions, as they have done since Colonial days, but of a large group of young intellectuals who are not happy unless they are expressing ideas consecrated by a birth overseas.

Ideas are, of course, world property and many ideas coming from Europe are as valid here as there, but, with the mass of young intellectuals who isolate themselves in New York, the thought of questioning the validity of an idea or of manipulating it independently of its source and in reference to the American environment

would be a sacrilege. Their borrowed ideas are marks of distinction. To distort the pure form of these ideas in the interests of any sort of practical application here would, they feel, give the lie to their intellectual superiority. Not all of New York's intellectuals are imbued with this parvenu spirit. It is, however, the predominant failing of those who give their attention to art in its relation to our changing postwar world.

Environments, though not unconquerable, are tremendously strong. Neophytes of the various arts, writers, musicians, painters, coming into New York from all parts of the country, are drawn as by a magnet into the intellectual atmosphere just described, where as a rule they succumb promptly to its effects. The new convert to an idea is always, of course, its greatest protagonist and goes violently after further new adherents for his beliefs. Young artists, from wherever they come, are always particularly desirous of representing the latest, newest, and most progressive thing. They fall readily into the logical traps of the careerist intellectuals and of those who, accepting their doctrines, work for them.

Intellectuals, as is well known, do not always agree. Even those of Europe are not in accord. Reflecting the disagreements from overseas there are opposing intellectuals here. The young artist or writer, in order to have friends, must take sides. The sides that he must take at the moment among those who regard themselves as progressive are determined by a curious mixture of political and aesthetic doctrines drawn from middle European philosophizing on the function of the proletariat in the cultural and political world of the future. They are based roughly on a variety of interpretations of the thought and intent of Karl Marx and of his Russian followers. They are passionately idealistic and, however they may vary, equally dogmatic, self-righteous, and humorless.

The upshot of this business is a network of warring cliques among the progressives who imagine their raging quarrels over doctrine important to the country and to the art which is to come out of it. I know this business pretty well for I have roared and raged myself, though frequently enough in late years with my tongue in my cheek and for the fun of stirring things up. I do believe, however, that the humorless mouthings of the indoctrinated intellectuals of New York's elevated circles are as bad for the development of an

American art as are the theory-ridden activities of their brothers in the political field who would develop a radical party strong enough to cope with the country's various mounting social injustices—and yet, not quite so bad, for even though social radicalism is limited to the pattern of sweatshop ideals, it is forced occasionally into the open world beyond and there is some evidence that it is learning to bow to the pragmatic necessities of political reality. But that does not concern the matter at hand. Not the real political workers but the vociferous "fellow travelers" and their disciples are the ones forcing the art of the young into the stereotypes of propagandist pattern. A few years ago the same psychological class, as yet unacquainted with Karl Marx, was just as intent on ridding art of all meaning in favor of pure abstraction. The values of the world of art were then, as now, compressed into the same ignorant coffins of urban isolation. The same, in spite of a different verbal context.

Though contrasted with radical intellectualism, another potent force for stultification thrives in the city. Just as the fellow travelers of Marxist communism believe that all human values are bound up in their conceptions of social change, so do the conservative academicians believe that they are bound up in the negative refinements of conformity. The conservative groups of the city represent outmoded practices and a narrow naturalism, but as they are in positions of power, they are more effective than the radicals in reaching out over the country and imposing their views on public art affairs, commissions, and projects. Though their power is waning they are still a force. In New York City they effectively squelched all the efforts of the P.W.A. workers to break with the trite conventions of academic mural decoration. In the smaller cities of the country, very creditable work from the hands of P.W.A. workers got on the walls of public buildings. In New York, because of the power of isolated conservatism, little of any value reached actual completion.

Between the forces of the narrowly conservative and the doctrinaire radical, another influential force thrives in the city. This last is even more completely withdrawn from the temper of America than either of the others. While urban isolation promotes the peculiar narrowness of the first two, it is essential to the very existence of the third. This last force is difficult to define. It is one of temperament rather than opinion. It comes from the concentrated flow of aesthetic-minded homosexuals into the various fields of artistic practice. Aestheticism

in its more fragile forms seems always to accompany sexual aberration when that is represented by the simple predominance of feminine characteristics rather than the cultivated vices of bisexualism. In the case of the latter, male sexual buffooneries, accompanied by a more or less open sadism, offset any exaggerated artistic delicacy. But in the homosexual circles of artistic New York there are few who, like the gentleman in the Klondike poem, are ready to jump anything from a steer to a kitchen mechanic. Our New York aberrants are, for the most part, of the gentle feminine type with predilections for the curving wrist and outthrust hip.

Far be it from me to raise my hands in any moral horror over the ways and tastes of individuals. If young gentlemen, or old ones either, wish to wear women's underwear and cultivate extraordinary manners it is all right with me. But it is not all right with the art which they affect and cultivate. It is not all right when, by ingratiation or subtle connivance, precious fairies get into positions of power and judge, buy, and exhibit American pictures on a base of nervous whim and under the sway of those overdelicate refinements of taste characteristic of their kind.

Taste, good taste, is simply the acceptance and cultivation of prevailing modes, manners, and attitudes. When such an acceptance is heightened by the exquisite differentiations of the homosexual, it becomes morbidly narrow and highly critical of innovation, not in line with fashion.

In presenting this picture of the homosexual in the art circles of the great city it is only fair to say that it is directed to generalities. Homosexuals, like other men and women, are individuals capable of considerable variation from standard patterns. There are individuals among them whose charm extends beyond the circles of their kind, whose intelligence overcomes the effect of erotic aberration and its psychological accompaniments, and who are able to take a place in the ordinary world of men and women. They are, however, rare. For the most part, the fairies are so deeply involved in their own peculiar sensibilities, so intent on their own jealousies, hysterical animosities, and nursed preferences that they cannot appreciate contemporary forces until these have been consecrated by general acceptance. Then they are at the head of the procession and start refining and narrowing the new forces as they did the old.

Homosexuals are very important factors in the museums and galleries of the cities. While it is too much to say that they have captured all of them, they are in evidence at every turn. In an important training school of taste, appended to one of the great eastern universities, they have made deep inroads, and potential directors of museums emerge from the sanctums of this institution with a lisping voice and mincing ways. They emerge also with specially conditioned psychologies. Not only in the great cities but in the smaller ones, trustees of museums, looking to diplomas in their search for expert knowledge, find themselves in odd positions. A very real danger to the cultural institutions of the country lies in the homosexuals' control of policy. Not only is it dangerous from the viewpoint of policy but because of its effects on the minds of those who support such institutions, who are apt, especially in the West, to confuse all art with sexual oddity and refuse to have anything further to do with it. The people of the West are highly intolerant of aberration. In the smaller cities there are no isolating walls of busy indifference where odd manners and cults can reach positions of eminence and power. Power, in smaller places, is promptly known and subject to the scrutiny of strong prejudice. Only the great cities allow for the easy growth of that which thrives mainly on its own juice.

Theoretical radicalism, extreme versions of nationalism, and homosexualism need isolation for their growth. They derive their sustenance from themselves and wilt when exposed to the realities of common life. Protected by the deep, indifferent shadows of brick and stone and steel, they grow and set their traps for the young who, unless they are very strong, fall into them and are led into accepting the various conformities of their captors.

All this is extremely hard on the young artist, who finds any tendency to original vision or innovation pounced upon by all cults. He must conform to their attitudes and practices or face a difficult loneliness. This loneliness is especially hard for the young who are so desirous of playing parts of importance and who react, consequently, so readily to the opinions of their fellows. The necessity of being right, of doing the right thing, is almost inseparable from the drives of youth.

In the great cities fewer and fewer escape the pressures of one convention or another. As these conventions, by their very isolated

nature, do not reflect America they work against the development of distinctively American forms. The great cities are failing us now, when training schools for the future and laboratories for free experiment are, owing to the changing temper and needs of the times, becoming more and more necessary.

Will the smaller cities and towns of the West, the Far West and the Middle West, and of the North and South, remedy this situation? No one knows. I am one, however, who is hopeful. In the vast driving energies of this country, changing their courses under the pressures of capitalist failure having no end, apparently, except in great change, there is to my mind much that is hopeful.

The age of raging greed is past. There is too little on which it can continue to feed. Though, as with the snake, which "won't die till sundown," the tail of this age will certainly continue to thrash around for some time to come, it will, each year, get feebler and feebler. The spirit of go-getterism, so ruthless, so little given to taking thought about everything that didn't show immediate monetary profit, has come to the end of its tether. It has come to the same pass to which, even in its heyday, its most virile actors had to come. It is approaching death, and like those dying actors who at the end dug out the old family Bible and began to reflect, it also, approaching demise, will come to reflection.

When men reflect they are likely to reach, finally, an appreciation of the drama of life, of the values of simple existence which stand apart from ends and purposes. That is the ultimate concomitant of reflection. There is evidence that such an appreciation is even now making itself felt and that in the ferment of ideas revolving in the country concerning the future it is taking no small place. A decided proof of this lies in the mounting interest in the expressive arts which are, above all things, proclamations of the values of existence. The interest in schools and museums in the smaller cities and towns indicates increasing tendencies to encourage such arts and, though they are subject, as yet, to many drawbacks and may be subject to many more, they hold one great promise. Bound by none of those aesthetic orthodoxies, cults, and conformist principles which in the great cities tend to sterilize expression before it reaches maturity they promise, for the students, a new and freer and more objective consideration of the things that are American. This is a

great promise for American art, for it is in the drama of *things that are* that art must take its first original steps. In those outlying places of the great rivers and fields which, in the self-satisfied vanities of the great cities, are regarded as the abodes of hicks and stuffed shirts, the promise of an artistic future seems to lie. The great cities are dead. They offer nothing but coffins for living and thinking.

After ending this essay I began to think of the twenty-four years I'd lived in New York and of the fun I'd had there so I wrote an addendum:

I must confess that Chicago, Paris, and New York have had for me, and still have, great attractions—particularly the latter. Even though I have little faith left in the leadership of New York and am through with it, I love the place. For over twenty years I have spent the better part of my time there and, though I have looked for a long period to other environments for the subjects of most of my pictures, I have become habituated in my manner of living to its ways. Although I have never belonged to any of them, the warring cliques of the city have provided a constant accompaniment to my doings. Their disapproval of these has been a source of stimulation and amusement. I have loved to go before them and shout and rant and step on the corns of their beliefs. With a few drinks, I could work up quite fervent beliefs of my own. Though I generally forgot them the next day, they afforded me many evenings of entertainment.

I have no faith in intellectuals, but I have been one of them and have traded generalities over New York cocktail glasses for years. It is probably a lingering intellectuality that is behind the commitments of the above essay, for when I take stock of myself, apart from alcoholic drinks and the equally intoxicating effects of words, I find that I don't believe anything very much. In my essay I have apparently succumbed to intellectual habits and committed myself, rather than stop talking.

This addendum didn't quite satisfy me so I wrote further:

When, and if, the hinterlands rise up and put an American art, and me with it, on the map of world culture, I shall continue to think of New York with affection. Particularly shall I think of that area

around the lower part of town that stretches from Union Square in all directions to the south, where I have lived so long.

I shall think of the shopgirls with their slim waists and swishing tails who, in the past before I was married of course, used to be a favorite subject of contemplation. I shall think of the burlesque shows, particularly of the one on Fourteenth Street, now gone, where Tom Howard used to split my sides and where the art of "stripping," just begun, used to make the old boys drool at the mouth and keep their hands in their pockets. Union Square with its enraged sincerities, manifested in all sorts of highly proclaimed nostrums for the ailing body, physical, social, and spiritual, I can never forget. Nor shall I forget the various entertainments and benefits of the region, always dedicated, in late years, to alleviating some difficulty of the toiling masses, where the proletarian dancers, generally a little too long or too short in the legs, or too little or too big around the sitter, would cavort in devastating pantomime against the evils of capitalism. I shall remember more respectable things too—nice houses where you talked quietly and got drunk in a leisurely way, with due regard for the manners and prejudices of the high-toned.

There are many people I shall remember, people I learned to like, artists and writers and lawyers, actors and pugs, homos and skirt chasers, radicals and conservatives, men and women, Jews, gentiles, yellow men and black. I shall remember best my students, especially those who used to sit with me on Monday night and blow on the harmonica to the guitar accompaniment of Rudy, the furrier who lived around the corner.

I wouldn't have missed living in New York even if I am now through with it forever.

I never got the different parts of this essay joined up very well and so never tried to publish it but it looked like a pretty satisfactory farewell to me. After I found myself settled in Missouri and began to run up against little things, I took the essay out and cautiously tacked a final statement on the end of it:

If it gets too hot or too frigid where I am now, I can always eat the words of this essay and go back.

I have been now two years in my home country.

Working in temperatures that ran from way below zero during

the months of preparation to as much as 118° above during those of execution, I have fulfilled the contract which was primarily instrumental in bringing me here. My *Social History of Missouri* is finished. Like my other murals it has received its full share of adverse comment. I have been put on the mat to defend it time after time. I have talked to Rotary Club, chamber of commerce, Junior League, church, school, legislative, and barroom audiences.

Although I expected criticism, I must confess that the character of some of that occasioned by my Missouri mural came to me as a surprise. I was not in the least hurt by it and have really profited by the advertising it gave me. I have had as well a lot of fun pitting my wits against those who objected to my ways of seeing and doing. Just the same when the storm of critical comment came I was not prepared for its astonishingly conventional and often vindictive character. I expected my legislative friends to have their little jokes and I expected a few moralists and conservative art lovers to express their distaste for my performance. But that was all. I did not expect any extensive objections. I did not expect that anybody would think that I was trying to degrade or make a joke of my state when I treated its society in a realistic manner.

During the period in which I was actually painting, thousands of people from all over Missouri came to see me. I left open the door of the room where I was working. I tacked a few warning signs about to keep the hands of visitors off my sketches and materials and to keep them from bothering me when I was painting, but I let them come in and look as long as they wanted to. At noon when I rested, and in the evening when I was through, I would talk to people. During all those days of work I never heard a seriously intended criticism. Everyone was friendly. Occasionally a farmer would object to some detail of farm life. When his criticism was valid, I would change the detail which offended and which might stand in the way of his appreciation of my work. I wanted plain Missouri people like the farmers to like my painting, and when my total design was not affected by their objections to

some detail of fact I remedied the matter for them. I had all the evidence necessary to make me believe that my realistic conceptions of Missouri's social history and life were in line with the reputedly realistic psychology of the state's people. Missouri is the commonwealth whose motto is "You've got to show me." I was pretty sure that what I was showing was taken favorably.

When, however, my work was done and I was gone from Jefferson City a storm broke over me, and my illusions about a good many Missouri things were broken with it. I saw that realism was not by any means a completely shared Missouri virtue, and that the habit of calling things by their right names and representing them in their factual character was not wholly agreeable to so many people as I supposed. I awoke to the fact that many of those who came to see me accepted my attitudes simply because of the strangeness and perhaps the fascination of my unusual activities which made them restrain for the moment the actual mushiness and vulgarity of their own views. But in the end they let it out to me, and I found that a lot of the very people I supposed were favoring me and standing by my work were really miles away from it. I found that my basic attitudes were entirely incomprehensible to many people and that my realism and intention to be faithful to my actual Missouri experiences were regarded somewhat as pretensions or poses. The idea that I could be sincere in my attitudes and performances was beyond the reach of a lot of Missouri minds.

One gentlemanly heckler, as I was giving an explanatory talk on my mural, rose from his seat with a sheaf of prepared questions. After reciting my family background in Missouri, he asked me if I was not proud of my state. Now I suppose the average person under the circumstances would have said yes, but I knew I was not proud of my state, and I told him that I was simply interested in it. He had to throw away a lot of his questions then. He lost the opportunity he had anticipated of getting me into a logical trap of words. I am certain that that man was in his way sincere, but the mere statement of his question indicated that he was without

the slightest understanding of the sort of thing I stood for. He could not see or believe that I really meant what I said when I told him that I judged the world and the people in it by what they did rather than by what they said. He could not understand any more than could my Communist friends of New York that I did not believe in patterns of words and that such a pattern as "Are you proud of Missouri?" was utterly without meaning for me. Like the New York radicals, he saw my kind of realism as cynicism, as something beyond even a touch of nobility or beauty. Time and time again as I talked about my mural people would rise with questions or statements that indicated plainly that they could not get the connection between beauty, sincerity, or honesty of purpose and the ordinary straight recognition of things *as they were and are* that is behind my work.

However, after three months' arguing, or rather telling, I think Missouri has got used to me. With my basic realism and perfect willingness to call a spade a spade, I have considerable advantages over my hecklers. I have got away with my stuff. I have answered every question and every objection put to me about my mural and because I answered these straight, without any beating about the bush, I think most real Missourians are beginning to like me and have come to the conclusion that I intended and made a pretty fair picture of my state. There are die-hards from the young Communists' nests of St. Louis up (or down if you will) to the strongholds of Missouri conservatism who still maintain that because I painted no "idealisms" my work is a disgrace. There are people even among the Democrats of the legislature who sponsored my job and paid me my money, who seem to feel that I should have done better had I painted a sweeter picture of my home state—something a little more delicate, a little more violet-scented. This seems to me a bit odd because in my whole experience of Missouri Democrats, I've never run across any little woodland flowers (among the bucks, anyhow) and I don't believe I've ever seen a single Missouri Democratic politician, drunk or sober, who wouldn't

bust you if he thought you mistook him for a violet. A great many of the objectors to the morality of my picture have been the saltiest kind of fellows in actual fact, perfect vindications by their appearance and language of the factual truth of my work. Seeing that most men are quite satisfied with themselves as they are in actuality, I expect that the attitudes of these fellows will change when they become familiar with the form of my picture and are able to look past its unfamiliar conventions to the Missouri people and life it represents. Their Sunday school horrors and resuscitated copybook maxims will be forgotten and they will come over to me and see that the value called "beauty" may reside just as well in the common, ordinary things of life as in idealistic dreams.

During the making of my Missouri mural I traveled all over the state. I met all kinds of people. I played the harmonica and wore a pink shirt to country dances. I went on hunting and fishing parties. I attended an uproarious three-day, old settler's drunk, in the depths of the Ozarks. I went to political barbecues and church picnics. I took in the honky-tonks of the country and the night clubs of Kansas City and St. Louis. I went to businessmen's parties and to meetings of art lovers' associations. I went down in the mines and out in the cornfields. I chased Missouri society up and down from the shacks of the Ozark hillbillies to the country club firesides of the ultimately respectable. From this it would seem that I should know my Missouri—and in a sense I think I do. But it is not quite the Missouri I envisaged when I wrote my farewell essay to New York. Somehow or other I had come to believe that I should find a relatively simple and transparent society in my home country, a society which, while it might have its modern prejudices and taboos, would at the same time retain a good deal of pioneer experimentalism and be free of the vulgarity of cultivated affectations and borrowed manners. All of my late notions of Missouri were formed while on bumming trips in extremely rural sections of the state. In my summer wanderings from New York I had avoided the cities of the West and dug into back-country life

where behavior patterns were uncontaminated by very many metropolitan hang-overs. I saw nothing of the ways of the well-to-do people of the cities who would, by the structure of our society, be responsible for the protection and cultivation of the arts. In my lecture trips I saw that particular society superficially. While I saw that it had an interest in my American localism, I did not take into consideration that as an expatriate Missourian I might more readily extol the interesting aspects of the real Middle West than I could as a permanent inhabitant. I failed to see also that a lot of the people who attended my lectures and were so friendly to me were doing so partly because I appeared to be like something out of Walter Winchell's New York column.

I came back to Missouri with a good many illusory notions. Not all of these notions have been dispelled and some that were have been replaced by equally interesting and entertaining facts of common life. But one illusion has been knocked out for good—that is, that the cultivated people of the Middle West are less intellectually provincial than those of New York or more ready for an art based upon the realities of a native culture. Those who affect art with a big "A" do so with their eyes on Europe just as they do in New York. They lisp the same tiresome, meaningless aesthetic jargon. In their society are to be found the same fairies, the same Marxist fellow travelers, the same "educated" ladies purring linguistic affectations. The same damned bores that you find in the penthouses and studios of Greenwich Village hang onto the skirts of art in the Middle West.

There is, however, a difference between the precious gentility of the West and that of the East. Your western people are very friendly even when the desire to be of a superior quality runs them into affectation and pose. Among the men of well-to-do society, there runs a strain of wholesome good-fellowship which forbids the hauteurs of Boston and Philadelphia and makes them a little self-conscious as they ape the manners of English country gentlemen. The better part of the male gentility of the western cities seem to

be secretly aware of the fact that the antics of a pink coat are not exactly in harmony with the substance of western life. They are aware also that in living above the run of life about them they have become somewhat dull. They invariably speak of one another as stuffed shirts, unconsciously mirroring thereby their secret appreciation of themselves. This basic uneasiness keeps them quite human and I must say that, so far, I have not met a really complete ass among them. If they are a little boresome at times, they are at least not contemptible.

What is called society is, of course, like the froth on a glass of beer, of no consequence. I speak of it mainly because it was very much of a discovery for me to find that it had developed in Missouri in the regular stereotyped Long Island-Philadelphia suburb style. I knew there were wealthy groups in the state, but I felt they would somehow keep the flavor of their background and some of its salty originality. I was fooled.

Below the top economic foam of Missouri, the true native life lies. Although I have painted that life as I saw it and felt it, I am not yet ready to analyze it or pass judgment upon it. Taken as a whole, I like the men and women who make the real Missouri. I get along with them.

From where I live I can take my car and in a few minutes run past the junk heaps and gaudy signs of Kansas City into deep country. In a few hours I can be in the utter backwoods.

There is a high rugged bluff above the Missouri River a few miles from Kansas City. I drive out when I get bored and sit on that bluff. The river makes a great curve in the valley below and you can see for miles up and down the running yellow water. Although I was born and raised in the hill country of southwest Missouri, the great river valley appeals to me. I feel very much at home looking down upon it. Either I am just a slobbery sentimentalist or there is something to this stuff about your native land, for when I sit above the waters of the Missouri, I feel they belong to me, and I to them.

As a matter of fact, I feel I belong all over my state. There is about the Missouri landscape something intimate and known to me. While I drive around the curve of a country road, I seem to know what is going to be there, what the creek beds and the sycamores and walnuts lining them will look like, and what the color of the bluffs will be. Feeling so, I don't believe I shall ever eat the words of the essay I wrote when I left New York. It will take a considerable pressure, anyhow, to make me eat all of them, and go back.

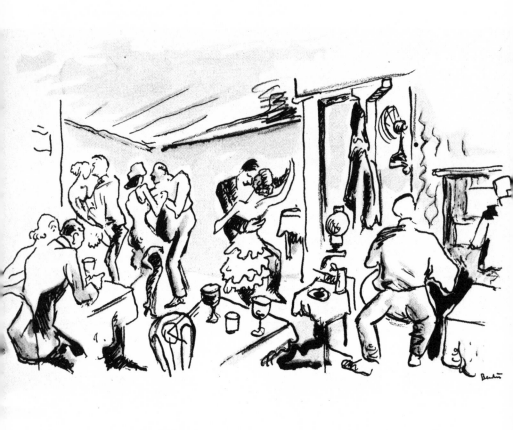

IX

After

SIXTEEN years have passed since my return to Missouri. I have never been seriously moved to eat the words of my farewell essay to New York. A few unpleasant things have happened out here since I closed the foregoing chapter in the spring of 1937 and a few people have, at times, expressed a belief that I was not the most desirable kind of fellow to have around. But, all in all, my differences with the home folks, when looked at in perspective, have not amounted to much.

The storm of protest which arose after the completion of the mural in the Capitol soon subsided. The work was fully accepted. Every year or so, it is true, some newly elected representative from the back counties of the State, rises and suggests to the Legislature that the painting be whitewashed, but that is only for publicity effect and is done with tongue in cheek. My Missouri history sits solidly with the Missouri people. As long as their Capitol lasts what I put there is likely to last also.

In addition to the local attention it drew to me, the mural vastly enlarged my place in the national scene. Almost immediately after its completion at the end of 1936 one of the most popular of the picture weeklies, then rising in the American publishing world, gave it a large spread with reproductions in color. This, added to the attention which the Indiana mural had already accorded me in 1933 and the new interest promoted by the daily press recordings of my various controversies, rapidly projected me into a country-wide prominence such as, I believe, no other American artist has ever attained.

As is well known, I found no difficulty in accepting this new situation. For nearly ten years I lived in a generally continuous glare of spotlights. Like movie stars, baseball players and loquacious senators, I was soon a figure recognizable in Pullman cars, hotel lobbies and night clubs. I became a regular public character. I signed my name for armies of autograph hunters. I posed with beauty queens and was entertained by overwhelming ladies like Hildegarde and Joan Bennett. I was continuously photographed and written about by the columnists. I received fan letters by the hundreds. Some of these, not so polite, told me where to get off. People wrote me from Europe, from Germany, Italy, Spain and even from France and from far-off Japan, India and Siam. Under the stimulation of all this attention, enhanced occasionally by other stimulants, I spouted endlessly and frequently without regard for consequences.

Needless to say, all this produced some pretty sharp reactions. The critics, who abhor articulate artists anyway, and whose sanctions I have never solicited or received, began eying me more and more distressfully. Wherever I exhibited a picture a pack of aesthetic uplifters would be sure to start singing. This made quite a chorus, for the bourgeoning American interest in art—which I was immensely furthering, although the critics did not recognize it—had increased the space given over to artistic matters in the national press. Nearly all newspapers of any consequence, even in the smaller cities, had set up art departments. These were frequently presided over by ladies of mediocre scholarship, often no doubt by some inefficient lady-secretary that the editorial room didn't know what to do with and often again by some home-returned graduate of the Eastern colleges spreading her intellectual attainments along the way to a husband. But this critical amateurishness was no drawback. Art criticism never suffers either from ignorance or unintelligibility. Most of these new critics, inclusive of the college art department males, or apparent males, numbered among them, felt there was something sacrilegious about my sayings and doings and they spoke out about these from coast to coast.

However, I had become quite hardened to criticism in New York and its extension over the country didn't bother me. In fact, I welcomed it, well sensing that the sharper the attack I drew, the sharper the comeback and that every blast against me would be sure to bring over as many friends as it gratified enemies of my doings. The proof of this I could see in my sales records and in the sympathies and writings of the regular common-sense newspaper reporters. These latter always regarded the boys and girls of the art departments as a bunch of prigs anyway.

About the time I began performing in the national scene, a young and able promoter, Reeves Lewenthal, hit the artistic scene in New York with some new and ambitious ideas about how to run an art gallery. Instead of depending on the limited number of very rich collectors and building up the depressing frockcoated and secretive gallery elegance which had been traditionally used to unloose the pocketbooks of these, he made a frank public business place of his show rooms and by what his competitors called "drugstore methods," set going a country-wide appeal for new collectors. To meet the trade of the less well-to-do he initiated the now famous five-dollar lithograph projects which not only spread a much neglected form of art over the country, but served as a "come on" for the more expensive items of his gallery. In addition to his business purposes Lewenthal had some idealistic notions to spark his efforts. He called his place the "Associated American Artists" and it was, as its name implies, to be devoted exclusively to the furtherance of American art and to the interests of American artists. It was not strictly speaking an association, at least not in the usual sense of the term. The artists involved had no hand in policy or management. Lewenthal was shrewd enough to see the disruptive possibilities of artistic pride in such practical matters as showing and selling and kept the direction of the business well in his own hands. Nevertheless as it started out his Association did offer a program in which intelligent American artists could readily participate and with a sense that they were part and parcel of it, that its interests were their own. This program

was to show by easily understandable public advertising that an American art was being made, and that it was not something for the few but for all. Its appeal was to the average American of the moderately well-to-do classes and it took the precious atmosphere from art and made it an easily approachable matter.

All this was, considering the nature of the gallery business with its general reliance on imported goods and snob atmospheres, decidedly revolutionary. Its democratic and American character appealed to me immediately, not only as an artistic benefit for the country but as a decided economic benefit for the artists who, it was plain, could not continue to live on the few very rich collectors, generally prejudiced, most of them, in favor of imports, or on the small prize handouts of the Museum exhibitions or, this was in 1938, on the diminishing subsidies of the W.P.A. and Treasury projects of the Federal Government. Lewenthal and his partner, Maury Liederman, seeing that my public reputation and the ways I had developed to sustain it were well-fitted to their own aims and ideas, opened up a new and spacious Fifth Avenue gallery in 1939 with a comprehensive exhibition of my easel paintings covering nearly thirty years of work. This was an immense success. Again the pictorial weeklies took me up, the daily newspapers sent their reporters and the critics analyzed my deficiencies.

In addition to the pictures of ordinary American life, for which I had come to be most known, I exhibited here two female nudes. Now, although scores of nude ladies are regularly painted and exhibited each season, these two of mine occasioned a furor. They were tied to quite conventional subject matter, to the old legends of Persephone and Susanna, but they presented these in American backgrounds and as if the occurrences involved were of the moment. Both pictures were realistic, detailed and developed in three dimensional compositions which so projected the ladies that their nudity was in quite positive evidence. Although I did not go in for what Mark Twain called the "explicitness" of Titian's celebrated nude in the Uffizzi Gallery in Florence, I left nothing out which the posi-

tions of my ladies permitted to be seen. When previously shown at an exhibition in the Municipal Museum of St. Louis, the "Susanna" had so drawn the male population of the city that a rope had to be thrown around the area where the picture was hung. This interest was so distressing to the director he was reported to be ready to remove the work from the exhibition. So far had the fear of popular interest gone in the museums! However, when the press got hold of this, the rush of art lovers made the idea of removal impossible. The director denied his reported intentions, no rapes occurred in the back corridors of the museum building, and scandal died down. Later the painting was regarded as tame enough for a place in the permanent collection of the Museum of the Legion of Honor in San Francisco. There it still is.

The other nude, the "Persephone," had her public adventures also. A couple of years after her first showing, in one of those Bourbon-inspired moments when Truth gets the upperhand of policy, I made the remark before a bunch of newspaper men that the museums were dead places—graveyards, I believe I said—run by a pack of precious ninnies who walked with a hip swing in their gaits and affected a certain kind of curve in their wrists. "As for me," I let fly, "I would rather exhibit my pictures in whore houses and saloons where normal people would see them." The New York papers, and then those to the west, made a big to-do over this even though I had made similar remarks before.*

One day Billy Rose, the famous night club entrepreneur, asked me whether I meant what I had said.

"Yes," I replied.

"All right," said Billy, "I've got the biggest saloon in town, down at the Diamond Horseshoe. You've got the biggest barroom nude." Persephone was seven feet high. "Let's get together."

I agreed. So Persephone with a protective plateglass front, which Billy put in her frame at my suggestion, hung in the Diamond Horseshoe. I had hoped she might find a permanent home there,

* See "Farewell to New York" essay.

but Billy never offered to put up any cash. I guess she was not enough of an asset where nakedness in the flesh was so evident. The old barroom nude, like the one described in my first chapter, hung in a male atmosphere of relatively contained drinking, where no actual female thighs and breasts could be seen, much less rubbed against, and at a time when public nudity was not common. In the new barrooms, like Billy Rose's, there were too many real ladies, practically naked, perfumed, painted and full of inhibition-curative gin, for a painted lady to get much attention. The brass-railed cut-glass places our fathers frequented were for serious men who stood up and drank and talked things over with other serious men. At Billy's tables, the pretty women customers, and there were always a lot of them, the wild-eyed women, and there were a lot of them too, and women with high nasal sopranos, to add to the generally high smells all about, turned the gravest of male drinkers into spit dripping idiots incapable of talking seriously about anything.

The special virtues of a picture, or its lack of these, could hardly be thoughtfully considered where all virtues were absurd. And then too the sneaking evil of old Pluto, come suddenly from his dark world on Persephone's youth and beauty, carried perhaps too apt a meaning for a lot Billy's male customers. Many of these, no doubt, had also sneaked out from darkness, from the spiritual darkness of the countinghouse or from that maybe of a Puritanical home, where some age-embittered fury ruled the roost, to take their own Plutonic peep at pink breasts and well-turned young asses.

Well, anyhow, Persephone's saloon visit was no great success and after a few months when a restorer friend told me that the heat of the spotlights thrown on the protective plate glass was cracking up the paint, I removed her. Examination showed cracks sometimes a sixteenth of an inch wide. For a while, I thought the picture was done for. But I said nothing to Billy, first because he had followed my own instructions for showing her, and secondly because he had already been a good sport and bought one of my more expensive pictures without trying to haggle, as so many collectors do, about

the price. When I loaned "Persephone" to the Diamond Horseshoe I had never thought of the heat that strong lights might generate beneath the glass cover, in the air pocket between it and the surface of the picture. However, back in normal temperatures, the cracks finally closed up and are now, after more than ten years, discernible only to close inspection. This experience downed my hopes for bar-room patronage. No one asked me to try the brothels. So I went back to the less exciting but surer sales channels provided by the Associated American Artists.

The remarks which sent Persephone on her night club career had further results. The national press, as I said, took them up and threw them, with the effects of a hot potato, into the hands of the respecta-ble trustees of the Kansas City Art Institute where I still held the job, as head of the painting department, which I had taken on my return to Missouri. These gentlemen, though it turned out later that some of them were not so respectable as they appeared, rose in a horrified body and threw me out of the school. I had afforded the big chance for which a number of them had long been looking. Ever since I became attached to the Art Institute there had been a lot of grumbling dissatisfactions with the craft-shop way I ran my classes, with my indifference to social affairs, with my refusals to interfere with student party doings, with my comments and with my long absences on lecture trips. The argument about throwing me out lasted a number of days, but finally the two or three liberal-minded trustees who favored me were squelched and, by a unani-mous vote, I was given the can.

Kansas City was much divided on this business. The students at the Institute, all on my side, picketed the place with the help of sympathetic brothers from the University of Kansas City. Profes-sional men, young lawyers, doctors, professors and some young businessmen who had an eye on my advertising value for their city, came to my defense. This rally of the young people only added to the convictions of the elder trustees that my position in their school was and had always been morally corruptive. The very fact that

the young took to me was a proof of this. In addition to being over-talkative about social skeletons in the local scene and thus disturbing to the faith of youth in the innate decency and rightness of the Kansas City hierarchies of wealth, I was objectionable on another count. I was too obviously a damned Roosevelt New Dealer. This meant to respectable Republicans, and Republicans most of the respectable people of Kansas City were, that I was something pretty close to a red-eyed Communist. Thus the violent political animosities of the time, as well as institutional and social moralities, were involved in the quarrel about my tenure at the school.

As there were two newspapers in Kansas City during this fracas—the *Kansas City Star* had not yet quite achieved its famous monopoly—I was able to play one paper against another, the Democratic against the Republican, and make a fight for my job. Out in the State this was effective enough to cause the President of a denominational college, presumably with the consent of his trustees, to offer me a position as "artist in residence" at the same salary I had received at the Art Institute. This was a beautiful answer to the charges of my corruptive effects on the young. But I couldn't take it up. I had just bought a Kansas City residence, a comfortable old stone house with trees and a garden and with a big stable behind it, which I had turned into a studio, and I was attached to all this. I had good neighbors and many good friends, and then I had a sort of sense that the whole Art Institute hullabaloo was a kind of a joke and would soon be seen as such even by the respectables who had taken it seriously. So I lived on in Kansas City. I think some of the elders were at first a little surprised. Not knowing much about the art world, they perhaps thought that in cutting off my job, they were cutting off my resources. When later, after the war had softened New Deal tensions, and it was seen, that for all my dubious ways, I was a pretty successful screwball and that the house my wife Rita managed, with its dinners, musicales, discussions and drinks was an entertaining place, there was a general dissolution of feeling against me. All but a few, even of the most diehard moneyed respectables,

came around. Having no real animosities, I received them. Today the *Kansas City Star* can write me up as one of the "leaders of the town" without protest from anybody.

On the tenth of July in the year that Rita and I bought and settled ourselves in our new Kansas City house, 1939 it was, we had a new baby girl born to us. We named her Jessie. Her coming stopped our annual trip to Martha's Vineyard, but she was so welcome that it made no difference. All during the hot Missouri summer, and for months thereafter, she was the center of our world and of all our attention. Twice during the hotter periods, T. P., the boy, and I slipped off down State and over into Arkansas for a little river floating and fishing, but we didn't stay long. The new baby and the new house drew us back. My new studio also was an invitation to work. I stuck close to home and for a longer time than I had in many years.

T. P., now thirteen, had given up his childhood recorders and was playing the flute. To while away the evenings, I picked up the harmonica again, having almost abandoned the practice after leaving New York, and we worked together on duets, old duets by Samartini, Handel and others by little-known German and Italian composers of the seventeenth and early eighteenth centuries. A few years before, when T. P. was still on the recorder, a New York musician, Ed Robinson, had written a trio for us, harmonica, recorder and guitar. Rita was supposed to play the guitar but Ed had given her a job that only a Segovia could have come around and we had abandoned his piece. This summer, the craze for trying to make music come back to me, I bought a virginal, a little preharpsichord type of plucked-stringed instrument, which sounded something like a guitar. We found a piano player who enjoyed the novelty of the virginal and we worked up Ed Robinson's music.

In the Autumn when Karl Kruger's Kansas City symphony musicians came back to town, some of them, with whom we had made friends, came over and heard us play. Lloyd Rathbone, then Karl's oboist, was one of these. He volunteered to take over my place in

the more difficult duets. This suited me fine because, although I liked
the music of these and wanted to hear them, some of their parts were
way beyond my capacities, no matter how much I practiced. I had
been collecting old music, it will be remembered, ever since I started
fooling with the harmonica back in New York, always looking for
something within reach of my instrument and my rather meagre
playing abilities. There was a lot of stuff around the house which
had looked simple when I bought it, but which actually called for
considerable musicianship in rendition. This material was a sort of
musical challenge to Lloyd Rathbone and soon he and his wife,
Betty, were regular Saturday night visitors. They came to dinner
and after dinner we played. T. P.'s flute teacher, Hale Pharis, also
a symphony man, was soon added to our group. Help was cheap
then in Kansas City and Rita fixed up big dinners. These and the
chance to play unusual scores drew more players, both woodwinds
and strings, and pretty soon our Saturday nights became musical
events in which, not only my own collection of small things were
played, but also the great standard trios and quartets. People began
dropping in to sit and listen.

Chamber music had already made some headway in Kansas City,
largely through the efforts of Clarence Decker, now President of
the University of Kansas City, who was himself a violin player and
an enthusiast on the subject, but our informal sessions very much
boosted its popularity. Decker was delighted with them. They helped
prove his contentions that if given half a chance chamber music
could be as popular as any other in our town. His concerts at the
University were beginning to include the world's most famous
quartets and the members of these came to visit the Benton house
and often joined in our sessions or gave us private hearings of things
too brief or too unusual for the concert stage.

All of this was great for T. P. and his flute. He had a chance to
play with fine musicians and improve his knowledge and his style.
But it left out the old man and his harmonica. I still played, but
very much on the side, as a sort of intermission novelty. However,

a few of the old hillbilly tunes I had picked up in my travels were fascinating to our musicians. Some of these were composers as well as players and they began making little arrangements of my back-woods findings putting strings, woodwinds and plucked counter-parts on the virginal, around them. As time went on and Clarence Decker's concerts at the University came to best represent the larger and better known forms of chamber music, our new folk-based music engaged more and more of our Saturday night attention. Some of our musical friends had come to miss the informal playing of their earlier meetings and these new things returned the spirit of fun which had then prevailed. The composers also liked the new creative opportunities and pretty soon we had a whole pack of ex-perimental scores to try out. A place was nearly always made in these for the harmonica. Ed Robinson had demonstrated in his "Chilmark Suite," the first, aforementioned trio, written for T. P., Rita and me, how to use the harmonica in relation to regular instruments and on the base of that a lot of novel effects were produced. I had to work like the devil, however, to learn my parts, and to come in at the right time. But the musicians knew me and the peculiarities of the folk style we tried to maintain, and we had a lot of fun. This fun went a little beyond music, however, especially for our listeners, and my liquor bills began to take on extensive proportions. We'd have twenty or twenty-five people for dinner and maybe fifty or more after and though none of the musicians drank much, the other folks did. It began to be like the old days in New York where we never knew who'd be sleeping on the living room couch when morning came. Rita began to have enough. Besides, wartime restrictions, now beginning to come, made all things more difficult to manage. We spaced our meetings farther apar . After Pearl Harbor, they became very infrequent, and when T. P. reached his eighteenth year and was called out of the University into the Army, they ceased alto-gether. I dropped the harmonica and have not played now for years.

It had been a gay sort of experience in my life, this musical inter-lude. And it did not pass without obtaining its little monument.

My old friend Frank Luther, the singer, who had taken part in some of our New York musical affairs, dropped off to see me one time on a trip west and heard some of our new goings on. Frank was now in the business of recording with the Decca Company, but he still had a quartet of folk singers and he suggested that we write voice parts for his group in some of our arrangements and make a Decca album.

"We'll call it 'Tom Benton's Saturday Night,' " he said.

The idea appealed to our composers and they came up promptly with new arrangements which included Frank's voices. The Decca people looked over the scores and thought they had something new and entertaining and a contract was signed with me. T. P. and I practiced our parts and in the early autumn of 1941, we showed up at the Decca studios in New York to start recording.

Then the fun started. Harry Sosnik, Decca's popular conductor, assembled an orchestra and went to work in thoroughly professional and musicianly fashion to rehearse our first score. Nothing happened but a lot of disconnected noises. I missed every cue and threw the other players off. The piece sounded like hell, all except the singing parts which Frank Luther, old hand that he was, knew how to hold together. We tried another score with the same results. A whole day, an expensive one for Decca, passed and we got nowhere. Once I began to miss I got panicky and missed everything. It was then suggested that we try one of our smaller things. So the next morning we picked up Ed Robinson's original trio, the old Chilmark suite, which T. P. and I knew by heart. But the guitar part, as I have said, was very tricky and one guitar player after another was hired and fired. None of them could play Ed's stuff at sight. Finally we picked the lock on a celebrated lady star's harpsichord, which had not been taken from the Decca studios after her recordings, and Ed, who was with us, played his own guitar part on this. Now we came through, not as well perhaps as we should have, but well enough for a record.

After this, we went back to the larger scores again, but with the

same confused results of the day before. Jack Capp, the finance man and head of the Decca corporation, began pacing the floor and tearing his hair, or rather what there was of it. He had hooked himself with a lunatic item when he had signed my contract, he thought. He came over and looked at the sheets on my music stand. They were marked with a lot of arrows of different sizes, pointing up and down; and with numbers, 8, 3, 5, 2, 2, 6, etc.

"What the hell's that?" he asked.

"That's my music. What I read," I said.

"Well, good God, and you're trying to play here with that stuff? Don't you know this damn business has already cost too much money? Go get somebody that can read music and let's get done with this. You don't care whether you play yourself, do you? You're a painter. We'll hire somebody and let on it's you."

"Oh no," says I, "I'm the only one that knows how to read these parts. What's written in the regular scores only indicates the place and time in which they come."

This was not wholly true but I knew Jack Capp couldn't question it from looking at my notation and I was determined to carry my recording business off some way, or other. Too many people knew about it and I didn't like to admit failure, even to myself. But, just the same, I was pretty much embarrassed.

I sensed something was wrong but I didn't quite know what it was. Back in Kansas City I had played our music with little difficulty. Frank Luther knew this and said so to Jack Capp and to Harry Sosnik. Sosnik insisted that he was reading the scores correctly. To settle the matter I was called over and Harry Sosnik and I sat down at a piano to make a little analysis. Right away the difficulty showed up. Harry was reading the scores correctly all right, too correctly. He took their time signatures 3/4, 2/4, 6/4 to mean what they normally would in most written music and gave them their correct emphasis. But the way I had been playing, and the way the symphony boys in Kansas City played with me, was on a steady and uniform quarter note beat. The time signatures were largely for

convenience, for getting between bars what in our folk style just went on most times irregularly, to its end. Frank Luther, who knew folk style singing, helped me explain to Sosnik what I thought was called for in our music.

"I'll tell you what, Tom," he said, "just take your shoes off, so you won't make too much noise, and beat time like the hillbilly you are. Harry'll keep his eyes on your foot and maybe we'll all know what to do."

We went back to the orchestra. I was placed so that Harry could see my feet, and for the first time we played through a full score. We finished the recording in a short time. It could have been polished up with another session or so, but Capp was tired of pouring out money, and I, with a blistered mouth, was glad myself to be done with the adventure.

Harry Sosnik is probably the only conductor who ever read a score from a wiggling big toe. But "Tom Benton's Saturday Night" still sells.

Although the period from 1937 to 1941 was full of trips to New York and Hollywood, of lecture engagements, harmonica-playing musical parties, of nightclub expeditions and of continued explorations into the hinterlands of the country, it was also one of much work. I turned out a mass of paintings, lithographs, and drawings. Only occasionally would I have moments of slack. The periodic depressions, known to all artists, would get me down now and then, but by and large these were exhilarating years. Perhaps the best of my life. Stimulated by the variety of natural growth around my house and yard, I began paying more and more attention to the texture of things. I painted detailed still-lifes, for the first time, and began also to have a concern for a more qualitative color. I studied and worked with the techniques of the Flemish masters, seeking for their wonderful transparencies.

My pictures began to rise in price. There was an increasing demand for them. Rita, always savings-minded, built up a bank

account. When I began to make twenty to thirty thousand a year it was possible, even with our expenses, to plant some of it. We bought more property on Martha's Vineyard. We added to and modernized our Chilmark house. Some of this modernization had a certain questionable value for me. Our new water system, for instance, was good for Rita—women always prefer bathrooms to privies—but it turned me into the slave of a gas pump. Instead of just going down to the spring with a bucket I now had to go down and get on my knees and kowtow to a temperamental piece of machinery and wheedle it into running properly. Still, it was all right. If you are to live in the modern world you have to accept some of its disadvantages.

My bet on the Associated American Artists gallery had turned out far better than I expected. I never believed I'd make so much money and be able to get things I wanted without pinching and weighing a lot of pros and cons. But while I was well satisfied with the gallery's ordinary picture sales, and with what I was making on these, Lewenthal's promoter instincts were not. Tasting money success, he wanted still more and he began reaching out into the advertising game, seeking commissions. No doubt he thought at first he could capture the advertisers and bring them over to the artists and handle them like ordinary art customers and do everybody a lot of good and make everybody, along with himself, of course, a pile of new money. So he made his contacts and convinced a number of painters, including myself, that we could bring up the levels of advertising and establish a much-needed relation between business and art. It was easy to recognize the desirability of such a relation. Many capable artists were not selling enough pictures for a decent living. There were just not enough picture collectors. If there was a way to bring the great business corporations to the support of art, a way of making them take on the artistic functions, say of the Medieval Church or the great banker nobles of the Renaissance, it would be a great gain, not only for individual artists, but for the place of art as a living factor in our American culture. It

would make it a real part of life rather than an insecure and mostly useless appendage. Back in my mind I had long harbored a conviction that unless the arts were returned to some functional place in the full stream of life, they would eventually become mere forms of play, vehicles good for personal release perhaps, but of no real consequence. I had come to know, through their patronage, that quite a number of big businessmen had aesthetic leanings and that a few of them even believed in encouraging a specifically American art.

In addition I knew that since 1929 business had come to be a little uneasy about its status in our world which was becoming more and more political and more and more concerned with the validity of naked money power in its new democratic schemes. Through its public relations men, big business was continually trying to justify its place in our way of life, trying in fact to prove that it best exemplified that way and promised the most for it. But it was somewhat on the defensive. I had a feeling it was within the realm of possibility that the great businessmen would undertake to justify themselves culturally as well as economically in their new situation, that they would attempt to show they were not just the greedy materialists which so many politicians and social theorists were making them out to be, but men of real cultural aspiration. So Lewenthal's picture of a new day for art and business found me a little prepared to believe in it.

However, it soon turned out that, whatever the possibilities of a fruitful relation between big money and art, it was not going to be furthered by the advertising racket. This had a vested interest in keeping things as they were. And if changes must occur, the advertising boys would see to it that they rather than any bunch of artists controlled the directions of these. Their game, run as one of them told me, "on whiskey, bicarbonate of soda and 'dripping' blondes," had been too delicately balanced between exaggerated fact and outright cynical fraud to risk a tampering with by amateurs. Entirely too much money was involved.

By the time Lewenthal had his first commission, he had been turned by the advertising fellows from a representative of the artists' interests before business to what amounted to being a representative of the advertising trade's interests before the artists. But he was such a persuasive and enthusiastic advocate that none of us involved in his projects noticed the difference. The end result of all this was, of course, not that advertising levels went up but that artistic levels went down. The most of us who went in on these new ventures didn't seem to be able to get down far enough and in a year or so we were dropped. I learned very quickly that it was impossible to attach any kind of serious artistic realism to product advertising. The accepted patterns for this permitted no frank or genuinely realistic approaches whatsoever. Institutional advertising, on the other hand, did offer better opportunities and I made a few pictures for banks, stores and big industrial corporations, in which I was permitted a straightforward approach to my subject matter. All in all, however, this business and art experience was pretty disheartening. It was too much of a whoring affair finally to inspire anything but disgust. Also I found that it did not pay off the way it was supposed to. I would put ten times the effort trying to meet the requirements of some lousy commercial job than on making an honest picture, and in the end get less money for it.

I did learn some things, though, about American life which I didn't know before. And I saw the insides of a lot of interesting industries which under different conditions might well have made good pictorial subject matter. I also had a chance to acquaint myself with the amusing cynicism of the advertising trade and with the ribald contempt which most of its practitioners appeared to have for their business customers. The better part of the fellows I met in the game were fairly young, smart types, with a sort of slippery and corrupted intellectual shrewdness. Few of them took themselves too seriously and they were, generally speaking, good company, good drinkers, good story tellers and good commentators on the vanities of the world. This latter they had plenty of chance to know about.

Some of the old business buckaroos with whom they dealt were vain as peacocks and chock full of the pride of their moneyed success. They had to be petted and wheedled and made to think that all publicity ideas were their own. All parasitical games are tough, but I suspect that advertising is the toughest of all.

At the very beginning of my experience with it I ran into a memorable example of that toughness. One of the first to be sold on Lewenthal's idea that art and business were natural pals was the famous old tobacco magnate, George Washington Hill. After an interview with Mr. Hill and his advertising representatives in the New York offices of his company, in which it was decided that a realistic picture of the tobacco industry was to replace the usual photographs of pretty models holding tobacco leaves, I, with two other artists, George Schreiber and Ernest Fiene, was sent down into the fields of southern Georgia. The trip was interesting and the scene full of rich color. We were all very enthusiastic and felt if this was what business wanted to picture there would be no trouble about realizing Reeves Lewenthal's plans for allying business and art.

Now in south Georgia the tobacco is largely handled by Negroes and our drawings and studies were, of course, devoted to them. I made a whole book of sketches, enough for twenty pictures, and felt sure that among these a suitable motif would be found for Mr. Hill's project. When on returning to New York, I showed my book to his advertising promoters, I ran into a most horrified protestation.

"You ought to know," these fellows said, "that you cannot picture Negroes doing what looks like old-time slave work when you are advertising tobacco."

"Why?" I asked dumfounded. "You said I was to make realistic pictures and the colored people were doing all the real work down where we were."

"Yes, yes, of course, we want realism. That's why we quit the conventional model stuff and hired you artists, but we don't want realism that will foul up our sales. The Negro institutions would

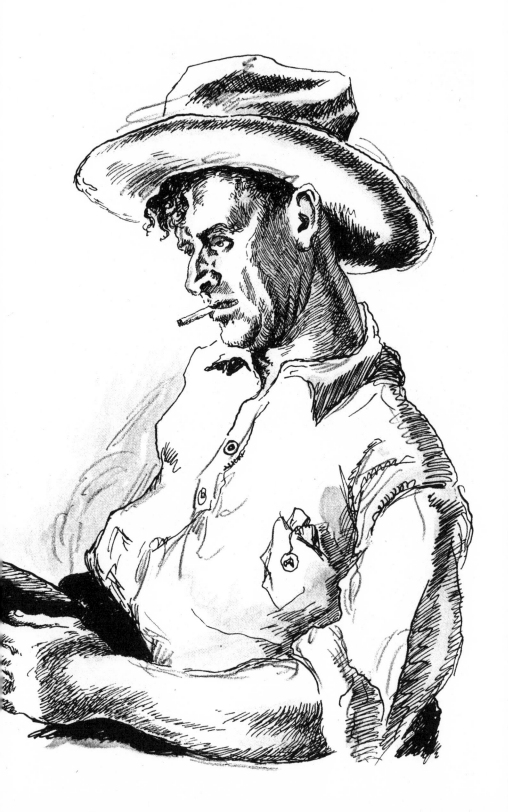

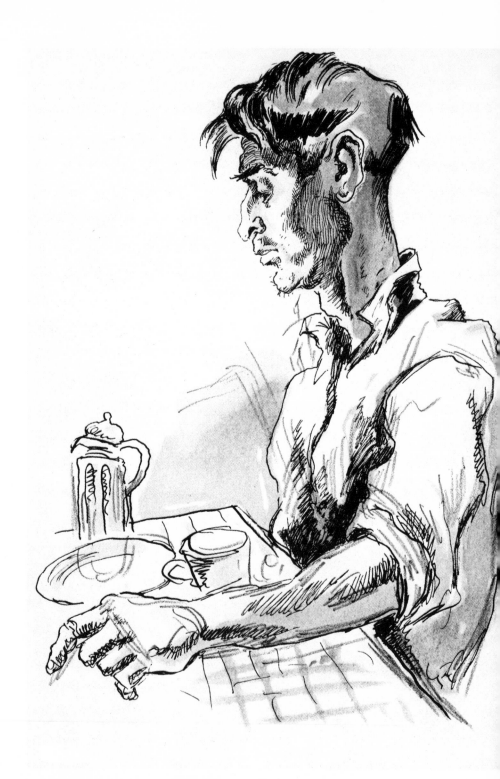

boycott our products and cost us hundreds of thousands of dollars if we showed pictures of this sort. They want Negroes presented as well-dressed and respectable members of society. If we did this, of course, the whole of the white south would boycott us. So the only thing to do is avoid the representation of Negroes entirely in tobacco advertising."

"My God," I said to myself, "why did these guys send me to south Georgia?"

After this I went to North Carolina where the hillbillies handle tobacco and came back with what appeared to be an acceptable picture. It was of an old hill farmer sorting tobacco with his granddaughter, a little girl about nine or ten years old.

"This is all right, but make the girl prettier," I was told.

To insure the prettiness, I borrowed the attractive little daughter of a friend and substituted her for the hillbilly girl. She was very cute and blonde but somewhat skinny. I worked up a highly detailed picture but, when I turned it in, I was promptly informed that while Mr. Hill liked the picture so much that he was going to hang it in his personal office, it was not suitable for public display because the thinness of the little girl might suggest that proximity to tobacco caused consumption.

"Everything about tobacco must look healthy," the advertising people declared.

Well, I tried again, this time leaving out girls. But now the report came that my tobacco leaves were too small and not nearly yellow enough. I had, if I remember correctly, a contract for three pictures and in the interest of the future success of our art and business alliance, I wanted to make good on at least one of them. So I decided to by-pass the advertising agency, go see Mr. Hill on my own and find out from him directly what I could do that would meet with his approval.

The old man received me in a most friendly way and after talking a little about river floating and fishing, for which he had a passion, I brought up the picture business. I argued for the first picture which

was standing in the office, saying that I thought the advertising boys were exaggerating the chance that my little girl would suggest disease. But Mr. Hill pushed me aside on this, so I went at the second picture. That, I finally induced him to use by comparing my tobacco leaves with other things in the scene and showing him they were larger than normal. I told him his printers could make them yellower. Then, I sold him on a new idea.

"Why," I asked, "don't you let me paint a still life of tobacco leaves? Just a bunch of big leaves sitting on a chair."

He thought this wasn't enough of a picture but I finally brought him around by promises of a glorious yellow and a rendering in utmost detail. Flushed by my success as a promoter, I went back to the first picture. "You know, Mr. Hill," I said, "that is one of my most finished pictures. I hate to see it left out of this project."

"You like it, don't you?" he said, eyeing me with a little smile.

"Why most certainly," I replied. "That's more than an advertising picture, that's a real work. I'd like to own it myself."

"Well, it is a good picture. Maybe we're mistaken about it," said the old man. I thought he was about to yield to my views, so I went full steam for a final argument. "Why, Mr. Hill," I said, "this picture is marketable for itself. Anybody would buy it as a straight work of art."

"How do you know that?" the old man led.

"Why I'd buy it myself," I burst out with conviction.

"Well then, Mr. Benton," old Hill leaned over and looked me in the eye, "I'll just sell it to you. It's yours."

Well I'd talked too much and too big and the old man had me. To save my still life commission and to show that my word was good, I had to shell out. This little piece of self-promotion cost me three thousand bucks.

In spite of all my success as we moved into the forties, there came over me now and then a sense of uneasiness. I could feel the winds from Europe blowing with accelerating force toward world conflict.

Beyond the political and economic divisions in our country and Roosevelt's struggle to overcome these with new democratic patterns, it was plain to anyone who, like myself, remembered the preliminaries of World War One that we were approaching World War Two. The "quarantine" speech made by Roosevelt in Chicago in 1938 predicted the way things must inevitably go. Only a few in America wanted to look, however, at the looming storm, much less face its pressures. Old-fashioned isolationist sentiment, so natural and so plausible to Americans, was rising and particularly in the middle west. So also was a peculiar brand of acquiescence in the rise of Nazi power. As early as 1936 I had seen evidence of this while going around the farm country of Missouri. Old native-born American farmers, of German stock, were by no means shocked by Nazi racialism, nor were a lot of other people without natural German sympathies, in more well-to-do circles.

Traveling around as much as I did, talking here, there and everywhere with all kinds of people, I had formed a pretty good picture of American sentiment. I knew positively that it was on the whole very much against any kind of war adventure in Europe. Whether or not there was any tincture of pro-Nazism involved, this was so. It was impossible with my Americanist convictions not to sympathize with this anti-European involvement feeling and I was much divided in my own mind. However, as the Nazi power grew and its atrocities multiplied and its influence on some of our South American brothers placed its menace on our very doorsteps, I began to favor American intervention. By the late autumn of 1941 my mind was so much on the international situation that I found it difficult to concentrate on painting. The American scene which had furnished the content and motivations of my work for some twenty years was outweighed by the world one. As I had no pictorial ideas applicable to this new scene, I was almost completely frustrated. In late November of 1941, to compensate for this impotence, I yielded to the importunities of a lecture agency and took on an extensive speaking tour, nationwide. Though I might be empty of painting ideas, I could still talk.

I was on the stand in Cincinnati when the Japanese struck Pearl Harbor. I got off promptly, telegraphed my agency to cancel all further engagements, and went home. I had an idea. I would try to wake up the middle west to the grimness of our national situation. Within six weeks, I designed and largely executed ten large-scale poster-like paintings dealing with the war. These, departing from any of my precedents were deliberate propaganda pictures, cartoons in paint, dedicated solely to arousing the public mind. I called these pictures "The Year of Peril." My intention was to hang them in the Kansas City Union Station where the milling travelers would see them, and be shocked, maybe by the violence of their subject matter, into a realization of what the United States was up against. My friend, Dr. Picard, head of the station's medical and hospital department, was arranging for their showing when my promoter partners of the Associated American Artists, Lewenthal and Liederman, showed up in Kansas City. I had written them that it was hopeless to expect further pictures from me for the present and had told them of my Union Station project. They were exceedingly sceptical about this and came to see me, no doubt, to persuade me that it was utterly foolish to drop my regular painting for so impractical a business. However, once in my studio they changed immediately. Not about the Union Station exhibition of the pictures, but about the practicability of the paintings themselves. After the first shock caused by the difference in content and appearance between the war pictures and my work in general, Lewenthal, following his quick and sure instincts for public promotion, said: "Tom, this is no local affair you have there. It's a national one. Forget the Union Station business. Leave these pictures to me and I'll put them over the whole country." He did.

Getting in touch with the Abbot Laboratories in Chicago, the better part of whose artistic advertising the Associated American Artists handled, Lewenthal got their instant cooperation and almost immediately thereafter the cooperation of the newly set-up wartime agencies of the Federal Government which were working to

impress on the minds of the people the dangers of the moment. At their own expense the Abbot people, after paying me handsomely for my work—something I had not counted on when I painted my series—reproduced most of the paintings in pamphlet and poster form and in full color. Charles Downes, head of Abbot's advertising department, worked furiously to get good reproductions, taking me around to the various Chicago printers for my approval of inks and processes. Accepted by the United States Government as a propaganda instrument, these reproductions went all over the country and all over the embattled world. In the first pamphlet issued, Archie MacLeish, then head of the Office of Facts and Figures, wrote an impressive foreword to go with my own interpretations of the pictures' meanings. One hundred and sixty thousand of these first pamphlets were circulated. The newspapers came out with over twenty-six million reproductions. The exhibition of the paintings in New York drew an attendance of seventy-five thousand people. The moving picture, that is, newsreel showings of the paintings here and in England amounted to over twenty-two million. Posters and card size reproductions for local and foreign use, circulated by the Office of the Coordinator of Information, numbered three hundred and twenty-six thousand. Magazine reproductions went over two million. All in all the circulation of actual single reproductions of the paintings came to well over fifty-five million.

This was a triumph for the Associated American Artists and for the idea which came to me in Cincinnati when the news of bombs on Pearl Harbor stopped my lecturing. It was no triumph, however, for the critics. They performed as usual for my doings. And as usual, they were wholly ineffective. Their aesthetic diatribe was not only irrelevant, but indicative of a complete disregard of governmental policy and of the clear need, in a dangerous time, for public stimulation. No one paid any attention to them.

With these war pictures, my public reputation reached its heights, not only in the United States, but abroad. Later in Italy and France I learned how far my name had gone into cultures which generally

accord but little thought to American picture making. The success of my effort went, however, far beyond mere personal acclaim. It drew general attention to the value of art as a public and patriotic instrument and suggested a way for the war-time employment of artists, a use for their representational talents on a large scale. "The Year of Peril" initiated that long series of war pictures which the great corporations and the popular magazines went in for during the period of conflict. In this way, it may be fairly said, I helped provide a living for a great number of artists who, without my initial propaganda step, might have had a tough time during the war. Many of the artists, let me record it here for the good of our trade, had the grace and friendliness to tell me so.

During the struggle I continued to paint and draw subjects pertaining to the national war effort. I pictured the first embarkation of our soldiers for Africa. This work was never used as a poster because of its gloominess and because its chief central figure was shown as looking back homeward rather than forward to his duty. But it was real. All the boys looked back as they were marched up the gangplanks and into the holds of the grey ships which were to take them away into the unknown. I went with the artist, George Schreiber, on a new submarine breakdown off the New England coast, and drew the life of the underwater sailors. Two days after we left this vessel she was sunk and all on board were killed. After this I drew and painted part of the war effort of the oil industry. Here I returned to what I had done in the first World War, to a rendering of machines, but with the difference that I was now paid with money rather than with a mere release from shoveling coal. I made a large study of the new "Catalytic Crackers" at Baton Rouge, La., which, for all its bald, mechanistic appearance, I still believe to be one of my best pictures. In northern Mississippi I undertook a series of drawings on the laying of a pipe line through a deep and heavy live-moss hung and rattlesnake-infested southern forest. I didn't have much luck here because I was afraid to get off the diggings

and risk a snake bite. The passing years had knocked some of the nerve of my earlier exploring days out of my system.

One night a little later I found they had knocked out some other things too. I was staying at a little hotel in Natchez and in the dining room there I picked up acquaintance with a couple of soldiers from a nearby training camp. They were off duty and were out for a little hoopla. They asked me if I wanted to go along, telling me they knew about some good joints around the country. I did.

Now, some ten or twelve years before, I had traveled in the South with an Italian newspaper correspondent. This I have told about in the chapter on the Mountains. As I said there, he was chubby and fat. He was also bald headed and, in terms of years, on the wrong side of life. But he liked girls. Especially blonde waitresses. He would try to be gallant with them but they would call him "Pop" or "Old Pop" or "Fat Pop" and this would make him mad. But it made me laugh. Bill, the old student who, as related, was on this trip with us, laughed also and we kidded "Pop" about his attempts to be a gay blade. "You think an old 'Pop' like you can make time with these flossies?" we asked.

Well, I went out from Natchez with my soldiers that night and pretty soon we met up with more soldiers and some girls they'd picked up and drove out in the country to a dancing and drinking joint. I had a car and one of the soldiers had another. Now Mississippi was a dry State, but along the big river it was at the time a very open wet one. Theoretically it was illegal to sell liquor anywhere on Mississippi territory, but rumor had it that the State fathers were always trying to find a way to collect liquor taxes just the same. Because liquor *was* sold, and plenty of it. It was explained to me that Federal control along the banks of navigable rivers had, in the minds of the Mississippi people and their sheriffs, been extended quite a few miles back and that as the State couldn't make laws for territory under Federal jurisdiction, those who lived in the river counties did about as they pleased in the matter of beverages. I've never checked the legal aspects of this account, so I don't know

how good it is. But anyhow the joint I went to with the soldiers was wet, soaking wet.

Now wherever there are joints where there shouldn't be, or are not supposed to be, they tend to be more hilarious and bawdy than those of open and legal toleration. At least they seem to so tend. Anyhow the place was like that where I went with the soldiers and it was full of girls who liked soldiers and whose chaperons hadn't come. There was a Negro band playing, red hot and tremendously loud.

I took my drawing pads along. Picture making excites the curiosity of girls and as I began to draw, more and more of those in the joint would come to our table and my soldiers had plenty of dancing partners. I worked along, but always with highballs at hand. After a while, when these began to work on me, I got the notion that I too wanted to dance, along with everybody else. I grabbed the girl next to me and set out. Things didn't go so well. I hadn't taken into account that the way I danced was devised about the time of the St. Louis World's Fair and that my partner wouldn't know about that style. But she was game and let me kick her shins once all around the floor. Just as we got back to our table, the music stopped and we sat down with the soldiers and their partners. My dancer heaved a sigh of relief, cocked her head over and gave me a "straight in the eye" kind of look.

"Looky here Pop," she said, "you take care of the drawin' angle at this table and let the soldiers take care of the dancin' angle from now on."

The young soldiers all laughed and slapped me on the back. I laughed too, but I remembered the Italian correspondent I had taken down South a decade before.*

When does a man start getting old? After I'd gone over into the fifties I often asked this question, but without ever quite looking myself in the face and answering it. I knew that the time-worn gag

* This story was told in Leonard Lyons' column in the New York *Post* in 1945 when Lyons asked me to be a "guest columnist."

"You're as old as you feel" bore only a very limited relation to the truth. It's generally when you are at your friskiest that you fall on your face. The night before my brother Nat died in 1946 of a heart attack, he pounded his chest before me and laughed because some of the doctors had told me that I ought to think about slowing up a little. Poor old Nat was feeling at his tops. He had a good paying lawsuit under hand and was exhilarated by his success with it. But his heart was old, and in a few more hours, it quit on him and he went out of the world.

When I was in my fortieth year and thought myself as hardy and strong as I'd ever been, I went across the street from our old Eighth Avenue walk-up apartment in New York and bought a sack of cement to fix a broken-down fireplace. We lived on the third floor here and, counting the stoop over the basement, there were three landings on the way up. A sack of cement weighs close to a hundred pounds, but I hoisted it on my shoulder, crossed Eighth Avenue and stepped briskly up our stairs. I went up to within three or four steps of the third landing when, without any warning whatever, my legs caved in, and I fell down. I was not winded or tired. My legs just gave out.

I didn't think much about this, but a couple of years later, another unexpected thing happened. Up in Martha's Vineyard, our south beach has a beautiful kind of surf which rolls in with great slow curves and is easy to ride even without a surf board. One day when the sea was pretty high I swam out with a young fellow and fooled around on the outside of the breakers where the waves lift you up and down. When we had enough and were about to take a comber back in, I noticed we had drifted down toward a lot of rocks where it would not do to land. So we tried swimming back to where we had started. But there was a sort of rip tide setting in, and it was hard going. Suddenly I felt tired, tired in my shoulders and down my back and, what was worse, in my stomach muscles. I knew, however, that if I rested I'd drift back to the rocks so I kept going, but with a sort of interior uneasiness which I'd never experienced in

the water before. When I reached a place safe for landing, I eased in toward shore. I saw my companion go in ahead of me on a big wave and then a smash of white water came on me, and before I knew it I was caught in its underside and turned head over heels. This happens all the time to surf swimmers, and if you keep your head and dive outwards, there is generally no harm, but with my weariness, it seems that I lost all my wits, for as soon as I came to the surface, I turned panically shorewards and got caught beneath another wave. This one ground me in the bottom sand and knocked the wind out of me, or what little I had left. I don't know how I got to shore, but I finally did and lay on the sand for a long time utterly exhausted and also utterly ashamed of myself.

For years I'd been a cocky and confident surf swimmer. There were a number of us who used to go out and show ourselves off and come in belly flat on the big combers and strut around before people who were too timid for the business. Lying on the beach I felt not only battered up physically, but pretty well damaged in my mental stuffing. For the first time in my life, it occurred to me that I was not all I should be. I asked myself, "Is it possible that you're running down already?" This was a damaging question. It brought up the idea of caution and once that idea is in your head, it means the end of free and easy fun.

I never was much of a fast swimmer, but I had always been enduring. In the old days when I worked under Rex Ingram's sponsorship in the movies, I lived in an ancient house at Ft. Lee not far from where the great George Washington Bridge now lands on the Jersey side. On those mornings when studio work was slack, I'd go down the Palisades and swim across the Hudson River, rest awhile on the New York shore and swim back. The river was over a mile across here, but I never had a boat with me and I never had any kind of fear but once. That was when, as I was pulling around a lot of drift, which used to gather in long lines in the river, I was caught in the wake of a big steamer and thrown into a lot of milling and pitching logs. Some of these were fifteen or twenty feet

long and had any one of them hit me, it would have put me out of business. Terrifying as was this predicament, it was something external and brought up no self doubts. But the surf experience at Martha's Vineyard was different. The trouble there was not in the surf, but in me. It led me to take stock of my physical equipment. I was forty-four years old, and I could see that for my age, I was in prime shape. My arms and legs looked all right, my abdominal muscles were still in evidence, no fat over them, and my wind, in spite of my smoking and at that time occasional drinking, was good. But something was gone, and I knew only too well what it was. When it came to the kind of effort which is added to effort, to the last quarter mile, so to speak, I knew that I didn't have the stuff any more. Recognizing this, I made up my mind to keep out of the high seas. Once this concession to the years was made, I made others. I quit bothering much about my physical self. I continued to swim, but only where it was perfectly safe, and to take on fairly heavy tasks around our summer place but in the winter I passed up the gymnasium work with which I had long made up for the physical dullness of city life. I soon began to get a little flabby around the middle and in a short time saw my shoulder muscles go down and my arms and legs get stringy. Still my hair stayed black, and keeping away from any over extension of muscular power, I could put the idea of physical loss into the background.

The realization of age hits people in different ways. Many completely close their eyes to it. These cannot give up their physical youth and cannot apparently find anything to compensate for it. There are lots of men and women who continue to believe in their bodily attractiveness when it is long past and who exhibit themselves promiscuously and with all the sure confidence of a teen-ager. Any visit to a metropolitan night club is certain to reveal a dozen or so old cuties, painted and fixed up to kill, and an equal number of old dudes, barbered, rubbed, manicured and perfumed to absurdity. These old squirts, under artificial light and in an atmosphere of alcohol and jazz, however, do quite well. Their very fraudulence

is amusing. But out in the daylight, they look like hell. Fortunately the most of them are aware of this, so they never show up till around the cocktail hour when the lamps are turned on.

I know lots of other people, however, people that you'd never think of comparing with old vintage night club sports, who outdo these in the matter of youthful urge and who by no means wait until the sun goes down for their displays. Our beaches at Martha's Vineyard are full of half broken-down middle-aged men and women, folks of real solid accomplishment some of them, who put on the most outrageous personal exhibitions, in full and glaring sunlight. We've always had the sensible practice up there of swimming naked, but in the course of years, this has grown into a cult of nudity and most any time you go down on our shores, you are affronted with some of the most extraordinary sights in the world. Draped all over the rocks or standing up in prominent positions here and there, often strutting flamboyantly up and down the beach, aggregations of female skin and bone with old dried-out udders hanging off or oppositely, monumental collections of bulbous flesh, are matched with hairy, potbellied, fat-assed male caricatures of the human race. You never see any of the young and beautiful around. These all wear bathing suits and keep well off to themselves in the more distant reaches. Once or twice I've seen a young Venus come naked out of the Martha's Vineyard sea, but generally it's something to make you wish you hadn't lived so long.

The taste for conspicuous nudity is an odd thing. It comes from something beyond the good love for the feel of the sun on your flesh, which can be had easily without display. Perhaps it originates in some of those deep pits of frustration where the self, unfully realized and checked in modern life, seeks a form of primitivism for release. Perhaps, but it has, as far as I can see, none of the character of such an unpremeditated escapist move. Not by any means. The usual cultivator of conspicuous nudism is always quite self-conscious, though he or she must act with the studied natural-ness of an actor to carry the business off. It appeals most to the

kind of people who pride themselves on their intelligence, to literary folks and very emancipated ladies and to the artists. From these it travels over into some of the regular professional groups, even to bankers and business fellows, who wish to show that they also, in spite of the conventions by which they live, are capable of free behavior. Such folks take great pride in their strip cults and expose themselves on principle. Once a convert has forgotten how he or she really looks and has learned to pose and strut around stark naked and with the proper degree of nonchalance, a wonderfully gratifying personal weapon is added to principle. This is the youthful tasting power to shock, and few there are among cultivators of the conspicuous nude who do not delight in using it. There is nothing a confirmed body exhibitor so loves as to stand up stripped and be introduced to some amazed stranger who has all his clothes on.

Whatever the real psychological causes of nudism as a cult, most of its adherents are, as I have indicated, on the way to physical senility. It is as if they were making a last blind gesture toward youthful sex and strength and beauty, which, though they secretly know to be lost forever to them, cannot quite be given up. There is a side to this which is grossly ridiculous, but it is also sort of pitifully human. Who doesn't want the sense of youth and strength and beauty and the fun of feeling young? And who, given half a chance, does not reach out and grasp at these? Most of us, in one way or another, tend to do so. I suppose this occurs, because, when we did have our youth, we lacked the wit, or the nerve or the opportunity to get all the good out of it. We look back with our flabby muscles, our sagging skins and our thrusting bellies and see all the lost moments, and they look so much better than we knew when we had them in our hands. So we put on our various acts of retrieval and try to imagine that the spring breezes of yesterday blow again. And we are all alike, prancing nudists, painted night-club hags, old suckers who shell out for the gold digging blondies and old fools who go around with soldiers and try to dance with their girls.

The Mississippi experience made me more careful about trying to act a part in the war life of the young. Nevertheless, I did get caught a little later in a two-bit gyp game in New Orleans where three girls dressed up as WAVES skinned me and a couple of young Navy officers out of some money. I had been given a commission to make a pictorial record of an L.S.T. from its construction at Pittsburgh to its breakdown in the Gulf of Mexico. The ship to which I was attached ran into a sand bar on the way down the Mississippi River and damaged a propeller shaft. This forced a stay in New Orleans for repairs and while there I went out every evening with some of the ship's officers and visited the French Quarter dives. The town was making the most of its wartime chance and the Quarter was jammed full of profiteering adventurers, male and female.

One evening toward the end of our stay I was sitting in a crowded drinking and dancing place with two of my young L.S.T. officers when three neatly uniformed girls came over to our table and sat down with us. They danced with the boys, not with me; I'd had my lesson, and drank and told yarns for about an hour, and then, saying that regulations did not permit their staying late in public places, they suggested we continue our party at their home. But it turned out they had no party supplies and they trapped us into buying these, a lot of very expensive liquors and fancy food. We got a taxi and took this stuff to where they lived and we had no more than put it inside the door when a regular old southside Chicago madam, acting the part of a shocked mother, chased us away. This was a transparent piece of business, but the Navy boys and I were so befuddled with alcohol, we didn't catch on until it was too late. Besides it was hard to connect these girls in uniforms, or what appeared to be uniforms, with this old game. The bill for the monkeyshine fell almost entirely on me, because the Navy boys were quickly cleaned out, and it made me feel most positively like an old fool sucker. It also put an abrupt end to all my youthful behavior urges. I said to myself that henceforth the young were going to handle their doings without my help.

I came to this conclusion with considerable reluctance because I very much liked going around with young folks. One of the chief reasons I always enjoyed teaching was the companionship it afforded with these. Even when they are cautious types or even a little crooked, there is a kind of hopefulness among young men and women, a confident flare, which transfers itself to you and makes you feel there is hope for you also. I suppose all people who begin to feel their age a little benefit by this, but it is particularly good for an artist because when you've painted for years and discovered finally that you never get any nearer a real mastery over your trade a lot of very doubtful moments come on. Such moments increase with the years and, no matter what your success, they keep occurring.

The older you become in the pursuit of art, the tougher is your competition because you tend to pit yourself, not with the contemporary world, but with the past. The more you learn of the art of the past, the better it looks and, if you are intelligent, the less you seem to know yourself. This is often very discouraging. So the kids, who don't know too much and who don't suspect what they are up against in life, are good medicine. But there is a limit to successful association with them. When they get you in positions where you are turned into a sucker and an old fool "Pop," it's time to clear away.

As my experience with the war went on, I saw that, in so far as it was interesting, it was almost too wholly a young man's affair for me to follow it. No doubt for Army and Navy professional men of my age, the technical aspects of the business were absorbing, but these meant nothing to me. I had to find my interest in life, not as it was instrumentally planned or directed from above, not as strategy or tactic, but as it was actually lived. When I began to discover I could not really participate in the youthful, and most essential and also pictorially significant part of this life, I began losing interest in it. As the desperate days of the war passed, and it became largely a matter of routine, I began to feel there was really nothing left for me to say about it. I, therefore, gave up making exploratory trips,

although I continued to hack out war bond posters for the Treasury Department. But this was pure hacking and provided little creative satisfaction.

I would have liked to paint some kind of stirring and at the same time realistic picture of our war effort, but I never seemed to get my hands on the right sort of material. The great human drama in which we were engaged always seemed something less than drama when I came close to its details. The purely imaginative ideas of danger, of peril, of violent effort which had been in my first propaganda pictures were not transferable to the actual facts of war life as I was experiencing them.

A soldier with a gal and a bottle, a bunch of fat politicos quarrelling in Washington, a war plant labor struggle, the continuous and greedy scrambling for profits over the whole national scene, were not, when added up, conclusive to the maintenance of a sense of crisis even though on the field of battle the crisis was real. Right after my early embarkation picture, I had had a sort of let-down. And after each succeeding reporting adventure, I would have another. This was not merely because I couldn't handle myself adequately in young company. Such playtime stuff was always on the side and apart from the real purpose of my explorations. It was because when I took stock of what my trips were providing, I could never find anything, as above suggested, to further the kind of serious and all encompassing war picture I had in mind to do. A few times I thought of asking for an overseas assignment, but I was not confident enough of my physical condition and I also sensed that a superficial survey of mechanical battle, which was the only kind the accelerating swiftness of the war would permit, was not likely to give me much more than I would get at home. I felt that I would need to perform as an actual soldier to reach any depths in an overseas experience. This I knew, of course, was out of the question. So little by little, I began turning my thoughts back to the ordinary things of life. I returned to painting foliage, flowers, wood and stone, to portraits, and, with a new slant, to representing the play of light over

things. In these returns to normal ways, I painted the "June Hay" of the Metropolitan Museum, "New England Editor" of the Boston Museum, the large sentimental "Music Lesson" and a number of other detailed pictures based on everyday experience or on the common folklore of America. There was nothing controversial about these things and no special notice was taken of them. By the time Germany was defeated and the new "cold" struggle with Soviet Russia was beginning to occupy the press, I had dropped completely out of public attention and was just a painter like any other. But my sales continued in sufficient volume to provide a living and I didn't care much. I had become a little tired of living up to my public self anyhow. This may have been because my capacity for whiskey was diminishing. I had begun to notice on my various war trips that I got soused on a very few drinks and also that I had unpleasant hangovers after nights of hoopla and big talk. With the fear of the morning after on me I began to be as cautious with the bottle as I had come to be with the ocean waves. Not quite, maybe, for I still had my loose moments, but generally I didn't drink enough to work up a good story for any of the newspapers. I lived, all in all, pretty quietly, as we moved away from the war.

However, after accumulating a dozen pictures and some new drawings, I took, in 1946, one more crack at the limelight. The Associated American Artists Gallery was very successful, even during the worst years of combat, and had now expanded its facilities to Chicago and Los Angeles. Fully realizing the ambitions of its promoter, it had become a really big-time art business. But the Chicago place, as was usual for art enterprises in that city, was not doing well or getting much attention. Reeves Lewenthal, counting on my old publicity drawing capacities, arranged an exhibition of my new things and called in the Chicago press for a series of cocktail and luncheon parties. By the time the show opened, and I had returned a few times to my old practice of getting drunk with the reporters, its success was assured. The Chicago papers gave me the works. The whole town came out, one picture after another was sold and it was

like old times, even the critics helping out with their habitual and timeworn pronouncements. All the old gags of America versus Paris were dragged up and chewed over again and even the national slick sheets found something to say. I missed selling a picture to the Art Institute, which disappointed Lewenthal, but I had started my career there and it wouldn't have been natural for its directors to believe I could paint anything worthy of their consideration, so I was not expectant in that direction.

Stimulated by the success of this Chicago affair, I immediately thereafter took up an idea which Lewenthal had worked out with Walt Disney and went out again to Hollywood. I was to concoct and draw the characters for an American folk operetta on the theme of Davy Crockett. Walt would animate this in his usual style. Salvador Dali was already in the Disney studios working on another project, and this encouraged me to believe there might be a workable connection between my painting and Walt Disney's art. I had a few conversations with Dali on the subject and he seemed very confident about such possibilities in so far as his own art was concerned. So I set bravely to work with a couple of musicians on a story and a score. However, after about two weeks, it became evident that I wasn't getting anywhere. There were practical objections to all the ideas I dragged up. If they suggested no offensive possibilities at home, they were sure to suggest them for the export trade. If the Americans liked them, the British, or the South Americans or the Italians wouldn't. I saw what a tough fence balancing art Disney was entangled with and realized that I was just too "sot" in my ways to learn to cope with it. So I gave up.

I was about ready to give up in other ways too. The exhibition parties in Chicago had started me to swilling too much again, and the Hollywood parties, which came, one right after another, encouraged its continuation and by the time I decided to go back home I was in a state of complete physical exhaustion. Working all day and partying all night wasn't my game anymore, but I'd forgotten it. The doctors in Kansas City laid down the law, and I had to quit

everything, even my pipes. It was just at this time my brother had
his heart attack. His death so depressed me in my run-down con-
dition I thought I was about ready to go too. Strangely enough I
didn't care whether I did or not. I remained in a state of sodden funk
for about a month. But there was a lot of toughness in my setup and
after a while I hauled myself together and looked out on the spring
flowers growing in our yard and got an itch to paint some of them.
I got well right away then. But I knew that I'd come permanently to
the end of public hoopla. I knew that I would never again be able
to pay the price for that kind of fame.

A little while after I recovered myself, I separated from the Asso-
ciated American Artists. A number of policy disagreements had been
arising for some time between myself and Lewenthal whose new
gallery ambitions were becoming world wide, reaching out to Paris
and the Parisian arts whose effects on American painting I had so
long deplored and fought against. I had wanted at least one place in
the country to stay with and push our homemade aesthetic ideas
exclusively. This was not because I thought these had yet proved any
supreme values for themselves, but because I thought their encourage-
ment offered the only hope of an escape from our imitation of
Parisian models and for the eventual erection of real American
forms. We had other differences, Lewenthal and I, but most of these
were minor when compared to the internationalization of the Asso-
ciated's galleries. I had spoken so often and so publicly against what
was now developing there that it was absurd for me to try going
along.

Lewenthal and his partner Liederman had worked with me for
nearly ten years and we had had a lot of fun. Never once did either
of them try to get out from under the responsibilities of my public
harangues. They took me as I was and what went with me and made
the best of it. That best was all right for we made fame and money
together. So it was not easy to leave them. But I didn't weep any.
After all I knew quite well that in the end the only artist who can

get along permanently with art dealers is a dead artist. Business and art, in its living form, have too many differences for a long-time wedding. But our separation was without enmity.

Here as I approach the end of my public adventures, I must go back a little and pick up an association which was for a time very much involved in them. I have neglected to mention the two artists whose names during the days of success were always connected with mine. John Steuart Curry and Grant Wood rose along with me to public attention in the thirties. They were very much a part of what I stood for and made it possible for me in my lectures and interviews to promote the idea that an indigenous art with its own aesthetics was a growing reality in America. Without them, I would have had only personal grounds to stand on for my pronouncements.

We were, the three of us, pretty well along before we ever became acquainted or were linked under the now famous name of Regionalism. We were different in our temperaments and many of our ideas, but we were alike in that we were all in revolt against the unhappy effects which the Armory show of 1913 had had on American painting. We objected to the new Parisian aesthetics which was more and more turning art away from the living world of active men and women into an academic world of empty pattern. We wanted an American art which was not empty, and we believed that only by turning the formative processes of art back again to meaningful subject matter, in our cases specifically American subject matter, could we expect to get one.

A book like this, devoted so much to personal happenings, is hardly one in which to deal extensively with the ideas underlying our Regionalism so I shall reserve a detailed study of that for another writing. The term was, so to speak, wished upon us. Borrowed from a group of southern writers who were interested in their regional cultures, it was applied to us somewhat loosely, but with a fair degree of appropriateness. However, our interests were wider than the term suggests. They had their roots in that general and country-wide re-

vival of Americanism which followed the defeat of Woodrow Wilson's universal idealism at the end of World War One and which developed through the subsequent periods of boom and depression until the new internationalisms of the second World War pushed it aside. This Americanist period had many facets, some dark, repressive and suggestive of an ugly neo-fascism, but on the whole it was a time of general improvement in democratic idealism. After the break of 1929 a new and effective liberalism grew over the country and the battles between that liberalism and the entrenched moneyed groups, which had inherited our post Civil War sociology and were in defense of it, brought out a new and vigorous discussion of the intended nature of our society. This discussion and the political battles over its findings, plus a new flood of historical writing concentrated the thirties on our American image. It was this country-wide concentration more probably than any of our artistic efforts which raised Wood, Curry and me to prominence in the national scene. We symbolized aesthetically what the majority of Americans had in mind—America itself. Our success was a popular success. Even where some American citizens did not agree with the nature of our images, instanced in the objections to my state-sponsored murals in Indiana and Missouri, they understood them. What ideological battles we had were in American terms and were generally comprehensible to Americans as a whole. This was exactly what we wanted. The fact that our art was arguable in the language of the street, whether or not it was liked, was proof to us that we had succeeded in separating it from the hothouse atmospheres of an imported and, for our country, functionless aesthetics. With that proof we felt that we were on the way to releasing American art from its subservience to borrowed forms. In the heyday of our success, we really believed we had at last succeeded in making a dent in American aesthetic colonialism.

However, as later occurrences have shown, we were well off the beam on that score. As soon as the second World War began substituting in the public mind a world concern for the specifically

American concerns which had prevailed during our rise, Wood, Curry and I found the bottom knocked out from under us. In a day when the problems of America were mainly exterior, our interior images lost public significance. Losing that, they lost the only thing which could sustain them because the critical world of art had, by and large, as little use for our group front as it had for me as an individual. The coteries of high-brows, of critics, college art professors and museum boys, the tastes of which had been thoroughly conditioned by the new aesthetics of twentieth-century Paris, had sustained themselves in various subsidized ivory towers and kept their grip on the journals of aesthetic opinion all during the Americanist period. These coteries, highly verbal but not always notably intelligent or able to see through momentarily fashionable thought patterns, could never accommodate our popularist leanings. They had, as a matter of fact, a vested interest in aesthetic obscurity, in highfalutin symbolisms and devious and indistinct meanings. The entertainment of these obscurities, giving an appearance of superior discernment and extraordinary understanding, enabled them to milk the wealthy ladies who went in for art and the college and museum trustees of the country for the means of support. Immediately after it was recognized that Wood, Curry and I were bringing American art out into a field where its meanings had to be socially intelligible to justify themselves and where aesthetic accomplishment would depend on an effective representation of cultural ideas, which were themselves generally comprehensible, the ivory tower boys and girls saw the danger to their presumptions and their protected positions. They rose with their supporting groups of artists and highbrowish disciples to destroy our menace.

As I have related, I profited greatly by their fulminations and so, for a while, did Wood and Curry. However, in the end they succeeded in destroying our Regionalism and returning American art to that desired position of obscurity, and popular incomprehensibility which enabled them to remain its chief prophets. The Museum of Modern Art, the Rockefeller-supported institution in New York, and

other similar culturally rootless artistic centers, run often by the most neurotic of people, came rapidly, as we moved through the war years, to positions of predominant influence over the artistic life of our country. As the attitudes of these cultist groups were grounded on aesthetic events which had occurred or were occurring in cultures overseas their ultimate effect was to return American art to the imitative status from which Wood, Curry and I had tried to extricate it. The younger artists of America were left, in this situation, only with an extenuating function. The sense of this humiliating state of affairs led many of them, and notably some of the most talented of my old students, to a denial of all formal values and they began pouring paint out of cans and buckets just to see what would happen or tieing pieces of wire to sticks and smacking them around in the air in the name of a new mobility. This American contribution to "modern" aesthetics, though it suggests the butler trying to outdo his master's manners, received wide applause in our cultist circles and it went out from there to the young ladies colleges and to the small-town art schools and into the minds of all those thousands of amateurs over the land who took themselves to be artists. These latter saw immediately the wonderful opportunities for their own ego advancement which this "free expression" afforded and embraced it enthusiastically.

Now all this anarchic idiocy of the current American art scene cannot be blamed solely on the importation of foreign ideas about art or on the existence in our midst of institutions which represent them. It is rather that our artists have not known how to deal with these. In other fields than art, foreign ideas have many times vastly benefited our culture. In fact few American ideas are wholly indigenous, nor in fact are those of any other country, certainly not in our modern world. But most of the imported ideas which have proved of use to us were able to become so by intellectual assimilation. They were thoughts which could be thought of. The difficulty in the case of aesthetic ideas is that intellectual assimilation is not enough—for effective production. Effective aesthetic production de-

pends on something beyond thought. The intellectual aspects of art are not art nor does a comprehension of them enable art to be made. It is in fact the over-intellectualization of modern art and its separation from ordinary life intuitions, which have permitted it, in this day of almost wholly collective action, to remain psychologically tied to the "public be damned" individualism of the last century and thus in spite of its novelties to represent a cultural lag.

Art has been treated by most American practitioners as if it were a form of science where like processes give like results all over the world. By learning to carry on the processes by which imported goods were made, the American artist assumed that he would be able to end with their expressive values. This is not perhaps wholly his fault because a large proportion of the contemporary imports he studied were themselves laboratory products, studio experiments in process, with pseudo-scientific motivations which suggested that art was, like science, primarily a process evolution. This put inventive method rather than a search for the human meaning of one's life at the center of artistic endeavor and made it appear that aesthetic creation was a matter for intellectual rather than intuitive insight. Actually this was only illusory and art's modern flight from representation to technical invention has only left it empty and stranded in the back waters of life. Without those old cultural ties which used to make the art of each country so expressive of national and regional character, it has lost not only its social purpose but its very techniques for expression.

It was against the general cultural inconsequence of modern art and the attempt to create by intellectual assimilation, that Wood, Curry and I revolted in the early twenties and turned ourselves to a reconsideration of artistic aims. We did not do this by agreement. We came to our conclusions separately but we ended with similar convictions that we must find our aesthetic values, not in thinking, but in penetrating to the meaning and forms of life as lived. For us this meant, as I have indicated, American life and American life as known and felt by ordinary Americans. We believed that only by

our own participation in the reality of American life, and that very definitely included the folk patterns which sparked it and largely directed its assumptions, could we come to forms in which Americans would find an opportunity for genuine spectator participation. This latter, which we were, by the example of history, led to believe was a corollary, and in fact, a proof of real artistic vitality in a civilization, gave us that public-minded orientation which so offended those who lived above, and believed that art should live above, "vulgar" contacts. The philosophy of our popularism was rarely considered by our critics. It was much easier, especially after international problems took popular press support away from us, to dub us conventional chauvinists, fascists, isolationists or just ignorant provincials, and dismiss us.

When we were left to the mercies of the art journals, the professors and the museum boys, we began immediately to lose influence among the newly budding artists and the young students. The band wagon practitioners, and most artists are unhappily such, left our regionalist banner like rats from a sinking ship and allied themselves with the now dominant internationalisms of the high-brow aesthetes. The fact that these internationalisms were for the most part emanations from cultural events occurring in the bohemias of Paris and thus as local as the forms they deserted never once occurred to any of our band wagon fugitives.

Having long been separated from my teaching contacts, I did not immediately notice the change of student attitude which went with our loss of public attention. But Wood and Curry still maintaining their university positions were much affected and in the course of time under the new indifference, and sometimes actual scorn of the young, began feeling as if their days were over.

It was one of the saddest experiences of my life to watch these two men, so well known and, when compared with most artists, enormously successful, finish their lives in ill health and occasional moods of deep despondency. After the time we came to be publicly associated in the early thirties, we had for all our differences developed a

close personal friendship and this loss of self-confidence by my friends was disturbing to me. It was, as a matter of fact, sort of catching and I had more than a few low moments of my own.

Wood and Curry, and particularly Curry, were oversensitive to criticism. They lacked that certain core of inner hardness, so necessary to any kind of public adventure, which throws off the opinions of others when these set up conflicts within the personality. Thus to the profound self doubts, which all artists of stature experience, was added in these two an unhappy over-susceptibility to the doubts of others. Such a susceptibility in times of despondency or depression is likely to be disastrous. It was most emphatically so for Wood and Curry.

Small men catch the weaknesses of their famous brothers very quickly and in the universities where Wood and Curry taught, there were plenty of these to add their tormenting stings to the mounting uncertainties of my two companions. Oddly enough, although Rita and I tried hard, our friendly encouragements never seemed to equal the discouragements which Wood's and Curry's campus brothers worked up to annoy them. Wood was pestered almost from the beginning of his university career by departmental highbrows who could never understand why an Iowa small towner received world attention while they, with all their obviously superior endowments, received none at all.

By the time we moved over into the forties, both Wood and Curry were in a pretty bad way physically and even psychologically. They had their good moments but these seemed to be rare and shortlived. In the end, what with worry over his weighty debts and his artistic self doubts, Wood came to the curious idea of changing his identity. Wood was a man of many curious and illusory fancies and when I went to see him in 1942 as he lay dying of a liver cancer in an Iowa hospital, he told me that when he got well he was going to change his name, go where nobody knew him and start all over again with a new style of painting. This was very uncanny because I'm sure he knew quite well he would never come out of that hospital alive. It

was as if he wanted to destroy what was in him and become an empty soul before he went out into the emptiness of death. So far as I know Grant had no God to whom he could offer a soul with memories.

John Curry died slowly in 1946 after operations for high blood pressure and a general physical failure had taken his big body to pieces little by little. He made a visit to Martha's Vineyard the Autumn before he died. Sitting before the fire on a cold grey day when a nor'easter was building up seas outside, I tried to bolster his failing spirits.

"John," I ventured, "You must feel pretty good now, after all your struggles, to know that you have come to a permanent place in American art. It's a long way from a Kansas farm to fame like yours."

"I don't know about that," he replied, "maybe I'd have done better to stay on the farm. No one seems interested in my pictures. Nobody thinks I can paint. If I *am* any good, I lived at the wrong time."

This is the way my two famous associates came to their end.

After my retirement from the public show and gallery business, I painted one more mural. This was for a very fancy ladies' dress-up store in Kansas City, famously known in the west as Harzfeld's. It may appear odd to some people that anybody could think of hanging a Benton picture in an atmosphere of silk nighties, pink slips and perfume, but Lester Siegel, the proprietor of Harzfeld's, believed it would be all right and commissioned me to fill a large space above his elevators. After he had given me the commission, however, he bethought himself of the public controversies my murals had occasioned in the past and he said to me:

"Tom, I'm not going to start interfering with what you paint for my store, but for God's sake, try to let me stay in business."

So I picked for my subject an old Greek legend—that of Achelous and Hercules—whose story had some aptness for our Missouri River country and painted it without introducing any naked female backsides or frontsides. It was taken calmly and didn't occasion any

howling which would interfere with business. Since then I have painted only easel pictures. Whenever I get a good one somebody buys it, so it doesn't seem that I'll ever again have enough pictures for public exhibition.

The mural I painted for Harzfeld's did me a notable good turn. The *Encyclopedia Britannica* people of Chicago had made a movie of its execution, a sort of educational thing which showed the mural's development and the technical processes used. This was extensively circulated and reached in some way, no doubt through State Department propaganda, to Italy. Now our son T. P. who, after he was discharged from the Army, had been studying flute with Mr. Laurent of the Boston Symphony received a scholarship which permitted a year's study at the Conservatoire de Paris. Rita and I decided we would go overseas with him and, after getting him settled in Paris, do a little touring on our own. I hadn't been back to France for thirty-eight years and I knew my French was pretty bad, but I undertook to take care of T. P. while Rita waited for me in Italy.

We landed at Genoa and checked T. P.'s baggage clear through to the Parisian customs. I bought two tickets to Paris and with the baggage checks put these in my pocketbook. In getting off the train at Milan, however, I found that some slippery crook had, in the crowded car aisles, got into my pants and stolen this. I lost no money. I had all that in traveler's checks which I'd kept separate, but the loss of the baggage claims was serious. I knew how tough a French customs officer could be, and I didn't know what to do. However, as a routine matter, we reported the theft to the Milan police office in the station. I could speak no Italian, so Rita set out to explain our dilemma. She was questioned and cross-questioned about everything under the sun—how much money we had, what we were going to do with it, where we were intending to go, whether we had ever been arrested, whether we had ever made a complaint to any police before, even about such an irrelevant, but apparently astounding matter, as how she happened to have our automobile ownership in her name when it was I who had bought the car. It was quite a

grilling and it was all duly recorded in a big book and took a lot of time. But as Rita spoke good Italian and showed familiarity with Milanese ways—she was born and raised but a few miles from the city—these policemen were friendly. However, they offered little help in the matter of the Paris claim checks and as Rita translated the interview, I couldn't see that it was doing us any good. Finally my passport was called for and handed to the chief, a big round-chested fellow built like a bull. He took a routine glance at it, started to put it down and then looked again, this time intently. Then he got up and came over to me, stared me straight in the face for a few seconds and then turned quickly to Rita, "Il pittore Benton," he exclaimed. "The painter Benton. Then your husband is the American painter Benton, the one from President Truman's home, from what is it? What—"

"From Missouri," said Rita, "Yes, that's him."

Now I understood practically nothing of this and was standing loosely by and utterly unprepared for the police chief's next move, which was to throw his arms enthusiastically around my neck and beat me on the back and all but kiss me and all but knock me down too.

"Eh Signora, I saw him in the moving pictures just last night. I saw him paint a picture, himself. I know him well, very well."

That was the end of our trouble. Whether or no the chief thought I was a kind of emissary of Harry Truman's, a sort of representative of the President's State of Missouri, or whether he simply had the old Italian respect for success in art, he took immediate action and sent an official telegram to the customs at Paris.

When I got there with T. P. the custom's officers, after they had identified me, dropped everybody and rushed our business right through, much to the chagrin of a lot of impatient tourists. They didn't even open T. P.'s trunks. It was a good thing they didn't because he had a recording machine in one of them which, we were told later, was contraband.

As soon as I returned from France, and Rita and I, with little Jessie, took on our Italian tour, we found the movie of Harzfeld's mural preceding us in nearly every city. That, with a "Voice of America" booklet, containing an article on my work, the memory of the war posters, which had received considerable Italian attention, and some nice introductions made our journeys in Italy exceedingly easy. Wherever we went some kind of velvet carpet unrolled and Italian hospitality even went so far as to enroll me in the ancient academies of Florence and Sienna. At Sienna for membership in the "Intronati" I had to change my name. I became there "Tomaso di Missouri."

After we returned home, Rita framed my new Italian degrees and some older ones. Missouri University had, just before our departure for Europe, made me an Honorary Doctor and the Argentines, a few years before, an associate member of their Academy, so when we hung all my sheepskins in our library, it made quite a showing. I let them stay there for a few months, and then I took them down. Along with my now pretty well enforced abstinences, they kept reminding me that I was on the way to ending a lively career as just another sober and respectable elder, not substantially different from the kind I had so often laughed at.

X

And Still After

EIGHTEEN more years have passed since I wrote the preceding chapter. The note on which it ends suggests retirement. I did have, in the winter of 1950-1951, some feeling that my active years were over.

The Regionalist movement was, as I then indicated, being pushed pretty well into history. It was even being pushed *out* of history by some. Grant Wood, John Curry, and Tom Benton, the "unholy trio," as one critic put it, had better be forgotten. The museums, so it was reported, were relegating the pictures of the Regionalists to their basements. The young painters, for the most part, had abandoned representation of the American scene, even the art of representation itself. The national exhibitions were sending me no more requests for paintings. As I had abandoned all my New York gallery connections, there was no way of showing my work there. This, however, was no great misfortune, because the sticky aesthetic Choctaw, which had come to be the preferred language of the art journals, could hardly have been applied to what I produced — even negatively. It would, simply, have been ignored. The situation was such that retreat seemed the only course possible.

Before I became resigned to it, however, a full-scale retrospective exhibition of my paintings at the Jocelyn Museum in Omaha drew so large a public response that I began to reconsider my position. If the Regionalist movement was dead, its case was apparently still arguable for a lot of people. This was further, and most decisively, indicated in 1951 by a scratch-cat review in one of the

popular intellectualist weeklies of the account I made of the movement in the foregoing chapter. The reviewer brought the whole question of the validity of Regionalism into the public eye again. The letters I received indicated I not only had support from the public in general but a much stronger and wider intellectual support than I had realized. A great many thinking Americans, even in artistic circles, felt that the concept of an American art, with an American content, was too important to be brushed aside. My mail piled up, the radio and television people solicited my comments, and calls for lectures began to come in. I could have hauled all my old controversies back into the limelight again if I so wanted.

However, I had soon come to take the demise of the Regionalist movement more philosophically than my supporters. I might, and did, deplore this demise, but I had had more than forty years of experience with artistic movements in our restless century and knew that none could retain a permanent influence. After all, Regionalism had lasted for more than twenty years, which was a considerably longer period than had any other artistic movement of our time except, perhaps, that of the kindred, socially oriented, Mexican school. This would assure it some kind of place in American art history. Besides, I had the consoling knowledge that paintings generated in a movement did not necessarily die with the movement, that attention to them was often revived.

The second World War destroyed, as I have said, that national concentration on our American meanings out of which the images of Regionalism grew and in which the movement found its justification and its successes. But this destruction occurred without putting any new meanings in their place — any meanings compelling enough, that is, to engage wide belief in their truth or in their applicability to real circumstances.

The transfer of American attention from the national to the international scene certainly did not produce any international meanings on which Americans, or any other peoples, could agree. What

ensued was a worldwide conflict of ideologies whose contradictory assumptions tended to twist accepted defintions into their opposites. All meanings were confused. As a consequence, the new generation of American artists, coming to maturity in the late forties and through the fifties, were left in a vacuum — in a world without a human content capable of inspiring attachment or of inducing representation. The situation, in general, was similar to that which had existed just before and just after the first World War, when artists had fled from their dissolving societies to the compensative securities of an "art for art's sake" philosophy.

As painting had then repudiated its marriage with socially communicable meanings and had gone in for an abstract play with its own properties, why, I said to myself, should it not do so again? If society itself provided no subject matter, to the meaning of which the artist could attach himself, what was there left for him to communicate except such meanings as he could find in art itself?

I have described how difficult it was for me to paint significantly about the social situation that developed in the later stages of the war and how in the mid-forties I began giving much of my attention to the details of the natural world, flowers, trees, and foliage. I had had a lifelong interest in such growing things, but my major painting themes, when I turned my attention to our native scene, were nearly always about the activities of people. The forms of nature, when I had used them, were accessory, often barely suggested. Now, however, people began to be accessory and the natural world my dominant theme. This is the case of the widely reproduced "July Hay" owned by the Metropolitan Museum in New York. It is equally so of a number of other paintings that followed. Although I did not realize it at the time, I was thus myself moving away from Regionalism, at least from Regionalism as I had heretofore conceived it.

When I recovered from the mood of retirement that had gripped me as the fifties opened and once again took up my old ways of wandering about the country looking for subjects, I found these

were increasingly of natural scenes. My journeys, now westwardly directed for the most part, over the Great Plains and into the Rocky Mountain country, resulted in filled sketch books, but they were largely those of a landscapist rather than of a recorder of human life.

I still felt that my pictures needed a human content, or something of life that suggested such a content, to be effective in more than a decorative way. I felt this to a large extent about all pictures. It had been one of the main reasons for my repudiation of the abstractionist tendencies that prevailed so largely in the first part of our century, before and after the first World War. I came to feel then, and still felt, that however clever the verbiage used to recommend it, a picture that represents no human meanings could never have much human significance, no matter how decoratively attractive it might be. So it was not a result of choice, certainly not of deliberate choice, that my sketch books were now lacking in studies of people. This was caused, not by a shift in my own basic interests, but by the radical changes in the old patterns of American life that occurred during and after the second World War.

In my travels of the twenties and early thirties, paved roads were rare in rural areas. In the late forties and fifties, however, they began reaching everywhere, and with them came the fast-moving vehicles for which they were built. While a farmer of the twenties, meandering in a Model-T Ford along a dirt road, would stop and answer any questions you might have, and probably entertain you with a leisurely history of his life, and even invite you home to dinner, the new countryman whizzed by. It would be rare now, in the new days, if he looked in your direction.

The drive toward urbanization and country-wide industrialization, which was later to cause so many problems, had set in. With distances becoming inconsequential, the country turned into the outlying part of the town, the town into an adjunct of the small city, and the small city into a suburb of the great one.

All this had immense effects on traditional behavior. The easy-

going friendliness of the American people, especially rural people, seemed to become more cautious, more reserved. The manners of the all-pervasive city were becoming the models for all manners, sometimes in the farthest of faraway places. It was getting so you needed an introduction to start even a barroom conversation.

During my earlier adventuring about the country, meeting and talking with people had been the chief stimulative factor of my work. It was through the people I met that I was led to the "motifs" for my drawings and paintings. More often than not, the people themselves were the motifs. I had always possessed a knack for insinuating myself into the conversations of the restaurants, small hotels, and barrooms of the back countries. I made friends easily with ranch hands, farmers, and young men and women out for a lark.

With the new urbanist developments, these easy contacts became more and more difficult to initiate. I found that attempts to butt myself into talking groups began to be met with curious stares and, in case there were young females involved, with stares that asked quite plainly, "What's that old goat after?"

Although my experiences with soldiers and sailors during the latter war days had told me that my years were counting against me, these new rebuffs convinced me of the fact. I then became self-conscious with strangers, especially with young strangers whose taste for lively situations had so often brought my most rewarding experiences.

So it was not only the changes occurring in American life that were modifying the Regionalist content of my work but changes in my physical self. I was simply getting too old for the newly developing human situations of our country — too old to penetrate into their meanings.

In spite of the shift of the art world away from representational paintings, which was so marked a characteristic of the late forties

and all of the fifties, I continued to make and sell such works. When they possessed human content, however, this factor began to be placed, not in a Regionalist present, but largely in the past. In dealing with the activities of people, I became more and more a painter of history, and in the stricter sense of the word. I was returned, thus, to somewhat the kind of imaginative historical subjects I had pursued in the early twenties, before the days of Regionalism.

In 1953 I executed a mural, with Abraham Lincoln as the central theme, for Lincoln University, a colored educational institution in Jefferson City, Missouri. I received a commission in 1955 from the River Club, an exclusive businessmen's organization in Kansas City, to paint an overmantel mural depicting Old Kansas City — pioneer Kansas City — for the club's lounge. During this time I also illustrated a number of books, but these also dealt mostly with happenings of the past.

So far, there had been no indication that the changes in the artistic world, plus the new critical evaluations which went with them, were having much effect on my personal status. I was still generally accepted as an artist even if, for the younger set, as an outmoded one. However, in 1954 officials of the Whitney Museum in New York informed me they were moving to new quarters and that these would provide no space for the murals I had painted for the Museum Library in 1932. They suggested I take them off their hands.

This was somewhat of a shock. I remembered the wave of critical disapproval that ensued when the murals were first revealed, and I suspected, on pretty good hearsay, that some of the Whitney people had gone along with that. But I had not expected the paintings to be so completely repudiated. Even if they did not fit in with currently approved patterns of aesthetic judgment, I believed the Whitney Museum's reputed attachment to American art history made their tenure secure.

When I let the Whitney decision be known, some effort was made by Clarence Decker, president of what was then the University of Kansas City, to bring the murals to one of its buildings, but when their size was ascertained, it was concluded there was no available space. After this, Sanford Low, director of the New Britain Institute of American Art in Connecticut, hearing of the situation, wrote me to ask if he could apply for possession of the murals. He said he could erect a wing at the New Britain Institute for their accommodation. I told him to go ahead.

In 1954, the Whitney Museum murals became the New Britain murals. To stage their arrival, a retrospective showing of my work was hung at the Institute. As at Omaha, the turnout of interested people indicated that Regionalism was not so dated, even in the East, as the critics had said it was. Some years were to pass before enough money could be raised by the trustees of the Institute to install the murals properly. It was 1964 before this occurred. The final setting, however, was so much better than that at the Whitney Museum I was happy about the change of ownership.

In the summer of 1956, after I had finished the mural for Kansas City's River Club, I was sitting one afternoon on the front steps of our Martha's Vineyard home when two men walked up. I recognized one of them, a former student, Herman Cherry, who had attended my classes at the Art Students' League in New York, back in the early thirties. He introduced me to his companion, the "abstract expressionist" painter Willem de Kooning, and said they had something to tell me. I invited them into the house and pointed out chairs, but they didn't sit down.

Cherry said, "Jack Pollock was killed last night in an automobile accident. We thought you should know." After that, they left. With such news there was nothing to talk about.

It is well known that Jackson Pollock began his first serious art studies under my guidance. It is less well known that he was

also, for nearly ten years, on very close friendly terms with me. Because of this and, more importantly, because he became in the last years of his short career the most discussed artist on the international scene and the only American ever to obtain a substantial following there, I am digressing here from the story of my own doings to give an account of Jack Pollock's relations with me.

Following an elder brother, Charles Pollock, he came to my Art Students' League classes in the winter of 1930-1931. He was very young, about eighteen years old. He had no money and, it first appeared, little talent, but his personality was such that it elicited immediate sympathy. As I was given to treating my students like friends, inviting them home to dinner and parties and otherwise putting them on a basis of equality, it was not long before Jack's appealing nature made him a sort of family intimate. Rita, my wife, took to him immediately as did our son T. P., then just coming out of babyhood. Jack became the boy's idol and through that our chief baby-sitter. He was too proud to take money, so Rita paid him for his guardianship sessions by feeding him. He became our most frequent dinner guest.

Although, as I have said, Jack's talents seemed of a most minimal order, I sensed he was some kind of artist. I had learned anyhow that great talents were not the most essential requirements for artistic success. I had seen too many gifted people drop away from the pursuit of art because they lacked the necessary inner drive to keep at it when the going became hard. Jack's apparent talent deficiencies did not thus seem important. All that was important, as I saw it, was an intense interest, and that he had. His chief difficulty was with the basic art of drawing. It is possible that my concepts of drawing, which depended less on the appearance of what was in front of you and more on what you *knew* to be there, were confusing. In my figure classes I stressed a search for anatomical sequences of form rather than the usual study of the model's appearance in terms of light and shade. I believed that if it were carried out long enough such a search would acquaint my students

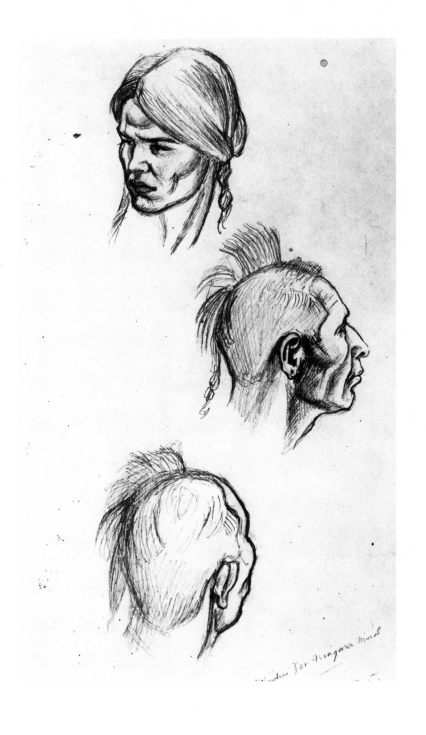

with the "logic" of human anatomy and movement and generate the ability to project these elements imaginatively, an ability very necessary for the planning of murals and other pictures of a conceptual nature. Further, it would help with the rapid summations necessary for reportorial drawing in the field of American life which, with my Regionalist convictions, I strongly urged my students to practice.

Looking back, I can see that I was not a very practical teacher, especially for novices. At the time of Jack's arrival in New York, although I had pretty clear ideas as to my ends, I was still searching for means to achieve them. Often, when I needed a figure action for some painting I would use the class model, making mistakes, rubbing out, and destroying my studies, with complete indifference to suspicions of ineptness that might be aroused among the students. After indicating in a general way the directions I thought profitable to pursue, I expected the members of my class to make all their own discoveries. I never gave direct criticisms unless they were asked for and even then only when the asker specified what was occasioning difficulty. There were several more convinced leaders of the young than I at the Art Students' League, and my students were always leaving me for them because, as they said, "I did not teach anything." I doubt that Jack ever felt that way, but his efforts in my drawing classes were highly frustrating anyhow. He had a discouraging time there, with only occasional flashes of insight to keep him going.

In another direction, however, in the study of design, which was carried on from reproductions of various works of the great historic periods by making reconstructions of these in the manner of the sixteenth-century cubistic exercises of Dürer, Schön, and Lucas Cambiaso, Jack quickly proved a perceptive student. He had an intuitive sense of rhythmical relations. He knew what counted. In painting also he possessed one rare and saving gift: He was an extraordinary natural colorist, and no matter how clumsy his paint-

ings might be, they always had some coloristic beauty. Even as an utter novice he never made anything ugly.

By the winter of 1934-1935 Jack's painting, though still deficient in drawing, had developed enough competence to interest some of our more substantially fixed friends, and Rita was able to sell a few of them and relieve a little of his poverty. We purchased a number ourselves, always, however, for small sums. I had at the time a growing reputation, but my market was much restricted and money was scarce in our family. I induced Jack to try his hand at china decoration with vitrifiable color, a technique I had picked up in my various early experiments. With this ceramic art he was quickly successful, producing some handsome and very salable works. I do not know how many of these survive, but a number of them, which we bought or which he gave to Rita, are still attractive decorations in our Kansas City home.

In the summers of the thirties Jack was a frequent and long-staying visitor at our place in Martha's Vineyard, where he helped me with the chores, gardening, painting trim, cutting firewood, and the like. We fixed up a little house where he could live and paint. He was treated as one of the family and encouraged to participate in all gatherings of people at our house. These were always highly talkative and were mostly directed, as the major interests of the time dictated, to the social and political problems of America or, because of a number of teachers in our set, to the question of American education, which was then much affected by the struggles between John Deweyites, Marxist radicals, and extreme conservatives. Jack never spoke at these gatherings and, though drinks were occasionally available, rarely touched them. Though plainly intelligent, he seemed to have no intellectual curiosity. He was not a reader. In all the time of our Vineyard intimacy I never saw him with a book in his hands, not even a whodunit. He was mostly a silent, inwardly turned boy and even in gay company carried something of an aura of unhappiness about him. But everybody liked

him just the same. The appeal he had for us was generally shared.

Although in our company Jack was quiet and reticent, rumors would occasionally reach us that he was not always so. Tales, emanating from student parties in New York, revealed a quite different person. Give him sufficient alcohol, it was said, and he became loud, boisterous, combative, and sometimes completely unmanageable.

Our first acquaintance with this side of his character came one summer in Martha's Vineyard, after we had known him about five years. He had arrived on the Island without arranging beforehand to be met at the boat landing, which was nearly twenty miles from our home. We did not in those days have a telephone, so Jack called the general store in our neighborhood and asked that a message announcing his arrival be delivered to us. As there was no one to tend store if the clerk departed, this could not be done immediately. We did not receive his message until several hours after it had been telephoned. On its receipt Rita drove promptly to the boat landing but could find nothing of Jack. Later, another message came, and this time I went after him. Again, however, he was not to be found. Late in the evening we received a call from the sheriff at the county seat, Edgartown, saying that he had Jack in custody and that it would be necessary to pay a disorderly conduct fine before he could be turned loose. The sheriff suggested we call in the morning.

Jack was most contrite when we delivered him from jail, but the chain of events that had led up to his arrest was so hilarious that it was impossible to take his case seriously. After waiting an hour or so at the boat landing, he had gone into a liquor store and bought a bottle of gin, intending, as he later said, to make me a present of it. As he continued to wait, however, monotony got the better of him. He opened the bottle and had a few sips. The sips were multiplied. After the gin began to work he went to a nearby tourist center and rented a bicycle, spending the last of the few dollars he possessed. He rode around the town — it was the resort

town of Oak Bluffs — occasionally taking sips of the gin, until he spied some girls crossing the street ahead of him. He promptly took out after them, yelling like a wild Indian, and chased them onto the sidewalk. After that, disregarding all remonstrances, he chased every girl he saw in the street. Finally, the gin knocked out his sense of balance, and he fell off the bicycle, cutting his face. The police then hauled him in.

This alcoholic prank was merely amusing and had no serious consequences, but others about which we heard later ended badly for Jack, entailing billy whacks by exasperated police officers and a number of detentions. I never saw him when he was in a dangerous condition from drink, but as reports of his wild behavior when under its influence kept coming in, I finally decided that he was plagued by frustrations much more serious than those which accompanied his struggles with drawing. Only something intolerably disturbing could compel him to keep drinking when he knew what unfortunate endings might result. What his basic troubles were, I never found out. It would have done no good to probe for them, because when his problems grew complex he developed some kind of language block and became almost completely inarticulate. I have sometimes seen him struggle, to red-faced embarrassment, while trying to formulate ideas boiling up in his disturbed consciousness, ideas he could never get beyond a "God damn, Tom, you know what I mean!" I rarely did know, but I didn't think it made much difference. One can be an artist without learning how to talk. Although intelligence is generally accompanied with some verbal ability, it need not be so. This is especially the case with artistic intelligence. The deeper wellsprings of the visual arts are in fact nearly always beyond verbal expression. Later on, it appears, Jack improved his ability to get his ideas out. Perhaps he found someone more skillful than I to help him, but during the time of his association with me he was always thwarted.

The Regionalist movement was attracting considerable public attention when Jack Pollock came to me. The Americanist aspects of

the movement appealed to him as it did to most of my students, especially the ones from the West. His early creative work, that undertaken beyond classroom study, was therefore concentrated on the American scene. Following my own practices, he made bumming trips across the country to seek the intimate experiences that would acquaint him with the meanings of the scene—its human qualities. He interested himself in American folk songs and learned to play the jew's-harp in order to participate in the Saturday night musical sessions based on these that were held in my studio. The outlook he cultivated at this time and the experiences he sought on the American scene were completely Regionalist. However, his reportorial drawing was too deficient to produce the convincing descriptions that are basic to Regionalist imagery. Details especially were beyond his capacities. But he made pictures of his experiences and, formulistically speaking, some very interesting ones. In these he exploited quite successfully the knowledge he was obtaining in his historical studies. He achieved rhythmical continuities that lifted his efforts well beyond the novice level. They were invariably attractive in color as well.

It has been said that a work of art is the sum of the stylistic influences that have been brought to bear upon the artist. In order to be consequential as art, however, these influences must be so amalgamated in the work, so reordered, that a new artistic statement results. The influence of Greek and Hellenistic styles on the artists of the Italian Renaissance is a case in point. All the basic formal patterns used by the Italians may be found somewhere in the earlier styles. Nevertheless, what eventuated in the Renaissance was an art utterly different in character from its predecessors. The determining factor in the creation of this new character was the difference in attitude toward the meanings of life with which the latter artists were imbued. Centuries of an evolving Christian outlook, replacing the classic pagan, had produced new meanings, and, by shifts of stylistic emphasis, what were substantially new forms were created

to express them. Meanings were the basic generative factors. The new content called up the new forms.

It was the Regionalist view that the continued effort to encompass an American content would eventually produce a variety of distinctively American forms; that stylistic influences inherited from our European predecessors would be so reordered under the pressure of American meanings that something analogous to what developed in the Italian Renaissance would occur here.

It cannot be denied that Jack Pollock reordered and reshaped the styles that influenced him. He made the kind of stylistic amalgamations I have indicated were necessary for new artistic statements. In his case, however, these were made apart from any meaningful context, and they differ in that respect from the great artistic statements of the past, where not only procedural and aesthetic values were affirmed but human meanings communicated. Though Jack's effort has been amply justified by the plaudits of contemporary artistic circles, there remains with me a suspicion that it did not deliver all that it could have, had he lived at another moment.

It is interesting to speculate about what might have happened had Jack Pollock adhered to the Regionalist philosophy long enough to have developed a representational imagery to implement it. Drawing *can* be learned if the need for it be strong enough. I have no doubt that his contributions to Regionalism, had he continued to make them, would have been quite as original as were the purely formalistic exercises to which he finally devoted himself. They would also have had some added values. Judging from his early efforts, he would have injected a mystic strain into the more generally prosaic characteristics of Regionalism. His Western boyhood had given him a penchant for all the spooky mythology of the West with its visions of wild stallions, shadowy white wolves, lost gold mines, and mysterious unattended campfires. When, as a young man, he talked at all it was about such things. We received early reports of them from our admiring son and about the imaginary hero Jack Sass,

who had explored, solved, or conquered all these mysteries. Jack Sass was, of course, Jack Pollock without the frustrations.

But, as I have said, the meanings that inspired Regionalist expression lost their power to engage allegiance. By the time Jack began to mature, the inclination to represent them had disappeared and would not show up again until some years after his death, when the "Pop" movements concentrated attention on a new approach to the American scene.

By the mid-forties, what was left of my influence on Jack's efforts was only that of the stylistic history I had called his attention to. To some extent this remained, even after he made his last steps into that free handling of plastic materials which brought him to world attention.

As has often been noted, there are usually three steps taken in dealing with ideas or performances that break with accepted patterns. The first is to treat them as absurd; the second, when they achieve success, is to treat them as of little consequence; and the third is to take responsibility for them.

As will be remembered from the preceding chapter, I regarded Jack's paint-spilling innovations as absurdities when I first heard about them. I did not, however, treat them as wholly inconsequential. I think I made quite clear how much a part they played in the general repudiation of the Regionalist outlook, how they helped to make that appear, for the younger artists of the late forties, a parochial aberration in the course of twentieth-century art. When later, after seeing some of them, I had second thoughts about Jack's actual productions—recognized their sensuous attractiveness that is—I scorned the idea of their possessing any long-term value. So in this latter respect I took the second of the above-noted steps. I am not, however, now that Jack's work has been apotheosized, going to take the third step and say that I am responsible for it.

A good deal has been said lately about Jack Pollock's indebtedness

to me. In some quarters this has been much exaggerated. As above related, I did point out certain stylistic factors for his early studies. These, however, were no more than were called to the attention of my other students. Although some of his rhythmic patterns, even to the end of his productive life, correspond to patterns I have myself used, it must be remembered that I did not invent these patterns. Their origins go far back in the history of art. Jack's use of them became radically different from mine as he matured. My own rhythms are always closed, their peripheries are contained, turned inward, within a predetermined space. The fully developed Pollock rhythms are open and suggest continuous expansion. There is no logical end to Pollock paintings. Nor is there any need for any because, not being representations of the objective world, they are immune to the conventions by which we isolate these and make them function as a unified whole. The Pollock structures may defy the "rules of art," but they do correspond to the actual mechanics of human vision, which is also without closed peripheries. Jack Pollock's work represents, not the objects we experience in the act of seeing, but the *way* we see them, in continuing, unending shifts of focus. I had nothing whatever to do with this final and very original aspect of Jack's art.

After leaving my classes, very few of my students kept in contact with me. Quite a number achieved successes of one sort or another, but I rarely, or never, heard from them. With Jack Pollock it was different. Even after I had castigated his innovations and he had replied by saying I had been of value to him only as someone to react against, he kept in personal touch with me and with Rita. At frequent intervals, and up to within a few months of his death, he would make long-distance telephone calls and would talk about his early days with us, mostly about those spent at Martha's Vineyard. Often on these occasions he would be pretty well tanked up, but that made him only more affectionate. He would tell Rita that she was his ideal woman and the only one he had ever loved.

Maudlin as some of this was, we knew there was truth in it. He did love Rita, and he always remembered how she had taken care of him when his case as a young aspirant of the arts seemed so hopeless. As for Martha's Vineyard, it is quite probable that the only really happy times of his life were had there, taking his end of a two-handled tree saw, swimming in the surf, gathering clams for chowder or wild berries for pies — times when alcoholic stimulation was unnecessary.

With all this deep-reaching personal stuff in memory, I could not but feel a considerable satisfaction in Jack's final success. However, there is a philosophy of art and life by which I have lived and which I cannot renounce, even for the sake of a friend. Though my initial judgments about Jack's accomplishments have long been reversed, I still must check them against my philosophy and must state what I believe to be their deficiencies.

First, they are symptomatic of what I have often said to be the most destructive tendency in the artistic circles of our century, the dehumanization of art in favor of a purely aesthetic formalism. Also, the success and widespread influence of Jack's work has added greatly to the already insidious influences working toward a worldwide artistic conformity. You see today in Venice and Rome what you see in Paris, London, New York, and Tokyo, a procession of more or less decorative patterns carrying no discernible meanings, no marked differentiations of content or of form either.

Even the "Pop" movements mentioned above have not sustained themselves against the general world tendency to replace meaning with abstract invention.

The ancient varieties of cultural expression that have enlivened the world for so many centuries are disappearing. It is inevitable that they should do so when art separates itself from cultural and environmental references and from the meanings that go with these.

When, on a trip to Italy in 1965, I asked a young Italian painter what was going on among Italian artists of his age group, he replied, "They are all trying to catch up with Jackson Pollock."

This is, of course, a high personal compliment to Jack, but it is not likely to add anything interesting to Italian art or tell us anything about Italian life and thought. The latter seems to have been left entirely to the artists of the cinema, whose tiresome clichés are also taking nearly identical characteristics everywhere.

While it seems inevitable that scientific and mechanistic operations should tend to become standardized, and probably to the world's advantage, and while it is hoped that political ideologies will tend to converge more than they have so far done, I do not believe we should try to establish a worldwide cultural conformity. I do not believe that we can, in fact, do so. As long as men live in different physical environments and keep their linguistic inheritances, basic cultural diversities will survive. If, however, art insists on ignoring these for a set of purely aesthetic "universals," it is going to produce only a universal academy. The labors of an academy are generally of interest only to academicians, so the result will be the separation of art from any true social function. It will become what John Dewey once suggested, "the beauty parlor of civilization," where you go to keep yourself up with aesthetic fashions. This is not an engaging prospect for what once produced the most various and the most enduring images of man's life on earth.

There is nothing objectionable to thinking of art in terms of its abstract properties. All art, even the most visually realistic, involves abstraction of some sort. No matter what they may represent, illustrate or symbolize in terms of meaning, the forms of art are themselves largely geometric artifices. And these possess a curious life of their own that is independent of the happenings of human or natural life, independent of any content they may enclose. There is a *vie des formes*, as the French writer Henri Focillon puts it, in which forms grow from other forms — one form or shape calling up, actually creating, another. This protean nature of artistic form is well known and has certainly always been known to practitioners of art. The emphasis placed upon it

in our century has, however, tended to make all forms appear as self-generated, as arising solely from the action of form upon form. This contradicts history. No matter how greatly forms act upon one another, the development of their historic varieties is the result of the injection of something beyond and outside the form-creative process itself — the injection of human cultural meanings for expressive purposes.

The processes of art are abstract and have truly their own inherent growth tendencies, but these have always been fertilized by the meaningful purposes for which they were undertaken.

The difficulty with our present abstract formalizations is that they are undertaken wholly for themselves. If they have any purpose, it seems to be largely for the exhibition of the artist's processive ingenuity or, as it begins now to appear, to provide items for a new kind of sideshow business for which the dealers and the art critics of the press serve as barkers. In any entertainment business, novelty is the essential factor. The outcome for art in our day, however, is a procession of contrivances, one supplanting the other. The public goes, takes a more or less good-humored look, and forgets; there is nothing to remember. The "abstract expressionist" movement of which Jack Pollock was the chief luminary lasted only a few years. It contained, in itself, no regenerative seeds, even for Jack himself, who, according to reports, lost all his creative urges during the last three years of his life. The various abstract movements that followed lasted even less time — none of them long enough to make even the stylistic impression of Jack's work.

There is apparently something very limiting to an artist's potential, even his form-constructive potential, when he turns his face completely away from the objective world and relies for inspiration only on what he can find in his private, interior impulses. These are admittedly important creative factors, but they retain their vitality and continue to operate only as they are tied, let

me say again, to exterior experiences, to the subject matter of the
world outside one's self.

Shortly after Jack Pollock's death, I was asked by Robert Moses,
chairman of the board of the Power Authority of the State of
New York, to do another mural. This was for a Power Authority
installation at Massena, New York, where the great dam across
the St. Lawrence River had been erected. The theme presented
to me was the discovery of the St. Lawrence River in the sixteenth
century by the French explorer Jacques Cartier.

After reading what I could run down in Kansas City about
Jacques Cartier, I went to New York to discuss whatever ideas my
patrons might have about our theme. I wanted to know also what
architectural setting they proposed and the time to be allotted
for the mural's execution.

The plan called for two panels separated by a relief map of
the St. Lawrence valley. This meant I had to paint my subject in
two parts, but parts, I remarked to myself, that should have some
meaningful relation to one another. This division was technically
feasible, so I raised no questions about it but went directly to the
problems of theme and execution time. I confessed that what I
knew of Jacques Cartier's Canadian expedition could be put in a
thimble and said I would have to do a lot of research before I
could think about a design or indicate the time I would need to
complete it.

I needn't worry about research, I was told, because all that was
necessary had been done, and I was given a sheaf of typed pages.
One glance showed that it provided little more than I already
knew and nothing at all precise enough to turn to pictorial account.
I explained that I would have to know much more about the
details of the discovery, the exact costumes, the exact character
of the arms and armor used by the discoverers, and also the
customs and dress of the aborigines. Although I was to paint a
sixteenth-century subject, I couldn't do it as a Renaissance artist
would have done, as if it were a contemporary happening.

Anachronistic mistakes, I said — remembering a few I'd made in the past — would be sure to raise criticism not only of me but of the Power Authority officials who permitted them.

In the end it was decided I had better go up to Canada, to Montreal and Quebec, and talk to people who were expert on the history of the St. Lawrence. So, armed with introductions, I presented myself to officials of the Quebec Hydroelectric Company at their Montreal offices. I was well received with old-time French-Canadian politeness. Secretaries were put to running down and listing the known literature, a number of books were graciously loaned to me for the duration of my studies, and I was directed to where I could purchase others. In Quebec I found an old secondhand copy of Cartier's own account of his adventures on the St. Lawrence, his *Relation*. This was a good find but it was written in sixteenth-century French, the spelling and construction of which made for the most difficult reading. After struggling with this for a couple of weeks I obtained a rare English, word-for-word translation which, with its learned notes, enabled me finally to grasp my theme.

Because of the division of the mural into widely separated parts, I decided I would give my subject two aspects. In one, Cartier and his people, with their arms, ships, and European dress, would discover the St. Lawrence and its Indian inhabitants. In the other, these inhabitants, with their own arms and equipment, would come out of their villages and discover Cartier.

In explaining this idea I pressed the fact that it afforded a logical reason for the theme's division. It would keep us on the main subject but account for its physical division by the two points of view.

I had been told by some of my New York friends that Robert Moses, the essential patron in this case, had the reputation of being a "tough cookie," a man whose own ideas about things were so strong that he found difficulty in adapting himself to those of other people. With this in mind I prepared myself for a long argu-

ment and memorized a mass of historical facts that were relevant to our subject in order to support my concepts.

I never had to use them. In the first few minutes of our discussion Moses said, "This is your mural. We hired you because we had confidence you would know how to do it."

So there was no "tough cookie" problem at all.

Although Jacques Cartier's *Relation* described most vividly the St. Lawrence Indians' life and the excited and extravagant nature of their behavior when they discovered the French explorers, the accounts were insufficient in visual detail to permit accurate pictorial reconstruction. For this I would need more objective references. Fortunately, these were to be had in a number of archaeological collections in the state, at Albany, Buffalo, and New York City.

The Indians Cartier encountered were Iroquois who, in the sixteenth century, lived in the Quebec and Montreal areas of Canada. Afterwards they moved into what became upper New York State, where they left physical remains, artifacts of various sorts, many of which were to be found in the above noted collections. My reference literature indicated that the particular Indians Cartier encountered were of the Seneca division of the Iroquois people. When I ascertained this, I bethought myself of the fact that Senecas had inhabited a part of Oklahoma directly adjoining my Southwest Missouri home country. They had been moved there from their eastern lands when the United States government initiated its plan for making Oklahoma an all-Indian reservation. I had seen many of them when I was a boy. A little inquiry informed me they still lived there, and I figured that, for at least one aspect of my mural, I might find direct rather than purely historical references, that is, find living Senecas for models.

Some years back I had met in Oklahoma City an Indian artist named Acee Blue Eagle, a Cherokee. I wrote him, asking about the prospects of finding pure-blood Senecas in Oklahoma. He replied that the person most likely to know was another artist,

who lived at Miami, Oklahoma, near the Seneca country, an artist named Charles Banks Wilson.

I then wrote Wilson and thus initiated an interesting, enduring, and profitable friendship. Wilson was not Indian himself but a student, painter, and illustrator of Indian life and lore. He knew many Senecas and he also knew what kind of persuasions to put in play to get them to pose for me. Too, he knew a number of young Indian athletes who could hold action poses long enough for me to draw them. This was of the greatest help because it is nearly impossible to simulate Indian bodies by the use of white ones.

The costumes, arms, and armor of the French were run down very easily. A scale model of Cartier's flagship was found at the Quebec historical museum. I had finished my research and my designs for the mural and was painting on the panels, set up in my Kansas City studio, six months after the initiation of the mural project — which was fast work.

In the spring of 1957, when the mural was approaching completion, two visitors showed up at my studio who were to bring me another mural project and a most interesting experience with the Thirty-third President of the United States, Harry S Truman. They were David Lloyd, a highly intelligent and artistic-minded young lawyer, who was secretary and Washington representative of the Truman Memorial Library, then reaching completion at Independence, Missouri, and Wayne Grover, at the time Archivist of the United States, who also had an interest in the Truman Library project.

The two studied my Cartier mural for some time, going over the details of each panel and plying me with questions about the meaning of these. Finally David Lloyd said, addressing Grover, "It is something like this mural we need to finish up the President's Library." He got immediate and emphatic assent. Asked as to the availability of my services, I answered, "Why not? I'll soon be

finished with this job, and nothing would suit me better than to have another."

We then went into the house, which is a few paces from my studio, and stirred up the idea of a Truman Library mural with a couple of highballs. I was delighted with the prospect, and my visitors were full of enthusiasm for it. Lloyd felt they could impart some of this to President Truman, whose consent for the mural would, of course, be necessary, by bringing him to see my Jacques Cartier painting. This they promised to do in a few days.

The days, however, passed into weeks, and I had pretty nearly forgotten my enthusiastic visitors when they telephoned and said they had finally captured the President and were, with some other interested people, ready to visit me. I told them to come ahead.

I had moved from New York to Kansas City just at the time Harry S Truman was elected to the United States Senate. When he returned from Washington in the summers, I would be in Martha's Vineyard or off on some exploratory trip, so I had never got to know him. He had given me a very short interview at the White House where, after attending a convention in Washington, I had gone with some other Missourians to pay my respects to our Missouri President.

He said to me at that time, in a bantering sort of way, "Are you still making those controversial pictures?" I judged from this that he knew all about the fracas which had occurred when I finished the Missouri mural, back in the winter of 1936-1937. I wondered which side he was on in those days.

A few times, after the completion of his Presidency, he had greeted me quite affably at Kansas City gatherings, but I had never tried to talk with him. The aura of the Presidency, which persisted in his presence even when its actual powers were no more held, forbade easy approaches, or seemed to. People who had known Harry Truman all their lives called him Mr. President. I wouldn't have known how to get close to him had there been

any reason for doing so. Now there was a reason, but I still didn't know how to proceed with it. So I was not quite at ease when he entered my studio, even though his greeting was easy, frank, and very cordial.

The session moved along, however, in the most encouraging way, with the President apparently impressed by the array of historical facts I could assemble in explaining the Cartier paintings. He told me he had not known before that artists could entertain such interests. With his Library mural in mind I said, "Mr. President, when I am commissioned to paint a piece of history, I take the trouble to know it."

Led by David Lloyd, we discussed the Library mural project, putting emphasis on the historical purpose it might be made to serve. The President agreed that such a mural might be a good thing to undertake.

He left, however, without committing himself.

A week or so later I went with Lloyd over to Independence, just few miles east of Kansas City, to look at the space in the Library entrance hall which was being considered for the mural. It could not have been better. While we were talking about it, the President, hearing of my visit, joined us, and we began again to seek a commitment for the mural project. This was continued at other times in the Presidential office at the Library.

Little by little, helped along by Lloyd, whose heart was set on the project, and by others who had become interested, the President began to accept the fact that a mural was eventually going to be painted in his Library, but he remained very cautious about it — as in truth, I did myself. If the President was wary of me I was also wary, not of him exactly, but of the kind of ideas he might have.

I was now getting pretty well acquainted with him. I discovered that beneath the rather formidable Presidential aura there was a simple, straightforward, essentially friendly man, without an iota of pretentiousness in his makeup. There were no paranoidal over-

tones to weigh in dealing with him, no discernible vanities. You could come right out and say what you had to say without fear of hitting some touchy spot.

But for all this, I sensed that he was very much used to making up his own mind, and I quickly discerned a quality of stubbornness there which I didn't want to activate. I was afraid that if he got an idea for the mural fixed in his thoughts, it would not be easy to get it out. I knew he was a very good historian, but I was pretty sure he would not take into account the technical limitations that would have to be faced in a *pictorial* representation of history. He wouldn't know about them.

My plan was to induce him to agree with me on a general theme and then to trust me enough to put its representation wholly in my hands, as Robert Moses and, in fact, all my other mural patrons had done. But the President shied off from this. It was not his habit to delegate *all* powers in any situation.

We had now come, in our many discussions, to the general idea that if a mural was to be made, it should deal in some way with the history of Independence, which was President Truman's home as well as the Library's location.

Independence, in the early part of the nineteenth century, had been one of the greatest of the "jumping off" places for exploration and settlement of the West. It had outfitted for both the Oregon and Santa Fe trails and for the river, plains, and mountain fur traders. It was the pivot from which radiated some of the most consequential lines of America's western development. The town's history encompassed enough subject matter for ten murals.

However, our continued speculations began leading us beyond Independence to that earlier history of the Missouri and Mississippi valleys which preceded and led to the foundation of the town. Eventually we were back to the Louisiana Purchase and, of course, to one of the President's most revered predecessors, Thomas Jefferson. Before long Jefferson began occupying too much of the President's thoughts for my comfort. I could see our theme taking on

vast proportions. I had fears of its running from Jefferson's administration to that of Truman, a pictorially unmanageable mass of subject matter.

The President's ideas were all perfectly reasonable in terms of verbal history. The sequence of events he envisioned from the Louisiana Purchase to the foundation of Independence and onwards were historically logical, but they could not be combined successfully in a single painting, no matter how extensive. So I began to fence off one line of thought after another, trying to narrow our subject to a practicable size. I made the point at one interview that, if the logic of history led from Independence to the Louisiana Purchase and Thomas Jefferson, it also led from the Purchase to the whole Napoleonic era and *that* I said was just too much to handle. The President agreed that it might be difficult.

One day, maybe tired of my dodging around with, "You can't paint this," and "You can't paint that," the President said laughingly, "Well, what the hell is it you *can* paint?" I grabbed the opportunity. "Mr. President," I said, "I'll write out my plan for this mural and bring it over for you to read. I'll get it out in sufficient detail so that you'll know just what I'm trying to put over. If it suits you, fine, if it doesn't, then you can tell me exactly why it doesn't. At least we'll have something positive and practical to go on."

When I started to leave he called me back and in the most emphatic Truman manner said, "Don't put any pictures of Harry S Truman in your plan. I don't want to be there." I must have looked a little incredulous because he added, and quite sharply, "I mean it."

When I told that to David Lloyd, he was considerably taken aback. "How can you think of Independence without Truman?" he asked. But I told him to let it go.

Though completely surprised by this Presidential admonition, it gave me a great sense of relief. If he meant what he said, I was freed from some of the greatest bugaboos of painting, the con-

ventions that must be adhered to in picturing the living great. Few of these figures are like Cromwell, who told the painter making his portrait to "put in all the warts and wrinkles." And if they happen to be similarly lacking in vanity and permit a painter to follow such an injunction, their friends and admirers will surely rise up and cry, "Caricature!" The great man himself might adjust to a realistic representation of his appearance, but his wife, his secretaries, his political adherents, and his public in general would vociferously repudiate it.

I had assumed from the very beginning of our discussions that it would be necessary to include a portrait of the President in his own mural, but I intended to inject it at some point where it would be apart from the mural's action. I would handle it as so many of the old painters of religious themes handled the donors of their productions by putting it in some kind of spectator role.

I made some pretense of deploring the President's decision, but really felt it was a godsend. Also, I admired it and the unusual modesty I began to see in it. After one or two exploratory thrusts I found it completely sincere. He really didn't want the mural to be an additional memorial to himself; the Library was enough.

Almost immediately after the President's visit to my studio and weeks before we had come to any even tentative agreements, I had started working on the history of Independence. I knew in a general way about the importance of the town as a frontier outpost, but I realized that if I were going to persuade President Truman to give me a free hand, I'd have to go far beyond generalities. I'd have to know as much about his home town and its history as he did and, if possible, a little more. Beyond that I'd have to find what was pictorially manageable in its record and be able to prove, not only its painting value but its historical value as well.

By the time I started writing up my plan I had read everything available about Independence. I found little documentation about the town itself that was precise enough to visualize, but a great deal in its explorative and expansionist history that was. Its place

in the opening of the West became the dominant theme for me and the town a subordinate one. With this shift of emphasis, a wealth of workable material emerged. There were plenty of accounts of the Oregon and Santa Fe trails, of Indian, fur trapper, and immigrant life that afforded the precise description needed for depiction, and I knew there were collections where supporting material facts could be found.

I made my plans, augmenting them with rough pencil sketches, testing out every historical fact by its pictorial workability. When the factual mass got too big, as it constantly tended to do, I'd start all over with a new point of view, always trying to simplify, to find particular actions, scenes, and characters that would typify or stand as symbols for the multitudinous scenes, actions, and characters of actual history. I spent a couple of months at this before I began to grasp the elements of a pictorial order.

When this finally took shape, I wrote it up and also presented a verbal account of my theme to the President. He apparently was pleased with it; at least he offered no objections. David Lloyd prepared a contract for the execution of the mural.

I then constructed a dioramic plastilene model of the over-all mural plan in which I carried some of the forward figures into considerable detail. The President, in spite of his implicit acceptance of my ideas, had not yet put his signature on our contract, and, thinking that a confrontation with objective evidence of my work might help get this, I offered to bring the model to the Library for his inspection. I arrived there when he was just ending a conference with some visitors, officials of some sort, from England. These people were fascinated with the sculptured figures, and the President, I could see, was impressed by and gratified with their interest. Before we got through talking about the model and I had explained the technical purposes it served for my painting, the President was taking a sort of proprietary attitude toward it, which I took to be a hopeful sign.

This incident apparently did something to make up the Presi-

dent's mind. I think he began to see how much the visual aspects of history had to be considered in painting — how ideas and facts were of no value unless they could be translated into visual objects. And I guess he decided that this was the business of a professional, because a few days later he signed our contract.

This was in the spring of 1958.

Shortly after obtaining the final permission to go ahead with the Library work, I received a letter from Robert Moses asking me to execute another mural for his New York Power Authority. This was intended for a new installation being erected at Niagara Falls. The mural was to depict the discovery of the falls by Father Hennepin, about a century after Cartier's discovery of the St. Lawrence. I was flattered by this new request for my services, but, envisioning the immense amount of work before me with the Library mural, I wrote Mr. Moses that President Truman had control of my time for possibly the next two years and that I saw no way of accepting a new commission.

But Bob Moses, one of these men who never take No for an answer, caught Truman while he was visiting in the East and invited him to make an inspection tour of the great dam across the St. Lawrence and of the power plants there. As the President had favored the treaty with Canada that made these works possible, he was interested and made the tour. At Massena he was photographed with Moses in front of my Jacques Cartier mural, now installed. There Moses revealed his plans for the Hennepin mural at Niagara and asked the President to lend him a part of my time for its execution. Without, I guess, realizing how much I yet had to do with his own mural, the President agreed to Moses' request and wrote a letter confirming his action. A copy of the letter was sent to me, with a note stating that there was now no reason why I should not undertake the Niagara project. So I signed up again with Robert Moses and had two murals on my hands.

I knew by this time what I was going to do with the project for the Library. I knew it in a general way, I should say, because even the plastilene model I had shown the President and his English friends was still highly tentative. I figured I yet had a year's study and planning to do. To get this started I again called on my friend Charles Wilson, at Miami, Oklahoma, for help with the necessary Indian research, not only for the Truman mural but for the Niagara Falls one also.

Fortunately, in the case of the Niagara mural, I had to deal with the same Seneca people that Cartier had encountered about Montreal and Quebec. The Senecas had moved to western New York, by Father Hennepin's time, and lived at and near Niagara Falls. Their descendants, as I had learned earlier, could be found in eastern Oklahoma, so the problem of getting authentic Indian models for this mural was easily settled. They were at hand and personally known to Wilson.

For the Truman mural, however, Pawnee and Cheyenne models were necessary. These people lived in other parts of Oklahoma, and we would have to figure out some way to get their cooperation. You, a perfect stranger, cannot go up to an Indian and say, "Come along, I'm going to make a picture of you." He would surely think you had something nefarious in mind. Obviously, we needed somebody to introduce us into the Pawnee and Cheyenne tribes in order to establish confidence. When I discussed this with Wilson, he called a Pawnee artist, Brummitt Echohawk, with whom he was on friendly terms. We went to Echohawk's home in Tulsa, and after listening to a short explanation of my needs, he agreed to help with the Pawnees. He didn't know any Cheyennes, he said.

Brummitt Echohawk was a full-blooded Pawnee, about six feet tall and a perfect specimen of his people. I would like to have drawn him, but that he'd let himself get too fat to look like an early nineteenth-century Plains Indian. A couple of years later, however, he remedied this by going into training for an unusual feat. A herd of buffalo, owned by some rancher in Oklahoma,

was getting too big. Echohawk volunteered to help kill off a few of the animals in old Pawnee style, that is, by shooting them on the run from horseback with a bow and arrow. This offer was enthusiastically accepted. So Echohawk started to run six or eight miles a day to get his fat off and to walk around Tulsa on his hands to strengthen his bow arm. He got a horse and trained it by galloping past barrels and shooting arrows through them. He planned every detail for the event except one.

When the day for crowd-surrounded action arrived and Echohawk came alongside a running buffalo with his bow and arrow poised, the horse, not used to such animals, shied off suddenly and threw his rider for a spectacular pratfall. Brummitt Echohawk had forgotten that his ancestors hunted buffalo with buffalo-wise horses.

But for me and for President Truman's Library, he performed with a full understanding of the situation. He got the right Indians, the right implements, and the right costumes. Well-informed about the history of his people and proud of their past, he was an invaluable research ally.

I now constructed another plastilene model for the Truman mural, going this time into its final actions. I then worked out, on a cartoon, the exact scale of the figures and the exact perspectives in which every item — figures, buildings, animals, etc. — would be placed. Heretofore, in my mural work I had handled perspective problems in a pretty free way, avoiding constructions based on one point of view. I knew the distorting effects of scientifically exact perspectives when the viewer leaves the particular viewpoints on which they are constructed. In large-scale works such perspectives can be destructive to all pictorial order, as with Father Pozzi's mural work in the famous Jesuit church in Rome, where, if you move out of a very small area, the whole building as well as the painting seems to fall apart into a disconcerting chaos.

The center of the mural wall at the Truman Library was cut by a large door leading into a hall, the architectural lines of which

were quite prominent. To counter the effect of these architectural perspectives, I felt I must set up a highly illusionary and exact perspective scheme in the mural. This meant designing from a single point of view. However, I got around the dangers of that.

In order that the mural perspectives would not seem to carry on or be otherwise linked to the architectural perspectives seen through the door or on the adjacent side walls and thus induce distortions when the spectator moved about, I placed all cubic forms represented in the mural and all perspective lines at highly oblique angles. None were conceived, that is, as parallel to the perspective lines of the actual architectural setting; they existed in a different perspective world of their own. In this way I obtained a convincingly realistic perspective scheme but avoided the confusions of form that might occur when the mural spectator changed his position. As it turned out, in the completed painting all lines and forms kept their places except from the very extreme corners of the room, and even there distortions turned out to be minimal. Only a thoroughly trained and critical eye could see them.

All this took a lot of time. It was well into 1959 before I was through with my preparatory work.

The perspectives of the Niagara mural were not themselves troublesome, but the space allotted, approximately twenty feet long and seven feet high, made it difficult to center my compositional lines on the figure of Father Hennepin, the mural's subject. I tended constantly toward a friezelike design, which flattens depth perspectives. But I finally got this problem worked out too and was ready to search out details, costumes, arms, implements, etc., of the proper historic time for both murals.

To begin my field work I went with Wilson and Echohawk to the Pawnee country, which is not far from Tulsa, Oklahoma. At a broken-down country church, where many Pawnees were congregated for a picnic, I found the perfect character for my main Pawnee warrior who, because he was to occupy the immediate foreground of the mural, needed to be thoroughly studied. He was

reluctant, however, to pose, even for the ten dollars an hour I offered, and continued to refuse until his preacher told him it would be all right, if he gave his pay to the church. After some persuasion, helped by the preacher, he consented and I got him stripped and made the necessary drawings, using the church for a studio. This occasion must have been a real windfall for the preacher because his Pawnees were mostly a poor people and he would not often get so sizable a contribution.

After making portrait sketches of a few more Pawnees for secondary figures, Wilson and I drove out into western Oklahoma to the Cheyenne country, taking our chances on running into somebody who could help round up Cheyenne models. We had good luck the first day. Going into a small-town restaurant for coffee, we got into conversation with the boss of a road repair outfit, who said he had some Cheyennes working with his crew. He agreed to help us induce them to pose.

We put up at a rickety motel that looked like a row of chicken coops. The next morning we were visited by a number of Indians who had been sent by our road-boss friend, among them a couple of young squaws. I took one magnificent old buck into my room and made a portrait of him. When I went out to get another model, I found our landlord, a fat, short, sweaty small-towner, in a state of utter fury. He was giving Wilson hell for bringing the Indians around his motel. Looking at the squaws he said, "I know what you fellers are doing. You're turning my place into a Indian whorehouse. I'm calling the sheriff right now and get you thrown out of town."

Neither Wilson nor I could cool him down. He was certain that the drawing business was a pretext and that we were pimping for the squaws. The town was a crossroads truckers' stop, so maybe the old boy had some reason for his fears. We did the rest of our drawings in various Cheyenne dwellings, mostly shacks surrounded by tin cans, old automobile tires, and other discarded junk.

After this we moved into Colorado, visiting the site of Bent's

old fort on the Arkansas River, and then farther on to the "Spanish" peaks, Colorado's southern Rockies, making studies of the land and plant life, all so necessary for the verisimilitude of the mural.

The last items requiring authenticity were the period costumes, arms, and implements, and these were found, albeit sometimes with difficulty, in various museums devoted to history of the West.

My investigations with Wilson were devoted to that part of the Truman mural which dealt with the Santa Fe Trail. For the Oregon Trail I called on an old friend and mountain companion, Aaron Pyle, the Nebraska painter, who drove me along what we could find of the mostly obliterated pioneer highway to "Courthouse" and "Chimney" rocks, the ancient landmarks of northwest Nebraska.

During the summer of 1960 I finished all preparatory work on both the Truman and Niagara murals. I had the color sketches, the cartoons, in full detail, and all the particular drawings of people and animals in their correct actions, and was ready for painting.

Having decided to do the Niagara mural with oil paint so it could be rolled for shipment, I had the canvas set up in my studio. I intended to work on it when the weather was too bad to allow driving over to the Truman Library in Independence. For the Library mural, which was to be executed with polymer tempera, I attached heavy linen to the mural wall at the Library and had its surface prepared there. A movable scaffold of several stages was built so that I could get at the different spaces and levels of the wall, which was nineteen feet high and a little over thirty-two feet wide. On November 17, 1960, with the help of two draughtsmen, Sid Larson of Christian College, Columbia, Missouri, and Duard Marshall, one of my former students, I started "squaring up" my cartoon. Most of this work was done by my assistants. One day, when they had about completed their task, an old lady visitor to the Library asked which of them was Mr. Benton. When she learned they were doing the drawing in my place, she snorted, "And Mr.

Benton just has to fill in between the lines. That's nothing," she said. "I could do that myself."

On the day that I was ready to paint I persuaded President Truman to climb the scaffold with me and put the first strokes of paint in the sky. This he did, to the clicking of news cameras and the applause of the crowd that had gathered in the room to see the painting started. He followed the progress of the mural day by day until it was completed in the spring of 1961, kibitzing only once. This was when he saw me put the face of a mutual friend, Randall Jessee, on a figure leading some oxen. "Why, Randall don't know 'Gee' from 'Haw'," he said. But he was wrong about that. Randall, like the President himself, had been a farm boy.

Every time some visitors from Washington or some delegation from abroad visited the President, he'd bring them into see his mural, and I'd have to climb down off the scaffold and shake hands all around and answer innumerable questions. Finally, however, he sensed that I did not always relish these interruptions, that it was not always easy to take up again an abandoned brush stroke, so he began to make his introductions from afar, waving me back when I started down to greet his visitors.

I always had spectators, and on Sunday afternoons they came out in force. Too many of them had cameras with flash bulbs, and though I was up and away from them on my scaffold, they often so blinded me that I had to stop work because of the spots in my eyes. Finally, the Library guards had to forbid the flash pictures altogether.

During the winter of 1961, when the mural was well along, I developed a painful bursitic condition, probably from too much stretching and climbing. I did not much feel my seventy-one years and could stand and work steadily for six or seven hours a day, but when the pain, which had started in my left shoulder, began to move all over my left side, I got worried. In the end I had to be full of cortisone in order to finish the mural. When I got down

to the bottom of the mural, where I had to sit on the floor to paint, I could never get up without help. The Library guards would pick me up off the floor. I became unable to drive a car. Lyman Field, an attorney and a good friend of mine who was then Commissioner of Police in Kansas City and much interested in furthering the mural, sent a police car and driver to pick me up in the morning for the trip to Independence and to bring me home when I was through work.

But I got the job done on time.

For the mural's dedication President Truman invited Chief Justice Earl Warren to make the leading address. So great a crowd of people asked to attend the ceremony that it had to be held outside, on the front steps of the Library. A scaffold was erected there for the speakers and rows of chairs were set for the guests. It was mid-April, but the wind blew a gale, strong enough to take the words out of your mouth. However, Justice Warren made his talk and then the President. When it came my turn, a sudden gust of still stronger wind blew my tie out of my coat, my hair in my eyes, and my breath down my throat. I yelled my speech at the top of my voice. When I got through the President yelled too.

He said, "What office you running for, Tom? You sound just like a politician."

Everybody laughed.

I finished the Niagara mural shortly after that of the Library. As I had foreseen, there were many days I could not go to Independence because of snow or ice. On these days I worked in my studio. The change of subject and medium was actually relaxing. Because it had been precisely planned to the last square inch, the New York job rolled off without need of any repainting. It was the first mural I had executed in oil since the experimental ones I exhibited during the twenties at the Architectural League in New York.

In May of 1962 my home town, Neosho, Missouri, honored me
with a "homecoming" celebration. This was very much of an affair,
the kind that, with bands and parading beauties, is often enough
given for politicians and soldiers but never, at least before this
one, for a picture painter. Certainly never in the United States.
The citizens of Neosho, figuring me as the town's most noted — or
most notorious — product decided something should be done for
and about me. A delegation of Neosho people had come to see
me in the winter for my consent to the proposition. It was led by
Dan Longwell who, in the thirties, was managing editor of *Life*
magazine and who, at that time, had sponsored and publicized
my work and that of my fellow Regionalists, Grant Wood and
John Curry. Dan had lived in Neosho in the early part of his life,
had attended high school there, and had returned there after his
retirement from the publishing business.

I was of course willing to go along with the Neosho plans. I
was even a little touched by them. Although I had been considered
somewhat offbeat by my elders when I lived in Neosho, I had been
well liked by my own age group. The things the town had taught me,
the first lessons of life, were permanently impressed in my memory.
I had learned there to swim, to ride horses, to chew tobacco, to
smoke a pipe, and to love girls. I had there acquired also the habit
of reading and of arguing about things. I retained strong visual
memories of the town's turn-of-the-century charm, its old horse-and-
buggy culture. So I was in a very reciprocal state of mind when the
day of the celebration arrived.

Mr. Bill Deramus, president of the Kansas City Southern Railway
Company, made up a special train to take the crowd of Kansas
City friends who wanted to go with me to Neosho. Because Presi-
dent and Mrs. Truman had agreed to honor the homecoming with
their presence, he attached his private car to the train for their use
and mine. We went to Neosho in style, Rita and I and our daughter
Jessie, riding in the luxurious car with President and Mrs. Truman.

I was not only highly flattered by the President's willingness to

go with me, but I also counted on his help for handling the situation. As he was our greatest Missourian I assumed that the first honors of the Neosho ceremonies would be directed toward him and I would learn by his experienced behavior how to behave myself. But it didn't turn out that way.

When, after three hours of riding, our train pulled up at the Neosho station and we prepared to get off, I said, "You first, Mr. President."

"Oh, no," he said. "This is your day. Go and take it," and he shoved me ahead, along with Rita and Jessie.

Around the station great crowds of people with flags and "Welcome Home" signs were gathered, a contingent of soldiers was lined up, and a band was playing. When I appeared on the car's platform, the people began to cheer. Stuck out in front of all this, I was so emotionally affected I could hardly keep back tears. I felt I was sure going to make a complete fool of myself. The only thing that saved me was the sight of our governor, Jim Blair, who had come down from Jefferson City, the capital, to be the first to greet me. Jim was a good personal friend, and when he grabbed my arm and shook me up a little, I came to. Jim, old politico that he was, sensed my predicament. He whispered a couple of things in my ear which, though they had no appropriateness for this honorable public occasion, were privately effective enough to let me get a little grip on it. Even so, there were times during the hours that followed when I could well have dispensed with my honors.

Two young and very pretty girls, dressed up in the costumes of my youth, escorted me to a car; I was placed between them, but made to sit high on the back of the seat. Then, with the band in front, President Truman with more costumed girls in car behind, and a long string of other dignitary-laden cars still farther behind, I was paraded around the town square, which was alive with flags waving and people whooping. I was damned ill at ease, emotionally upset, and sweaty as hell in the 85° heat that prevailed.

I had sent an exhibition of my paintings for the homecoming, and it had been set up in the town library. After the parade I was taken there and in a packed room signed autographs until I could no longer grasp a pen. Following that came lunch, where I was embarrassed by not remembering the names of the officiating ladies, all of whom I had once known and had danced and partied with, in my Neosho days. I had also forgotten the men. The only person I remembered well enough to recognize immediately was a fellow named Dave who had had his forefinger cut off by a buzz saw when he was a kid. With the others I had to dodge around until they told me who they were, which is the worst sort of politics when greeting old companions.

My friend Brummitt Echohawk had brought over from Oklahoma a troupe of Pawnee dancers to rehabilitate old-time Neosho celebrations, where Indians had always danced. After lunch we went to the town square and sat on elevated board seats to watch the dance. No sooner had the Indian drums started than a buxom and good-looking squaw climbed up to where I was and insisted that I participate in the dancing with her. The applause was such that I couldn't refuse. I had to get down and stumble around with a lot of complicated shuffling, about the intent of which I did not have the least idea. This was the damnedest thing I ever undertook and the most ludicrous because, whenever I got my steps going with the drums, the rhythm and the steps would change. I never caught up with them.

There were four hillbilly bands set up on the four sides of the square and more square dancers cavorting about them than I had ever before seen. We visited each of these after the Pawnee performance, but I managed to get out of dancing by saying that if I joined one set, I'd have to join them all; that, it was recognized, would be too much.

In the evening a great speechmaking dinner was held in the new high school gymnasium and auditorium. When the eating was over, the famous old Ozark hillbilly congressman, Dewey

Short, started things off with one of his long and flowery orations. After he was through others took over until, finally, President Truman spoke. As he concluded his remarks he turned and waved towards me and I thought it was my turn to start talking. So I got up and let fly. However, I had not looked carefully enough at the dinner program. It was not the President who was to introduce me but a prominent Southwest Missouri judge, "Chip" Ruark. So the Judge's talk had to come last, and it was kind of awkward for him — and for me too — when I got the sense of things.

However, all ended well. Dan Longwell, who, as aforementioned, was one of the main instigators of the homecoming, took all the main performers and guests to his house for postceremony libations. So before it was time to return to our train, which was waiting on a sidetrack for the trip back to Kansas City, I was in good shape again, strains, embarrassments, cockeyed behavior all forgotten. Only good and happy memories remained of the homecoming.

It might appear from the preceding accounts of my activities during the fifties and early sixties that my time was entirely occupied with the problems of mural painting. This was largely true but not wholly so. I continued to travel as usual over the United States and took a number of small-boat trips in the Bahamas and on one occasion a long three-week Caribbean sail from Antigua to Grenada. Nearly every spring and often in the autumn I floated down our Ozark rivers. In 1952 and again in 1954 I returned to Europe. On the latter trip, which was confined to Spain, I had my first complete view of Spanish painting, sculpture, and architecture. I also found time to produce quite a number of landscape pictures, among them a large mountain scene based on a view of the Tetons in western Wyoming. This was my first effort with "grand" scenery.

After completing the Truman and Niagara murals, I made two expeditions into Wyoming's Wind River Range and one, in 1964, into the Assiniboine area south of Banff in the Canadian Rockies.

My reaction to the rigors of the Assiniboine trek, which involved nearly ten hours on horseback, indicated that in spite of my age I still possessed a pretty good measure of endurance — especially since I had been in the saddle very little since my boyhood.

During the preparatory research for the Truman Library work, I had become fascinated with the journals of the Lewis and Clark expedition up the Missouri and conceived the idea of sometime painting an historical picture about it.

In the summer of 1965, with this in mind, I made a three-week reconnaissance of the upper Missouri River, from Omaha to its headwaters at Three Forks, Montana, searching out Lewis and Clark camp grounds and other sites of historic and archaeological interest. This expedition was organized for me by the Corps of Army Engineers and the National Park Service.

Though most of the trek went upriver, the one hundred and eighty-five miles of "Wilderness" country between Fort Benton, Montana, and the headwaters of the Fort Peck reservoir, were taken in a five-day float down stream.

I there passed through the last extensive stretch of the Missouri that remains in its primitive condition. It is the area of the gigantic white cliffs and eroded rock sculptures so graphically described in the Lewis and Clark journals. It is also today a center of controversy between nature conservationists who wish to keep its primitive character and the Corps of Army Engineers who wish to turn it into another reservoir. Although I am indebted to the engineers for the opportunity to explore the region, I went along, and still go along, with the conservationists.

All of these latter-day expeditions were immensely interesting and because they were undertaken in parts of our country I had not visited before, added much to my general experience.

In September of 1965 Rita and I flew to Italy and established ourselves near the little town of Pietrasanta, not far from Pisa. There a younger artist friend, Harry Jackson, a painter and sculptor

of Western Americana, had built a sizable studio and workshop. He had offered me the use of this and of his workmen to carry out a sculpture project I had in mind.

I worked daily in Harry's studio, but with considerable frustration. Modeling tasks that I had always found easy at home now presented curious difficulties. I kept running myself off track compositionally, away from my intentions, getting elements out of proportion, and so on. Something was offbeat in my ability to perform, probably the unfamiliar Italian environment. However, sacrificing my original idea, which involved three figures and an old-fashioned steam engine — a sort of John Henry spike-driving theme — I finally achieved a small bronze of one figure.

Toward the end of November, after a tour of the Italian hill towns and a revisiting of Florence, Venice, Ravenna, and other cities, we came home. I then made a painting of the three-figure composition I had intended to sculpt in Italy. This and some other projects that developed carried me well into January of 1966.

With spring in the offing, and feeling in fine physical shape, I began working out plans with some friends for a canoe trip on the upper Buffalo River in the Arkansas Ozarks. This venture was to be undertaken quite early, in April, when the river would be high enough to avoid portaging.

Our arrangements were just being concluded when, without any warning whatever, I had a stroke that partially paralyzed my left side. This occurred on January 30. I spent a week in the hospital and seemingly recovered.

However, it was not to be that easy, for on February 12, again without warning, I was hit by a full-scale heart attack and was promptly hauled back to the hospital, where I stayed this time for five weeks.

During the first night of my return to the hospital, I woke up, or returned to some consciousness of my existence, to find my doctor, Jack Wolf, sitting at the foot of my bed, looking tired. It was maybe two or maybe three o'clock. I said to myself, if a doctor

sits up all night, things are bad. My arms and hands were stuck full of needles attached to little hoses that led off backward out of my sight. Around my chest were contraptions of various kinds, again with lines leading off beyond vision. I had no pain, only a sense that there probably was some, kept out of my ken by drugs.

It seemed to me at this moment that it was up to me to decide whether I should live or die. This may have been an illusion, but I was convinced, just the same, that the decision was mine to make, that by a simple act of will I could control my fate. It was an interesting moment. I had no fear. I did not, as is often reported of people in such situations, think of my past life, have a flash picture of the whole of it. Nothing like that. I didn't think of anything except whether I should live or not live. For no reasons I can remember I decided to live.

The next morning Rita visited me. The doctors had talked to her, and she was serious. She knew, of course, that I had no religious convictions, but, fulfilling her Catholic duty, she asked me if I wanted to see a priest. Remembering my decision of the night before, I said, "What the hell do I want with a priest?" She knew I would live.

But I was damaged. The canoe trip on the Buffalo River had to be abandoned. Although now more than a year has passed since I left the hospital I have not planned another. Maybe I will yet come to do so, but as I end this chapter I have a feeling that my days of physical adventure are over. I find myself once again in a mood of withdrawal, of disinvolvement. It is not, however, like that which enveloped me when I finished the preceding chapter eighteen years ago. It is purely physical, coming simply from a loss of coordinative power — the power to make rapid adjustments of muscle and nerve — from the knowledge that a sudden output of muscular effort in a critical exterior situation might occasion a worse interior one.

There is no sense of what might be called spiritual defeat about this, like the gnawing suspicions of failure that gripped me for

a while when the Regionalist movement was repudiated. I now know there is no such thing as failure in the pursuit of art. Merely to survive in that pursuit is a success. Pictures may fail to please, movements may fail to survive, but the artist has his rewards anyhow. He may lose his public and his market and still get full compensation for his efforts. Quite apart from the public values of art — those which give it significance in the social history of a people — the act of artistic creation has its own psychological payoff, and a very considerable one. The rewards of art, for the artist himself, are concomitants of its practice. They lie in the life-heightening acuteness of his everyday occupational experiences. The only way an artist can *personally* fail is to quit work.

Afterword to the Fourth Edition

by Matthew Baigell

When Benton finished writing the last chapter, "And Still After," for the last revision of his autobiography, he probably did not realize how much work still lay ahead of him. He was, after all, seventy-nine years old and entitled to do as much or as little as he desired. But the last sentence of that chapter indicated that he intended to push himself to whatever limits age and the infirmities of age had imposed upon him. As far as anybody knows, he worked until the very end, the just completed mural, *The Sources of Country Music*, a six by ten foot panel still in his studio and waiting for its final coats of varnish. The image of the artist dying with his brushes and palette at the ready is an image that Benton might have appreciated.

Certainly, his mind always remained very clear concerning his art, his intentions as an artist, and the place he hoped his art might hold in the history of American art. Although mellowed by time, he also remained keenly alert to everything about him. For example, during the celebratory speeches marking the opening of a major retrospective exhibition in Kansas City's William Rockhill Nelson Gallery of Art —Mary Atkins Museum of Fine Arts in October 1974, Benton managed to correct the choice of language as well as pronunciation of one of the guest speakers. Benton was also the only man in the room not wearing a tuxedo.

From the late 1960s until his death in early 1975, Benton painted a variety of subjects, exhibiting the same restlessness that characterized his earlier activities. He painted working people discussing matters in greasy-spoon restaurants and, presumably, these same people enjoying themselves in the countryside. He continued to paint farm scenes and

371

also finished at least one sporting scene (for which a small sculpted model still exists). In addition to portraits, he also completed two murals, *Joplin at the Turn of the Century* in 1972 and *The Sources of Country Music* in 1975.

Many of his vacation pictures were set in and around the Buffalo River, an Ozark stream Benton liked to visit. He relished canoeing and fishing on the river, and found particularly paintable that part called The Chute, a section noted for its eroded cliffs. These are among Benton's most amiable and relaxed works, the riverbanks and trees lovingly detailed, the people enjoying themselves in the spacious and sun-filled landscape. Clearly, he had found his little piece of the American countryside and he painted it with at least as much if not more affection than any other place. Benton also painted the beaches and hills of Martha's Vineyard, where he had summered since the early 1920s. In both groups of paintings, one senses his eagerness to absorb the beauties of the particular scenes and his pleasure in recording boats, rippling water, waves, rocks, and clumps of grass. His brushstrokes virtually dance across these canvases.

His farm scenes are more elegiac and retrospective than modern: mules rather than tractors are usually the source of power, and farmers still bend their bodies in obvious sympathy and harmony with the contours of the land. Such curvilinear passages are a hallmark of Benton's early and late works. The land undulates in long, easy arabesques. Piles of hay form soft, curving mounds, attesting to the continued bountifulness of the American earth. These paintings are celebrations of rural America, lost, in Benton's mind, in a turn-of-the-century time warp.

For one whose energies were so evidently directed toward capturing images of the countryside, Benton was a remarkably fine portraitist. He said that he tried to capture an aspect of a sitter's personality in a glance of the eyes or in an added object that might reveal the quality of the sitter's personality. In a famous portrait of eighty-six-year-old Harry Truman, painted in 1970–1971, Benton added several books to suggest Truman's probing mind and thirst for knowledge.

(Benton remarked in personal conversation that Truman was "an interesting older gentleman!")

At about the same time that Benton painted the former president, he designed and completed the mural celebrating Joplin's centenary. He tried to capture the flavor of Joplin as it was turning from a town to a city, the period in which he had worked there as a young surveyor's assistant and then a cartoonist. With the same zeal for authenticity that characterized his murals of the 1950s and 1960s, he consulted old photographs of the community as well as of its various mining operations and he also studied rocks from the area. From these sources, as well as from his own storehouse of memories, he developed a panoramic view of the city composed in two main parts. Superimposed on a view of the main street with its electric trolly cars and saloons there are overscaled individuals, which include a self-portrait of the artist as a neophyte cartoonist. The second part of the mural shows various mining operations that flank a settler's wagon with the sign "Joplin or Bust" on its tailgate.

Benton followed this work with yet another "last" mural for the Country Music Hall of Fame and Museum in Nashville. Delighted by the prospect of honoring a type of music he often played—a harmonica player, he once made a record of country songs—he depicted various musicians representing its different aspects. Against a backdrop that includes a river steamboat and a steam engine, there are a black banjo player, white fiddlers, hymn singers, a dulcimer player, and a cowboy singer. Although Benton had decided not to portray recognizable stars or individuals, a habit that reaches back to his earliest murals, he captured Tex Ritter's likeness as the singing cowboy, since Ritter, who was instrumental in convincing Benton to paint the mural, died during the course of its preparation.

Benton also wrote autobiographical accounts through the early 1970s. Most accompanied exhibitions of his work, and in them he reexamined his attitudes toward art. Even though he did not change long-held positions, he did modify, if slightly, his insistence on a specifically Americanist point of view. As he wrote in the catalogue

of the retrospective exhibition held in Kansas City in 1974, "Most of the meanings [of my art] are grounded in some aspect of our general American culture, our everyday life, and should be readily discovered by any American who has the will to do so. These meanings are, of course, indeterminate, suggested rather than precisely defined, and open to free interpretation, as I believe they should be. In the end, the meanings of pictures must be found by those who view them." For the mural in Joplin and, no doubt, in Nashville, he invited the viewer, depending on his experiences, to interpret the subject matter in a personal way. Multiple meanings were, for Benton, quite legitimate.

Since Benton had always praised as well as pilloried aspects of American culture, multiple meanings are usually inevitable in any reading of his work. How else to interpret, in the Joplin mural, the juxtaposition of a card game and the Bible or the earnest family of settlers and the sign on the main street advertising a bawdy house? In the country music mural, how else to explain the relative isolation of the black musician from his white counterparts? As in the past, the discovery of American meanings did not always imply the discovery of positive ones. Until the end, Benton tried to see beyond the hypocrisies that govern American attitudes of self-understanding and self-awareness. However well or poorly he accomplished this task will probably be argued for years to come.

Among his late writings, at least one important manuscript has come to light. It is a handwritten account, fifty-three pages in length, describing Benton's activities during the 1930s. (Benton gave me a copy during his lifetime that I passed on to the Archives of American Art, Smithsonian Institution.) The general tone of the essay suggests Benton's desire to set the record straight. In it, he reviews events surrounding the completion of his murals of that decade, he discusses at length his differences with Social Realist artists in New York City, and he reaffirms his own critical responses to America during the Depression. Even though Benton's radical political preferences during the 1920s are well known, it is still surprising to come on passages such as this one. "I made no effort to conceal [to those involved with

commissioning the mural *The Social History of the State of Indiana* in 1932–33] the fact that Marxist economic and political theories had interested me from 1915 to 1930 and openly told of my association with Bob Minor and other communists and how in the early twenties I had conspired with Bob to provide secret meeting places for the persecuted members of the commie [*sic*] party, one of which included my own apartment in New York."

In a different way, the discovery and exhibition in 1981–1982 in an art gallery in New York City of several dozen oil sketches and studies dating from the years around 1915 were equally surprising. Since Benton repudiated his modernist past, and a catastrophic fire in 1917 prohibits reconstructing his early career accurately, these newly found works add considerably to our knowledge of Benton's early artistic concerns. Just as his position as an Americanist calls for further study and redefinition, so does his position as an important first-generation modernist. Despite the fact that we are already well acquainted with Benton, it still seems that we are just beginning to get to know him.

Chronology

Prepared by Thomas Hart Benton

1889

Born Neosho, Newton County, Missouri. Parents "Colonel" Maecenas E. and Elizabeth Wise Benton. Col. Benton served in Confederate Army and settled in Neosho as a lawyer in 1869. He became politically prominent under President Cleveland as U.S. Attorney for the Western District of Missouri, and subsequently went for five terms to the Congress of the United States.

1894–1899

Began drawing Indians and railroad trains. Executed first mural with crayons on newly papered staircase wall in Benton home at Neosho. Work unappreciated. Grade schools in Washington, D.C. First introduced to formal art in the Library of Congress and the Corcoran Gallery in Washington.

1900–1904

Finished grade school. Met Buffalo Bill and saw his Wild West Show. Had first training in art at Western High School in Georgetown. Visited St. Louis World's Fair. Saw first Remington pictures and shook hands with the last fighting Indian chief, Geronimo. Returned, with father's political defeat, to all-year residence in Neosho.

1905–1906

High school in Neosho. Began acquiring steady reading habits in father's library and with dime novels in the hayloft. Continued drawing work in summer of 1906 as surveyor's assistant, rodman, around Joplin, Missouri, mining field. Found position as cartoonist on *The Joplin American*—first professional work as artist.

1906–1907

Attended Western Military Academy at Alton, Illinois, until February, when serious study of art was begun at Chicago Art Institute. Abandoned plans of doing newspaper work and took up painting.

1908–1911

Went to France. Enrolled at Academie Julien, Paris. Made first approach to classic composition and to anatomy and perspective. Learned French. Attended lectures and musical events. Developed life-long attachment to chamber music. Painted in various opposed manners from "Academic" chiaroscuro of Academie Julien to "Pointilist" landscape. Met with many personalities later to become famous in the art world, such as Leo Stein, brother of the famous Gertrude, John Marin, Jacob Epstein, Jo Davidson, Andre L'Hote, Leon Kroll, Diego Rivera, Morgan Russell, and Stanton McDonald Wright. Was an habitué of cafes and studios where problems of new art were vociferously discussed. Stimulated by work in galleries of the Louvre, began the study of art history. Read extensively in French literature, aesthetics, and philosophy, along with classics. Became acquainted with Balzac, Baudelaire, Verlaine, Gautier, de Musset, and other writers who were in vogue at the time. Read Hippolyte Taine's *Philosophie de l'Art*, whose environmental aesthetic was to have its full effect later when American "regionalism" became an issue in the art world. Influenced by Zuloaga, well-known Spanish painter, and became interested in Spanish school. Out of this grew later fascination for El Greco. Left France and returned to America without any defined directions of style.

1912

Stayed a few months at hometown, Neosho, Missouri. Made an abortive effort to settle in Kansas City, then moved on to New York.

1913–1916

Struggled to make a living and find a "way to painting." Occasional commercial art jobs, decorative work in over-glaze ceramics, set designing, historical reference and portrait work for the moving picture industry, then mostly located at Fort Lee, New Jersey, across the Hudson from New York. Worked with directors Rex Ingram and Gordon Edwards, and with such stars of the day as Theda Bara, Clara Kimball Young, Stuart Holmes, etc. Set up a studio in an old house at Fort Lee, and met Walt Kuhn, "Pop" Hart, Arthur B. Davies, and other artists who frequented the west side of the Hudson River. Tried acting, unsuccessfully. Met Alfred Stieglitz and frequented his gallery at 291 Fifth Avenue. Intimates of the period: Rex Ingram, the movie director; Thomas Craven, then a poet and teacher; Willard Huntington Wright, art critic and editor of *Smart Set*, known later as S. S. Van Dine of detective story fame; Ralph Barton, famous caricaturist; and Stanton McDonald Wright, earlier friend who had returned from Paris, a city now war-ridden. In spring of 1916, had first public exhibition with a series of paintings in the Forum Exhibition of Modern American Painting held at Anderson Galleries in New York. These paintings, though mostly "figurative," were variants of the synchromist "form through color" practices of Morgan Russell and S. McDonald Wright. They were highly generalized, purely compositional, and contained no hint of the environmentalist work of later years. Began to sell an occasional picture. Joined People's Art Guild, dominated by socialist theory and founded by Dr. John Weischel, a mathematician, social theorist, and critic well known in "radical" circles of New York. The People's Art Guild was designed to bring art to the workers and to enlist the interest of the unions. At the Friday night discussions of the Guild was introduced to the thinking of Owen, Prud'hon, and Marx. Ideas about the social meanings and values of art were germinated in these discussions. They were to bear fruit later. Met Bob Minor, Max Eastman, John Sloan, Mike Gold, and the other

"radical" artists of the *Old Masses* magazine. Entered into first controversies at Stieglitz 291 gallery on future values of "representational" versus "abstract" art. This was the beginning of a series of controversies on the purpose and meaning of art which was to last for more than thirty years. Met an extraordinary income producing patron, Dr. Alfred Raabe, who would pick up studio experiments, frame them, and sell them to his patients in the Bronx.

1917

Through People's Art Guild obtained position as gallery director and art teacher for Chelsea Neighborhood Association on the lower West Side, which was supported by well-to-do conservatives but followed the social directions of the People's Art Guild. It had little success, but provided a skimpy living in the difficult period of America's entrance into World War I.

1918

Enlisted in the U.S. Navy. Shoveled coal for a month, engaged in Saturday night athletic exhibitions, boxing and westling, and ended up finally as draughtsman at Norfolk Naval Base. Sketched constantly during "off-duty" periods. Spent evenings reading American history.

1919

Returned to New York with Navy discharge and collection of drawings and watercolors of Naval Base activities. Though at times semi-abstract, this was first work based wholly on environmental observations of the American scene. It was shown at the Daniel Galleries in New York and received considerable public attention. Continued reading American history and conceived idea of a series of paintings to illustrate its progressions. This constituted a return to mid-19th century subject painting and involved a definite break with modern theory, which was moving away from repre-

sentational concerns toward pure abstraction. Started tentative designs for this historical project and, to increase their objectivity, began modeling the designs in clay. This was a frank return to Renaissance method. The emphasis involved, on chiaroscuro and realistic form rather than color patterns, caused another step away from accepted modern theories.

1920–1924

Continued moving toward "realistic" subject painting and present style of painting now developed, largely determined by practice of modeling compositions. Pictures began attracting considerable attention and argument. Participated in 1922 Philadelphia Exhibition of Modern Americans and sold a large work to the famous Philadelphia collector, Albert C. Barnes. Married Rita Piacenza. Began diagrammatic analysis of the compositional history of occidental painting. This project was undertaken for Albert Barnes but, because it failed to jibe with his growing "color-form" theories, it led to disagreement and was never finished. Sections of it were later published in the *Arts Magazine* (1926–1927). Began showing series of paintings on American historical themes at the Architectural League in New York. These were mural-size works. They were controversial because, with their sculptural and three-dimensional character, they were in opposition to prevalent beliefs of architects and critics that mural paintings should not break wall surfaces but remain flat and linear in the manner of the French muralist, Puvis de Chavannes. Published first theoretical paper, "Form and the Subject," in *Arts Magazine*, June 1924. During the period, began exploring the back countries of America by foot, bus, and train, searching out American subject matter.

1925–1927

Gave series of lectures on art at Dartmouth College and at Bryn Mawr College. Thomas P. Benton, first child, born in New York City in 1926. Through influence of the famous draughtsman, Boardman Robinson, obtained permanent teaching position at the Art Students League in New York, which supplied a much needed basic income. Debated with Frank

Lloyd Wright on architecture and mural painting at Brown University, Providence, Rhode Island. Debate punctuated with complete disagreements on relation of architecture and painting. Purchased permanent summer home on Island of Martha's Vineyard, Massachusetts.

1928–1929

Joined with Clemente Orozco, famous Mexican painter then living in New York, in exhibitions at the Delphic Galleries. Showed drawings and paintings of the current American scene, the outcome of the exploratory travels mentioned earlier. Among paintings were "Boomtown," now at Rochester Museum; "Cotton Pickers," now at Metropolitan Museum in New York; also "Rice Threshing," now at Brooklyn Museum. Received commission with Orozco to do murals for the New School for Social Research. These murals were executed for little more than expenses, but offered opportunity for a public trial of the new mural styles.

1930–1931

Drawing upon mass of factual material gathered in travels, the New School mural, *Modern America*, was painted. This was the first large-scale American work executed with egg tempera. It was both widely praised and heavily criticized. Reproductions were published in magazines and newspapers all over the world. Through Thomas Craven, met John Steuart Curry. Because of similar beliefs and interests, an enduring tie was made with Curry. It lasted until his death.

1932

Received commission from Mrs. Juliana Force to do murals for library of Whitney Museum of American Art. Finished and unveiled in December. These murals again drew sharp criticism. Fellow instructors at the Art Students League drew up a round robin letter of condemnation. The *New Republic* published a special article on the mural's inadequacies. Represent-

ing facets of ordinary American life and folk lore, the Marxist group of New York attacked the work as a form of chauvinism, as politically reactionary and "isolationist." A "question-answer" appearance on the meaning of the murals at the John Reed Club, the center of artistic and literary radicalism in New York, wound up in a chair-throwing brawl and resulted in the loss of many old radical-minded friends. From this time on, "American Regionalist" works would never be free of the political charges—"reactionary" or "isolationist."

1933

Given Gold Medal of Architectural League for mural work. Received commission and executed mural for the State of Indiana. This mural, 200 feet long by 12 feet high, was researched, planned, and executed in six months of intensive labor. Covering the theme of social evolution of Indiana, it was shown as Indiana's exhibit at the 1933 Chicago World's Fair. It now is installed in the University of Indiana Auditorium at Bloomington. The work was well received. Criticism was leveled chiefly at the propriety of the subject matter. The inclusion of Indiana's Ku Klux Klan episode drew most of the objection.

1934

Received commission from Treasury Department for a mural in new Federal Post Office in Washington, D.C. Abandoned work during planning stages because of difficulties in accommodating artistic ideas to those of Treasury Art Commission. Took on a country-wide lecture tour on American Art. Speaking at Iowa University met Grant Wood, and, as with Curry, established an intimate and enduring friendship. After a lecture at Kansas City Art Institute, went with brother, Nat Benton, and State Senator Ed Barbour, to Jefferson City, where preliminary discussions about a mural for Missouri State Capitol were begun. Returning to New York, had exhibit of paintings at Ferargil Galleries along with Grant Wood and John S. Curry, and thus became permanently associated with "Regionalism" or the "Regionalist School." There was no such "school," but the

designation "regionalist" stuck. *Time* magazine catapulted the "school" into national attention with a Benton self-portrait in color on its cover and a well-documented article on the "New American Art." Gave lecture to a large audience at the Art Students League Auditorium on "American Art and Social Realism." Bitter debate from the floor. This was followed by attacks in art magazines and pamphlets on "provincialism" of regionalist aesthetics.

1935

Received commission for mural in Missouri State Capitol, along with a request to head department of painting at Kansas City Art Institute. Seeing in the latter a chance to escape continuing New York controversy, promptly accepted. Moved to Kansas City. Spent the year teaching and planning Capitol mural.

1936

Executed Missouri mural. Here again, a storm of criticism arose, mostly, as in Indiana, about subject matter. Mural was given wide attention in the press. It eventually came to please, or at least interest, most Missourians, and remains on the Capitol walls.

1937–1938

Reported on "sit-down" strikes in Detroit for *Life* magazine with a series of on-the-spot sketches. Made for same magazine a painting and a forty-drawing commentary on Hollywood and the movie industry, latter not published. Made series of drawings on 1937 floods in Southeast Missouri for *St. Louis Post Dispatch* and *Kansas City Star*. Wrote and illustrated (1938) an article for *Scribner's* magazine on Disney, Oklahoma, then on the boom. Painted "Susannah and the Elders." This once controversial nude now in Museum of the Palace of the Legion of Honor at San Francisco.

Began a series of lithographs on the American scene for Associated American Artists of New York, which eventually ran to some fifty stones. Sold "Cradling Wheat" to St. Louis Art Museum.

1939

Illustrated *Tom Sawyer* for George Macy's Limited Editions. Became interested in texture, an aspect of painting neglected during years predominately devoted to murals. Painted "Persephone," another highly publicized nude. Purchased present Kansas City home. Jessie P. Benton born. Had retrospective exhibition at William Rockhill Nelson Gallery in Kansas City, which went afterward to Associated American Artists' new galleries in New York. From this exhibition, Metropolitan Museum purchased its second Benton, "Roasting Ears." All except the very large works in this exhibition were sold. This was first substantial success with a New York exhibition.

1940–1942

Illustrated John Steinbeck's *Grapes of Wrath* for Limited Editions. Lecture tour, teaching experiments with texture painting and increased coloration. New interest in Flemish paintings stimulated partly by Grant Wood and partly by exhibitions of such paintings held at Nelson Gallery in Kansas City. Fired from position at Kansas City Art Institute after various disagreements with trustees. Illustrated *Huckleberry Finn* for Limited Editions. Made an album of flute, harmonica, and voice with son, Thomas P., an accomplished flutist, and Frank Luther's singers for Decca records, "Tom Benton's Saturday Night." Music based on American folk songs, especially composed for album. Was lecturing in Cincinnati, Ohio, when news of Pearl Harbor was released. Returned to Kansas City and commenced series of war paintings designed to help awaken American public to dangers of the moment. This series was purchased by Abbott Laboratories of Chicago. Reproduced in full color, it was presented in book and poster form to U.S. Government for propaganda use. Distribution of reproductions ran to

18,000,000 copies. Exhibition of original paintings at Associated American Artists in New York attracted 75,000 people. Paintings were later presented by Abbott Laboratories to Missouri Historical Society at Columbia. Painted "Negro Soldier," also now at Missouri Historical Society, and "Prelude to Death," World War II embarkation scene.

1943–1944

Continued paintings and drawings of the war for Abbott Laboratories and U.S. Government. Visited industrial plants, training camps, oil fields. Went to sea on submarine, and down Ohio and Mississippi and into Gulf of Mexico on L.S.T. Illustrated Mark Twain's *Life on the Mississippi* for Limited Editions. By end of 1944, returned to normal painting activity. Wrote article on Grant Wood (now deceased) for *University of Kansas City Review*.

1945

Made Honorary Member of Argentine Academia Nacional de Bellas Artes. Productive year. Among paintings, "July Hay," was third to go to Metropolitan Museum. "Flood Time," now in collection of Harpo Marx, and "Custer's Last Stand," now in the Richard Russell collection, Scarsdale, New York.

1946

Exhibition of paintings at Chicago galleries of Associated American Artists. Chicago press generally receptive, although an echo of the old New York charge of "provincial" was heard. Received commission for mural at Harzfeld's store in Kansas City. Went to Hollywood and worked with Walt Disney on plans for an American operetta on the theme of Davy Crockett. Could not accommodate to Disney needs and abandoned project.

Errata

The following copy replaces the 1949 entry and adds the missing years through 1964.

1949

Returned to Europe. In Italy, made honorary member of L'Accademia Fiorentina delle Arti del Disegno at Florence, and of Accademia Senese degli Intronati at Siena. Revisited Paris. Had a hard time reviving French, which now had a Missouri accent.

1951

Retrospective exhibition at Joslyn Museum, Omaha, Nebraska. Added chapter to a new edition of *Artist in America,* which reawakened old New York controversies about "regionalism" in the *Saturday Review of Literature.*

1952-1953

Revisited France and Italy. Returned to America with Admiral James Flateley on U.S.S. *Block Island.* Made lithograph illustrations for University of Oklahoma Press limited editions of Lynn Riggs' *Green Grow the Lilacs.* Painted Lincoln mural for Lincoln University at Jefferson City, Missouri.

1954

New York's Whitney Museum, moving to new quarters, gave its Benton murals to Museum of New Britain, Connecticut. Along with exhibition of murals, the Institute staged a retrospective showing of Benton paintings. Institute also purchased portrait of *Dennys Wortman* and portrait of *Benton* by Dennys Wortman.

1955

Made study trip to Spain. Received commission for, and began planning mural, *Old Kansas City,* for Kansas City River Club.

1956

Finished River Club mural and received commission from Power Authority of the State of New York for a mural representing discovery of the St. Lawrence River by Jacques Cartier. Began research and planning for work.

1957

Executed St. Lawrence mural, now installed in New York Power Authority administration building at Massena, New York. Received honorary degree of Doctor of Letters from Lincoln University, Jefferson City, Missouri.

1958

Painted the *Sheepherder,* an interpretation of the Grand Teton Mountains in Wyoming. Now divided time between home in Kansas City and summer home on Martha's Vineyard. Occasionally lectured and taught at University of Kansas City, and elsewhere. Signed a contract with the Truman Memorial Library, Independence, Missouri, for an historical mural on the theme *Independence and the Opening of the West,* and another with the Power

Authority of the State of New York for a mural on *The Discovery of Niagara Falls by Father Hennepin.*

1959

Worked on plans for above murals. Researched in the field and at museums and historical societies. Found models for Pawnee and Cheyenne Indians through help of Charles Banks Wilson, Oklahoma artist, and Brummit Echo Hawk, Pawnee artist. With Wilson went along as much of Old Santa Fe Trail as could be found, to the site of Bent's Fort, and beyond to Spanish Peaks in South Colorado Rockies. For Oregon Trail section of Truman mural, was driven by Aaron Pyle, West Nebraska artist, to Chimney and Courthouse Rocks, landmarks of Oregon Trail. Books of drawings made on research trips.

1960-1961

Finished mural designs. November 17, 1960, started execution of Truman mural. Installed canvas in studio seven feet by twenty feet for Niagara mural. Planned to work on this when weather was too bad to get over to the Truman Library at Independence. Finished both murals in the spring of 1961. Developed bad bursitis condition while working on Truman mural which went over whole body. Finished both murals under cortisone treatment. Dedication of Truman mural was presided over by President Truman and Chief Justice Earl Warren. It was a memorable occasion.

1962

Overcame bursitis condition and effects of cortisone. Decided, however, that I was getting too old for mural work and began thinking again in terms of easel painting. In May 1962, my hometown of Neosho gave me a "homecoming celebration." This was a delightful honor. President and Mrs. Truman went with a whole special trainload of friends from Kansas City to the celebration. Only a small handful of the friends of my youth were left in Neosho. Elected member of the National Academy of Arts and Letters.

1963

Revisited Wyoming in summer on a sketching trip. Painted a complicated composition of *The Twist* dance scene.

1964

In good physical shape again. Made interesting trip into Canadian Rockies. Rode horseback from Banff to Assineboine. Nine and a half hours of riding divided into two days. First horse ride in many years, certainly more than thirty years. Made a series of drawings of Mt. Assineboine, and, in the autumn, started a large painting from these.

1947

Executed Harzfeld's mural, *Achelous and Hercules*. Encyclopedia Britannica made film of mural's technical progressions which had international distribution.

1948

Wrote article on John Steuart Curry, after his death, for *University of Kansas City Review*. Began intense study of West—New Mexico, Utah, and Wyoming. These areas began taking place of Middle West and South, which had heretofore furnished bulk of "regionalist" subjects. Received honorary degree of Doctor of Arts from University of Missouri. Made honorary Phi Beta Kappa.

1949

Returned to Europe. In Italy, made honorary member of L'Accademia Fiorentina delle Arti del Disegno at Florence, and of Accademia Senese degli Intronati at Siena. Revisited Paris. Had a series of drawings of Mt. Assineboine, and, in the autumn, started a large painting from these.

1965

Finished painting of Assineboine, called "Trail Riders." Resigned from American Academy of Arts and Letters because of an inappropriate and compromising political speech by the organization's president. Went on a long exploratory expedition up the Missouri River from Omaha, Nebraska, to Three Forks, Montana, and from there into the "Rendezvous" area of the Wind River Mountains in Wyoming. Five weeks' trip, following routes of Lewis and Clark and the fur traders and trappers. Went, in autumn, to Italy for two months to try hand (in American sculptor-painter Harry Jackson's Italian studio) at bronze sculpture. Learned modeling in

wax. Made tour, Orvieto to Venice, across Apennines. Revisited Padova, Bologna, Florence, etc.

1966

Mr. Lyle Woodcock, St. Louis collector, set up exhibition of Benton paintings, drawings, and lithographs at Illinois College, Jacksonville, Illinois. Well received. Had "stroke," followed by heart attack. Remained in hospital five weeks. Recovered, but mode of life would have to change. Now among the "old folks." Large retrospective in Detroit, Michigan, in October. Reelected to American Academy of Arts and Letters under sponsorship of Alan Nevins, American historian and new president of Academy.

1970

Painting continued as it had always. Executed self-portrait, with hands, showing old man getting older but still going. Made new lithograph of portrait. Sculpture, with five figures, of football subject was put underway.

1971

Football sculpture cast in bronze. Commission offered, and accepted, for mural celebrating 100th anniversary of the incorporation of the City of Joplin, Missouri.

1972

Completed Joplin mural in April. Spent four months of the summer building a stone retaining wall to control erosion on our beach at Martha's Vineyard. The wall is sixty feet long, from four to seven feet thick, and in some places twelve feet high. For moving the larger stones I had the help of younger men, John, Dick, Mark, and Eddie, but I did most of the work

myself. If the wall stands up to its purpose, I shall have defeated one of the forces of nature and thus arrived at my greatest achievement. Immediate side achievement—lost pot belly.

1973

Went to Joplin for its Centennial celebration and the unveiling of the mural.

1975

Thomas Hart Benton died January 19 in Kansas City. Final mural, *The Sources of Country Music*, dedicated at Country Music Hall of Fame and Museum in Nashville, Tennessee, in July.

Bibliography

Catalogues and Collections of the Works of Thomas Hart Benton

The Arts of Life in America: A Series of Murals by Thomas Benton. New York: Whitney Museum of American Art, 1932.

Benton's Bentons: Selections from the Thomas Hart Benton and Rita P. Benton Trusts. Catalogues and essays by Elizabeth Broun, Douglas Hyland, and Marilyn Stokstad. Lawrence, Kans.: Spencer Museum of Art, 1980.

Benton Drawings: A Collection of Drawings by Thomas Hart Benton. Columbia: University of Missouri Press, 1968.

Catalogue of a Loan Exhibition of Drawings and Paintings by Thomas Hart Benton with an Evaluation of the Artist and His Work. Chicago: The Lakeside Press Galleries, 1937.

A Descriptive Catalogue of the Works of Thomas Hart Benton. Spotlighting the Important Periods during the Artist's Thirty-two Years of Painting with an Examination of the Artist and His Work by Thomas Craven. New York: Associated American Artists, 1939.

Fath, Creekmore, comp. and ed. *The Lithographs of Thomas Hart Benton.* Rev. ed. Austin: University of Texas Press, 1979.

"Thomas Hart Benton: An Artist's Selection, 1908–1974." *Nelson Gallery and Atkins Museum Bulletin* 5:2 (1974).

Thomas Hart Benton: A Giant in American Art. Catalogue of an exhibition held at University Art Gallery, University of Arizona, Tucson, 1963.

Thomas Hart Benton: A Comprehensive Exhibition of Drawings, Watercolors, Oils and Temperas. Preface by Henry A. La Farge. New York: Graham Gallery, 1968.

Thomas Hart Benton: A Personal Commemorative. A Retrospective Exhibition of His Works, 1907–1942. Joplin, Mo.: Spiva Art Center, Missouri Southern State College, 1973.

Thomas Hart Benton: A Retrospective Exhibition of the Works of the Noted Missouri Artist. Presented on the Patronage of the Honorable Harry S Truman and Mrs. Truman of Independence, Mo., April 12 to May 18, 1958. Lawrence: University of Kansas Museum of Art, 1958.

Thomas Hart Benton: A Retrospective of His Early Years, 1907–1929. Introduction by Phillip Dennis Cate. New Brunswick, N.J.: Rutgers University Art Gallery, 1972.

Thomas Hart Benton's Illustrations from Mark Twain: The Adventures of Tom Sawyer, The Adventures of Huckleberry Finn, Life on the Mississippi. Introduction by Sidney Larson. Kansas City: Mid-American Arts Alliance, 1976.

The Year of Peril: A Series of War Paintings by Thomas Benton. Foreword by Archibald MacLeish. Chicago: Abbott Laboratories, 1949.

Written by Thomas Hart Benton

"America and/or Alfred Stieglitz." *Common Sense* 4:1 (January 1935): 22–25.

An American in Art: A Professional and Technical Autobiography. Lawrence: The University Press of Kansas, 1969.

"American Regionalism: A Personal History of the Movement." *University of Kansas City Review* 18 (Autumn 1951): 41–75.

"America's Yesterday." *Travel* 63 (July 1934): 6–11, 45–46.

"Answers to Ten Questions." *Art Digest* 9 (15 March 1935): 20–21.

"Art and Nationalism." *Modern Monthly* 8 (May 1934): 232–36.

"Art and Reality: Reflections on the Meaning of Art in the Social Order." *University of Kansas City Review* 16 (Spring 1950): 9–11, 38.

"Art and Social Struggle." A Reply to Rivera. *University of Kansas City Review* 2 (Winter 1935): 71–78.

"Art vs. the Mellon Gallery." *Common Sense* 10:6 (June 1941): 172–73.

"Blast by Benton." *Art Digest* 15 (15 April 1941): 6, 19.

"Business and Art from the Artist's Angle." *Art Digest* 20 (15 January 1946): 8, 31.

"Confessions of an American." *Common Sense* 6:7 (July 1937): 7–9; 6:8 (August 1937): 10–14; 6:9 (September 1937): 19–22.

"The Dead and the Living." *University of Kansas City Review* 7 (March 1941): 171–76.

"Death of Grant Wood." *University of Kansas City Review* 8 (Spring 1942): 147–48.

"Disaster on the Kaw." *New Republic* 125 (19 November 1951): 9–11.

"Form and Subject." *The Arts* 5:6 (June 1924): 303–8.

Independence and the Opening of the West. Independence, Mo.: Harry S Truman Library, 1961.

"John Curry." *University of Kansas City Review* 8 (Winter 1946): 87–90.

"Mechanics of Form Organization in Painting." *The Arts* 10:5 (November 1926): 285–89; 10:6 (December 1926): 340–42; 11:1 (January 1927): 43–44; 11:2 (February 1927): 95–96; 11:3 (March 1927): 145–58.

"My American Epic in Paint." *Creative Arts* 3 (December 1929): xxx–xxxvi.

"The Nature of Form." *University of Kansas City Review* 17 (Autumn 1950): 9–32.

"The New American Art." *St. Louis Post-Dispatch*, 11 December 1938.

"The Ozarks." *Travel & Leisure* 3:3 (June–July 1973): 30–33.

"Painting and Propaganda Don't Mix." *Saturday Review of Literature* 43 (24 December 1960): 16–17.

"Random Thoughts on Art." *New York Times Magazine*, 28 October 1962, p. 42.

"Thirty-six Hours in a Boom Town." *Scribner's Magazine* 104, no. 4 (October 1938): 16–19, 52–53.

A Thomas Hart Benton Miscellany: Selections from His Published Opinions, 1916–1960. Edited by Matthew Baigell. Lawrence: The University Press of Kansas, 1971.

"To the Artists of Brazil: An Exchange of Letters." *University of Kansas City Review* 10 (Summer 1944): 245–49.

"What's Holding Back American Art?" *Saturday Review of Literature* 34 (15 December 1951): 9–11, 38.

"Year of Peril: Text and Paintings." *University of Kansas City Review* 8 (Spring 1942): 178–88.

Illustrated by Thomas Hart Benton

Amlie, Thomas R. "How Radical Is the New Deal?" *Common Sense* 5, no. 8 (August 1936): 21–24.

―――. "In Darkest Cleveland." *Common Sense* 5, no. 7 (July 1936): 8–11.

Chambers, David Laurance. *Indiana: A Hoosier History Based on the Mural Paintings of Thomas Hart Benton.* n.p., 1939.

Eifert, Virginia S. *Three Rivers South: The Story of Young Abe Lincoln.* New York: Dodd, Mead & Co., 1953.

Enslow, Ella, with Alvin F. Harlow. *Schoolhouse in the Foothills.* New York: Simon and Schuster, 1935.

Franklin, Benjamin. *The Autobiography of Benjamin Franklin and Selections from His Writings.* With an Introduction by Henry Steele Commager. New York: Illustrated Modern Library, 1944.

Huberman, Leo. *We, The People.* New York: Harper and Brothers, 1932.

Mencken, H. L., George Jean Nathan, and Willard Huntington Wright. *Europe After 8:15.* New York: John Lane Co., 1914.

Packman, Francis. *The Oregon Trail.* Limited Editions Series. New York: Doubleday & Co., 1946.

Riggs, Lynne. *Green Grow the Lilacs: A Play.* Introduction by Brooks Atkinson.

Printed for members of the Limited Editions Club. Norman: University of Oklahoma Press, 1954.

Steinbeck, John. *Grapes of Wrath*. New York: The Limited Editions Club, 1940.

Stuart, Jesse. *Taps for Private Tussie*. New York: E. P. Dutton & Co., 1943.

Twain, Mark. *Adventures of Huckleberry Finn*. Edited with an Introduction by Bernard De Voto. New York: Limited Editions Club, 1942.

———. *Adventures of Tom Sawyer*. With an Introduction by Bernard De Voto. Cambridge, Mass.: Limited Editions Club, 1939.

———. *Life on the Mississippi*. With an Introduction by Edward Wagenknecht. Edited by Willis Wager. New York: The Heritage Press, 1944.

About Thomas Hart Benton

Abrahams, E. "Alfred Stieglitz and/or Thomas Hart Benton." *Arts* 55 (June 1981): 108–13.

American Artists Group. *Thomas H. Benton*. Monograph no. 3. New York: American Artists Group, 1945.

Ayers, D. Drummond. "Benton Returns to His Home Country." *New York Times*, 26 March 1953, p. 54.

Baigell, Matthew. "Benton in the 1920's." *Art Journal* 29:4 (Summer 1970): 422–29.

———. *Thomas Hart Benton*. New York: Harry N. Abrams, 1974.

Baigell, Matthew, and A. Kaufman. "Missouri Murals: Another Look at Benton." *Art Journal* 36: 4 (Summer 1977): 314–21.

Beer, Richard. "The Man from Missouri." *Art News* 43 (24 January 1943): 11.

"Benton Depicts America Aggressively for the Whitney Museum." *Art Digest* 7 (15 December 1932): 5.

"Benton Goes Home." *Art Digest* 9 (15 April 1935): 13.

"Benton Holds First Show in Four Years." *Art Digest* 8 (15 April 1934): 15.

"Benton in Indiana." *Art Digest* 7 (1 March 1933): 20.

"Benton in New Set of Murals Interprets the Life of His Age." *Art Digest* 5 (1 December 1930): 28, 36.

" 'Benton Is Getting Better' Say N.Y. Critics." *Art Digest* 15 (15 April 1941): 6.

"Benton Taps the Heart of America in Monumental Indiana Mural." *Art Digest* 7 (1 July 1933): 5, 12.

Boswell, Peyton. "Benton Sounds Off." *Art Digest* 15 (15 April 1941): 3.

Burroughs, Polly. *Thomas Hart Benton: A Portrait*. Garden City, N.Y.: Doubleday and Co., 1981.

Canady, John. "Tom Benton of Mazura Comes Back to Joplin—Grown Up." *New York Times*, 8 April 1973, sec. D, p. 25.

————. "Young Artist En Route to the U.S.A." *New York Times*, 8 April 1973, sec. D, p. 27.

Chirico, R. F. "Benton and Pieter Bruegel." *Arts* 54 (September 1979): 148–49.

Cohen, George Michael. "Thomas Hart Benton: A Discussion of His Lithographs." *American Artist* 26:7 (September 1962): 22–25, 74–77.

Craven, Thomas Jewell. "Thomas Hart Benton." *Showland Magazine* (September 1921): 11.

————. "Thomas Hart Benton." *Scribner's Magazine* 102:4 (October 1937): 33–40.

————. "Thomas Hart Benton, American Painter." *The Nation* 120 (7 January 1925): 22.

Dark, Harris Edward. "Thomas Hart Benton Paints Again." *Modern Maturity* 16:3 (June–July 1973): 34–39.

Devree, Howard. "Benton Returns." *Magazine of Art* 32:5 (May 1939): 301–2.

Edelman, Nancy. *The Thomas Hart Benton Murals in the Missouri State Capitol: A Social History of the State of Missouri*. Kansas City: Missouri State Council on the Arts, 1975.

Farber, Manny. "Thomas Benton's War." *New Republic* 106 (20 April 1942): 542–43.

Flint, Rolf. "Modernity Rules New School for Social Research." *Art News* 29 (17 January 1931): 3–4.

Glassgold, C. Adolph. "Thomas Benton's Murals at the New School for Social Research." *Atelier* 1 (April 1931): 284–87.

Goodrich, Lloyd. "In Missoura." *Arts* 6 (December 1924): 338.

————. "The Murals of the New School for Social Research." *Arts* 17 (March 1931): 399–403, 442, 444.

"Greater America in the Drawings of Thomas Benton." *Art News* 36 (30 October 1937): 16.

"Interview with Thomas Hart Benton." *New York Times*, 8 February 1935, p. 23.

Janson, H. W. "Benton and Wood, Champions of Regionalism." *Magazine of Art* 39:5 (May 1946): 184–86, 198–200.

Jones, Robert F. "The Old Man and the River." *Sports Illustrated* 33:6 (10 August 1970): 28–34.

Keese, V. A. "Regionalism: The Book Illustrations of Benton, Curry and Wood." Ph.D. dissertation, University of Georgia, 1972.

Koshkin-Youritzin, Victor. "Thomas Hart Benton: 'Bathers' Rediscovered." *Arts* 54 (May 1980): 98–102.

Lawless, Ray M. "Thomas Hart Benton's Jealous Lover and Its Musical Background." *Register of the Museum of Art* (University of Kansas, Lawrence) 11, no. 6 (June 1961): 32–39.

Levin, G. "Thomas Hart Benton, Synchromism, and Abstract Art." *Arts* 56 (December 1981): 144–48.

Lieban, Helen. "Thomas Benton, American Mural Painter." *Design* 36:5 (December 1934): 26–35.

McRoberts, J. W. "The Conservative Realists' Image of America in the 1920s: Modernism, Traditionalism and Nationalism." Ph.D. dissertation, University of Illinois, Champaign-Urbana, 1980.

McWhirter, William A. "Tom Benton at Eighty, Still at War with Bores and Boobs." *Life* 67 (3 October 1969): 64–66.

Morrison, I. G. *Thomas Hart Benton Murals, Missouri State Capitol: An Interpretative Lecture.* n.p., n.d.

Mumford, Lewis. "An American Epic in Paint." *New Republic* 50 (6 April 1927): 197.

————. "Thomas Hart Benton." *Creative Arts* 3: 6 (December 1928): xxxvii.

Pearson, Ralph M. "The Artist's Point of View: Thomas Benton Paints Missouri." *Forum and Century* 97 (June 1937): 367.

Pickering, Ruth. "The Restless World of Thomas Benton." *London Studio* 115 (June 1938): 324–29.

————. "Thomas Hart Benton on His Way Back to Missouri." *Arts and Decoration* 42:4 (February 1935): 15–20.

Polcari, S. "Jackson Pollock and Thomas Hart Benton." *Arts* 53 (March 1979): 12–24.

Singer, Esther Forman. "Thomas Hart Benton: Still Youthful at 85." *American Artist* 38 (November 1974): 48–53.

"Thomas H. Benton Conceives a New Styled Mural Painting." *Art Digest* 1 (1 March 1927): 7.

"Thomas H. Benton Paints the History of Missouri, Starts a Civil War." *Art Digest* 11 (1 February 1937): 10–11.

"Thomas Hart Benton, American Modern." *Survey* 57 (1 October 1926): 31–34.

"Tom Benton in Omaha." *Newsweek*, 3 December 1951, pp. 56–57.

Vaughan, Malcolm. "Up from Missouri." *North American Review* 245 (Spring 1938): 82–93.

"The War and Thomas Benton." *Art Digest* 16 (15 April 1942): 13.

Wernick, Robert. "Down the Wide Missouri with 'an old s.o.b.'" *Saturday Evening Post* 238 (23 October 1965): 92–97.

Wright, Willard Huntington. "Modern Art: An American Painter of Promise." *International Studio* 61 (May 1917): xcv–xcvi.

Yeo, Wilma, and Helen K. Cook. *Maverick with a Paintbrush: Thomas Hart Benton.* Garden City, N.Y.: Doubleday & Co., 1977.

Zigrosser, Carl. *The Artist in America.* New York: Alfred A. Knopf, 1942.